By My Hands

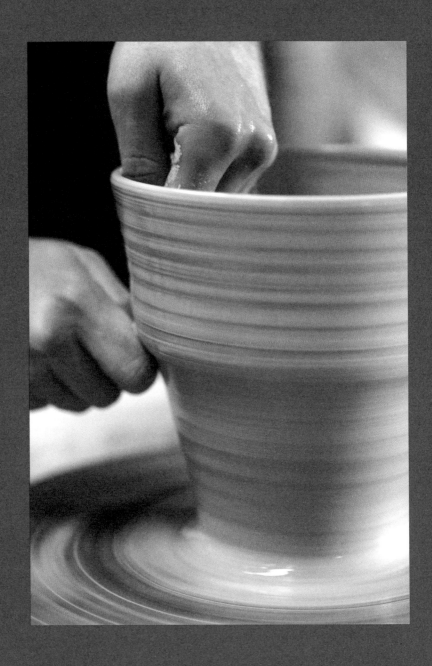

By My Hands
A Potter's Apprenticeship

Florian Gadsby

TEN SPEED PRESS
California | New York

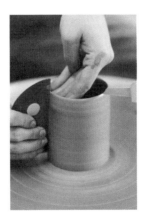

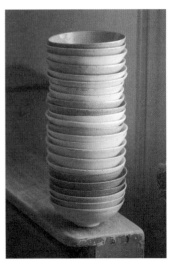

Kings Langley

Where I discover clay

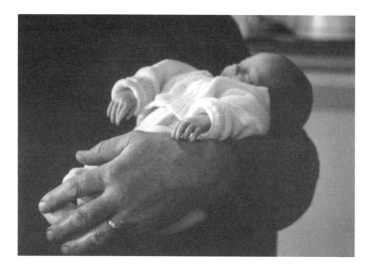

Three weeks old, in the hands of my grandfather,
Frank Gadsby. I never really knew him, since
he died when I was four. He's still remembered,
though, notably for his kindness.

Holly Cottage, our idyllic small house in the
countryside, surrounded by acres of green.

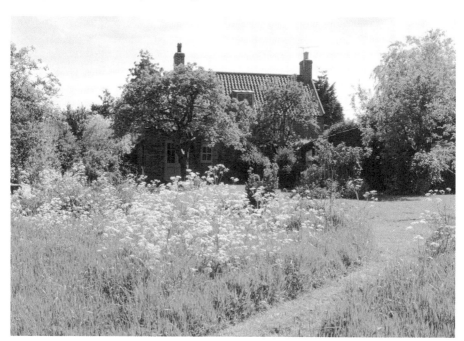

I SOMETIMES FEEL as if my life didn't really begin until I started throwing pots. Until the age of sixteen I more or less lived online, peering into a virtual world. After arriving home from school, one that was so focused on craft, community and, often, spirituality, I would come in and switch on a screen to forget reality. My hands were moulded around a lump of plastic, a video-game controller, but this was soon to be replaced by a lump of soft, malleable clay.

I was born two months premature, incubated, only a speck in my grandfather's sturdy hands. We lived in a quiet village in Norfolk called Maypole Green, where hedges, dank ponds and furrowed fields make up a majority of my memories from this time and all I have left are fleeting sounds, smells and stories I've been told. Our home was surrounded by what I remember as dense, monolithic hedgerows and we spent our time outside in the garden, running in the neighbouring fields, building dens and climbing branchy, wavering trees. We followed the tails of our cats who lived happily in the abundant greenery, apart from Dotty, a mean, scrawny white cat, spotted black, who would hiss hellfire as soon as we tried to stroke her.

I was six years old when we moved to London in 1998. My father's commute into the city had become untenable and so we left the green surroundings for residential – and still comparatively green – north London, packing everything into a house on a corner next to Alexandra Park. We were downsizing, and my father still tells the story of how he burnt many of his belongings in a heaped bonfire prior to leaving, both as a means of accommodating his possessions in a smaller home and as an expression of protest, since he really loved the countryside.

My father, Mark, spent decades working in advertising; he was a successful art director and travelled relentlessly, even assisting in introducing McDonald's to the UK at one point, but his heart was really in making, in craft. Alongside his career he pursued this passion, and throughout his life he has also been, and still is, a woodworker, metalworker and jeweller, and an acclaimed illustrator. He has long blond hair, like me and my brother, a kindly, crooked smile and thick-rimmed spectacles – the resemblance we share is at times uncanny.

My mother, Kate, is a photographer and gardener. As a parent she is carefree and never once questioned the choices I'd make in my life. She's sharp and keen-eyed, quickly loses her temper and has a vast knowledge of the world, languages and the plants she surrounds herself with. She cared for Anatole and me, photographing gardens whilst we were in school. Tolly, which is what I've called my brother since I learnt to speak, is four years older than me. He has my dad's blue eyes; I have my mum's freckled brown. He's left-handed like my dad, I'm right-handed like my mum. We grew up in houses crowded with pots, paintings and sculpture. My father even made pots of his own, the pieces once photographed by my mother, a picture that has come to sum up my life quite succinctly.

The new house was in a leafy part of the city, in an area built up with rows upon rows of houses running up and down the surrounding hills. It was all new to me, with vistas limited by buildings wherever I looked. As we first drove into London on the dreaded moving day we stopped on the side of the motorway, the skyline glinting in the distance, and I followed the ever-dwindling, glowing streetlights along the twisting road as they disappeared into the skyscrapers on the Isle of Dogs. That was in August, a few days before my birthday, and just a few days later I started at my new school in Kings Langley, which was a Waldorf Steiner school. In 1919, a year after the Great War ended, the educator and spiritualist Rudolf Steiner visited Waldorf-Astoria-Zigarettenfabrik, a cigarette factory in Germany. Emil Molt, the owner of the

My father's porcelain pots, captured on film by my mother. He learnt pottery as a release from the mayhem of working at Saatchi & Saatchi. I can't remember ever being *in* his metalwork shop, but I certainly recall the sound of beating metal and the slick smell of polish. He hammered tableaux that were photographed and used to illustrate the *New Scientist*, and crafted the symbol that represented Britain's millennium celebrations at the Dome in London.

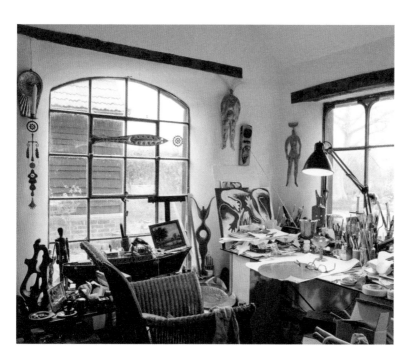

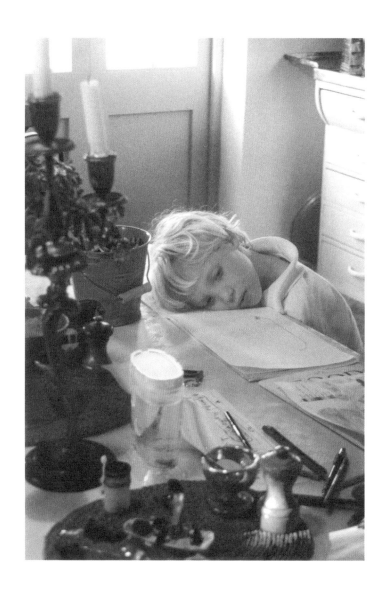

Home after primary school, with the outline drawing
of a battle-tank in front of me, drawn by my father
for me to colour in. Resting my head on our forever-
crammed kitchen table, Sea-Monkeys and all.

factory, asked Steiner if he'd like to set up a school for the workers' children – the doors opened later that year and the first Waldorf Steiner school was established. The curriculum was based on Steiner's anthroposophical philosophy (which encompassed the arts, architecture, agriculture and medicine) alongside the more traditionally academic school subjects. Anthroposophy is a way of life, a spiritual movement even, which claims to link the arts, the sciences and religion, aiming to nurture the soul in each of us and in human society as a whole. Steiner thought that we, as humans, were fashioned from spirit, soul and body, and that these developed throughout childhood and into adolescence.

I went into this education at six years old and found myself in a system that I adored, but which also contained some highly dubious ideas, embracing a multitude of pseudosciences – if you look far enough back, you'll discover that Steiner himself had some rather frightening ideas concerning race and ethnicity. During all my time at Kings Langley, though, I can count on one hand the number of times we were taught anything actually anthroposophical. Steiner's philosophies may have created the underlying infrastructure for how these schools are run, and many of his ideas remain, but many others have become outdated over the past century and aren't taught – or, at least, they never were to us.

My parents decided that my brother and I would go there after visiting the school with friends to pick up their kids. They saw young children playing in lush gardens, where there was an emphasis on exploring and being outside, on playing, on socializing and singing together. The school wasn't rigorously academic and the teachers they spoke to made it apparent that they wanted to focus on the children simply being themselves. I've never been a spiritual person, my family certainly isn't either and even though we spent singing lessons chanting hymns, we also sang The Beatles and Frank Zappa. For me, singing the Lord's Prayer had nothing to do with religion; instead, I revelled in the comradeship of being

in a choir. Singing together, working well together and functioning as a community is, to me, what this system taught exceedingly well.

The Goetheanum, the building in Switzerland at the centre of this anthroposophical movement, looks quite unlike anything else. The exterior is built entirely from cast concrete that was poured into giant wooden moulds crafted by boat builders, for the obvious reason that they knew how to craft seamless, curvaceous structures. Right angles are few and far between and even if you search you'll have a hard time finding many, save where the building meets the ground. This is one of Steiner's philosophies: he thought that buildings should follow the human form, avoiding straight lines and harsh angles and, instead, embracing rounded edges, curves and billowing shapes.

The inside follows suit, but instead of cold concrete it is clad with warm wooden floors and furniture, the walls are painted with shades of soft primary colours with ethereal, angelic figures materializing from the contours of the brushwork, and there is colourful stained glass that bathes the curved rooms in swathes of beautiful light. Steiner believed that colour and human souls were intimately connected, which they might be, but he also believed that mushrooms weren't to be eaten as they grow in dark and squalid places and contained hindering lunar forces, so I'll let you think that over.

Steiner and the Waldorf education I had played a tremendous role during the first quarter of my ceramics education, and I want to put everything in context. I very much gave myself over to the craft and academic aspect of my Waldorf Steiner education but the other parts, the spiritual side of things, fell flat. I was placed into this education as a young child so it's imprinted onto my being whether I like it or not, agree with it or not. All I know is that I probably wouldn't be a potter had I not gone there.

My kindergarten mirrored the Goetheanum and it genuinely did feel like a mystical dwelling taken straight from the pages of a children's book. It was in an entirely separate part of the school, hidden

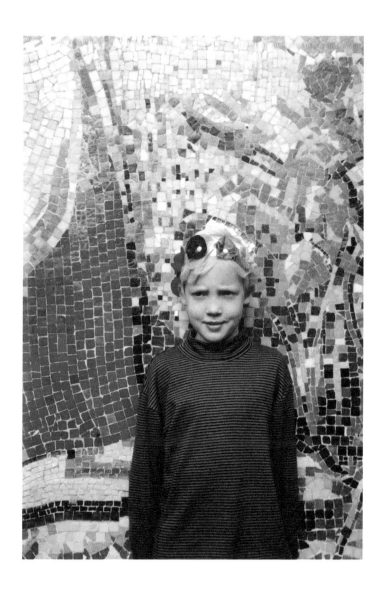

Celebrating my sixth birthday in kindergarten,
wearing a pastel paper crown in front of a
student-crafted mosaic depicting a haloed
saintly figure, roses and doves.

behind trees with a little winding path through some woods. It was surrounded by arching concrete walls that enveloped two large classrooms with wooden floors trodden smooth with the patter of tiny feet, filled with miniature handcrafted wooden furniture fit for five-year-olds. Part of the façade was covered in handmade mosaics; some tiles gilded gold that glinted in the sun. The smell of beeswax wafted through the corridors and light trickled in gently through wafer-thin, silky curtains that were draped across windows that had no right angles. The rooms themselves didn't have severe corners, only soft angles. Even the paper we used in the early years had rounded corners.

Inside we'd sing and play games. Our toys were wooden or made from other natural materials and there wasn't a single piece of plastic in sight. There were no worksheets and no tests. Instead we sat in circles and learnt to knit together and throw and catch soft, handwoven balls and create ghostly woollen figures, angels, to place atop Christmas trees. Our teachers were kind and gentle, and often they'd be joined by younger teachers in training, or even students from the upper school returning to lend a hand. It was tranquil and otherworldly, and as a child I felt free, cared for and happy.

Before we were allowed to graduate from kindergarten to class one we'd have to pass a 'class one readiness' evaluation. A teacher took us aside individually to ask us questions. We'd play catch and throw a ball up into the air and grab it with one hand and hop around on one leg in various directions, then they'd look at our drawings done with thick slabs of coloured wax (pencils weren't allowed yet). They'd observe how well we could finger-knit and tie our shoelaces, and test our memory, imagination and social skills. If we passed, we'd then be ready to move onward, and Theo, my new best friend, and I gleefully advanced together.

Class one doesn't begin until you're six years old, following the way children are taught throughout much of Europe. If the body isn't ready to learn then the mind isn't. (Steiner believed that children weren't

ready for an academic education until their milk teeth started to fall out.) This means that children taught in a Waldorf Steiner school start learning to read and write later than in most schools in the UK. Children being taught in Europe aren't expected to be able to read and understand written language before the age of six or even seven, as a child who only just has a grasp of the language orally shouldn't be expected to be able to write it down. Reading and writing didn't come naturally to me. My teachers consoled my parents, telling them not to worry and that I would get there eventually. My mother thinks that it's partly due to my obsession with our family's brand-new computer and keyboard that finally all the letters began to make sense for me. They were all there, organized and in neat rows, and I just had to go back and forth across the keys to construct the words I wanted.

As we learnt to read and write we also practised what's called form drawing. We'd sketch out repeating patterns or we'd take certain shapes, drawing them out multiple times and rotating them across the page. Most importantly, we'd take a page and bisect it from top to bottom with a line. Then, with a wax crayon or pencil in each hand, we'd simultaneously draw on either side of the line. Our hands mirrored each other as they moved, sketching a complex, winding line, both hands following the same route but reflecting the other. It's a task that helps to grow children's sense of spatial orientation and I adored it – the smell of the warm wax on my fingertips and the symmetrical, weaving, colourful lines. My drawing became more confident and I found joy in creating strong linear patterns and shapes that slowly became more intricate, both hands working in unison, very much like they do when you're throwing on the potter's wheel.

Clay was a material used extensively throughout my Waldorf Steiner education. As children in kindergarten we'd dig it up from a deposit in the grounds beneath the roots of a soaring pine tree at the end the long garden. We'd mould the gritty red mud into lumpy animals and figurines that were baked alongside the bread we'd

cook in two towering wood-fired brick ovens. The clay wasn't fired to a hot-enough temperature to last and our creations, scorched black, would crumble and chip.

I wish I still had some of those pieces as they'd complete my archive, but some things are perhaps better kept as memories: fragments are what I have left of this time, strewn throughout my mind. Rudolf Steiner thought that playing with clay, or even sticky mud, and moulding it, would activate your hands. Children will subconsciously take clay and shape it, turning their imagination into physical entities as they press their digits into it and, therefore, over the years clay remained a substance that we persistently used. Not only in our official pottery class but in main lesson too, which is what we called the first two hours of class every day.

The subjects taught in main lesson changed periodically. Five weeks could be spent learning about Norse mythology, then for four weeks we'd all be outside in the crisp cold in our wellington boots building a new fence or planting trees. We'd even plough fields, dozens of children forming lines and heaving with all our might the heavy metal ploughshares through the earth in the school's gardens. Each class had its own plot of land and throughout the early years we'd spend a few hours a week planting, weeding, ploughing and, finally, picking berries and making creamy flans topped with sweet redcurrants that we all gorged on in the sun.

We would learn about Roman history, and in doing so we spent time in the pottery, which, like the kindergarten, resembled another small Goetheanum of sorts. It had walls of red brick interrupted by strangely shaped windows and was topped with a green, angular roof, a contradiction to Steiner's beliefs. The pottery lay on the cusp of the cricket field, at the extremities of the school's grounds and, technically, 'out of bounds' to the lower school students during break times. It stood alone, surrounded by grass, with a short path snaking to it. It was the first pottery I ever knew and it was a quiet corner, away from the bustle of the main block of buildings.

This was the school I grew up in, on ancient grounds in a landscape that was open and green, a stark change from the city I lived in. We were given stupendous freedom during our lunch hours to explore and play and there were forested areas we were allowed to build dens in, and classes would wage war with each other over building materials, sturdy logs, rare planks or branches that made good spears. Months were spent constructing these dens, some even had a second floor and towers that followed trees into the air, only for them to be dismantled between terms by the groundskeepers, to our collective horror.

AS TIME PASSED, we began spending more time in the pottery. We'd shuffle out of our classrooms after registration and walk the five minutes through the grounds to the workshop. Weeks were spent rolling out slabs of thick earthenware clay that was cut into mosaic pieces which were glazed according to the designs we chose for giant murals of animals that ran along the walls in the lower school's corridor. They were crude and colourful, the tiles anything but perfect and blobbed over with glaze.

My first experience with a kiln was during one of these morning main lessons. As a class we constructed a small wood-fired lime kiln, built initially from wicker that was then smothered in coarse clay laced with straw. We took turns stomping this mixture together with our bare feet. Our aim was to produce lime mortar for prehistoric-style huts we spent years building as a class, with low flint-knapped walls topped with wattle and daub and with a tall thatched roof. Sadly, not only did the lime kiln collapse mid-firing, as we all watched in despair from our classroom window, the structure sagging and spilling over, seeping hot embers and molten iron and lime across the grass, but our huts were also burnt down, rumoured to have been set alight by students from a rival school nearby.

Our education was hands on, but it also delved into all the normal subjects every school teaches, as told by a slogan the school plastered on the side of its minibuses, 'Head, Heart and Hands'. The idea was to teach in

a balanced way, equal parts head – the academic stuff – heart – to create students that are passionate – and hands – to teach children to be practical, to understand how the objects around us are made, where food comes from, and all the processes involved to get it from land to table. As a class we visited local farms, learnt how to grow our own vegetables, planted trees and pressed juice from apples we'd watched grow. All of this might sound very trivial, or obvious, but I don't think many schools and groups of children experience these things. I was in a privileged position to be there – the school is private, after all, with expenses that rise gradually throughout the thirteen years – but one day I hope this approach bleeds into the mainstream education system, as it has done in Scandinavian countries. I don't think it's any surprise that those nations consistently come out on top in quality-of-life surveys.

Alongside studying crafts, which quickly became my favourite subjects, we had to practise dance, more specifically Eurythmy, an expressive, flowing, moving art form Rudolf Steiner created together with Marie von Sivers, his second wife. We'd don colourful smocks and matching plimsoles and, as a piano was played, we'd dance together and move our arms in such a way that reflected words being spoken; it was 'visible speech'. There were movements for consonants and vowels and our arms and hands would flutter or form shapes in sequence to spell out words or our own names. We'd move as a group in such a way that mimicked a poem spoken in conjunction with the movements, our Eurythmy teacher reading, us moving. It's said to help with a child's spatial awareness, which it certainly did, as whilst constantly facing forwards we'd have to tiptoe backwards and loop around to fill the spaces others were moving away from. As children we enjoyed these classes but as young teenagers, we grew to resent them. Dressing up in colourful smocks that billowed as you moved and gracefully waving your arms around clearly wasn't cool. We were beginning to drink and smoke and listen to heavy metal, and Eurythmy was the last thing any of us wanted to be doing.

Then, as we matured the opposite happened. By now we had decided on the subjects we'd like to study, yet Eurythmy persisted, if you wanted it or not. Eventually, when we were all bogged down for hours a day in the library, swotting for exams and writing papers, or in my case making pots and studying art history, Eurythmy classes were a chance to decompress. We didn't have to read or write or deliver arguments or take tests. We simply, almost subconsciously at this point thanks to more than a decade of practice, moved together. It was a welcome reprieve, even if it was just for one hour twice a week. We could switch off, listen to the piano and move as one.

POTTERY CLASSES BECAME more frequent as we got older. Our class of thirty-something students was split into four groups and we'd rotate between different crafts throughout the year. These four crafts might change from year to year but primarily they were pottery, metalwork, woodwork and fine art. Being youngsters, the classes were somewhat chaotic, as you might imagine when there's one teacher trying to show twelve or so inattentive students how to slowly hand-build pots.

We started with soft wax before moving on to clay, then we pinched pots. This is when you take a soft lump of clay, usually patted into a round, ball-like shape. You then push your thumbs into the centre to create a well: this is the base of your pot. Next you rotate the vessel with one hand as the other pinches the walls of the doughnut shape, pressing them ever thinner and finer and forcing the clay upward. It's slow, repetitive work and something I avoided at all costs when given the option. Following this came carefully modelled animals, imitations of our hands and, finally, we worked on constructing exacting platonic solids.

Now we had enough skill to start coiling pots, which is the process of laying down a base before slowly adding to the walls coil by rolled-out coil, shaping and smoothing it as you go. After this was slab building, where thinly rolled-out slabs are cut and joined together, like folding up a cardboard box, only the joins are

reinforced with scoring and slipping – the clay is roughed up with a serrated edge, and then dabbed over with watery clay which acts like a glue. These pots are often angular, at least the rudimentary vessels are, and I made grey cubes, doused with flowing green and brown glazes, that stacked together poorly. Then eventually, and at long last, we were shown how to use the potter's wheel, a contraption on which pots could be quickly fashioned. In a lesson where you might be working on just a single slab-built pot you could throw a dozen or so on the wheel, at least with practice.

My first ceramics teacher was Caroline Hughes. She was known as being the strictest of the art teachers at our school and I now know why: you can't be lackadaisical in a ceramics studio without it descending into utter mayhem. Clay sculptures and pots take up space in ways paintings and drawings don't. Potting also creates dust and is, well, extraordinarily messy, especially in the hands of children. If you do let it get out of hand a workshop can quickly become impossible to work in comfortably. Not to mention that the powdery dust that's produced slowly embeds itself in your lungs like tiny shards of glass.

Caroline came to ceramics as early as I did, studying it throughout school and college. She trained as a teacher but also spent time production throwing at Carlisle Pottery, throwing masses of domestic stoneware and honing her skills. Raising three children intervened but finally, after seeing an advert in a local pottery guild magazine for a pottery teacher at the Waldorf Steiner School, she found her way back to clay. She wasn't drawn in by Steiner and his philosophies, rather it was the pottery that brought her there and I'm so thankful we crossed paths.

She brought into being a bellied vase with a collared neck and flared rim in what seemed like seconds, before plucking it from the wheel and setting it gracefully aside, as if by magic. I was completely transfixed. The process is hypnotic, the wheel spins, the clay follows, a fluid, ever-changing lump that wobbles and moves upward as it is shaped by the hands that guide it. When an experienced potter throws a pot it looks effortless.

The first two pots I ever threw, which were made in the school pottery, below, on an old, worn Alsager potter's wheel. Red and green, misshapen and heavy, but a start.

No strength is needed and the hands miraculously create something from nothing. I couldn't wait to try it myself and rushed off to prepare my clay, a process that's always necessary when throwing on the wheel.

Clay comes into studios in various ways. You can have it delivered in sealed bags, soft and ready to throw with immediately, or you can order sacks of powdered clay that you water down yourself until it's the desired consistency for throwing, hand-building or slip casting. You can also go out and dig your own clay. In some rare cases dug clay is usable straight away, but you can also dry it out in the sun, crush it to a fine powder and sieve out any impurities, pebbles, roots, or leaves there might be. This powdered clay can then have other materials such as feldspar and silica added to it, or it can be used straight, the whole lot wetted down once again to your desired texture.

At school we had it delivered in bags, malleable and ready to work with, although even though the bags are tightly sealed it may have been sitting in a warehouse for months or years – which is a good thing as it means the clay is given time to age, improving its plasticity and therefore the workability of it. Most commercial clays aren't dug straight from the ground, where they've already been ageing for millions of years, and sold. Rather, some clay suppliers purchase the raw, powdered materials and mix their own blends of clay together in-house.

This ageing process can also cause the clay on the outside of the block to become firmer than the clay in the middle, which means that, once opened, these bags of clay need to be kneaded to mix and amalgamate the various textures so it's completely smooth and even throughout. This is a process that can be done in several ways. You can wedge it up by hand, in a similar fashion to kneading bread dough, or it can be run through a machine called a pug mill, which chops through it and extrudes out completely blended lengths of clay. Beyond just making sure it's even in texture the aim is also to remove any pockets of air there might be within the clay, so the clay's folded and rotated so that any voids of air are popped.

And so there I sat, with yet another ball of clay in my hands, clay filling up the wheel-tray and clay spattered on the walls around me. I span the wheel and I struggled to create anything. It might look easy, but attempting to get your hands to coordinate as the clay twists beneath and within them, whilst also monitoring the clay's level of moisture and the speed at which the metal turntable spins, can quickly lead to one slamming a fist against the wheel in frustration. I ended up with nothing but two lumpy pots by the end of my first session, squat pieces that weighed far more than they should considering their size. They still exist somewhere, glazed and hidden away in a box in my mother's attic.

CENTRING THE CLAY is the first hurdle any potter throwing on the wheel must overcome. It's the process of forcing the soft material to be as central on the wheel as it can possibly be, so that it spins perfectly true, like a spinning-top spun so it twirls without any undulations or irregularities in its motion. It's a process that's much easier said than done and I certainly struggled at the start, like every beginner does.

As a more experienced potter I now say to others in those early stages not to be too precious. Clay, when it's soft like this is, is easily recyclable, after all, so it isn't the end of the world if you ruin a few pots – but at the start you want nothing more than to actually make something. You'll be damned if you don't try your hardest to lift away at least one successful pot, even if it is a heavy, poorly formed mess. The first few are precious like that and their mishap shapes can be forgiven. A realization quickly makes itself apparent though: your pots will keep getting better and better, so why keep something that's disastrous when in twenty more attempts you'll be making something many magnitudes better. This learning curve doesn't last forever though; it can take years before it begins to plateau but it'll never really flatten. Rather it tends to take leaps every now and then quite suddenly when a new skill is learnt – that's how it tends to be for me at least. 25

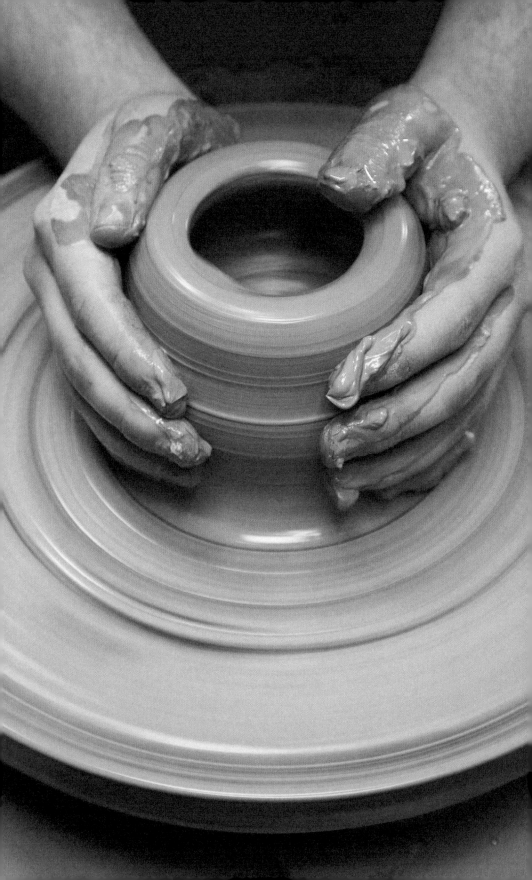

One of the joys, and downsides perhaps, of learning how to make pottery is that there's no single way to do things. Every potter throwing on the wheel follows a rough set of steps in order to end up with a pot, but the positions of one's hands, the tools used, and even the order in which the steps are performed will change drastically from maker to maker. It can seem as if another potter is doing something entirely different from what you've been taught, but mostly it isn't so. It can be infuriating when you're beginning as you'll watch countless films of people seemingly doing different things but ending up with more or less the same thrown pot. This means that at the start you're absorbing a vast array of techniques, if you're anything like me anyway. I was receiving tuition from my teacher at school before scurrying home and watching as many videos as I could. Eventually, though, something clicks and suddenly parts of the process make sense. Then you'll link these successes together until you can throw a well-made vessel.

One of the most pivotal 'click' moments that occurred for me was when I saw someone brace their left elbow into their torso, with their forearm and palm outstretched onto the clay, in order to centre it. Instead of using all the strength in your hands and biceps to squeeze the stoneware into the middle of the wheel, you simply lean your upper body weight onto your arm, which forces your arm and your hand to press firmly against the rotating lump. Clay is a soft, squidgy material after all and if what's pushing into that is mostly the hard bones in your forearm and hand, which are kept steady, then the lump of clay has to conform to it. Once that's figured out you can practically centre the clay in mere seconds and thereafter you can combine that motion with a process called 'coning'.

When the clay is spinning neatly in the middle of the wheel it can sometimes feel like there's something not quite right. The mass's weight might be distributed unevenly, or there could be a few little lumps or bubbles somewhere inside. To remedy this, I push the mass of clay into itself from either side, starting at the bottom and directing it upward into a cone that tapers to

One of my first thrown vessels and my hands, photographed for the school's prospectus. I can still remember the feel of this smooth stoneware clay body.

27

a narrow point at the top. Once it's spinning up high the clay is carefully compressed back down onto itself until it resembles the puck shape I want.

Coning also affects the clay on a microscopic level, as it causes the particles it's made up from – platelets – to align. Think of clay's structure like a bag of rice, where all the grains point in different directions from one another. The process of coning gradually causes all of these grains of rice, these platelets, to align in the same direction. Suddenly, after two or three cones up and down, the clay begins to feel as if it runs perfectly beneath your hands, without even the tiniest wobble, and it even does what you ask of it more attentively, like a well-trained dog.

With all that said, it's a process that took me months to get comfortable with and even then, only to a relatively basic level. I remember feeling infuriated when my hands wouldn't do what I was telling them, but eventually it did click for good, thanks to the patient tuition of Caroline.

There are a few things, though, you should know if you want to make your life easier when centring. These are techniques I've been taught or have learnt myself over the past decade. The first I'm only putting here for sentimental reasons as it might sound a bit wishy-washy, but it does hold true. One of my future pottery tutors would tell me, 'In order to centre the clay, you must first centre yourself.'

I'm mostly not one for anything metaphysical, but if you look beyond that this essentially just means that if your mind isn't in the game at that moment, take a break and try again later. There have been times when I'm attempting to throw a specific shape and I just can't get it, even years into my practice. I'll ruin a dozen pots attempting it and I'll beat myself up over it, when in fact I should just stop, wait, and try again. There have been other particularly tricky forms I've had to learn to make, such as one very curvaceous and altered jug, that once thrown is pinched either side of the spout and hoisted backwards. This gave it an almost comical lean and made it appear very figurative. They were hell to throw and there were

days when after five unsuccessful attempts I'd just

stop, admit defeat, and continue throwing something that I was more familiar with. Then a few hours later, or even the following day, I'd try again. This is what I took from that quote, not sitting and chanting mantras to myself.

Another topic that comes up a lot is strength. People watch potters throw and often say, 'You must be so strong to do that!', and while this may be true when centring gigantic lumps of clay, it's all technique when it comes to small and medium amounts. Learning to use your upper body as an anchor is essential. I've seen beginners puff their cheeks out, red in the face, as they squeeze all the muscles in their arms and tense their hands and fingers in order to force the clay to comply. While this might work, you'll end up being exhausted after only a few attempts, compared to simply letting your body bear the brunt of the work by anchoring yourself in a certain way and gently directing the clay into position.

Eventually you'll get to a point where it doesn't matter if the clay is slightly off-centre, as you'll still be able to control its wobbling as you throw. A bubble might cause a minuscule undulation to form in the walls, but you can pop the bubble, compress the rim and move on. Any distortion in the form is exaggerated by the fact that the pot is spinning in place, rotating on a central axis. Once it is off the wheel, trimmed and fired in a kiln, you'll probably never see it again if it's only subtle. This doesn't mean that you shouldn't try to reach a level where you can centre perfectly, but once you have there comes a certain point when you're good enough to control the clay and make pots even with some irregularities. To quote the ever-enlightened Geoffrey, a future teacher of mine, when questioned by pesky students about why the rim of his pot was wobbling slightly: 'I just don't give a shit any more.'

There can be beauty in imperfection.

IF I'M HONEST, after my first real attempt at throwing on the wheel, making pots wasn't something I found myself immediately smitten by. Up until this point in my life I'd been a keen draughtsman, and both fine art

and graphic design were routes I could see myself following. In my mind, a potter never touched a computer; they simply lived in a ramshackle studio out in the countryside, making brown pots and taking them to fairs to sell. At sixteen years old, this was my only real perception of the craft. I just didn't know it existed in other forms.

Every day, after I arrived home from school, I'd plug myself in and play video games online. My parents had divorced, for better and worse, and I was often down, sometimes lonely and felt isolated in London as my friends were all an hour away, and so I found solace playing video games. My mother still tells me about the times she'd be coming home and from halfway down the street she could hear me inside, shouting commands to my teammates. I'd occupy myself well into the early hours, completing my homework between rounds of search and destroy. My friends online felt as tangible as those in real life, and I still often wonder what they're doing all these years later. I was overweight, self-conscious and tremendously shy, but at least I still had a very strong group of friends, both in real life and online, which I'm thankful for. I'd have been lost without those people. The self-consciousness has never left me and I'm still shy, too, but some things would change.

Up until this time I wasn't particularly good at anything, and this was brought starkly, and horribly, into reality for me at a joint three-way family birthday party. It was my eighteenth, my great-uncle's eightieth and my second cousin's twenty-first. We were all sat in my great-uncle's garden in Blackheath, and he was giving a speech about the things the three of us had achieved. There was an awful lot to say about the others but for me he said, reading from a piece of paper, almost puzzled as he spoke, 'And ... Florian has the most amazing computer skills!'

Nobody clapped or cheered like they had done for the others. I stared at the floor, averting my eyes from everyone else's. All the praises sung about the others and all they could say about me was that? Was that all I was? I spent the rest of the party sulking. I couldn't bring myself to speak to anyone else and sat in the living room

as the party continued outside. On the way home I asked in the strangely quiet car why he had said that. Surely David didn't know I spent such a lot of time playing games. Unexpectedly my brother answered, 'Well, David rang and wanted to know about some nice things to say about you.'

'And playing computer games is the best thing you could come up with for me?' I snapped back. 'Do you have any idea how embarrassing that was?'

Surely he could have thought of something else to tell him, but maybe there wasn't anything. I was fuming. Why didn't he speak to my mum? Now fifty people knew I was a video-game obsessed nerd and as we drove home all I could think about was how that had to change. What else could I really do, though? I couldn't speak another language or play an instrument. I didn't excel in any other academic subjects. I was overweight and avoided gym classes. I did at least like the sciences and had always loved technical drawing. Art classes, though, were where I felt the most at home and *now* there was ceramics, and more specifically throwing on the potter's wheel. Maybe that's where I belonged, maybe that's something I could actually do.

There's a point when learning how to make pots when certain parts of the process click and the better you get, the more you want to do it. It begins to get addictive and you can easily see the progress made. The pots I'd thrown the previous week were already outdone by the new ones in front of me. From this point on, after being humiliated in front of my entire family, I spent much more time in the pottery. I was often the only student there, sitting at the wheel throwing rows of pots that slowly, over time, started to become more similar to one another.

I wanted to be able to throw pots that were all identical to one another: that's what proper potters do, I thought. Mine were roughly akin but if you looked at a line of my mugs, they'd all be a little different. Mugs are where I started, throwing endless bodies and scrapping all the outliers. Not only was I in the studio during my lessons, but I'd also spend my lunch breaks potting when my classmates were outside playing football on the

A mass of stoneware clay halfway through being
spiral wedged. This removes pockets of air and
amalgamates the texture. Next, it'll be rhythmically
folded up, culminating in a conical shape ready
to be thrown into a vase.

field next to the workshop. I could hear them through the windows of the studio, yelling and laughing together, yet I was content, learning by myself. I'd do the same after school, as I often had to wait for a lift home back to London.

I was always jealous of my friends who could walk back home in minutes, rather than spending their free time in the evenings commuting home. They grew up spending more time playing together and therefore growing up together, having relationships and fights and smoking pot hidden in bushes. Instead, at home I'd watch pottery videos online, hoping to glean some small piece of information about pulling up the walls of clay, or perhaps a new method of centring, or making handles. I also set about teaching myself how to spiral wedge clay, which is the process of folding and pressing the clay in a rhythmic fashion that causes any air pockets to burst as they're stretched into a spiral that shrinks ever smaller, creating a texture that's homogeneous and smooth to throw with. Back in the pottery I practised for weeks, trying to mimic the movements I observed in these videos. I'd consistently end up smearing the clay across the wooden workbenches until, finally, a sloppy spiralling shape started to emerge. I was getting there, slowly.

My pots were still heavy, but the weight was feeling more balanced throughout the vessel and they appeared more purposeful too. I threw with a vision of what I wanted to make, rather than letting a pot materialize from a struggle. The glazes, however, were patchy, often brown and green and were rather unpleasant, or at least that's how I see them now.

There was a small side-room that led off from the main workshop that was stacked from floor to ceiling with buckets and small sealed tubs of glaze. I'd mix and match all of them – I was infatuated with testing and layering glazes – and ended up with dozens of mostly sepia pots. As with paints, if you mix all the colours together you by and large end up with brown. Maybe that's what led me to Bernard Leach initially – that and my interest in creating functional pottery. Caroline pointed me 33

in his direction, informing me that if I really wanted to learn about the recent history of studio pottery, then Leach was the place to start. So, I did and I kept practising.

CENTRING THE CLAY is only the very start of the process when making pots. It's the setting of the foundations, but you still need to build the rest of the structure above it. Poorly laid foundations can lead to subsidence and the same can be said when throwing pots.

Once the lump of stoneware is spinning perfectly in the middle of the wheel, I begin by plunging my finger and thumb into the thick centre of clay and pressing down to create a well. I don't press all the way through, as most pots need a base, so you envision, or measure, the thickness in the bottom, which once set is 'sacrosanct', as a tutor of mine used to say. To check the depth you can pierce the base with a potter's needle, pushing it through the clay vertically until the tip hits the wheel.

With enough practice you can begin to judge the difference by sight, which is what I do these days, comparing the depth of the base in the pot with that of the wheel head beside it. After the base thickness has been defined you cannot press any further down, otherwise you might dig all the way through to the metal of the wheel – a mug with a hole in the base isn't useful for anyone.

After the base has been set you then draw the clay outward, dragging your fingers horizontally across the bottom to form what is the internal floor of whatever type of pot you're making. The first shape any budding potter should become comfortable with is a basic cylinder. Most pots have walls of some kind, and even plates or very shallow dishes have a section that juts upwards around the exterior, so figuring out how to channel the walls up consistently is the next step after centring.

To begin, you pinch at the thick mass of clay that encircles the base you've formed, pressing it between the pads of your fingers on the inside and a protruding knuckle on the outside. Make a tight fist with your right hand, fully extend your index finger and then

34

Scrawled notes. I wasn't mixing my own recipes from scratch at this point, rather I was experimenting by layering dozens of premixed glazes, hoping for the best.

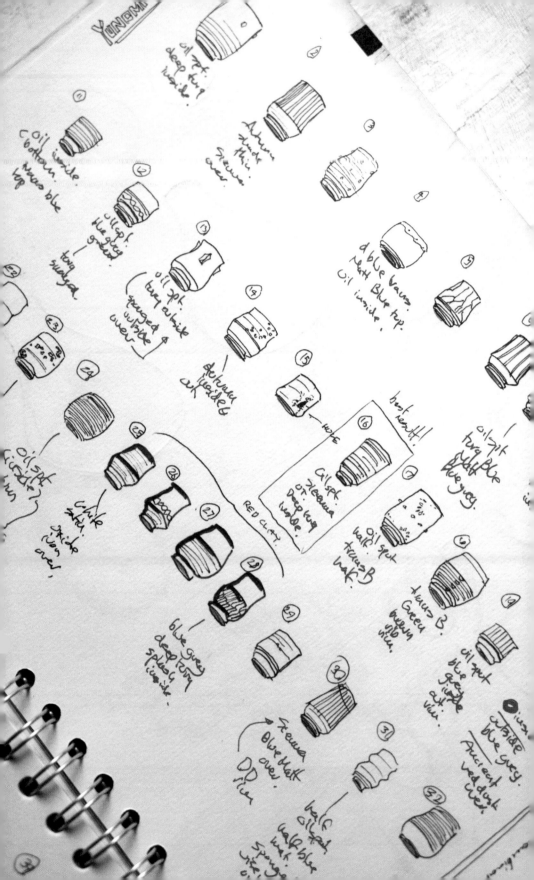

fold it back down at the knuckle, tucking your fingertip so that it's in line with the base of the same finger.

That knuckle is then pointed down, an awkward position if you've never done it before. Then, with that knuckle extended, you slide the side of it into the outside of the pot, creating a groove around the base of the vessel. This is then pinched against the pads of your fingers on the inside and together they squeeze the clay and force it upward in one gradual, even motion. The thicker mass of clay is carried up, leaving thinner walls below, the cross-section defined by the space left between your digits on the inside and outside.

For the subsequent pulls – normally you gain height with numerous repetitions of this procedure – I once again press a groove in around the base, pushing the excess clay into a usable position, and from the inside I push out a bump just above my knuckle on the outside and once again, together, the fingers pull, or lift if you will, that bulge of clay up. Now, if you thought centring was difficult, then this is much harder, and it's another one of those processes that many potters do in alternative ways. Some use wetted sponges to move the clay up, others use their fingertips to apply pressure both inside and out. I've seen an upturned thumb used and the palm of a hand too. The truth is, they are all applicable and they all are perfectly acceptable. You've just got to find what feels the most comfortable for you – and initially they'll probably all feel rather strange. Your hands, arms and shoulders have to be tensed and controlled whilst moving at the same time, maintaining a constant shape with your hands as a slippery wet mass of clay travels through them. It's a skill you'll never learn by reading books – you've got to get your hands dirty.

The aim of the game is to pull up the walls evenly, so that the clay is distributed at the same thickness from top to bottom. You don't want to leave too much clay in the base, otherwise the pot will feel bottom-heavy, a sure sign the piece was made by a beginner. You also don't want a pot to negatively defy your expectations; for instance, when you go to pick up a jug with a certain

preconception of its weight and it's much heavier than you expected and you can feel the heft in the base, that isn't good. Especially if the jug isn't yet full. You could say the same thing about a vessel that's as light as a feather when picked up, but it has the opposite connotation. If it's a handmade pot you marvel at the weightlessness as it demonstrates the skill of the maker.

Together with pulling up the walls of the pot you also need to think about the amount of water you're using, as the clay must stay lubricated as you throw. Otherwise, it just sticks to your hands, resulting in the vessel twisting or simply collapsing. Wheel-speed is another factor, and beginners tend to either put the pedal to the metal, or go at a deathly slow pace. Ideally, the wheel should spin at different speeds for different processes. Fast for centring, slightly slower for pulling up and shaping the walls, and perhaps slower again for the finishing touches. Yet it varies, of course, from potter to potter and even from wheel to wheel and clay to clay.

Whilst in these early stages of adapting your body to throw pots, your mind is constantly flickering between a multitude of things. From how to position your hands, the way you move them in unison, to the speed at which the wheel is spun, and whether you're using enough water or not. It really is a lot to concentrate on and it can be over-whelming. Ultimately, with enough practice, it all becomes second nature and it does begin to feel intuitive. Muscle memory is a perplexing concept and it's engrained into the process of throwing. Occasionally nowadays I'll be making pots and I won't even realize what my hands are doing and suddenly there'll be thirty vases all in a row and all I've been thinking about was what I'm going to have for dinner.

Back to the task at hand, throwing a cylinder. If you think about thrown pottery, most forms are either cylin-drical or bowl shaped. With these two shapes combined in different ways you can create bellied vases with tall necks, which, broken down, are just two bowl shapes stacked rim to rim with a cylinder on top. These two basic shapes are the cornerstones of learning to throw 37

pots, which is handy, as often when you're learning to pull cylinders they collapse outward into bowls, so not everything is lost.

Once the clay of the cylinder has been pulled up to an appropriate height and the walls feel even from top to bottom, it can be cleaned up and removed from the wheel. Typically, for my own pots, I scrape away all the excess slip that accumulates on the outside of the vessel with a metal tool that has a sharp, flat edge. I sponge out the excess water from inside and carefully smooth the rim over with a chamois leather, and finally a wire is slid beneath the vessel, separating it from the wheel. It's lifted away delicately and set to one side, the first step now complete.

A cylinder can become so many things: a jug, a teapot, a storage jar, a vase or an inkwell. Infinite variations are possible. When making cylinders, you're constantly struggling against the clay wanting to fight back. The quick rotation of the wheel wants the soft material that's vigorously revolving to gradually splay outward. This means that as you throw narrow vessels you have to continually fight against it, constraining it and preventing it from flying out, whereas when making bowls you're really just gently coaxing the clay outward, guided by centrifugal force.

I was taught to make these two basic forms by Caroline. She didn't sit with me constantly and guide me through the process over and over again. Instead she threw an example or two, and then left me to my own devices, which ended up being how all my teachers taught the craft over the coming years. Like riding a bike, after a point you just need to tackle the basics until it makes sense in your mind. For bowls she insisted that it was all about the internal form. As long as that section had a lovely, uninterrupted curve, the outside would follow suit. So, that's where my focus lay, pushing my curved rubber kidney tool into the walls like a template. This same ethos was echoed again later, in college, when a tutor told us that if you were to let a marble drop from the rim of a bowl inward, it should rock back and forth smoothly and come to a natural, graceful stop, perfectly in the centre.

It shouldn't collide with a flat section on the bottom or an arbitrary undulation that throws it off course.

This advice is exceptionally useful for a beginner and it does instil some good practices, but it's also the case that once these are mastered the rules can be broken and some of my favourite bowls I use in my kitchen, which I've collected from makers around the world, are crooked and intentionally misshapen. They may not be perfect, yet they show wonderfully the character of their makers. They say dogs look like their owners – well, I think the same can be said about pots and the potters who make them. Our attitudes and levels of exactingness are all channelled into these objects our hands create.

Looking back at my early wobbly bowls and sorry excuses for cylinders is like looking back at drawings I did when I was an infant. I only started to throw pots on the wheel when I was sixteen, so to me these early pots correlate in the same way to the scribbles done in my early childhood. Yet they're different from my kindergarten drawings, as my mind was far more developed at this point in my life. I knew what kind of pots I wanted to create, but my hands just couldn't manipulate the material expertly enough to see them come to life physically. My child-self drew for the sheer joy of it, without a care for whether the results were any good or not.

There was one exercise for making cylinders that I found tremendously helpful. The task was simple: throw cylinders from two-pound lumps of clay – about 900 grams – as thin and as tall as you can. Even if they break, tearing where the clay thins out too much before buckling and crumbling down, that's part of the task. I wasn't trying to create beautiful cylinders. In fact none of these pots would be kept. Rather, it was an exercise to gain an understanding of the material itself, to find its limitations.

I WAS EIGHTEEN and I had become consumed with pottery; I was itching to throw more and learn new skills. I wasn't good at anything else. In fact, it's all I had and all I could see myself pursuing. It's incredible 39

the effect somebody telling you 'You're good at that!' can have. For most of my life, up until I started making pots, that just wasn't really applicable to anything I did. Nobody had ever told me I was good at anything, other than computer games. My teachers had directed me towards pottery, and my classmates were flabbergasted that I was making pots that could actually be used. Not many had got to that point at our school, and Caroline said she was over the moon that her final student (she was soon to retire) had taken the craft to heart in such a way.

We were provided with a list of topics to choose from for A-level Fine Art and Ceramics which would provide the basis of our final project. There was 'Realism', 'Opposites', 'Heritage' and, luckily, one titled 'Vessels'. I only had one choice really and I did exactly what Caroline instructed me to do: I went down the rabbit hole of Bernard Leach and the impact his approach had on pottery in the UK and abroad. I filled pages in my project book with the history of his pottery, studying his pieces and trying my best to replicate some of the wares Leach and his many apprentices made. I would fantasize about living in the past, in his pottery, learning alongside other apprentices as enthusiastic as I was.

Bernard Leach is known as 'the father of British studio pottery' and from the ages of twenty-four to ninety-two he was inseparable from the craft. He was born in Hong Kong in 1887 and travelled extensively throughout his life from the East to the West, knitting together cultures of pottery in Britain and Japan and forming relationships with makers that still exist to this day. Beyond making pots he also wrote, drew wonderfully expressive illustrations and etched. Pottery is what he became devoted to, though via the enticing flames of raku firing, which is when pots are drawn out from a roaring hot kiln, the vessels shimmering red. The Western corruption of this process has the pots plunged into hay or wood chips or swung at with seaweed and horse hair that instantly carbonizes, leaving ghostly prints over the surface of the pot, but Leach simply laid the fired cup, which he had painted,

Early sketches, often colourful beyond anything I create nowadays. Strange shapes and pots that mostly never saw the light of day as physical objects.

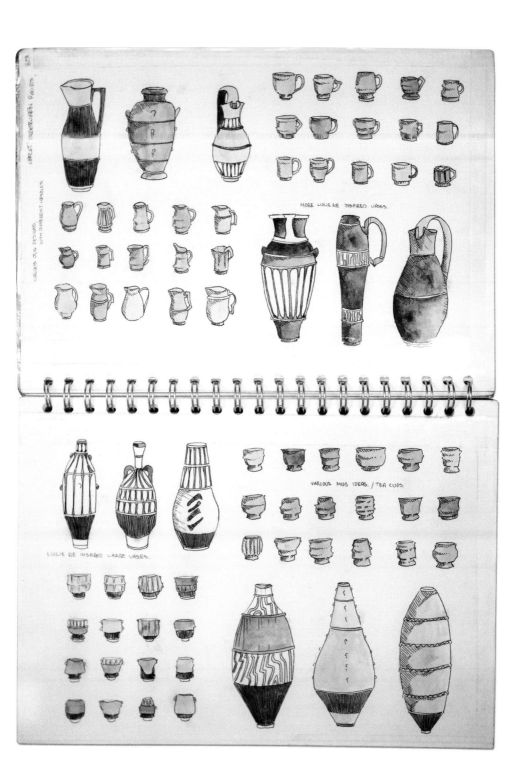

GREAT MODERN FERN PAGES 23

VARIOUS JUG DESIGNS WITH DIFFERENT HANDLES

MORE LUCIE RIE INSPIRED VASES.

LUCIE RIE INSPIRED LARGE VASES.

VARIOUS MUG IDEAS. / TEA CUPS.

onto a tile where it could gradually cool in the air, the red-hot surface slowly fading to reveal his design.

Bernard Leach is the reason so many people became potters in Britain. He encouraged a generation of apprentices that have all left long, influential trails throughout the world of ceramics, and I latched on to the end of one of these trails. I was transfixed by his faceted bottles and strong jugs and his decorative brushwork that seemed so fresh and lively, even though fired and frozen in layers of now motionless glaze.

Amateur ceramicists learning the craft will often copy the pots they see and like. I did it; every beginner does it. Leach's pots were those I tried to emulate, albeit poorly, thrown as thick, lumpy vessels with clumsy spouts and even more awful brushwork. I was still getting accustomed to throwing. It isn't a skill that you suddenly complete, like the video games I was still playing so many of – although both tasks require a similar level of focus. When you're lost playing a particularly captivating game, you can't really do much else. Your attention is entirely absorbed by the activity and the same can be said for throwing pots, especially when you're first learning the ropes. You have to invest every gram of muscle and thought into keeping your hands steady, and in your mind you're actively going over all the steps, constantly.

One minuscule, split-second mistake can result in the sudden, messy end of the pot you're making. This happens a tremendous amount at the start. In fact it almost feels like you're destroying more pots than you're finishing. It'll all be going well only for the walls to unexpectedly twist, or for a tool to be used too forcibly and suddenly what was a delicate, thinly walled vase is just a pile of crumpled clay. To some degree you do need to think about these first, fledgling pots as tests. Of course, it's nice to hold onto the earliest pots you ever make, but after you've made ten successful pieces, the tenth will be far better than the first, and after a hundred attempts you won't even recognize those embryonic pots initially thrown. They'll probably just resemble little squashed ashtrays.

Perhaps naively, I contacted the Leach Pottery, asking whether they needed a new production thrower. To my disbelief they replied to my email, saying that they didn't have any full-time positions but I would be welcome to come for a week-long work placement.

I took the train from London Paddington down to St Ives. I walked up the long hill from the station, the sea breeze pushing me along, and at the pottery I knocked on the door. Up until this point my entire perception of this craft was based upon my experiences in my school's pottery and from what I'd seen and read. I thought I'd be stepping into a bustling pottery, full of life, potters throwing and kilns smoking away, but it wasn't anything like that. I was shown to a tiny room in the half-built guesthouse behind the modern studio, where I slept poorly and awoke early. It was cold, the house half open to the elements, so I quickly got ready and dashed into the pleasantly warm workshop.

Jack Doherty was running the pottery at the time and the only other production thrower there during my visit was Kat Wheeler. She showed me around the historical workshop, which was founded in 1920. Pots are still made in the old studios but they're primarily a museum these days. In 2008 the site underwent renovations and a new, modern studio was built alongside the old. The original kilns stand stoically, built from well-worn bricks, and the studio itself sits in silence, tools propped up in jars and with an open fireplace in one corner, the walls and brickwork scorched black by use. Then there was the room lined with stillages, which are a sort of shelving system made up from beams of wood that long boards of pots can be slotted into. There were manually powered potters' wheels, contraptions with a heavy flywheel beneath that you'd need to turn in order for the wheel above to spin. They're known as Leach treadle-kick wheels but they were designed by Dicon Nance, an apprentice at the pottery in the 1920s, and were later widely used by English potters.

The days passed slowly and quietly. The pottery wasn't remotely busy during my visit and I sat next to Kat quality controlling the mugs she was attaching 43

handles to. I didn't actually know what I was meant to be checking, as of course they were immaculate, but I sat and watched as she talked me through the process. I'd only tried pulling handles a few times and, so far, had had little success. Throwing really is just one part of being a potter after all; there's trimming, handling, decorating, glazing, loading kilns, firing, packing boxes and shipping, and up until now I'd only focused on the first few hurdles.

I spent a number of days in Bernard Leach's old office, which was up a rickety set of wooden steps and through an attic I could barely stand up in. Unlike the rest of the studio, this room was flooded with white. Porcelain coated everything. It caked Jack's wheel; wooden throwing batts had it flaking off in heaps; and buckets brimmed with curls of white reclaim, the excess trimmed away from his pots.

I set about recycling this porcelain with the noisy pug mill that ate up one corner of the room. This machine recycles clay trimmings and reclaim by churning it all up in a chamber and extruding it out one end. Some even de-air the clay by creating a vacuum in the extrusion barrel, which removes pesky air pockets trapped inside the clay that can cause issues later when throwing. I pushed the level down to squeeze the clay inside, sliced away the pugged logs and smelt the oil emanating from the machine.

Afterwards I scraped clean all the throwing batts. These are wooden discs that slot snugly over the wheel head. Some pots are difficult to remove from the wheel without distorting them, such as wide, flat dinner plates and larger vessels. So, instead of lifting the pot itself away from the wheel you can lift the throwing batt away with the pot on top of it. I'd watch Jack throw. The shelves quickly filled up with clean curved forms marked with a swish of a serrated metal kidney, a flat piece of metal with little sharp teeth all around its edge, a signature move of his.

Up until now I'd only ever seen Caroline throw pots in the flesh and so seeing a new pair of hands throwing was electrifying. Not only that, but I'd also never seen porcelain thrown with either. At school, all we were allowed to use was grey, textured stoneware. Porcelain

seemed wonderfully vibrant and silky smooth, and seeing somebody else's hand manipulate the clay, pull up the walls and scrape clean the slip was spine-tingling. He was approximately following the same steps Caroline took but his hands were clasped in ways I hadn't seen before, and he also used an entirely different set of tools.

I thought everyone would more or less do the same thing, but over time I've seen just how varied different potters' approaches can be. We all do a different dance, with different tools, but can somehow end up with the same finished pot – there isn't just one way. This was my first time seeing this; my eyes were transfixed on the tall, spinning white bowls that were thrown throughout the day. From wedged lump to thrown pot, and finally nimbly placed on a ware board. These are long wooden planks onto which freshly thrown pots are placed. The boards are heaved up onto a shoulder, like a waiter carrying a tray full of drinks, and then slotted into stillages for storage, so the pots can slowly dry out in order to be trimmed.

The following day I set to work trying my best to replicate some of the soda-fired mugs that were being produced here at the time. They were low forms with straight walls that tapered outward to a sharp bevelled rim, thrown from a grogged, coarse stoneware clay that tickled my hands as I tried to copy the example that was given to me. My reproductions weren't bad – they were relatively similar to one another – and I found the challenge of recreating the same shape again and again both pleasurable and exasperating. I knew they weren't absolutely identical but I just couldn't get my hands to create the clones of them I so desperately wanted. One was just a fraction too tall, another had walls that curved in too much, and another mug's base was too narrow. Others were a little stout and there was another pile of them next to me – pots that had been thrown, sliced away and immediately squashed.

Frustrated, and in need of a break, I headed off to brew another round of tea for the two busy potters. I returned to find white handprints over my recently thrown mugs. Jack had obviously reached inside the pots 45

to judge the thickness of the walls and had felt how the rims came to a point. I could see wherever Jack went, where he sat, even the objects he touched, by the white porcelain dust he left behind. He was encouraging, telling me that I could throw well but needed to practise my repetition making. Then he disappeared up to his white studio again, a cloud trailing him. My remaining time in St Ives was spent polishing the bases of fired pots with progressively more fine sandpaper, reclaiming even more clay and, of course, brewing round after round of tea, which I'd carry around on a tray from room to room: potters' fuel.

Returning to school, I set about production throwing ranges of functional wares: cups, mugs, bowls, plates, and my first ever teapots, barrelled square forms with poky spouts and crooked handles.

Centre,
knuckle in,
push the clay up,
form the sides,
set the rim,
repeat.

I worked hard and could see my pots improving. My ugly, ill-formed pieces were slowly becoming a little more refined; the shapes were better and the handles flowed more naturally, and my trimming was becoming more consistent – this is the process of using sharply bladed tools to carve and refine the pot once it's leather hard. Many of these pots have since either been given to relatives and my friends, or they've been thrown into giant landfill-waste containers at the local tip, pots chucked in to smash satisfyingly. Breaking pots would become a constant throughout my pottery education. It can be difficult letting suboptimal work out into the world, as controlling the quality of one's wares is vital – these objects represent you, after all. Pots bear your name, a maker's mark that's pushed into the vessel to identify it as being made by you. They're marked when the clay is leather hard and the pot is finished for the time being, and at that moment

you may very well like it. Yet, after it's been glazed and fired, all manner of accidents can happen. You may end up despising the same pot you previously loved due to no fault of your own.

As I was learning to make pottery my level of skill quickly rose and I'd look back upon pieces I'd made a month or two before and be filled with dread. They were awful. Their shapes wobbly, the bases finished naively, and the handles of my mugs were just proportionally all wrong, their edges jutting into my hands uncomfortably or simply being too small to even fit my fingers around. That's why at the start it helps to not be too precious about the pots you create. Yet as a means of practice you've still got to see some of the pots through to the end, otherwise you'll never learn anything. Nowadays my pots do still get better but it's a far more gradual process, unlike these early stages where visible progress was there, for all to see, in every new batch of my work.

There was one step I wasn't practising, though, and that was firing my pots in the electric kiln. It's commonly a process that during early education, and even in colleges, is kept as a task for the technicians. It's a shame, as firing in kilns is an integral part of being a potter. It's the machine that fundamentally changes soft clay to hard ceramic and without one the pots thrown will just dissolve in water. Imagine training to be a cook without ever learning how to use the oven. You can read about how to do it but eventually you need to actually use one yourself ...

In some circumstances it's understandable. If you're teaching a whole classroom of young students pottery, they can't all participate in loading a small kiln, and in our early years' potting it didn't make sense to involve everyone. After all, what were the chances that any of us would actually become potters after leaving school? Not only that, but if you knock the delicately glazed surface of a pot against another, the walls of the kiln, or a prop, there's a chance the glaze will chip and need repairing. Using a kiln is a skill, just like throwing or trimming pots is, and during this part of my education I only ever caught 47

A heavy stoneware vase, clay coarse like
sandpaper, flecked with orbs of molten
granite. The first vessel of mine with a neck
and opening that didn't appear clumsy.

glimpses inside the shadowy kiln room. I was told what the kiln does but it still seemed like a mysterious metal box that somehow changed the very nature of the material I'd be working with for months, and I yearned to learn more.

IMAGINE A COLOSSAL toaster with a lid on top that can be tightly shut, sealing in the heat so it can't escape. That's essentially all an electric kiln is. They're built up from carefully cut insulating fire bricks, course by course, sometimes in the shape of a barrel, to be loaded and unloaded from above, or they're like a fridge, with a door that swings open so you can access the inside.

The bricks are soft and aerated, light as a feather but also very fragile; a misjudged lowering of a weighty kiln shelf into the kiln's brick wall will gouge a scratch into the brickwork forever. They're manufactured to be as efficient as possible, heating up quickly and containing that warmth so you aren't using too much fuel simply firing up the bricks. This wasn't always the way. Kiln bricks of old were heavy and inefficient. The bottle kilns in Stoke-on-Trent were built from these heavier, dense bricks. They'd take a long time to heat up but would also retain that heat much longer once saturated. This meant they'd take longer to cool down too, and if the wares were needed quickly, or if there was a fast turnaround to get the kiln packed again, the kilns would be unloaded whilst still unfathomably hot, the men draping cloths over themselves and slapping wet towels onto their shoulders in order to withstand entering the stifling chambers to pull out the saggars stuffed with fired pots – saggars shield the pots from the open flames. They'd then refill the kiln and fire it up again immediately, so the brickwork didn't cool down fully.

Within the electric kiln rows of thick winding element wire encircle the pots placed inside and gradually heat up, ever hotter and hotter, from electrical resistance. At first, they only buzz into life for a few seconds at a time, but as the firing progresses and the temperature rises they zap into life for longer, humming quietly, sealed in the kiln's chamber, heating the pots slowly overnight.

There are customarily two firings in the process of making pottery. The first one, to 1000°C, is called a bisque or biscuit firing. This is done before the pots can be coated in glaze. For this firing the pots are piled up in the kiln – bowls ten to a stack, teapots placed base to lid and other wares all jumbled up around them. It might look like a mess, as if the pots are just arbitrarily heaped, but it's in fact all a careful game of Tetris. I try to fit in as many pots as physically feasible, this way the firings are as cost efficient as possible. During this firing the fragile, bone-dry pots become hard. The clay changes to ceramic and once unpacked and coated in glaze they'll then be reloaded for a second firing, which normally goes to a higher temperature in order to melt the layer of glaze that now covers the ceramic pots. The only difference this time is that the vessels cannot touch, as the molten layer of glaze on each pot would fuse and stick them together.

The lid or door is tightly fastened and gradually, over the course of a number of hours, the kiln heats up to the desired temperature. Nowadays this process is entirely automatic. I can be at home, in bed, and watch how the firing's progressing through an app on my phone. But I've also fired electric kilns that are operated manually, where a knob or a lever is turned throughout the day to increase the temperature. I would watch Caroline pack the kiln from the threshold of the kiln room but more often than not she'd pack and fire kilns out of class hours, so it was a somewhat mystifying process. I was told what was happening but I always felt as if it was something dangerous or incredibly difficult to do. It was the teachers' domain, with menacing metal boxes that fired up to 1000°C, or even as hot as 1300°C, a white heat emanating from the spy-holes of the kiln causing the air to haze where the warmth flooded out.

For most potters, electric kilns are their first experience of firing pots. They're the easiest type of kiln to use and are typically cheapest, both in terms of the cost of the kiln itself and the fuel used, electricity. This doesn't mean it's a lesser form of firing, but that doesn't

stop some completely unwelcome resentment towards it from those who wood or gas fire. The real deciding factor is the ceramicist's technical prowess, but it is perhaps harder to obtain certain qualities with an electric kiln compared to what a gas, soda or salt kiln naturally yields, as the internal atmosphere is relatively sterile; it's just superheated air. Whereas with gas kilns or wood kilns the atmosphere itself inside the kiln changes the pots and adds flavour. You have to work *so* much harder to achieve complex surfaces with an electric kiln: you have to layer slips, glazes, add materials that melt and flow and often think outside the box. That's why I have such respect for those ceramicists who use electric kilns and create beautiful, depth-filled pots with captivating surfaces.

In the last year of my Waldorf Steiner education, Caroline retired and a new pottery teacher appeared. Our relationship was never the same. He changed the layout of the studio, moved things around and introduced new rules, and quickly I found myself dreaming of escape. He even ruined the pots I made for my final practical examination, although I didn't properly realize what had happened until years later. I threw a batch of pots in a ten-hour period over two days, bowls and vases made in grey, granular stoneware, trimmed and encrusted with extruded elements – clay pushed through a fine sieve – to resemble coral-covered vessels you might find lost at the bottom of the sea.

Caroline had a firing programme already set that worked flawlessly. In this programme the pots were slowly fired to 1000°C in order to harden the clay, strengthening it for the glazing process. As the firing progresses, things like carbon and sulphur and the gases from any organic matter in the clay are burnt away and it ventilates out of the kiln. At 550°C the water that's chemically bonded to the particles of clay evaporates entirely, which releases steam, a byproduct that, again, needs an escape route. This is an irreversible change and once clay has been fired to this temperature it cannot be undone or crushed and fed through a pug mill back into usable clay. 51

A few degrees later, at 573°C, the clay undergoes what's called quartz inversion. Here the crystalline quartz in the body of the clay increases in size by 1 per cent and, if rushed, this period is when pots can crack. Beyond 900°C the clay begins to vitrify, meaning that the silica in the clay starts to melt and seal the pores in the body. The more it vitrifies, the less absorbent the body is, so in order for it to be successfully glazed, we need to stop the firing before the clay becomes fully sealed and watertight.

Bisque firings typically stop at around 950–1000°C and then they maintain that temperature for a further fifteen minutes or so, which is called soaking, a process where the kiln holds at a certain temperature and allows the heat to do the work of melting glazes and evening out the temperature from top to bottom in the kiln. Most electric kilns are automatic, and once this final soak is over they'll switch themselves off and begin to very slowly cool down.

Pots fired to this temperature are known as bisque, bisqueware, or as being biscuit fired. Previously, the pots would have been bone dry, a state also known as greenware.

Greenware pots are particularly fragile objects. There's barely any moisture left in them, which means they're very brittle and will snap like dry mud if handled incorrectly, or even if squeezed a touch too much, developing a hairline crack that you'll never find until they've been fully fired. Bisque firing makes the pots stronger but you must still be extraordinarily careful about how you hold bisque fired vessels, or how you grasp them with glazing tongs. These days it doesn't help that I trim my work to be exceptionally thin, a few millimetres at most, and quite regularly my glazing tongs, which clasp the bisque fired pot as it's dunked into glaze, simply pierce right through the walls.

If you pack a kiln for a bisque firing with pots that are still damp, they can potentially explode as all that internal moisture suddenly turns to steam – an event that seems to occur a lot with students' pots, as these vessels are often fairly bottom heavy and thickly walled. Commonly technicians will blame these explosions on students leaving great voids of trapped air within

the pots, which yes, if they fill up with steam will cause a blast. But, if the pots are properly dried out beforehand, so there's almost no moisture at all left inside the clay prior to firing, then this doesn't happen. I'd place my thrown pots either in sun during the summer or above the radiators in the winter to ensure they were completely dry, and I'd check the dampness of these pots by raising their bases to my cheek. If they felt cold and damp it meant they needed more time in the wind or with warm air blowing up around them.

The other important factor about bisque firing, beyond just hardening the clay, is that it makes it sponge-like. The lower the temperature of the bisque firing, say 900°C, the more porous the clay is, whereas if fired higher – 1000°C and above – the opposite is true. Glazes consist of an assortment of raw materials that are suspended in water and when the pots are dipped into them, or if the glaze is brushed over them, the absorbent clay sucks in this water, leaving a layer of the raw material mixture on the outside of the pot. If the bisque firing is too hot the clay will barely absorb any water, and therefore hardly any glaze will stick to the pots.

That is what happened to my bowls and vases. My new teacher changed the previously functioning firing programme and all of my exam work over-fired. They were meant to be green and white, glossy in places and iridescent and black where the glazes pooled thickly. Instead, they were brown and dull, rough too, with only thin washes of glaze covering the pots as it just wouldn't adhere to the surface thickly enough. At least the pots hadn't exploded. I was persuaded I never wanted to make a brown pot ever again. I needed to know how to programme and fire an electric kiln myself. I needed to have control over that part of the process too.

IT WAS AROUND this time that I started to visit pottery fairs. I wanted to ask potters what they thought the best ways of learning were. At one event there were potters exhibiting who I'd been researching and 53

writing about for my final projects. I'd carefully drawn their pots and used their pieces as inspiration for vessels I'd made and I'd written biographies about them, information collected from books and from the web; now I had the chance to meet them in person. They were like celebrities to me.

Warily, I went over to the stall of one of my favourite potters, nerves racing. He makes generous stoneware jugs, wide bowls and platters coated in gleaming wood ash glazes made in similar styles to Leach and old English medieval pottery. I tried to strike up conversation, stuttering about how I'd been doing a project about him and his work and how it had inspired me to become a potter. Looking back, I might have been a pesky teenager distracting him from his customers. I've done fairs since and understand what it's like being bombarded with enquiries, but I persisted and asked away. Not all potters were happy to talk to me. In my ignorance I didn't really think about the fact they were there to sell, not talk pottery to some young, long-haired enthusiast. I would push my way through the throngs of collectors and shyly try to meet them. Instead of answering my questions, one potter plainly said how it's a craft that you'll probably spend your entire life pouring your soul into, only to get nowhere, and that it just isn't worth it. 'Look for something else before it's too late,' landed abruptly on me, and I faded back into the crowd.

This sentiment seemed to be one shared by several potters I met around that time, before pottery (and craft as a whole) started its resurgence. Ceramics education had been in decline. Pottery university courses across the country had been gradually closing for years, leaving only a few notable degrees left standing. As courses go, ceramics is an expensive one to run, considering the equipment needed, the raw materials and expertise too – and that last one is really important. Making the pots is one thing, but firing kilns, mixing large quantities of glazes, fixing machinery and keeping the whole pottery operating smoothly is not an easy task. Finding someone capable of doing all these tasks and requiring

A stoneware vase, coated with a black oil spot
beneath a scattering of turquoise glaze, its shape
inspired by taller bottles by Bernard Leach.

them to teach a ceramics course as well means these precious people are few and far between. It's difficult to teach full-time and pursue a career as a potter, so often sacrifices are made in one to aid the other.

I visited a number of university courses searching for what to do next. But at each institution I was unimpressed and frustrated with the lack of throwing tuition on offer, and the absence of the teaching of notable, practical skills. It would have been impossible to go from leaving school to immediately setting up my own practice, but I didn't think that any of the courses I'd visited so far offered what I really wanted, which was skill, knowledge and practical experience. I wanted to learn how to be a potter, one who could throw all varieties of pots, fix wheels, fire kilns and develop their own, unique glazes. Extortionate university fees had just been introduced, and the thought of studying something that didn't provide me with the skills I wanted, together with pinning decades' worth of debt to my back, made me feel sick.

During this time, I continued visiting fairs, meeting potters in person and handling their wares, rather than only peering at their pots through a screen. Suddenly I could feel cross-sections and inspect how they'd been put together. My pots were still too hefty in comparison to many objects I saw, but these were ceramicists who'd been making for decades, whereas I'd only been potting seriously for a year, intermittently throughout the week.

It was during one of these visits to Ceramic Art London that I first met and spoke to Lisa Hammond, a world-famous soda-firing potter who ran a charity called 'Adopt a Potter'. It paired younger makers with master ceramicists and she suggested that the money I'd spend on university fees would be better spent attending masterclasses with experienced potters, and that maybe one day I could apply to be an apprentice via her charity.

Tim Hurn's stand was next. He fires maybe the most beautiful wood-fired *anagama* or cave kiln you'll ever see.

The pots are piled inside a curving, cramped chamber, before being sealed up, like a tomb, and

fired. His robust, functional pots were coated in thick washes of greens and browns, wood ash that's accumulated and then liquefied into glass over the vessels as the kiln hits top temperatures. He mentioned a course I hadn't heard of before, one based in a small town in Ireland called Thomastown. The course was focused entirely on teaching practical skills and taught potters to a very high level, providing them with kilns galore, a glaze laboratory and as much throwing tuition as you could dream of. He couldn't tell me much more but pointed across the room at a potter who'd attended the course himself, Adam Buick, who also got us talking to another chatty and enthusiastic potter called James Hake, and between them they painted a vivid picture of a school that sounded almost fantastical, like a fairytale, just like my kindergarten had been. They explained how they had more kilns than there were students, that they taught tangible skills and that it was all set in a charming ancient mill next to a roaring river deep down an overgrown drive and across a tiny arching bridge.

IT ALL SOUNDED too good to be true, and it was exactly what I had in mind. The Design and Crafts Council of Ireland's Ceramic Skills and Design Training Course was the name. It's a mouthful, hence why most people just called it the Thomastown pottery course.

In 1990 this programme was set up to train throwers to fill the ravenous production potteries throughout Ireland. During this time there weren't any industrial ceramics being manufactured in the country, nor was there much being imported. Initially, the course was only a year long and focused almost entirely on skill. They didn't worry about the students' own aesthetics or their opinion of what looked good or bad. That wasn't the point. It was just a way of transferring as much skill into the trainees as possible before sending them off to throw countless tens of thousands of pots. Students would come in, gain the basic skills needed to work in a busy pottery throwing handmade wares, and then head off to work in the industry as a contract thrower or a studio potter themselves.

As times changed and the need for new blood was sated in these potteries, the curriculum changed and in 2004 an additional year was introduced, where the focus became nurturing each potter's individual voice, helping to find a style that was unique to them. The idea was to really push the students' skills so that they gained a high level of fluency within the craft. Then, once they had acquired a thorough understanding of how to make all kinds of pots, glaze and fire them, the teachers would help guide the students' ideas and their own creative paths. It was thorough; students would be there nine to five, five days a week, with lots of overtime, for forty-four weeks a year. It was like a job, with the added bonus of continual access to tutors, the principal of whom was Gus Mabelson. He had moved to Ireland, leaving behind a career as a successful salt-firing potter, to help establish the course, to write the curriculum and to control the budget. It was a blank canvas and he channelled his approach into it, which was learning through doing. He still worked on his own projects, exhibiting and taking on commissions as he taught. He was a maker who teaches, but he never thought he'd spend the next thirty years doing so.

I put together my application and was accepted for an interview. A few days before my final A-level History of Art exam I flew over with my mother, together with a bag of carefully wrapped-up pots I'd made and a tablet computer loaded with many more photographs of my still-stout pots.

We rented a car and drove to Thomastown, which lies in the south-east of Ireland, about an hour's drive from the coast. I had sent an email to Gus, asking whether it would be possible to visit the day before the interview to see the workshops and kilns. The drive from Dublin to Thomastown took two hours, motorways turned to single carriageways and finally into small, hedged-in lanes.

The roads wound tightly through the centre of the medieval market town as we made our way towards the old grain mills that lined the River Nore, which is where the pottery school is located. We found the entrance down a lane, crossing a treacherous blind corner

that makes accessing it by foot a challenge. The path to the school is lined either side by a canopy of trees and old walls, and a babbling stream separates the small island the mills are on from the rest of Thomastown. It finally leads into a tranquil courtyard with buildings on three sides. The pottery course I wanted to attend took up the smaller structures straight ahead, with the neighbouring Grennan Mill Craft School, a foundation course, housed in the lofty mill on the right, still stuffed with the giant cogs that connected to the dilapidated mill wheel outside that was once powered via a millrace that channelled water from the Nore through a crevice where the waterwheel slotted.

The pottery was right on the water and half the potters' wheels, of which there were twelve, one for each student, looked out onto the racing river, whilst others had views of the courtyard. I spent an afternoon here talking to the cohort of students. I asked abundant questions as they made me tea and answered as best they could. Their level of skill was staggering, to judge by the pots I saw in the showroom; they were on another level compared to what I was making. They were professionals, and that was after only two years spent studying here.

I was given a tour and shown all the kilns. The glaze laboratory followed next, then the two floors of potters' wheels. There were eight workstations on the top floor and four below, in rooms lined with stillages for storing pots and damp-cupboards built from plastic sheeting, for slowing down the drying process for work still in progress. There were diagrams and cross-sections of pots covering the walls and glaze tests hung from the rafters. Thrown pots were everywhere, made by the current cohort, or those long graduated or by Gus himself, who had his own workstation too. There were cabinets full of ceramics thrown by well-known potters, made during visits to teach masterclasses. It was idyllic, perfect. It had the same warmth and character as the Waldorf Steiner School and it immediately felt like home, in a way that none of the other universities and facilities had done. I knew I had to come here, there were no two ways about it. 59

Early next morning I headed to the offices of the Design and Crafts Council of Ireland and waited. With all my pots in a bag, I sat on a chair in a long row of others that steadily filled up with more prospective applicants. Some looked hopeful, some were laden with pots like me, others without, waiting anxiously. I didn't have time for the nerves to take hold and as soon as the clock struck nine o'clock, I was called through. I was the very first to be seen. Inside the interview room was a long conference table with three seats on one side and one on the other – I'd never done anything like this but had heard from the students from Thomastown the previous day about what sorts of questions they might ask. Opposite me sat Gus, the course's founder, director and the teacher the successful applicants would spend two years with. To his left sat Ann McInerney, alumna of the course and now an intermittent tutor herself, and on the right was the council's education facilitator.

The interview began:

'Do you think you'll manage in a quiet village since you're coming from London?'

'Why do you think you'll be a good fit for the course?'

'What do you expect to learn?'

This continued for some time. I unwrapped my pots and nervously told them what I liked about my selected pieces. 'Which do you think the best pot is?' I was asked. I turned a small bowl over to show them a meticulously cleaned foot-ring. 'This bowl is the first piece I've made that really makes me think I could do this for a living, it looks like you could have bought it from a shop.'

Then it was over.

As the car pulled in at home after a long day travelling back to London my phone buzzed in my pocket. It was Gus. 'Hello Florian! Thanks for coming to the interview this morning, just to confirm, you've passed and we'd like you to come back for an aptitude test in a few weeks' time.'

I travelled back, alone this time, flying to Dublin and boarding a bus that rumbled to Thomastown. The coach pulled up on the high street in the pouring rain as the sun went down and I hopped out onto a street

flowing with water, and headed down the long road to a guest house, one mile away, next to the ruins of a local abbey. I was sopping wet by the time I arrived, soaked from above by the rain and by cars that had whipped past me on the narrow roads, splashing my side.

It was a grand building, built from white stone that was overgrown with ivy. An elderly couple ran the place and the wife showed me to my room and warned me about the ghosts that she'd seen in the corridors. I told her why I was in Thomastown, for the looming aptitude test the next day at the pottery. She knew all about it and insisted that her husband would drive me there early the following morning and enthused I must try her full Irish breakfast. 'You'll need the energy!'

I jumped out of the car at the end of the lane that led down to the pottery's entrance, stuffed with a breakfast big enough to keep me fed an entire day. I wasn't sure how I'd sit and throw comfortably, especially with the nerves that were now seeping through me. This time, instead of the students who were on the course chatting happily to us, they were all dead silent. The aptitude tests ran over two days with ten applicants participating on each. We met outside with Gus, Ann and Geoffrey Healy, another one of the course's part-time tutors. The surroundings were still picturesque, and the rain had stopped at least, but the atmosphere was different; there was a tension that filled the mill, of nerves and sweat and competition. We were marched up to the top floor where there were ten wheels set up. The current students ignored us as we trudged past them on our way; they even avoided looking us in the eye. It was quiet with anticipation and we had no idea what to expect. Today would decide what I'd spend the next two years doing and I would focus with laser accuracy. I needed this, perhaps more than anything else in my entire life.

Upstairs were piles of clay already prepared for us on the central workbenches. Long logs of stoneware that had been sliced into one-pound discs. Gus had built a contraption, a wooden jig lined with taut, sharp metal wire positioned in such a way that you could quickly cut

through an entire log of pugged clay and separate it immediately into eight one-pound rounds. There was a jig for one-pound lumps, 200-gram discs and a range of other common weights.

I firmly believe that if Gus had helped me set up my present studio, I'd be immeasurably more efficient in everything I do as he knows how to make every process streamlined. It might be worth mentioning at this point that potters, at least those of a certain generation and who live in the UK and Ireland, use both metric and imperial weights. There's something profoundly useful about a pound weight, 454 grams; it works well for soup bowls, big mugs and small jugs, and many potteries I've worked in since use it for various forms alongside metric weights for other vessels. It's an amount of clay that also just sits comfortably in your hands as a patted ball waiting to be thrown into a pot. Using both systems can be confusing but you quickly become accustomed to it and both have their benefits. Old ways meet new ways and things are slow to change with traditional crafts.

The morning was spent throwing cylinders, or mugs rather, plain straight forms. We weren't given dimensions to throw to and were instructed to just sit and throw as many as we could. I got the wheel right by the stairs, an old Shimpo with a faded yellow tray and rusted metal chassis, which buzzed loudly as it spun; the ten wheels filled the room with a cacophony of metallic noises and it sounded like we were sitting inside an aeroplane. The man next to me, with a bushy head of curls, threw confidently, fast and accurately; all his pots looked exactly the same and I definitely thought he'd be one of the chosen few – after all, there were twenty contenders that would need to be trimmed down to twelve. I was slower by comparison and my cylinders weren't nearly as neat.

The tutors progressed from person to person. Later I'd discover that they weren't looking for skill, rather they were looking at how we responded to tuition and, perhaps most importantly, our attitudes were being
judged. Ann showed me how she cones the clay

up and down to centre the lump perfectly and how to bend it to one side as you press it lower, which causes the clay to compress in a more controlled manner. That was new to me and she seemed happy, and smiled, knowing that I'd learnt something.

After an hour and a half of throwing we stopped and proceeded to the next part of the test, a lunchbreak in town, all together. We walked out, up the lane and across the bridge and sat in a cafe's gardens, stuffed too many onto tables too small. This was the aptitude test that assessed our sociability. As you'd spend two years together in very close proximity, I suppose having a gauge of what people are like when they're not working is helpful, but everyone was on their best behaviour, of course, laughing at the tutors' jokes, being helpful and asking polite, considered questions. We had soup and sandwiches and, quite frankly, I can't recall a single word said – it was a stressful blur.

We marched back to the pottery, single file across the narrow bridge, back down the lane and upstairs past the skilled students potting, up into the sweltering loft space studio filled with stillages brimming with greenware. The smell of damp clay was strong and the air humid from wet stoneware and working bodies. The afternoon was to be spent throwing bowls, which I was better at, churning out dozens of pieces that filled the long ware boards. Once again, they weren't identical by any means.

I was focusing on getting the curve on interior form right, head down peering into a bowl and I heard a 'Uh-hum!' from my right. It was Geoffrey, head almost level with mine. 'You should try sitting up more,' he said, tapping my back sharply. 'It'll keep this from aching over the years.'

'I know ... my mum is always telling me I should start doing yoga.'

'You won't need to if you sit up properly! Oh, and never try lifting a potter's wheel by yourself!' He grinned and moved on to the man next to me, who by this time had thrown what must have been fifty bowls. I sighed and flung my next lump of clay onto the wheel; 63

I had to keep up. The rest of the afternoon went on like this, the teachers going from person to person offering tips but never praise. Then it was over.

'WE'LL BE IN TOUCH in a week or two with the results; you'll receive a letter in the post!' Gus told us as we left and made our way home. Weary, I climbed back onto the bus and slept, my head pressed against the glass as we travelled back through tiny winding roads and through fields with bungalows dotted amongst them. I'd never thrown so much in a single day before, my arms felt warm and stiff and I clutched my hands together tightly, stretching my knuckles and listening to them crack.

I didn't hear from them in a week, or even two. In fact, I never heard from them by letter or phone. I was certain that I hadn't made the final cut. We went on one last class trip to Switzerland to visit the Goetheanum, the epicentre and heart of how I'd been taught for thirteen years.

I arrived back home late at night, a week later, and sitting in my email's inbox was an unopened message from Amanda, from the Design and Crafts Council of Ireland:

> Hello all,
> Can I please ask those of you who have not yet confirmed to do so by the end of the week? Thanks.
> All the best,
> Amanda

My heart leapt – had I made it? I had been certain I hadn't. I was filled with relief, a smile spread across my face. The next two years were set in stone. I immediately tapped out my reply and struck enter. 'I confirm!'

I ran out onto the landing and yelled the news to my sleeping family. I was going to be leaving home. More than that, I was leaving for another country. I was leaving to *properly* learn a craft. From more than two hundred applicants I'd made the final cut of twelve, and for once in my life I felt like I had accomplished something. It would be a leap out of my comfort zone, I had no idea what to expect, but I knew I'd work myself to the bone.

Describing my thirteen years of education at the Waldorf Steiner School is difficult; to unpack everything that happened, impossible. I have such meandering thoughts about its origins and find it difficult to say I truly loved it as it spun two stories: that of spirituality, which I'm sceptical of, and that of the arts and crafts in everyday life, which I'm eternally grateful for. Even with my secular scepticism, I'll never forget the times we sat around fires in circles, even jumping over them and chanting, or my being the star-bearing boy at the end of a line of girls all clad in white and with candles on their heads in a midwinter's procession.

At the start of every year, the students of class thirteen, who've entered their final year of education, line up on the school's stage with bundles of flowers picked from the school's grounds in their hands. The students of class one, on their first day of school, each go up and take a bunch of flowers from those who've been at the school for more than a decade. The children draw closer gingerly, not looking at the towering teenagers in front of them, blindly grab the flowers and run back down to their seats.

At the end of the year the roles are reversed. All the members of class one line up, some twenty-five to thirty of them, packed into a tight row, shoulder to shoulder, holding bright bouquets as large as their heads. Class thirteen then descend from the top of the theatre, from the very back row. By now there are ordinarily fewer members of the class, twelve or fifteen people at most; they collect their flowers, the favour returned before finally graduating. Tears fill the eyes of the parents, who are allowed to come to these festivals, and our eyes are just as red. Thirteen years in one place cements it into your memory. My classmates and teachers felt like family.

Thomastown

Where
I find
my
voice

One of my watercolour paintings of the mill — Gus didn't only have us making pots. We spent a lot of time in the courtyard, especially during the summer months, cooking late into the night with the wood-fired pizza oven while we managed drying pots around us.

WE TOOK THE FERRY over to Ireland, me and my mother, the black camper van packed to capacity with all my belongings. I'd be moving in with two of my course mates, Edward, an Irishman with a tumbling long black beard, and Magda, who was Greek and cooked glorious meals for us under the condition we had a shot of ouzo with it. Both of them were quite a bit older than me, as were all the people on the course. You didn't have to fill in your age on the application, which meant cohorts could range greatly in age and with our intake it spanned from twenty to forty-four. I was the youngest.

Not only was the course open to applicants from anywhere in Europe, it was also free and, perhaps most remarkably, there was an allowance of €80 a week that was given to each of us, which just happened to cover all my rent. The course provided everything else – the clay, the glazes and the cost of the fuel for the firings. It was perfect for me, a four-year course condensed into two years that focused on teaching practical skills. We even had the chance to earn some extra income by way of pot sales as pieces could be sold in a little gallery on site. It helped us to get by, which meant anyone, from any walk of life, could apply.

We finally arrived at my new home in the pitch black. It was a newly built house a five-minute walk away from the mill. My bedroom was on the ground floor; it was unusually long and had an ensuite, but only had windows in the tiny bathroom and on the front door – my room had its own door leading onto the street. It was perpetually damp and felt a bit like being in a gloomy, cold bunker. Compared to thirteen years of commuting for almost two hours a day, this commute felt 69

unnaturally easy. It was bliss; I could actually come home during my lunch break if I liked and I didn't have to leave in the morning until the very last minute.

It wasn't all quiet, though, like I had imagined living in the Irish countryside might have been. The road next to my bedroom was full of potholes and local tractors would race up and down the lane from six in the morning onwards, their wheels bouncing and the wagons they pulled clattering after them, causing the house to shake. Despite this, the surrounding roads and lane that led to the pottery were peaceful, and much of the town felt like it hadn't passed into the new century. But it wasn't all like that. Behind our house was a more modern estate, where local children would throw rocks onto our roof and fill our cell-like concrete garden with leaves and chunks of mud. Thankfully most of my time wasn't spent there but rather at the pottery on the secluded island.

For a young potter who'd previously only experienced a small studio at school, this new workshop was positively awe inspiring. There was every type of kiln imaginable: a salt kiln, multiple gas kilns, raku kilns and endless electric kilns of all shapes and sizes – even one that we cooked a turkey and roast potatoes in for our Christmas parties. I finally also had my own space to throw in that I didn't have to tidy up every day, and a giant stillage shelving system too, to slot my pot-laden ware boards onto. During my Waldorf Steiner years I had to clean my wheel each day to make way for other classes and I lived in perpetual fear that somebody would knock over and break my laboriously finished pots whilst I was away.

MUGS ARE THE GATEWAY DRUG into the pottery world. Not only for the beginner taking their first tentative steps into the craft but also for the collector. For the beginner they pose the first challenges: throwing simple cylinders combined with attaching handles, which is no easy feat. For those just starting to collect ceramics, mugs are often the pieces that draw them in. They normally encompass the entire aesthetic style of a particular

maker and are relatively affordable, hence why my shelves at home are chock-full of the damn things.

I happened to straddle both aspects at the same time. I started making crude mugs and attending pottery fairs, where my mug collecting began. There's something about using a handmade object for your own everyday rituals that makes them feel more meaningful and connects you to craftspeople in an intimate way every time you take a sip from a vessel, as opposed to drinking out of a mass-produced mug with no soul.

I'm sure most of you have a favourite mug you use, regardless of whether it's handmade or not, but when that item holds a personal tale of someone's life's work and is the embodiment of their ideas, it becomes something much more. As you dig deeper you might invest time into meeting your favourite potters or even visiting their studios if they'll let you, to slowly try to understand what it is they're endeavouring to achieve with their work and to see the space where they create. Holding and using handmade objects every day that have a story behind them, a person, makes those ceremonies of yours feel much more significant.

Now, every time I drink coffee at home I can choose from an abundance of handcrafted mugs of all shapes and styles, all made by different people. Stoneware, porcelain, terracotta, some gas fired, others soda fired; a few are bathed in molten wood ash or are even pulled white hot from the kiln and submerged into hay or sawdust. They are made by potters who are my friends or by potters whom I've admired for years as I've learnt the craft. I know their history, how the pots have been thrown, glazed and fired, I can feel the marks left by their maker's fingers on the handle and I can run my palm across the base of the vessel and feel the raw clay. For that moment there's a connection and suddenly my friend in Japan who made the mug in my hands doesn't feel so very far away.

The same concept can be applied to any pot but for me the mug is what started it all. I've kept examples of those I've made throughout my ceramics career so far, and unpacking them all is like looking back through

a photo album of my childhood. I can see how they've progressed from when I was a young potter making wares for less than a year to those that are made by my hands now, more than a decade later. They're worlds apart in appearance although my hands themselves haven't changed much in that time; rather, the way I move and shape the clay has.

My design choices have evolved as I've grown older, and with each iteration of mugs there's probably some minute change. I throw them to be more or less identical, but if there are slight variations in those I produce throughout the year then I don't mind. I remind myself that I'm not a factory, but am an individual craftsperson making pots in relatively small quantities. The notion of how they'll look in another decade's time fills me with excitement and I want to keep making them just to see what my preferences are in the future. As time has passed, I find myself liking finer edges to drink from, and comfortable handles are a necessity, although at the same time I find myself being less critical and more welcoming. I'll drink out of anything as long as the potter has clearly poured their heart into it.

The 'Thomastown mug' was our first real project. The shape felt old-fashioned, like something you might find in an antique shop. They were thrown from 12 ounces of clay, 340 grams, to a cylindrical shape with a moulding around the base, almost like a skirting board. The form had a slight inward curve around the waist and a soft, bevelled rim that nestled comfortably into the corners of your mouth, as opposed to culminating in a squared block that felt crude to drink from. The handles for these were extruded, the long lengths cut into individual segments and then laid out into a curved, handle shape. These extrusions were left to firm up until leather hard and finally they were scored and slipped onto the mug's body, about halfway up. As Gus put it, 'I know these aren't phenomenally designed mugs but they'll teach you exactly what you need to know.' He said this as he handed us photocopied worksheets covered with his intricate technical drawings and cross-sections of the mug we had to copy, with the dimensions jotted down for the height, width and the weight of clay.

Gus took portraits
of us all, to be used
for our first exhibitions.

A poor rendition of the
'Thomastown' mug, splashed
inconsistently with Tenmoku
glaze and crafted with a
shape and handle that still
make me wince. This doesn't
stop my father from using it
every morning for his coffee.

This is how every project that first year went; we had to be very accurate. The mugs were a good way of extending our repetition-making beyond just the form of the pot: now there had to be handles, mouldings and rims that all had to be made identically too.

The decorative moulding around the bottom was created by a small plastic tool made from an old credit card. There was a bowl of bygone cards in the workshop, which we could add to if we liked once our own plastic expired. They were free to take and fashion to our liking and we'd cut one into thirds and then file a half circle into one corner. It's this that was offered up to the mug and pressed into the soft clay around the bottom as the pot spun, the negative shape transferring onto the pot as the stoneware flowed through it. After we'd spent days throwing hundreds of cups the tutors would assess our attempts, walking amongst dozens of boards of pots, a thousand mugs between us, some better than others. They'd select those that were good enough for handles and then they'd do the same again after we'd attempted attaching them. For all of us, out of hundreds made, we were left with four or five each – our tutors were incredibly critical.

'Don't be too precious,' they said, as we watched them set aside mugs destined to be destroyed and reclaimed, 'when we revisit these again in a few months' time they'll be much better.'

The shape may have been one that I could never imagine making in my own practice, but sometimes being forced to do just that is no bad thing. It pushes you to learn and to adapt, and over the next five years of studying how to create pots I'd do an awful lot of this: creating pots to other people's designs with a range of techniques, styles, glazes and firing methods. All of which helped me to develop a catalogue of skills that I could later pick and choose from and fashion into pots of my own.

If we look back at the burgeoning mug, this is often where your voice first sounds. They're usually the object you'll throw the most of, and even after throwing and trimming several thousand in my lifetime

I'm still always eager to make new batches, as it's a constant process of refinement. I correct features I don't like, handles are altered, the lip thinned. One batch might have a quieter form whilst others retained more of the marks left with my hands, such as grooves – throwing lines – left in the clay where my fingers have pulled the walls up, or where my trimming tools have left more pronounced, turning marks. It changes, continually, ebbing and flowing and following my mindset at the time.

I've always disliked the term 'mug'; it holds with it some sense of heft and a lack of beauty. Perhaps that has to do with how it's used colloquially to mean a face, and often one that isn't pretty. One train of thought is that the slang derives from toby jugs, which often feature grotesque and unpleasant faces on their sides. Mug has Germanic roots, the Swedish being *Mugg*, the Norwegian, *Mugge*, or in Low Saxon, *Mukke*. None of which are any better.

THE WAY OUR WEEKS worked went as follows. We'd be given a demonstration early on Monday morning, followed by an in-depth discussion about whatever form it was we'd be learning to create. The tutors threw twelve samples and gave us each one of them to use as a reference as we threw, which we could hold, carefully, and inspect – but if we damaged or broke our precious example then we'd have to pay a €2 fine. We'd put this pot in front of us as we worked, copying the size and shape and trying to replicate it as best we could, training our eyes, and really learning how to see profiles and proportions. Then, we'd be given a straight-forward task: throw this shape until the end of the day. Naturally, with twelve students throwing hundreds of frankly terrible mugs, there was an extraordinary amount of clay recycling to be done.

Clay is a truly wonderful material for many reasons, one of those being its almost endless recyclability. As long as the clay hasn't been fired, all of the trimmings, offcuts, waste and other scraps, provided they're relatively clean and uncontaminated with dirt or other materials, can be recycled and thrown again into new pots.

Excess clay, if it's in larger chunks, is dried out until bone dry, after which it can be easily dissolved in water, whereas the finer, wafer-thin ribbons from trimming can be immediately thrown into a bucket of water. We'd let all of this slake down overnight or for a few days until it turned to a fine slurry – the heavier clay particles settle and we'd sponge away the water left above. The clay that's left in the bucket is then mixed up and smeared out onto thick plaster batts, where it's spread out evenly like jam on toast. If you aren't careful it spills over the sides, as was often the case in the earliest months at college. These absorbent slabs pull out much of the excess moisture from the clay, which takes a few days, or even up to a week, depending on the weather and humidity in the studio, or if the kilns have been on or not. Once the slops have partly dried up, approximating the texture clay should have when being thrown, it's peeled off the batt and taken over to a plaster wedging-table, a wooden workbench, or a pug mill.

The reclaimed clay can then be wedged up by hand or it can be mixed and extruded through a pug mill. The reclaim is loaded into the machine, which then churns it all up between powerful rotating blades before pushing it through an extruding hole at one end, where it emerges fully mixed, pristine and ready to throw with. The barrel of our pug mill held a vacuum, which meant our clay was air free; the pugged clay could be thrown with immediately, without having to wedge it by hand.

We'd store this clay in giant piles. The extruded shapes stacked neatly into colossal pyramids that we'd wrap up tightly in plastic to keep it soft. All it takes is a sneaking draught finding its way in to quickly dry and harden the freshly pugged stoneware. Clay that's continually reclaimed begins to weaken, it tears more easily, and this affects its usability. You'll notice this when your pots begin tearing as you belly them out as the strength of the material lessens.

There comes a point when either you have to mix reclaimed clay with new, fresh clay, to add strength back, or you can age the reclaim by wrapping it up tightly in plastic to keep the moisture in, and

setting it aside for a few months, or even years. This gives time for water to seep deep between the clay's platelets, and even the bacteria that grows within it is beneficial, like cheese. Bacteria consume organic matter inside the clay and defecate waste that lowers the overall acidity of the clay, making it both more plastic and, in some cases, horribly odorous, stained with streaks of festering black. Some potters mix vinegar in to get rid of it, and I've even heard of some urinating into their reclaim buckets, but we just let it be.

When you're a beginner and learning how to throw pots, that's when you'll produce the most reclaim and we generated mountains of it. Black bin after black bin, so heavy their wheels would crumple and sink into the linoleum or fall between cracks in the wooden floorboards. In some instances, the slip clay spilled through cracks in the floor, cascading from one storey to another and carrying its stench with it. So, whilst throwing mug after mug after mug for this first week, we'd continually be reclaiming clay for months – so much so we'd have teams doing it almost constantly, rotating in whilst others threw. One person chopping up and mixing the clay ready to go into the mill; one working the lever to squash it into the chamber; and another slicing the logs of clay off and storing them away into covered heaps. Cleaning the mill out was an altogether more terrible experience, especially when the clay caked inside was either left to become very mouldy or was allowed to turn rock solid. Nonetheless, we were taught how to maintain these machines.

We were told consistently how quickly we'd improve when practising with such vigour, throwing the same pots over and over again, and the tutors weren't wrong. We went from strength to strength, throwing faster, more accurately, and with a focus on making pots that were identical. Each had to be the same as the last. Like learning scales as a musician, repetition is the key to becoming a more efficient maker, and the mug is the form that exemplified that, as we made thousands of them. Throw, trim, handle, repeat. I could almost do it in my sleep. 77

At the end of every day our tutors would do the rounds and assess our pots, making us decide which ones were worth keeping and which were destined to be destroyed and reclaimed. They didn't always tell us what was wrong with them. Rather, they'd encourage you to be the one to find the errors, a task that quickly improves your eye for detail, with some guidance – no one likes to point out their own shortcomings. At the end of the week we'd hold on to the best of what we'd made. Those who did better got to keep more, but if you struggled you'd get less. The first term was hard. We were all expected to improve at a similar rate, and those who didn't could very well fall behind. It was vicious, but after a while we mostly levelled out.

As we learnt how to make new forms, we'd also learn how to fire gas and volatile salt kilns and to programme more straightforward electric firings too. At the end of most terms we'd finish with a specific project, such as creating a group of five functional pieces with a glaze that unified them, or we'd knock down an old kiln and build another. Our group renovated the cupboard-sized kitchen into something more usable. It took us away from potting solidly for a week, and ate late into the night too, but this was all part of Gus's can-do attitude. Why hire someone to put up your studio shelves when you can do it yourself? The same went for building stillages, mending furniture and all manner of other tasks in the studio. This is how I bonded with Peter Montgomery and Steve Meek, my two closest friends on the course. As a trio we were fairly capable and happy to do some woodwork, so Gus often gave us tasks to complete, like building a bespoke stand for the projector, or building new shelving systems in the glaze laboratory.

THROUGHOUT MANY OF my teenage years I'd felt socially awkward and disconnected. I had friends to talk to but lacked any real confidence in myself, and barely any of my real-world friends liked the same things I did. But now, as I slowly eased into this new world, I was starting to find friends who had similar passions.

During long summer evenings we'd sit outside the pottery or by the weir, feet dipped in the rushing water of the Nore, talking about everything other than pots. Our cohort of twelve stayed friendly during the course, although towards the end it was fractured by a love-square that I, thankfully, just observed from the outside.

When working together in a pottery as a group there are, however, innumerable causes for quarrels. We'd all be working on the same project, backs to one another as we sat at our wheels, each with our own window. Half of us looked onto the courtyard, half onto the turbulent River Nore and the view beyond over grassy knolls and the ruins of a castle next to Thomastown bridge, some version of which has been there since the thirteenth century. There are remnants of ruinous walls and towers throughout the local area, although now they're surrounded by fields of windswept grass and lots of cows. Those wheels with the views were the most sought-after and when we periodically switched workstations, sticks were drawn to see who got the best seats. Arguments would arise. The messier potters would be yelled at for allowing their disorder to seep out around them, and once, after I swatted a wasp that was pestering me, its head flying off, my course mate screamed at me, 'I wish somebody would cut your head off!'

As the weeks passed, each wheel and its surrounding area would be slowly customized by whoever sat there. I'd pin up all my own drawings and the worksheets Gus made us, full of cross-sections and the ideal weights to throw vessels from. I hung all my brushes up in a line in front of me, imitating what Gus had done, and positioned my throwing gauge and mirror to my liking. These two things, a gauge and a mirror, were tools I hadn't used before coming here, but each wheel had a pair as Gus thought them vital. These days, if I happen to throw without them I feel lost, as if someone has taken away one of my senses.

The mirror is positioned on the workbench in front of the wheel in such a way that it shows the side view of the pot you're working on, which sits between you and the mirror. Without one you have to lean back

I've always liked inclement weather and we experienced a lot of that during my two years in Ireland. Steve, on the right, was the other young participant on the course, and my English comrade. We didn't immediately bond — he was brash, I was timid — but that quickly changed.

awkwardly to see the side view, or even hop off the wheel and take a few steps back. Straining backward like that can't be good for your back and Gus seemed to think so too, and made sure we all used these mirrors. Then there was the throwing gauge, a contraption that sits next to the mirror and has a retractable, alterable arm, with a rubber pointer that can be moved around and fastened in place. The idea is you throw an initial form, say a mug, to 10 cm high, 8 cm wide. You then adjust the gauge and tighten it so the pointer rests just beside the rim of the vessel, set at the height and width. This way you don't have to constantly measure the pots you subsequently make with a ruler; instead you just throw them to this physical point set in space. It's like a target, a bullseye, and it makes repetition throwing far easier.

Gus swore by these tools and to this day both are permanent features on my workstation. Many of his practices have stuck with me since, as have those from my other teachers too. Children often resemble their parents somewhere down the line, whether they like it or not; perhaps the same is true with students and their teachers.

GUS OVERSAW THE running of the course and was with us for most of each day, but every term we'd have a few weeks blotted either red or blue, to indicate time spent with Ann or Geoffrey. Learning pottery from one person works but what's even better is learning the craft from several skilled people, as each ceramicist has their own distinct way of doing it, their own colloquialisms in amongst the wider language of pottery.

Gus was methodical, which matched my own person-ality the closest. He approached everything with a plan, taking notes and making illustrations of the tasks ahead. His work was meticulously thrown and everything was neat: his glazing brushes were all hung up in an orderly row, his tools were stashed away and categorized, and his workstation, wheel and stillages were all well kept. Fascinated, I'd go and look around his end of the studio, which he didn't mind us doing. He didn't

spend much time producing his own pots. Rather, he'd be in his 'clean room' behind the wheel – a little space tucked away, the old foreman's office, with glass windows that looked out over the main studio.

His method of teaching was well planned and straight-forward. He'd explain what he was doing with his hands and why, discussing what worked and the reasons why it worked. He was prompt, he'd show us how he did it, throw each of us an example of the pots we were to copy, then he'd leave us to struggle alone for a while. After lunch he'd do the rounds, checking in on our progress individually and advising us. He had an authoritarian demeanour – this was very much his kingdom and we his people – but he was also kind and caring and knew how to impart knowledge wonderfully, breaking down processes into multiple small understandable steps.

Ann had a very different approach. She was herself a graduate of the course from many years ago – the same potter present during my interview – and was now a pro-duction thrower, making pots in their tens of thousands. She was from Limerick, or 'stab-city' as she liked to remind us, gripping an imaginary dagger in her hand and digging it into our sides. That was her way of saying, 'Take me seriously', which we *all* did. She was a self-proclaimed 'hard arse' and if you mucked around during her tutorials, or were just generally problematic, she'd call you out on it immediately, and in front of everybody. I made it my mission to never be on the receiving end.

Ann was far more hands-on compared to the others when teaching, which for throwing pots is eye-opening. As a beginner with any craft, you're probably quite timid when using the material. You take it slowly or you don't apply enough pressure with your hands. You're precious – and in some crafts for good reason. If you're, say, a jeweller or a woodworker, your raw material is expensive and can't easily be reused in the same way clay can. Regardless of that, having someone personally take your hands and push them with the required pressure into the clay, or to physically change your grip when clasping

a tool, or position your hand to the correct orientation, is invaluable and that's exactly what Ann would do.

She'd watch you throwing for a few moments before breaking the entire process down, taking your hands in hers, rotating them to more favourable positions, pushing on them to demonstrate the correct motions and the right amount of pressure to use. In that way her approach was very personal. She'd go from potter to potter, spending five minutes or even an hour with each of us, depending on the individual's difficulties. She was motherly and caring, whilst equally being the bluntest with her answers. The last thing to note is that because she is a production potter, she is superbly quick at throwing. I remember thinking that Caroline could throw a pot rapidly, but Ann took it to another level. It was astonishing to see the clay flow in her hands, walls racing up, the pot's form billowing outward and neck collared in tightly. She threw gracefully and quickly and kept us all under her wing.

Then there was Geoffrey – a wicked thrower and self-proclaimed protector of spiritual stones who was capable of seeing auras, although he'd never disclose ours despite our ceaseless requests. He had a soft, eloquent voice and his pots were full of life. The walls were rugged, the pieces spun into being in mere moments, still gyrating and full of tension, like a new-born waiting to burst into tears. He was a show-off, taking our throwing challenges and relishing completing them in front of our astonished faces, creating towering cylinders a metre tall, giant rippling jars, complex teapots and shapes I didn't even know existed. He obviously had the same level of skill as the others but he both harnessed and let it loose in a different way.

Geoffrey had his own pottery where he made and sold his wares, and every few weeks he'd visit to spend a Monday to Friday making pots with us. He was jovial and honest, and if your pots looked phallic, like they often do despite your best effort, he'd have no compunction in telling you so. He introduced us to the 'kiss of steel', a quality he both liked and disliked. For most of my potting 83

life up to this point, I'd only used rubber or wooden kidneys to scrape pots clean and shape them, but he used metal. It's sharper and will snag more easily on the clay, but once mastered it's a highly effective way of cleaning up thrown vessels before taking them off the wheel. He liked it for that reason, but he also disliked it because it left the surface of the piece finished by metal as opposed to marks left by his own hands.

He was difficult to please and a compliment from him was worth its weight in gold. My classmate Chloë Dowds, who threw porcelain pots so finely they clearly shouldn't be allowed to stay standing, summed up his approach wonderfully. Each of us was finding our voice in clay, sticking with a stylistic choice and chipping away at the edges until it resembled something. Geoffrey came to Chloë, who was throwing porcelain mugs that had a spiralled unevenness pulled into the walls, and told her, 'Next time you throw a batch, try to make them either more feminine or masculine.'

She said she was perplexed at first, both laughing and sputtering angrily, 'What on earth does he mean! More masculine? Could he be any more vague?' But the next time she set about throwing them she tried focusing on the feminine form. They were slightly more curvaceous, delicate perhaps, and it worked. She understood what he meant and this is how Geoffrey operated. His advice was often unclear, like a riddle, but once unpacked there was meaning a-plenty. He saw things where others didn't and showed us an approach to ceramics we hadn't experienced yet. We might not have always agreed with him, but he'd hit the nail on the head about why a pot might not be working: he knew when something felt off. Pots to him were like people, and he saw character where others didn't.

ON FRIDAY AFTERNOON we'd tidy up after a week's toil. The topmost studio had floors covered with linoleum, which was vacuumed and mopped spotless. All our towels and aprons would be soaked and hung up and the wheels would be stripped clean. It was also a good

moment to reclaim clay and to empty the revolting clay-traps beneath the sinks. When you wash pottery tools, or parts of your wheel-tray, you shouldn't let clay go down the drain as eventually it'll build up somewhere and cause a blockage. To get around this, beneath each sink in most pottery workshops is a clay-trap. Ours were large containers, about half the size of a bathtub, and all the water and clay from the sink would drain into these. The clay itself settles and the water moves through various grades of mesh and eventually only clean water escapes.

The problem is that people would empty their milky tea into these same sinks, of which I too was probably guilty. This, combined with the clay and all kinds of microbes from our hands, would cause bacteria and mould to grow inside these tanks. The clay jellied and turned a variety of putrid colours, and as long as it wasn't disturbed it wouldn't smell – so it sat, festering. If you were unfortunate enough to agitate it, you'd be caught by the scent of rotting sewage. The smell clung to your skin and even with long rubber gloves there was still the chance it would splash onto you when emptying it. As the weeks progressed these tanks filled up with our waste, and on one awful occasion, the largest of them on the uppermost studio became blocked and overflowed, sending streams of stinking, mouldy sludge down throughout the studio. I was in the glaze laboratory on the ground floor and, all of a sudden, my nose picked up the stench. I looked up and saw it trickling through the ceilingboards and oozing down the wall. The entire studio stank for weeks but we cleared the blockage.

We all donned thick gloves, goggles and aprons, protecting ourselves as much as possible from the devilish reeking slip. One team would wheel the tanks out and begin slopping the muck into buckets, whilst others went outside with them, behind the pottery, over a tiny bridge which was more of a precarious plank with rails on either side, onto another small island that jutted into the Nore. On this island another team would dig a deep hole, neatly peeling back the grass and setting it aside 85

in a mound. 'Imagine you're digging a big hole, big enough to bury a body, like you see in films,' Gus said. 'That's how deep it needs to be.'

We'd chop through roots and dig out stones and once a sizeable pit was dug, we'd form a line of sorts from the grave to each of the clay-traps. We'd chain out each bucket of stinking clay, passing it bit by bit along the line, down the stairs, across the bridge, until the person at the crime scene would dump the slops in. It was messy work. We'd all stink but at least we stank together. Once the clay was level with the ground, we'd lay the patches of grass back over it and that was that. The small island must be littered with these covered pits and we took joy in stepping on the freshly placed ground as it jiggled beneath our feet. You could too, if you were quick enough, run over it. A game I'd never recommend playing as I can't imagine a worse experience if it were to go wrong.

Gus would oversee us clearing up. It was another lesson in not letting things get too out of hand. Above all, clay dust isn't good for you: silicosis is a side-effect of breathing too much of it in over the years, and ever since I've made mopping the floors and sponging down workbenches a daily ritual of mine – so much so that people jest about how I must do no work as the studio is so clean.

AT THE END of each term there was either an internal exhibition of sorts, which would be scrutinized by our tutors and an external examiner, or there would be a test, a challenge, like an exam but instead of writing essays it was all based on the physical pots we made.

'Production projects' lasted a week. For our first one we were all given a long list of items to make. Five teapots, ten bowls of varying sizes, ten mugs, five teacups and saucers, eight eggcups, a series of jugs, some side plates and dinner plates, six lidded jars and, my least favourite, ten stemmed goblets – an object that frankly shouldn't exist, unless you plan on drinking blood out of it. We'd be given this list the Friday before and we'd have

the weekend to prepare our making schedule for

the forthcoming hell. We'd receive minimal help from the tutors as this was a test to see if we could make everything we'd been taught over the previous months. I hatched a plan, a making strategy. It started with all the complex pots and then eased into the more straightforward bowls and mugs. That way, if anything did go wrong with the more finicky vessels, I'd have time to make more. I pinned my making schedule in front of my wheel and got cracking.

The studio was unusually quiet as we were all taking this very seriously. There was no music allowed, no headphones either, and the only sounds were the whirring of wheels, the slapping of clay and intermittent curses when mistakes occurred. Gus's stories about throwing students off the course if they weren't trying hard enough, or if they fell drastically behind the level of the rest of the cohort, stuck with us and no one wanted to be the student who didn't manage to produce everything.

I'm relieved to say I managed with time to spare. Others didn't, and were left working late into Friday afternoon as those of us who'd made everything celebrated at the pub, hands aching and heads fried. I'm one of those people who hates being late, to appointments, to events, or even to friends' houses for dinner parties. I get anxious just thinking about it but I think it's why I did well in challenges like these, as being late just wasn't an option. Looking back at this list of pots it doesn't seem all that daunting, but back then it was the first time we'd all made such a vast array of work. We all passed that first round and the following week was spent with the tutors judging all of the pots individually.

We'd go to our workstations with the pots surrounding us and discuss how we did, what our pitfalls were and how we'd planned our making, after which all the pots were thoroughly assessed. We *all* had quite a lot to destroy and recycle. Squashing teapots in our hands or shattering them into the reclaim buckets. At least there's some satisfaction that comes with destroying pots, like taking your anger out by thrashing a punch bag. 87

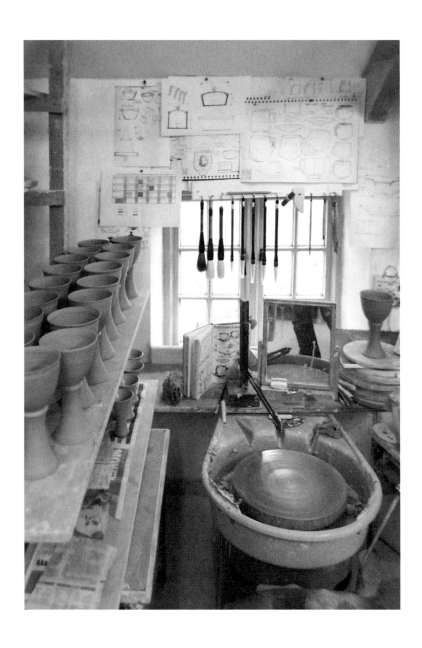

The four workstations on the first floor were highly sought after, offering more space, fewer distractions and large, old-fashioned pottery wheels you had to climb up onto.

The next production project was at the end of the following term and was quite different as the list of pots was customized for each of us. The tutors had taken account of who was quickest last time and increased the number of pots they needed to make, and the list of items I was given was long. They also allowed us to introduce our own designs, at long last, which you'd think might make things easier but in fact the opposite was true. For the first production project we'd all been making pots we were well versed with, shapes drilled into us for months on end, whereas now they were all new, and our acquired muscle memory for those rigorously practised shapes was gone.

We all struggled; this was more than we'd ever been expected to produce in a week's time and I finished late in the afternoon of the final day. My pots had an uncomplicated theme. They were pretty generic really, curved bowls and straight-sided mugs, but with an overarching theme of a groove around some portion of the pot and an impressed dimple, like a beauty spot that the glassy green glazes I planned on using would pool into. Once again, we smashed most of the bone-dry wares to shards, leaving them in water to dissolve to sediment over the weekend. Only three of us finished on time, Peter, Steve and myself. But Gus was compassionate – he could have easily rung the bell at five o'clock to tell us all that the project was over, regardless of where we were. Instead he was quite happy to let those who were behind work late into the night, as long as one of them locked up. He put a lot of trust in us.

Then there were the skills tests that were sprung on us at random. We were all asked to wedge up forty lumps of soft stoneware, each a pound weight. We piled the clay next to our wheels and gathered together, and Gus explained the rules: 'With each lump of clay, you'll throw a bowl. For each bowl you'll only have a certain amount of time to make it, and when you hear the bell you have to stop throwing, no matter the state of the bowl. Set it aside with the others. After every few attempts the time allocated will decrease, so we'll start at two minutes per bowl and we'll keep cutting that down by ten seconds until

A milk jug from one of
our weekly projects, thinly
thrown with a crisp spout
and extruded handle.

One of my first reduction fired
pots and the first that earned
a compliment from Geoffrey,
a genuine cause for celebration.

you only have thirty seconds to make them. You have to try and throw the bowls the same, so I recommend setting your pointer after you've thrown your first one.' We stood in silence. 'There's no points for style, so you can throw any shape you like.'

We all stood around in horror. This was a speed challenge, a race. We sat poised at our wheels raring to go then Gus struck the bell. As we threw, Ann, Geoffrey and Gus paced amongst us to make sure we all followed the rules and stopped throwing when the bell sounded again. I decided to make the simplest of shapes. A bowl with prominent throwing rings and straight, angled walls that concluded with a thick rim that met my throwing gauge's pointer. They were unpretentious pots, like small versions of traditional dairy bowls, pancheons, which have straight sloping walls and a thickly set, robust rim. The bell rang and twelve simultaneous thumps sounded as twelve balls of clay were thrown against twelve wheel heads, which was followed by twelve motors bursting into life.

Centre the clay,
pull up the walls,
push out the shape,
control the rim,
sponge out any water,
scrape off some slip,
wire through,
carefully lift it away.

With enough practice two minutes is easily enough time to make a bowl, but as the time limit decreases you need to begin to physically move more quickly and swap tools more rapidly, whilst keeping any faffing around to a minimum. It's very common when learning to throw pots to spend an age shaping a vessel to make sure it's *just* right, whereas this was a task of eliminating faff, of forcing us to work more efficiently and in as few movements as possible. Ultimately, as a potter you need to decide upon your modus operandi. Do you make vast collections of pots to wholesale to restaurants and shops? Or do you 91

create smaller batches of work to sell yourself? Do you only create tableware or are there sculptural pieces too? Or is it a combination? If you're making tableware on any level and want to sustain a business you need to be able to make it relatively quickly, unless you're very lucky and can sell your pots for a lot of money right off the bat. Making ten mugs a week isn't enough, or even ten a day. You need to be able to throw dozens an hour.

In reality, the throwing of pots themselves is often the quickest part of the process and these days, in a few hours, I can spin off a hundred or more. What takes time is waiting for them to dry, trimming them, handling them, drying them again slowly so that they're bone dry to be bisque fired, and lastly glazing them, cleaning them up and firing them again. The throwing is just the start of the journey. Additionally, once you're running your own business, there's all the admin that suddenly appears that eats into making time. And so, learning to throw quickly and efficiently is an important lesson to learn, and often it takes a very mindful approach to get there. Throwing whimsically won't yield great results. You need to put your head down and focus, and that's what this skills test was all about.

Throwing a bowl in a minute is tough. There's no room for error or any amount of meandering and usually you'll know whether the pot will make it to the end or not in the first few seconds. Some of us were lifting away pots that were disheveled, lopsided and barely formed, whereas others were plucking off successful pots that were full of life as they'd been thrown in mere seconds flat.

Throwing a bowl in thirty seconds is sheer luck. There's no point in making a vessel this quickly except for a challenge like this, unless you live in a part of the world where pottery is sadly seen as the lowest of crafts. It's doable, but my bowls made at this speed were poor imitations of those that came before. You have to sacrifice time spent centring the clay, which means you end up with something jaunty and crude. They certainly had character, they were covered in fingerprints and smudges, but well-crafted they were not.

Then the final bell sounded. We were all out of clay, sweating and huffing deeply. We reassembled and moving from workstation to workstation we'd take turns showing what we'd managed to create in the timeframe. For the most part the pots made between one and two minutes were good. By this point we were all fairly proficient makers, and small, one-pound bowls are straightforward forms to produce. Whereas those made in less than a minute took a turn for the worse. They started to lose their shape, slip wasn't cleaned off sufficiently and many had collapsed. They were covered in fingerprints and varied in size from pot to pot. Mine were all roughly similar, the simple form I'd gone for had worked to my advantage in terms of speed and those made in the final rounds weren't shambolic – but they weren't pretty either.

THE TEAPOT IS the final boss of the functional pottery world. Its creation encompasses assembling a thrown body with a handle, lid and spout, all of which must work together visually and functionally. The visual strength and angle of the handle should match how the spout projects whilst remaining ergonomic to use, and the lid needs to stay put whilst the vessel is tipped over and poured. Holes must be pierced into the body to allow tea to surge out through the spout, as must a single hole in the pot's lid, so air can be pulled through the top and out via the spout, which prevents the liquid from pouring poorly, glugging.

The first time we made teapots was part of a week-long project. We had to copy a shape given to us by Ann that had three feet, a moulding around the base, a tapering body that led to a lid topped with a knob that was textured and squashed, combined with an extruded handle and a thrown spout cut at the opening, which made it appear as if it was pursing its lips. It looked like a toad about to leap. I disliked the form but trying to replicate such a complex shape with so many intricacies was some of the best practice I've ever had. I think that one of the reasons my work ended up being so minimal was simply as a rejection of all these styles we were tasked to create.　93

I almost like drawing pots as much as I like throwing them. Here's a page from one of my Thomastown sketchbooks, filled with cross-sections and pot illustrations – this was the first teapot we had to tackle.

In the week leading up to this project we all made our own pair of measuring calipers, cut from a sheet of acrylic using a jigsaw. Two arms with pointed ends were created and screwed together. Some of ours were perfect, the points matching precisely, whilst other pairs had ends that didn't even come close – I can't think of a more useless object.

Gus had us make a double-ended pair. With one end, you could reach the arms inside a pot's opening and move the calipers outward, like opening a pair of scissors. Once both points spanned the internal space of whatever pot it was you were making, they could be tightened and that measurement set. The other end of the calipers measured the same dimensions, but instead of the arms' points measuring from the inside out they measured from the outside in. This meant that when making lidded forms you could measure the internal diameter of the opening of the teapot and, in one fell swoop and with one tool, you'd have the measurement needed for throwing the lid too.

My attempts at making teapots were fine, nothing more than that. The lids fitted but they were somewhat clunky in appearance and, overall, quite heavy too. At least the tea flowed out in an even stream. When the teapots were bone dry, we'd fill them up with water and immediately pour it out, merely to test them. They'd work well for a few rounds but water quickly dissolves dry clay and we'd watch in despair as they slowly disintegrated. We were taking dozens of hours of work and watching it all melt right before us.

Once again, the importance of not being too precious was hammered into us. Wheel-thrown pottery all happens quite quickly after all; if you destroy a board of pots accidentally, well, you can just reclaim the clay and throw the pots again. The material cost is relatively low, until you fire the clay, whereupon it becomes permanently changed and can no longer be recycled. Compared with other crafts, clay can easily be saved up until this point, and boards' worth of melted teapots could at least be turned back into usable clay, ready to be made into a second batch of hopefully better teapots. 95

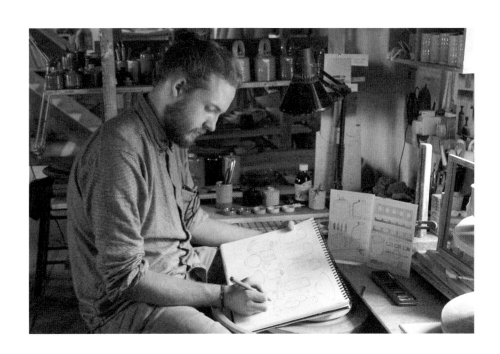

A portrait taken by Gus for our final graduation show – it's fitting he thought I should be pictured drawing as opposed to throwing. By this time, each of our workstations was a mess of experiments, pots in progress and our own illustrations pinned all over the walls. No two of my cohorts' pottery were alike.

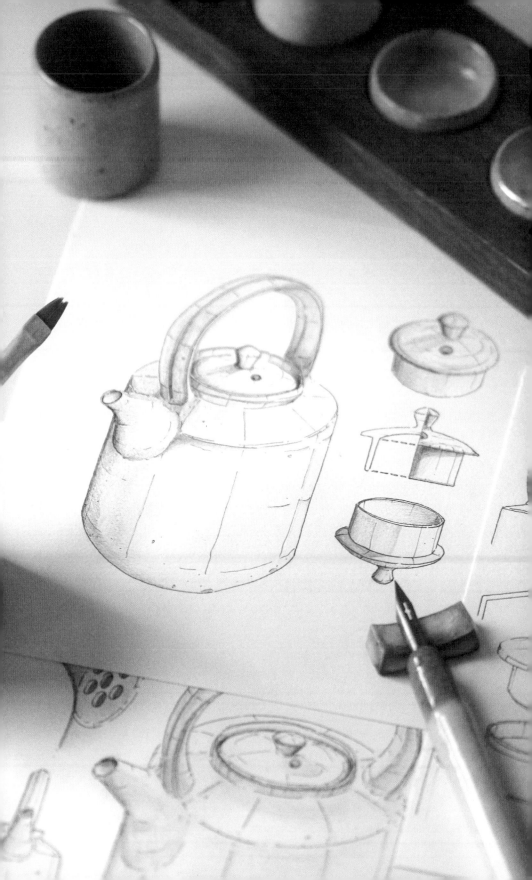

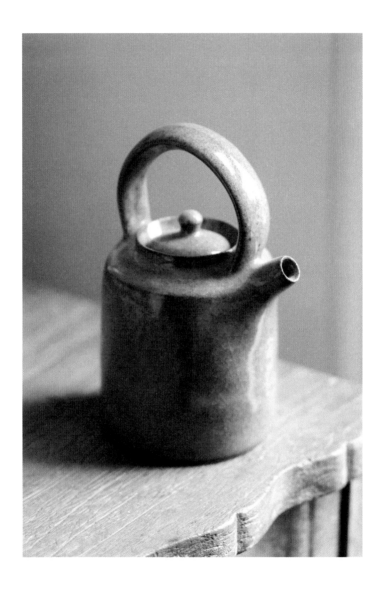

This teapot glugs when poured, the knob is too dainty
to lift comfortably, and the dark green crackle glaze has
sloughed away from parts of the arching handle. I adored
it then, but it isn't perfect. It still lives with me today and
for the reasons above I'll never let it out of my sight.

This was the first real batch of teapots I'd ever tried to make and it pushed all of us to our limits, especially at the end of the week when Ann and Gus did their rounds and judged our attempts. I'd never seen the reclaim bins as full. Smashed pots were piled up, teapots stacked one on top of another, squashed into the sludge in the bucket, left to slowly fade away over the weekend. We all had a long night at the Bridge Brook Arms after that.

The following week's task was to construct teapots in the style of our own choosing, so, over the weekend, rather hungover and the worse for wear, I lounged and drew dozens of iterations of the teapots I wanted to make.

After months of being told exactly what to produce, being given total freedom suddenly felt strange. I'd made teapots of my own before. Well, that's not strictly true; I'd only made two other teapots, in school, that didn't really follow any real design rules. Rather, they were examples of what I was capable of making as an amateur, resulting in four arbitrary components being stitched together clumsily. They were proportional disasters.

I decided now to make straight-sided vessels that sloped in at the top. The lid was inset slightly, partly hidden, resting on an internal ledge, and I'd fasten a thrown spout onto one side. Instead of having a handle opposite this I decided to pull longer lengths of clay, which I would then arch and attach so the handle sprang over the pot with the lid beneath it. I had been looking at vessels made by Lisa Hammond and Anne Mette Hjortshøj, two potters who add woven vine handles to their teapots attached via little loops of clay, lugs. I wanted to try it with clay instead of woven vine and photocopied and printed dozens of images to pin around my workstation for inspiration.

Making a teapot of my own design was altogether a better experience. I don't dislike the challenge of being made to replicate forms but, given the choice, making vessels that you actually like and put some thought into and that might one day be added to your repertoire of pieces makes you engage on an entirely different 99

level. We still had something to prove too. It was unspoken, of course, but there was some competition between all of us students. Who could make the most? Who got the best praise from the tutors? Who was allowed to keep more of their creations after the Friday afternoon cull? We noticed all of these things and some of us certainly had it easier than others. Making one teapot is easy enough but assembling a dozen or more that are identical, that's hard – let alone glazing them successfully and then, at long last, firing them. Just pray that they don't splutter and spit tea out poorly once they're filled up and poured into awaiting cups.

I HAD STARTED cycling everywhere and living off measly salads in an effort to lose weight and embark on a healthier lifestyle. I was sick of being heavy, and there was a girl on the foundation course next door I liked. Whilst I felt great, mostly, I was always tired. I'd been waking up early to work out, then I'd spend a full day at the studio busily throwing before either going straight home to work out again, or going to the pub with the others and *then* arriving home to exercise. One morning, as Gus was an hour into a lecture about how to correctly use the bandsaw, with us all standing around propped up on elbows, leaning on the bannisters, I felt my head begin to get blurry, as if black-and-white static caused by a loose connection phased across my vision. My ears started ringing and suddenly I couldn't see. I came to a few minutes later. I was on the floor with faces close around me, peering into my eyes.

'I passed out, didn't I?'

'Yes, yes, you did Florian, can you tell me my name?'

'You're Gus Mabelson and we're in the workshop. I'm on the floor.'

Bernadette was caressing my head. I could feel my cheeks heating up, turning rosy red with embarrassment. Then Chloë clattered up the stairs from the kitchen with a tankard of water and some toast slathered in thick, strawberry jam. 'You need some sugar! Get this down you.' I sat up, head spinning, and took the plate.

I'd been pushing it. I was exercising every day whilst also keeping up a busy social life and doing all my college work. A few weeks later I got a cold, which developed into tonsillitis, whilst having mononucleosis, or glandular fever, at the same time. I spent the weekend at home barely able to eat or even drink as my throat was so swollen. I had planned to go to the doctor's on the Monday but it was a bank holiday. Tuesday came and I slowly ambled to college, a foolish idea. I took one step into the pottery and Gus said, 'You're green, you need to go to the doctor.'

Karen offered to drive me, it wasn't far, just a few minutes into town. The doctor saw me, took one look down my throat and insisted that I had to go to hospital. I was starving. My stomach was growling at me as Karen, my saviour, drove me all the way from Thomastown to Waterford, a forty-minute journey. I was sent straight into the emergency room, Karen waving goodbye through the glass as they rolled me through on a bed, a drip already pricked into my skin. This seemed to have gone from zero to a hundred in the space of an hour and I was a little bit scared. They wheeled me into a small room with a giant metal dentist's chair and hoisted me up onto it. I was told I needed to take a painkiller, a suppository, which I did in a little private room. Back in the chair they sprayed another painkiller down my throat and up my nose and inserted a camera through my nostril and into my windpipe, so they could see what they were doing. They then warned me, 'Whatever you do, spit it out, *don't* swallow.'

A peritonsillar abscess is a boil, essentially, also known as a quinsy. Mine was enormous, almost blocking my entire throat. It was so large that it had affected my hearing, and for weeks before all the music I listened to had sounded as if it was slightly out of tune. They're dangerous, as if they burst whilst you're asleep you can drown – a notion so unsettling I'm wincing just writing about it. They need to be treated quickly as the infection can spread and sepsis can set in too, and so two nurses stood in front of me holding deep trays by my mouth and a doctor reached into the back of my throat with a scalpel.

He sliced. A jet of pus and blood shot out of my mouth. It felt as if I was projectile vomiting. The trays held in front of me filled up, the nurses staying valiantly still. It was dreadful. The smell was awful and the mess was terrible, but I felt *great*. A huge bubble in my throat had been burst – I could immediately breathe properly and I pulled down huge mouthfuls of air. Two minutes later a nurse brought in a plate stacked high with sandwiches that I wolfed down. It hurt to swallow but my hunger didn't care – I hadn't eaten properly for two weeks.

I spent the night on a bed in a corridor. The doctors kept me in for a few days with my arm plugged into a drip filling me up with penicillin to fight the infection. Finally, a proper bed was found, in the corner by the window in a ward that seemed to be full of elderly, coughing patients.

My first day of rest didn't go smoothly. One nurse swapped the drip to my other arm but failed to position it correctly and I awoke the next morning with a giant, swollen arm that ached and pulsated, full of liquid. Gus came that afternoon to check in on me. He stayed and chatted and insisted I not worry about the work I missed. Then, about ten minutes after he left it was time for more penicillin. I remember the nurse letting it flow in and all of a sudden my arm felt like it was on fire. I awoke with my chest and legs stripped and with a ring of doctors around me, positioning wired metal discs all over my skin. I felt like my head had been slammed against a wall and my arm seemed like it would explode from the pressure.

I passed out again and this time woke up hours later.

Eyes blinking open, I jabbed the 'call' button on the side of my bed repeatedly and a nurse rushed over. I asked what happened. It turned out I had gone into anaphylactic shock. This was the nurse who had administered me the penicillin; she said that as soon as she'd done so, my eyes had rolled back and my tongue had literally fallen out of my mouth to one side. So, now it turns out that I'm allergic to penicillin. Like my grandma was. Not genetics – just bad luck, and another thing to coop me up when all I wanted was to be making pots.

A few days later I was discharged. I ended up being held in for longer than anticipated due to the surprise anaphylaxis. Gus collected me in his people-carrier and we drove back. I insisted that I wanted to go straight back to the pottery so we did. Ann was there. She immediately jumped into mothering mode and yelled at me for being such a 'nitwit', and for not going to the doctor's sooner. Later that day whilst I was setting up our end-of-year exhibition in the gallery space next door she yelled at me again, for sitting on the cold concrete floor as I wrote labels. She shot off and came back with a thick wad of cardboard that she jammed beneath me.

I had a long rattling box of drugs I needed to take for the next two weeks, multiple pills three times a day, some of them giant. In a way it had felt like a short holiday, holed up in the hospital, in bed, with nothing to do other than watch films late into the night as the ward switched off around me, the elderly snoring echoing through the room. I caught up on the work I'd missed and prepared sketches for the following week's final project; after all, I couldn't let the others learn something I hadn't. I tend not to have half measures, as my friend Peter tells me, 'You're either in, or you're out.' Meaning that if I set my mind to something I'll pursue it at all costs. This was true with my weight loss. I didn't think about nutrition, or how best to do it, I just wanted it gone. I needed a change, and I pursued it until it put me in hospital.

THE FINAL EXHIBITION of the year consisted of the best of our pots from the last term, which meant we were all showing a cross-section of the work we'd made. We didn't have to travel far, as we were setting up in the gallery space next door in the other craft school's entrance hall.

It was set out on white plinths and we spent the day scrubbing them clean of cobwebs and dabbing Tipp-Ex onto the areas where the paint had chipped away. It was meant to be authentic, like a real exhibition, a test to show us what setting them up was like. Gus told us that the next day an external examiner would come and

we'd each go in with him and the rest of the tutors to look over our work. He also advised us that Neil, the examiner, was a stickler for a well-finished base on the bottoms of pots. We all scrounged as much sandpaper as we could find, from coarse to exceedingly fine, and rushed back over to the gallery to polish our pots' bottoms glassy smooth.

Was he just being kind and warning us? Or did he not want Neil to think he hadn't already taught us the importance of this? Nowadays I'm a stickler about this too, although it's complicated. Fundamentally it comes down to the fact that the base of a pot should never be forgotten. More often than not it's the part of a vessel that tells you the most about its maker. Is it scruffy and crudely finished? Has it been concluded with spontaneity, with a flick of the thumb or quickly trimmed? Or has it been carefully crafted and precisely turned with a delicate foot?

We were taught that the base of a pot should match how the rest of the pot is finished. If a pot, like a purposely naively thrown bowl, for instance, is cut around the sides, faceted and thrown with jagged and rough parts, then the base should echo that. If the pot has been made with a coarse black clay that's full of life, molten iron and manganese, then having some of it visible on the base lets you glimpse the material used to craft the pot, instead of it all being hidden by glaze. The same goes for vessels that are crafted immaculately. The foot should match the quality of the rest of the pot; it should be harmonious, or at least intentional. Most importantly, it shouldn't just be forgotten about.

Neil ran his palm over the bases of my bowls, content enough to comment on them. 'Your foot-rings are lovely and smooth,' he said. Thanks Gus.

We broke up for summer and I flew home. Eight weeks of not making pots every day, bliss, although Peter and I had booked a weekend masterclass at Maze Hill Pottery with Svend Bayer. Maze Hill Pottery in Greenwich, London, is where Lisa Hammond pots. She's the potter who steered me away from attending a more traditional university course in favour of taking a route that

was more skills oriented. Svend Bayer is a famously skilled thrower, and another world-renowned potter, who was once an apprentice to Michael Cardew, who himself was one of Bernard Leach's flock. They are a trio of potters who've inspired generations of throwers and I couldn't wait to see his hands at work in none other than Lisa's studio. We stayed at my great-uncle's house in Blackheath and learnt buckets over a few busy days.

Peter and I were the only students really capable of following Svend's instructions. I'm not saying that to toot our own horns, but it wasn't meant to be a beginners workshop. Yet, the six others attending were still stuck in the grey zone at the start where you can't really create the pots you have in your head. It was a struggle for them to replicate the vessels Svend was showing us, so little of his teachings could be passed on to them as they were yet to get to that point; nor could they practise the subtleties he showed us that made him stand out as a potter.

Svend threw in a way I'd never seen before. Each movement was so efficient, so purposeful. Even though I had spent the last year making pots practically every day there's a mesmeric quality present whenever you watch somebody throw, especially someone new. Perhaps it's the spinning clay or the slip spiralling around the pot in sinuous lines. There's a joy found in watching anyone who has mastered their craft, be it pottery, woodwork or cooking. They flow, their movements natural, it all just looks effortless and the pots Svend threw never once looked like they might collapse.

Yet, this isn't always the case. Some experts work to another extreme, like Francis Power, an apt name for a production thrower at a pottery close to Thomastown we visited often. There was a plastic enclosure around him, viewing glass, as if he were an animal at the zoo. Outside, the room was clean and tidy, a little museum of the pottery and its history. Inside his sty the area was caked in clay, literal inches of the stuff plastered practically every surface, the glass, the floors, the wheel, save for the metal wheel head which he threw upon. Clay would

be piled to his right and ware boards were slotted to his left and *all* he had to do was throw. Someone would take the freshly thrown pots away and somebody else would continually supply him with soft, balled-up lumps of clay ready to be used. He could simply sit and throw, board after board, hundreds of jugs a day or even a thousand mugs, so I was told, an unfathomably high number. At the time I could probably throw twenty pots an hour, pathetic in comparison.

Francis threw differently to Svend. He was a production thrower after all, not so much a studio potter, and for him all that was important was the number of pots made per hour, thrown to preordained designs. The soft clay was centred in two seconds flat. Then the walls would be jerked up in another moment, the sides of the pot trembling as if it might collapse at any second. He'd belly the form out, like a balloon being blown up with a great gust of breath before collaring the neck back in with a stranglehold grip. In one continuous motion the slip was removed from the outside of the gyrating vessel, leaving the entire form perfectly refined and, with one last flick, he'd create the spout. A tall jug thrown in sixty seconds; I don't think I've ever witnessed one made so quickly. A master maker, without question, yet his journey to a finished pot seemed chaotic and fraught with peril, at least to an outside observer. Svend, on the other hand, threw steadily, like a rock, gradually shifting the clay into place as if it was always meant to be there.

A good masterclass always fills you with excitement and I longed for a chance to practise what I'd learnt, especially a morsel about getting the last bit of clay out from the bases of my pots. Here's what he shared, and it revolutionized my throwing.

Naturally, the lowest parts of the walls of a pot are just that bit thicker. They can't always be as thin as the walls above, especially with soft clay, as there needs to be a foundation to support what's above. Yet getting enough of that excess clay up can be a challenge. Usually, you reach down with fingers on the inside of the

pot and with a knuckle on the outside. They're positioned slightly askew to one another, and together they press against the spinning clay and move up, forcing the thicker clay in the walls through a thinner gap between your hands, almost as if you were extruding it through a finer die plate.

What Svend showed me was intended to be done when a majority of the clay had already been pulled up. You reach inside as normal, a knuckle positioned outside ready to push inward and upward. Inside, though, you place the palm of your hand parallel to the wall of the pot, bracing it from the inside so your fingers rest vertically against the rotating wall. This inside hand remains firmly tensed and stationary as the hand outside pushes up against it, through the wall of clay. The outside knuckle slowly compresses the wall against the palm and it means you can precisely gauge the thickness you want in the foundations of the walls. Although you do need to be careful; it's very easy to overdo it, removing your hands gleefully and watching the whole vessel suddenly shrivel and collapse as you've made your foundations too thin.

WE STARTED BACK. It was September and the rain was constant. A wet mist hung over Thomastown and Gus started wearing boots, telling us about all the times the pottery and courtyard had flooded. He dug out old photographs to show us the torrents of dark water that had seeped into the pottery and the kitchen. We all squelched up and down the lane and muddy footprints started to cover the steps and studio inside.

The second year was when the tutors started to really care about our personal vision. We'd be tasked with designing a set of pots over the weekend and we'd present them to the cohort the following Monday morning. Now things were getting interesting. We'd be encouraged to give each other feedback, tell one another what we thought worked and what didn't and at times the criticism could be savage, especially as the fractures between certain individuals grew. Our tutors would scoff under their breath as remarks were made against each 107

other's ideas, and they'd be just as blunt in telling you that something didn't work or that your slip decoration looked like a squirt of seminal fluid – that was on one rare occasion I should note.

As we settled into the new year we went back to basics – mugs, yet this time made with porcelain. Porcelain is unbelievably smooth; it feels like you're throwing with putty and it's notoriously troublesome to work with. It cracks more easily than stoneware and warps too, if poorly handled. It's durable and is typically fired to a higher temperature, and is made from finer-grained raw materials that contain practically no impurities, like stoneware commonly does. It's composed of a high percentage of kaolinite, kaolin, also known as China clay, a material first mined and used in China some ten thousand years ago – a deposit was finally found in Cornwall in 1745. The matter it's made from is ground extremely fine and it can be thrown and trimmed to a point of translucency, light shining through it as if it's a semi-opaque sheet of glass. Hold a delicate porcelain plate up to a light and you'll be able to see your hand through it.

As I got to grips with this new, unwieldy white clay, I watched the river outside flow faster and become ever more dangerous. It seethed and soon, as a storm from the Atlantic smashed into Ireland, logs and branches started to float downstream. They became entangled on the bridge, wedging on the piers that plunged into the water. Whole trees were caught, wrapped around the cut-waters and soon the water rose even higher, lapping the shores; the body of a poor soul was even found amongst the flotsam, pinned down by the currents. The skies were plastered black for days and it remained gloomy and sodden for weeks as the sun struggled to show its face.

There were power cuts that plunged us into darkness, all our wheels suddenly petering out, followed by a wave of sighs. Suddenly we realized how vital electricity is to making pottery, especially to a group of ceramicists who hadn't learnt how to use the manually powered kick-wheels hidden away in the boat shed.

We stashed our pots away and continued with work we could finish, like slipping and glazing mugs and drawing, which we did by candlelight. Up the lane a tree had crashed onto the power lines, cutting off electricity for half the town. There wouldn't be any power for a while, so Gus, unwillingly, called it a day. Splintered slates from the roof littered the courtyard as we walked out, some wedged, flung into the soaked ground. Porcelain would have to wait.

My room in the flat was as damp as ever; my clothes, washed of clay and hung up, remained perpetually wet and water started to seep beneath the front door and across the linoleum floor towards my bed. It was miserable. And so we lived in the pottery, in our flats and in the pub, sitting beside the fire that was already lit in September.

Before switching to porcelain, the entire workshop was given a deep clean. The place had been stained by a year of using groggy grey stoneware clays and red terracotta that had filled every crack. All of it had to be scrubbed clean and removed almost surgically, as one blot of colourful clay easily stains white porcelain. We each cleaned our wheels spotless and all of our tools too, before starting work on the floors, batts and workbenches. One job remained before we were allowed to finally open up the bags of porcelain and that was to swap the pug mills over to porcelain, which meant disassembling them, stripping them clean and removing every last tiny speck of stoneware before putting them back together again. Gus gave the place a once-over, going from wheel to wheel to make sure we'd all cleaned up sufficiently well. Then we all manned the pug mills and churned through dozens of bags of porcelain, which left us with mountains of lovely soft clay, like stacked pieces of chalk.

Porcelain is a strange material. In the bags it was delivered in it felt quite solid, a firm press of a thumb would barely indent it, yet once wedged and moved, the body stirred, it started to loosen up. It's sort of thixotropic, firm when stationary, fluid when disturbed, and running it all through the whirling blades of the de-airing pug turned what was an unusable material into one 109

ready to be thrown with. Nowadays at the studio, as I don't have a pug mill yet, this process has to be done by hand, which means when I use porcelain, I often have to do a lot of wedging. But to get things started, I simply fling the bag of porcelain firmly against the floor a handful of times, resulting in a series of loud slaps. This blunt force is enough to change the porcelain from being a nightmare to wedge to being quite easy to knead.

Porcelain was introduced later in the course as it's fundamentally a more difficult material to work with. It's punishing, incredibly so, and having a base set of skills practised on stoneware pots should mean that learning to use this white gold (porcelain is much more expensive than stoneware clay and, historically, once had as high a value as gold as we didn't know how to reproduce it in the West) is a little bit easier, compared to, say, if you started immediately with it as a beginner. It's harder to throw with and loses strength quickly, which means it tends to be more troublesome to control on the wheel. It's a more refined material, and once highly fired it's unbelievably strong – as demonstrated to us by Gus standing on a wafer-thin porcelain dinner plate placed upside-down on the floor.

As it dries, porcelain has a tendency to crack and warp, and glazes interact with it in an entirely different way, as they're being placed onto a very sealed, bright, white surface – they seem to sing. Colours are vibrant, blacks more intense and whites seem to become even more vivid. The clay also shrinks more throughout the process, which means you have to throw pots up to 15 per cent larger than they'll finally be, compared to stoneware that mostly shrinks about 12 per cent. As a result, when throwing porcelain you need to throw pots that are unusually large – colossal teapots, vases and cups that appear fit for giants when initially made, but they will shrink down to a normal size once fired.

Stoneware clay, in comparison, is a walk in the park to work with. You can get away with murder when throwing and trimming it; you can stick pieces of it together without it splitting; and it only warps if you treat

it exceptionally poorly or trim it paper thin. Stoneware clays can be smooth, but more often than not they contain a fair amount of grog, which is what we call the particulates added to stoneware to give them 'tooth': texture and added strength. It's normally made from clay that has already been fired that is ground up to various grades before being added to smoother clays. It makes the pots less likely to crack as the clay itself can't shrink as much and, beyond that, the grog adds a reactive aspect.

You can hear the tools trim and drag through a sandy body. When you push firmly against it with a hand or tool the audible response becomes more noticeable, you can feel it, like sandpaper, followed by a tearing sound. It's like the sound of a revving engine, and the sound is an additional indicator of what you're doing. Porcelain is like an electric car, it's silent. It's so smooth that it can be difficult to feel what's actually happening. You can add grog to porcelain to give you this tactility. It adds strength too, but by doing this you begin to lose all the qualities that make porcelain so wonderful to work with in the first place.

Even smooth stoneware never feels quite as buttery sleek as porcelain does. It feels like you're throwing with gritty mud, whereas porcelain can feel like liquid plastic flowing through your hands. Getting to grips with porcelain is what led me to find my own voice in ceramics, as I discovered that creating fine and delicate pots resonated with me on a whole new level. Up until then, I'd been creating quite cumbersome work. My vessels were thickly potted with sturdy handles and echoed the work I'd been following so closely that was Leach-esque – classic studio potter's pots and brown functional objects. Porcelain, though, can be thrown and trimmed to exceedingly fine edges. Textured stoneware can only be made so delicate as the particles of grog begin to take up so much space in the edges themselves, and I quickly became transfixed by this quality, throwing bowls and bottles that tapered to vanishing lips. I'd trim them finely, so they defied your expectations when lifting them up, and I'd coat them in a shimmering black iron-spot glaze, only to finish them with

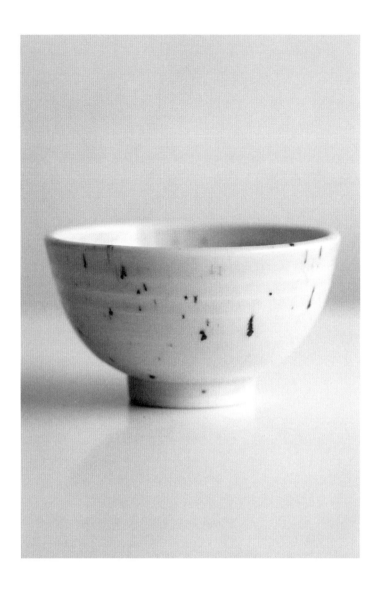

To achieve this finish, I sprinkled flecks of iron onto the surface of a bucket of simple celadon glaze. I then dipped the bowl into it, the suspended metal clinging to the vessel as it emerged from the liquid. Initially, this worked wonderfully – as you can see here – and yet, as each new pot was dipped, requiring new flecks to be scattered on top, the celadon glaze became more and more saturated with all the additional iron, so that whilst the earliest of the batch of wares started off a pale blue, as intended, subsequent pots fired to a dark green, then brown, and finally black, the iron flecks no longer distinct or even apparent.

a scalpel that I ran around the rims, revealing a hair's width of white amongst the black, a halo that caught the light and almost seemed to hover.

That was the work I ended up making, the conclusion of my stint with porcelain, whereas the porcelain pots I started with were altogether heavier things that more closely resembled the stoneware pieces I was making at the time. Mugs with spiralling walls and weighty feet, coated with thick veneers of grey-green celadon glazes, some green, others blue, and a few speckled like duck eggs with intermittent blots of iron covering them. These were glazes I had been using on my stoneware pots, transferred over, and they glowed even brighter on a white canvas.

When we switched back to using stoneware clay it felt like I had superpowers. It was so easy to throw with in comparison, and the walls of pots simply floated up as if by magic, obeying my every command. I felt more at home with stoneware, even though porcelain had shown me a realm of finesse I hadn't encountered before. I was using a stoneware that contained lots of iron; it seeped into the glazes as drops of metal, like ink blots on paper, never appearing the same way twice, and I adored it. There's a romanticism in creating pots that resemble the earth and the materials used to create them: be it unrefined clay, crusty surfaces and wood ash glazes melted over them like icing spread over a cake that's still too hot. There's another romantic notion in creating something from nothing. From taking clay, dirt, earth, rocks and minerals from under our feet and turning it into an object that's highly refined, delicate and light. Into an object that's the opposite of the source materials used. It feels like sorcery, or like taking lead and turning it into gold, and I find that idea captivating.

The first porcelain project culminated with an absurd test, done in order to show us just what's possible if you really try. This was to throw, handle and raw fire a porcelain mug in a single day. It went against everything we'd been taught, as making pots is a process that's often at the whim of the weather. Thrown vessels need to

dry before they can be trimmed and handled, then they're usually bisque fired to 1000°C, dipped in glaze, and fired again to an even hotter temperature – and all of this takes time. Weeks, months, not days or hours. Potters don't work in timeframes that small. Raw firing in this instance means that the pots are only fired once, with a glaze that's more akin to a slip that's coated onto the pot when it's leather hard, a process called raw glazing.

Typically, potters never work on just three or four mugs from beginning to end. Instead we produce dozens of mugs, bowls, jugs and all manner of other objects, which are all then bisque fired together and finally glaze fired together. It's a process that can take weeks or months and most potters tend to work in longer making cycles like this, creating hundreds of pots before firing them all, a culmination of weeks of work, all packed into one large kiln. This means that kiln-firing disasters are dreadful. Not only can you potentially waste the raw materials but hundreds of hours are tossed down the drain too, weeks' worth of wages.

Making went like normal for the throwing part. We all made a selection of mugs, more than necessary to allow for breakages, before taking the freshly thrown, sodden vessels and placing them above the storage heaters. There, we rotated them carefully and blasted the pots with hair driers to quickly turn the clay leather hard, a state where the clay still retains some moisture. We wanted the pots to be firm, so they could be held without the shape deforming, still cold and slightly damp, and when in the perfect condition they do feel just like leather. This is a process you normally allow to happen naturally, perhaps overnight, or the pots can be laid out in the sun or in a draughty location. A keen eye is kept on them so they don't turn bone dry too quickly, as, if they do, they'll warp and crack.

Once our porcelain mugs were leather hard, they were trimmed and the handles were added and then dried again, slightly. Yet the bodies of the mugs were considerably drier than the handles, and if one part dries more quickly than another then a crack will form

between them. So, over lunch we sprayed them with water and wrapped the handled forms up in plastic, so the clay of the mug and handle could briefly acclimatize to one another.

As soon as the entire pot was firmly leather hard the cups were raw glazed. The outside was dunked in slip, which is a solution that contains the raw materials needed for a glaze together with much more clay than usual, which helps it stick nicely to the porcelain body. As there's so much water in this slip the pot essentially softens back down again, reverting to the delicacy it had when freshly thrown. So, once again, the mugs had to be left out in the sun to dry before glazing the interiors by pouring slip inside them, swirling it around and then pouring it out. Again, the pot reverts to being soft, as the clay body absorbs the water from the slip, so back in the sun they go. This was the last time, though, thank goodness, and at this point we let them turn bone dry.

I didn't like raw glazing at first. It is messy and one mistake can cause the whole pot to simply collapse. If you use too much slip, or slip them prematurely, the clay foundation beneath just subsides. Compared to normal glazes that are applied over bisque fired, hard clay, if mistakes are made with those you can easily just scrape the glaze off, like peeling the skin off an orange, wash the remnants away, and dry it, ready for a second attempt. Whereas with raw glazing you've only got one shot to get it right. One of my mug's handle fell off, the raw glaze overwhelming it. I still had three left. Another person forgot to wipe the glaze off the bases of his mugs and they all stuck firmly to the wooden ware board; upon prying them away he was left with a collection of useless mugs without bottoms.

Finally, as five o'clock passed, we started to fire them. This was done in Gus's rocket kilns, so called as they could be fired from 0°C to 1250°C in about an hour, or a little less if you felt brave. Built from ceramic fibre encased by a wire frame body to hold it all together, the kiln comes in two parts, opening in the middle like a matryoshka doll. On the very top is a vent that can be opened

or closed to one's whim – a flue, essentially, just like a gas kiln has – which means it can be fired in a special, reduction atmosphere, which opens up a new realm of colours. At the bottom is a circular opening through which we shoved a gas burner, linked up to a tall bottle of propane. Inside there is a raised kiln shelf, onto which you can stack two layers of mugs, or about six mugs for each kiln load.

Everything was assembled and the burner held in place with bricks. It was all rather ramshackle and at this point the rain had started again. We took turns firing beneath Gus's overhanging office balcony, as water fell around us and inched ever closer to the bases of the kilns. As we fired, we kept a log of the rising temperature and the position of the damper, while huddling into the corner away from the spitting rain as the four kilns increased in heat. Soon their interiors were white hot and through a slit in the top (welding goggles donned of course) you could just about see the mugs and the pyrometric cones, glistening as the glaze gradually became molten on the pots' surfaces. Another's mugs had all exploded, littering the inside of the kiln with thousands of fragments – this was the result of the clay not being dry enough before going in and being taken up too quickly in temperature, turning the moisture that remained to steam instantly. From the outside all we heard was a few muffled pops.

After the kilns had reached top temperature and the propane was switched off, they took about an hour or so to cool down. We were all waiting around nervously, peeking inside the kilns, through spy-holes, to see if the mugs had survived. Pots do benefit from longer firings, the glazes are allowed to soak in at higher temperatures, giving them a chance to melt properly. Rocket kilns were good for quickly seeing if an idea worked, or to give you a rough idea of the fired properties of a clay and glaze. Yet, Gus would show us a very serious set of beautiful porcelain vessels he'd made, all coated with varying shades of green celadon, little pourers and cups displayed in a specially made cabinet, all of which were rushed through in a rocket kiln. It was doable.

Once the pyrometer read about 160°c I lifted the top half of the kiln slowly away to reveal my mugs. At first glance they'd all made it. The celadon glazes looked successful but one mug was patchy and boiled in places, the glaze bubbling on the surface and fracturing into tiny, sharp craters when poked. I picked one up with my bare hand and immediately dropped it, the searing-hot porcelain scalding my fingertips. Patience is a virtue, an expression that's particularly appropriate when crafting pottery. One mug had a deep crack in the base, enough to let any tea quickly gush out through it. The other two mugs survived unscathed. Yes, they did have slightly unusual shapes, the rims distorted, but Gus didn't mind; you simply don't make and fire porcelain pots in a day, so a few irregularities were more than expected.

We'd all managed to produce something at least, a series of misshapen mugs. They were wonky but they were usable. This was a skills test only Gus would initiate and I've never heard of anything like it since: a test of somebody's ability to control how pots are dried out effectively is what it boiled down to, together with tasks we were more in tune with like throwing and firing.

In actuality, how pots dry is a vital part of making pottery, albeit a process that mainly occurs when you aren't there. How do you leave pots overnight to dry if you want to trim them first thing in the morning? Do you leave them uncovered and run the risk of them drying out *too* much? Do you sling some plastic partly over them to slow the drying down? Do you place them up high where the heat rises or on the floor where it's colder? Is it a hot day? A cold day? Is there a draught? All of these points are considered when making pots, and at the beginning it's overwhelming. But after some experience, and after becoming well-acquainted with a certain space, it becomes second nature.

Damp, cold Ireland meant our pots would take days to dry out sufficiently before they could be finished. Although in the height of summer, with the pots laid out in the sun they could turn bone dry in minutes. In the warmer months the courtyard was littered with pots of all

shapes and sizes and periodically we'd come outside and flip them around, so they dried evenly. It was with our pots outside, although not always, that they could be blessed by the tiny feet of Reuben.

Gus had befriended a robin – a plump little fellow who was so tame he'd fly into the kitchen and perch on our shoulders, seeking morsels of biscuit crumbs and little pieces of bread, which we happily gave to him. He'd hop around the rims of freshly thrown pots outside, leaving little claw prints on them: tiny Y's, in rows, impressed in the soft clay. They were his blessings and pots marked with them were left as is.

MY WORK DURING the course – after I'd churned through a multitude of arbitrary styles, glazes and clay bodies – can be split into three distinct styles. Perhaps most notably there was the immaculate white porcelain, thrown and trimmed finely with rich, black oil-spot glazes coated over them, save for the rims, which I'd scrape clean with a tiny sponge and razor blade to reveal a hairline band of white clay. This was channelled into bowls and bottles mostly, inspired by my single favourite piece of ancient Chinese pottery, which is a small bowl in the Victoria and Albert Museum (FE.175-1974, if you want to find it yourself), and by Lisa Hammond's monochrome poured white slip over coarse black stoneware clay that was soda fired.

My focus then switched to making more functional pots, although they were jagged, the stoneware cut and faceted. Teapots, teacups and saucers, bottles, bowls and mugs. They were coated with pale green glazes in thin washes and were relatively dull. The grey clay body beneath shone through and these pots were still, sadly, a bit heavy and clunky. I tried to facet their sides with knives and potato peelers, turning rounded forms into ones with eight distinct sides, but they didn't resonate with me.

Then, the style of pots I made changed yet again. The pieces now were mostly straight sided and consisted of jars, bowls and cups coated in black *tenmoku* (a speckled glaze) and a white *guan*-type crackle

Reuben could often be seen outside, perched on the windowsill, peeking in and bobbing around, waiting for someone inside to notice and let him in — we did so happily.

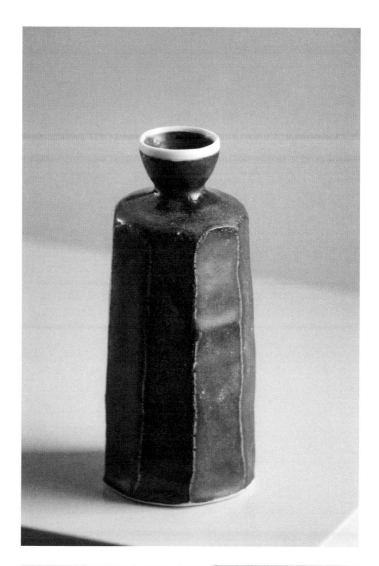

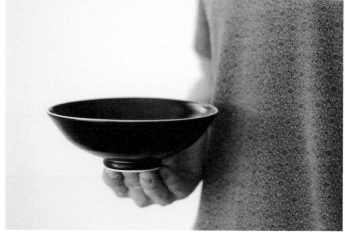

Some of my favourite early designs, on paper and in the flesh. Jagged in places, delicate in others, black and white — maybe one day I'll revisit them.

glaze that is complex in appearance, with purposeful crazing that happens in fractal-like shapes, almost like crystals of ice or the unfurling petals of a rose. Eventually, all three of these styles would lead into the pots I'd make for our graduation exhibition. Each had qualities I liked and all, in some way, shape or form, are still present in the pots I make a decade later. It was a journey of trial and error, of making pots I didn't like until I finally settled on something that gripped me. Finding your own style in ceramics is one of the trickiest aspects of becoming a potter. You want people to be able to identify your pots at a glance, so that there's no question that anyone else's hands could have thrown such a vessel.

There are infinite possibilities when making pottery, and I use that term carefully. But just consider how every type of raw material can be mixed in different proportions with others to act as a glaze, how these can be applied in layers and with clay-based slips or washes of oxides. It's utterly overwhelming, so what do you decide to create? Most people are instinctively drawn to a certain style of ceramics, and as we started testing the waters and trying out different materials and ways of crafting, each person's pots started to acquire their own personality. Throughout the first year and the first two terms of the second year we were encouraged to try out as many techniques as possible, but we were given the freedom of choosing what *we'd* like to pursue for the final exhibition.

Now, it's one thing to choose a specific clay and glaze but how do you decide what to actually make? There are boundless ways of potting and unlimited forms you can create, so how do you find *you*?

Looking at a broad scope of work I was fond of, the pots had a tendency to be monotone in colour. They were functional, usually, and ranged from Rupert Spira's muted tones and delicate forms imprinted with text, to Lisa Hammond's monochromatic black-and-white soda-fired wares. I liked Anne Mette Hjortshøj's utilitarian pots with ash glazes over dark clays speckled with tiny orbs of molten white glass. Akiko Hirai's faceted cups

and plates were pieces I could see myself using each day and I adored the rope-impressed work of Tatsuzō Shimaoka. Then there was Chinese Longquan pottery; these were celadons mostly, watery surfaces of greens and blues, sometimes crackled and crazed and inherently simple – at least, the pots I liked were. Bowls have always been a fascination of mine and these were fluted or scalloped into ornamental sections that radiated out. Others simply had elegant curves and were raised up on tall feet. It's quite disconcerting to consider the age of these pots – objects created in a period that ranges from the eleventh to the eighteenth century – as they could very well be made by potters from this day and age, they seem so contemporary.

Looking at the work I create nowadays you might not think many of these potters directly influence it, but photocopies of their pots were tacked up all around my potter's wheel, references that I'd hope would bleed into my making. I'd look for a subtlety in one and try to mix it with another and I longed to craft straightforward, undecorated work, because those were the pots I could imagine myself living with and using. The inherent problem with simple pottery, though, is that making your voice heard becomes even more difficult as there are fewer ways of standing out.

I normally settled on quiet forms that for the most part were straight sided when projects gave us the freedom to design our own pots. I liked crafting cylindrical jars, teapots and mugs that perhaps had a slight taper in the form that narrowed from bottom to top. Finding a glaze, on the other hand, was altogether more onerous, and I began searching for one that's applied to bisqueware, dunked ideally, held with tongs, the prongs grasping the pot both inside and out and the vessel submerged into a large bucket of glaze, like when dipping a candle wick into a giant vat of wax.

The glaze laboratory had two walls lined with hundreds of glaze test tiles. Row above row above row, spanning different colours, textures and bases. The laboratory was small but well equipped, with little electric test

kilns, rotary sieves and containers of every raw material you could imagine. It led off from the showroom on the ground floor, which was in the entrance hall to the pottery – here, once they were deemed good enough, our pots were displayed and sold to visitors. The money from these sales was split fifty-fifty, half going to the maker and half to the course to cover material costs.

The glaze room was surrounded by thick stone walls and it was always cold and damp. Inside there was enough room for two people to work comfortably, although sometimes we squeezed more in, four or five along the single workbench, elbows clashing as we fought for space. On the far wall sat a series of tiny electric test kilns, the size of microwaves, that could be run overnight with experimental tiles inside; then, on the walls either side were shelves lined with raw materials, tubs of oxides and fluxes were stacked up high and below these much bigger receptacles filled with materials generally used in larger quantities, such as powdered clays, feldspars, quartz, talc and whiting. We'd carefully weigh out glaze recipes, alter them bit by bit, experiment with them, subtract and add new materials, all with rounds of firing in between, all in the search for something new and unique.

An air-filtration system hummed and constantly refreshed the room. Glaze dust is harmful, powdered quartz especially is like minuscule razor blades that imbed themselves into your lungs. Too much of this and you can eventually develop silicosis, a lung disease that can lead to death. It's also known as 'potter's rot'. At the end of the room was another door that opened into a dank alleyway that led to the rickety bridge that connected the mill to the island behind. This door was kept open too when mixing glazes, even in the winter, so that fresh air could blow inside and ventilate the space, keeping us safe.

It was in here that we trawled the test tiles, each with the respective recipe scrawled on the back. I'd select a few and test them, altering them in ways deemed appropriate.

We were instructed to find base recipes we liked.

These were mainly clear glazes and whites, some

translucent in nature, that had different surface textures and qualities. Some were glossy, others matte, a few were crackled whilst others had crystals that grew in them; a few felt like eggshell and others like the wonderfully smooth glaze that covers porcelain toilets. Some bases worked best for electric, oxidized firings, whilst others were more suited for being fired in a reduction atmosphere, in the gas kilns.

There are thousands of glaze recipes out there, millions of combinations of raw materials, minerals and oxides that yield different results. In their most simplified form, glazes are the glass that's melted onto the surface of a clay pot. A recipe is measured out in dry weight, accurately, usually to the sum of a hundred and, like a sourdough starter, there are hundreds of recipes that are passed on, altered and passed on again, from potter to potter.

Glaze recipes are endlessly variable – two similar materials, mined in separate places, can contain different impurities. Ingredients are combined and there tends to be a rough set of rules that are followed. Glazes typically contain a silica – glass. By itself this melts at a stupendously high temperature, some 1700°C, and conventional kilns used by potters can't withstand such intense heat. So, added to this silica is a flux, a material that helps to reduce the melting point of the glass component, such as sodium, calcium and wood ash, just to name a few, or more specifically materials like talc – the same talcum powder used for babies to prevent nappy rash – or potash feldspar, which is a potassium-based flux. These two components combined, a silica and a flux, once mixed and fired hot enough will turn into a liquid, essentially flowing off the pot and destroying your expensive kiln shelves. So there's one last thing that needs to be added to the base recipe and that's a stabilizer, an ingredient that stiffens the glaze so it doesn't run. This stabilizer can be aluminium oxide, which is present in most clay bodies to some degree, so powdered clays are used. Not only does it stiffen the glaze during the firing but, when freshly applied to a pot, it makes it stronger and less susceptible to chipping off. 125

Colourants are added to this base recipe in the form of metal oxides and carbonates, like cobalt oxide, which creates blue tones, or, when reduction firing, you can use red iron oxide, which turns green. Many of these ingredients are tied to other chemicals that bubble and seep out during the firing, such as the carbonate in cobalt carbonate, which literally escapes from the surface of the molten glass as it melts and exits the kiln through the exhaust as a gas.

Simply put, different glaze recipes are made up from varying amounts of all these raw materials. You weigh them out and tip them into a bucket partly filled with water: this way less dust goes up into the air and therefore into your lungs (although you should really be wearing a mask throughout this process). When testing glazes, we mixed up small quantities of our recipes, usually about 100 grams dry weight, which was then mixed with water and clay test tiles were dipped into it. Once we knew it worked to our liking this would be scaled up to batches of 5 to 15 kilograms, and if you're using an expensive colourant, like cobalt or black stain, these mixtures can get quite costly. All the materials are piled in, slaked down in water and thoroughly mixed before finally being sieved through a very fine mesh, just to ensure there are no large particles left that might interfere with your glazes.

The thickness of a finished glaze is dependent on how you're using the glaze itself. Some need to be about the thickness of double cream, a consistency that coats my knuckle nicely, holding the hairs down, whereas other glazes require a thinner application. For this you simply add more water to the mix. There are limits for each glaze recipe, though, and if coated onto a pot too thickly it can crack and peel away from the vessel as it dries. Equally, if a glaze is dipped onto a pot in too thin a coat, in a measly, watery layer, it can yield dull results after being fired.

For one particular project we were split into pairs and given a colour to investigate over one term. Bernadette and I drew brown, of all the damned colours, brown.

Brown pots are notoriously troublesome to sell. It's the blues and greens that fly off the shelf,

A collection of my glaze test tiles, each an 'L' shape to keep it
upright. The glaze is dipped onto the upright portion and inscribed
on the bottoms with the specific recipe. All of these were fired
in a reduction atmosphere to 1290°C.

whereas brown pots are known as being 'potter's pots', as they're pots that potters like to collect, which means you won't sell nearly as many of them. We were jealous of those who got blue and green. Red and yellow weren't as much fun to formulate but at least you ended up with brilliant, vibrant tones. Brown did open up the world of metallic glazes, many of which I tested in reduction firings. I made sap-like, shimmering bronzes that verged on grey and sometimes even blacks that looked like streams of cooled lava. Alongside these metallic glazes I was also experimenting with crackle glazes – surfaces that intentionally craze. They split and fracture over the clay body as it cools and contracts and it can look like a sheet of shattered ice.

I thought, and still do to some degree, that because I was creating such inherently simple forms, I needed a glaze with more depth and character to it. I didn't want flat colours covering my vessels, instead I searched for gradients of hues, specks of molten iron and glassy layers to look through. On one tile on the wall, amongst many others, was a white crackle glaze, a base derived from John Britt, a ceramicist who has dedicated his life to formulating and experimenting with glazes. It emulated early Chinese glazes that went by the name of *guan* or *kuan* glazes, created during the Song Dynasty. *Guan* means 'official' in Chinese and they were produced in the imperial kilns, which makes those early specimens highly sought after these days. The glazes had intentional cracks in the glassy surface and were produced in ranges of blue and green tones generally, and even nowadays these types of glazes are still widely used. They look just like partly crackled watery blue and green celadon glazes, which may be one of the most commonly used surfaces in the entire pottery community.

Britt's version of the glaze looked like fractals of ice that had formed over each other. It had a random nature yet occurred in such a way that the crackles appear almost systematically. It was a start perhaps. I'd have liked it to be more fluid and was curious to see if it worked with colourants too. I altered the recipe, increasing the

Test tiles only provide you with so much information — eventually there comes a point when you need to see a glaze on an actual vessel. These are some of my old celadon and crackle glaze experiments that nowadays live high up on a very dusty shelf in my studio.

Early crackle glaze experiments. The blots of iron are like freckles, constellations, or even beauty spots, depending on how many reveal themselves during the firing. They add to the glaze's character, and my having no control over how they occur is what makes them so attractive.

flux, as well as introducing varying percentages of red iron oxide, which would cause it to turn into greens and blues once reduction fired. The more iron I added the more it started to move, as iron is a flux, and it began oozing down into thick glassy bands where it flooded around the bottoms of bowls. Too much flux, I made a note. As it pooled around the lower section it would pull away from the top, the rim, and the iron-rich stoneware clay I was using became almost metallic where the glaze peeled away from the sharply thrown rims. You'll find some crackle glazes have splits occurring arbitrarily across the otherwise unspoilt glaze, like a single canyon in a desert. This is called open crazing. Other crackle glazes occur in much more regular patterns, those known as *guan* glazes, snowflake crackle or ice crackle.

When reduction fired, the crackled surface became permeated with blots of iron that are pulled out from the clay body during this process. Some make it all the way to the surface of the glaze, where they blossom into molten puddles of metal. Others don't and instead remain partly clouded over, hidden by panes of white. It was rich with detail and depth and it was glorious to see how it moved over the bowls I coated it with, but it was still very much in its infancy at this point.

My first few test tiles looked promising, the first few pots even more so. It's best to take it slowly before committing months of work to one glaze you aren't acquainted with very well. They were fired in a heavily reduced atmosphere to about 1280°C, in a kiln-load of work that contained many of our pots, all of us who had chosen to gas fire at least. Their glassy surfaces twinkled in the light as they were unpacked from the kiln and laid out on the long trestle tables outside, the iron rims on the darkest green especially so, not a halo of white porcelain any more but iridescent metal. We unpacked the kiln slowly, Gus with us, inspecting each vessel mindfully as it was plundered, the pots still piping hot to the touch. I handled one bowl in particular which had a slightly indented rim that then flared out. It was a deep dark green contrasted

with an almost orange-red lustre that encircled the lip. I think I'd found something that worked.

THERE ARE MANY different types of kilns. Each will give you a certain quality and each requires a different set-up and approach, both in terms of the infrastructure needed and how you create the actual pots themselves. Electric firing is most common, and that's the only way I had fired kilns prior to arriving at Thomastown. They're programmable and can fire automatically with the press of a button, and they have a relatively sterile internal atmosphere as the electric elements simply heat up the air around them. Compare that to gas firing, which has swirling flames turbulently moving throughout the kiln, or wood or salt firing, where you put combustible materials inside that greatly affect the pots themselves.

Firing with electric kilns also means that you're firing with an internal atmosphere that contains oxygen. There's plenty of oxygen inside the kiln and that causes the glazes and the clay body to act in a certain way. With any kiln that contains flames, such as a gas or wood or oil one, you can place the kiln into what we call a 'reduction atmosphere'. This is where you limit how much oxygen is in the chamber, which, as a result, changes the way the fuel burns. It isn't by a lot – perhaps only 2 or 3 per cent of the oxygen is removed – but that's still enough to make a considerable difference to the clay and glazes.

Most potters with access to these types of kilns will initiate the reduction atmosphere at anywhere between 700°C and 1000°C. I set mine at exactly 860°C, which is perhaps a little early, but it means the reduction affects the entire kiln's contents rather than missing a pocket at the bottom that remains oxidized. It's very specific to each potter and even to the model of kiln. Up until reduction my gas kiln contains plenty of oxygen so the gas inside burns efficiently. When reduction is initiated, I slide dampers over the exits of the flues, which limits how quickly the exhaust escapes, and at the same time I increase the gas pressure quite dramatically.

Suddenly there's too much gas inside the chamber and not enough oxygen to burn it all sufficiently – there simply isn't enough oxygen to go around. The burning flames begin to look for it and even start to shoot up and out through the flues leading to the chimney and out of the spy-holes in the door. The iron inside the pots is searching for oxygen too and so it travels to the surface of the vessel in order to find it, thus achieving a colour that's only possible when there's an oxygen deficit.

Reduction firing creates pots with a lot more character to them. Iron droplets begin to settle and melt on the surface; variation in the strength of reduction can cause subtle changes in colour throughout the kiln; and even localized patches of oxidation can occur in certain spots, discolouring sections of the pots and capturing the movement of the flames within the molten glass. That's putting it all rather straightforwardly, but essentially reduction firing opens up another door in terms of colours, textures and surfaces that you can't obtain with electric kilns in quite the same way.

After spending the first few months only using programmable electric kilns we eventually had a project that introduced us to manually fired gas kilns. We all made pots as usual but the glazes were different. We fired them together as a group with Gus guiding us, showing us how every little thing worked. It's a complex process as there are quite a few inputs that change how the kiln operates and altering them accordingly, and at the correct time, is crucial if you want your pots to survive the process. There's the gas pressure, which is gradually increased over time; there's the air input, be it via a little slide on the burners or a larger air compressor; and then there's the damper that you slide over the flue's exit, which essentially makes the exhaust's opening either smaller or larger. I've fired kilns where you have to move the dampers with a gloved hand. Others are controlled by a built-in lever system and, if you're lucky enough, you can purchase gas kilns that fire automatically, but they cost dearly. Gus used the analogy that gas kilns are like cars. Each one fires 133

slightly differently and the only way to really get used to one is by trial and error and practice.

I was immediately intrigued by the process. It felt more engaging and energetic, and the slight variation in finish the process created was exciting. Not only that but I had been researching celadon recipes: they look best in a heavily reduced atmosphere and I'd been trying to develop one that fired equally well in an electric kiln in oxidation – but nothing could imitate the gas-fired look exactly.

First things first, the kiln is lit, either with a lighter or spark ignition switch that slams quartz against metal. The doors of the kiln are left open as it's ignited. This prevents the gas from building up inside a sealed chamber, which could cause an explosion on suddenly being lit, as you might expect. Once all the burners are happily firing, the door is shut, the pots sealed in. They will never look the same again after this, months' worth of work is locked away and you hand control, and fate, over to the kiln as you cannot see inside properly during the process. You can catch glimpses perhaps but you can't watch how the flames move or observe the surfaces of the pots as they change in any real detail.

This explains why so many potters pray to the 'kiln gods', or have a little ceramic deity placed on the kiln for good luck. When we visited Lisa Hammond's pottery in the summer, Peter and I had found a little *guinomi*, a sake cup, set atop her soda kiln, filled with what looked like sticky black tar. We asked her about it and she told us that it was filled with wine during each firing, a gift for the kiln for good luck. I'd also seen pictures of little shrines built into the wood kilns in Japan that serve a similar purpose.

As potters we know what *should* happen inside the kiln, of course, but there's a good chance you'll find yourself surprised by one thing and disappointed by another. A pot could fire beautifully in a way you hadn't expected and a kiln shelf might crack during the firing, spilling the white-hot contents onto the shelves beneath it. Disasters like this are far more common with wood, salt and soda firings, as you're introducing an element that

coats every single thing inside the kiln in glaze – the pots, the kiln shelves, the walls and even the ceiling. In comparison, electric and gas firings are relatively timid as the atmospheres aren't nearly so volatile; it's either just extraordinarily hot air or swirling flames, there's no explosive salt or molten wood ash that surrounds the pots So, we pray to kiln gods, place an offering and fire the kiln according to the firing charts. These are detailed records of each firing, from which you can replicate firings quite easily by following the notes left by the previous potter – which in Thomastown was easy as we simply followed the successful charts left by the previous cohorts of students. If you don't have any prior information, the first firing in an unknown kiln, or firing a brand-new kiln, is always a bit of a leap of faith; in theory you know what to do but it might not go entirely as planned.

Once the kiln is lit the temperature is steadily increased until it's time for reduction, at which point the dampers are closed and the gas pressure is increased. You'll know if the reduction has started as flames should very quickly begin to emerge from the flues, be they very faint and blue. You'll also smell a strong sulphuric odour for a few moments that emanates from the kiln. Neither occur immediately, rather it can take a few minutes for even the faintest clues to appear. Once started, this process slows down the rate at which the kiln climbs in temperature. I aim for an increase of about 60°C an hour and keep the kiln in a heavy reduction up until the very end of the firing, as I've found that helps to evenly distribute the temperature from top to bottom. I want the entire chamber to fire to the same temperature but, obviously, heat rises, which means the top shelves inside, and therefore the pots on them, tend to be hotter. Steadily increasing the temperature towards the end and purposely stalling it helps even things out. That way, all the glazes fire to their desired temperatures. It's possible to under-fire glazes, resulting in dull, matte surfaces, and over-fire them too – these tend to bubble and become especially fluid, sticking pots to shelves and possibly damaging the brickwork of the kiln itself. 135

It would take us from seven in the morning until about six in the evening to finish a firing. At the beginning it only needs to be checked occasionally but after the reduction has been set it helps to be more attentive.

The kiln is lit,
the temperature is slowly risen,
at 860°C reduction is started,
dampers are slid over the flues,
the gas pressure increased,
controls adjusted until it climbs 60°C per hour,
as 1250°C approaches I start checking the cones,
peek through the spy-holes to see them,
wait until cone ten is flat, 1290°C,
I switch the kiln off.

There's no one way of doing it. It's personal, each potter forging their own way according to how they want their pots to look, and it takes years to perfect this process. It becomes instinctive; you understand how to push your kiln's buttons in a way that somebody else simply wouldn't be able to.

Alongside the pots inside the kiln, sets of pyrometric cones are positioned. These measure heatwork, which is heat over time. If you were to simply pack a kiln with pots and fire it as fast as you could – to, say, 1250°C – you'd get terrible results, and many pots would explode. Instead, like baking a cake, for example, they need a sustained period at certain temperatures for the glazes and clay body to melt and mature. These cones initially look rather like little pastel-coloured spikes, made up from very specific ratios of ceramic materials and flux designed to melt at different temperatures. You place them opposite the spy-holes in the kiln's door, so you can observe them during the firing. Towards the end of the process, as the chamber inside becomes white-hot, these spikes begin to melt and bend over. If you straighten your index finger and slowly bend it down in a graceful arch, that's what these cones do.

Once they've bent over sufficiently the firing can be concluded, the gas switched off.

Pyrometric cones used for measuring heatwork. Here you can see them before and after being fired for ten hours. Potters sometimes use their first three fingers, bent over to certain positions, to mimic what the cones are doing inside the kiln – to portray them more accurately to those they're firing with. I've even seen spiky illustrations of cones tattooed on the fingers of some ceramicists.

Typically, you use three cones, but you can use many more, each one melting just before the other, every 10°C or so. The first is the guide cone, which melts at a lower temperature than what you're aiming for. This lets you know the kiln is approaching the correct temperature range. Next there's the target cone, which, once fully slumped over, marks the end of the firing. Finally there's the guard cone, which if it bends over too much means the kiln is being over-fired, whereupon glazes can boil and blister and pots can collapse. Cones are as important as the digital pyrometer's temperature readout, if not more so.

Now the hardest part arises, which is patiently waiting as the kiln slowly cools down. This in itself can play a significant role in how the pots look. If you allow it to cool extremely slowly crystals can grow within the glazes, the colours can become more muted and glossy surfaces can turn matte. For this reason I crash cool my kiln back down to 1000°C as soon as the firing has concluded, which I do by opening up the dampers fully and removing the bungs in the spy-holes. This keeps colours bright and the surfaces glassy but once again it's entirely down to the potter and what they are trying to achieve.

Whenever I'm waiting for the kiln to cool, which for me only takes thirty-six hours, I always – without fail – have nightmares. I'll be moving the pots inside the kiln as it fires, my hands somehow able to pass through transparent kiln walls, or I've dreamt of kilns collapsing as I fire them, pots emerging that are puddles of glass at the bottom of the kiln, or, more recently, after a discussion with another potter about the fumes emitted, I open the kiln's door mid-firing and feel carbon monoxide chase and suffocate me to death.

During the second year, we were all allowed to pursue the firing type that interested us most. I chose gas firing. A small group of us went with this option and we'd pack and fire the kiln as a team, mixing together all our pots and figuring it out for ourselves, only occasionally scurrying off to find Gus for help. The most intense moment was during a weekend firing and the issue didn't

become apparent until after we initiated reduction and flames were flowing out from the spy-holes and flues but with less ferocity than usual. We peeked beneath the kiln and, to our horror, all four burners that were jetting fire into the kiln were slightly offset. Half the fire channelled through the intended holes, whilst the rest was slamming into the underside of the metal casing of the kiln, now red hot. It had started enveloping the entire base, flowing around it like flames around a cauldron placed over a campfire. The heavy chamber of the kiln had somehow been shifted off centre on its frame. I pulled my phone out, almost dropping it in my haste, and called Gus. He couldn't make it to the pottery but calmly advised us.

We turned the gas down and lessened the reduction. This caused the flames to recede a little and to stop spewing out beneath the kiln. We donned thick fire-proof gloves and each of us grabbed a corner of the metal chassis, full of fiery pots, and we very, *very*, carefully shifted it back into place. Millimetre by millimetre, until the flames were shooting directly back inside the kiln.

There were other disasters – such as Peter's thickly glazed moon jar deciding to shed its skin during the firing, littering dozens of painstakingly made glaze test tiles in fat globular layers of celadon glaze. The glaze that had fallen off the jar then flowed off the shelf, a seething mass of molten glass, like a wave, pushing pots to one side and even knocking two very tall vases against the wall of the kiln. Of course, when it finally came time to unpack the kiln we didn't expect this. The door was cracked open and the sound of snapping glass followed. The glazes had all cooled down at this point and everything was stuck together in one giant fused mass of conjoined pots, glaze and bits of kiln shelf. Gus wasn't happy and spent the better part of the next week repairing the brickwork and fibre walls, and Peter was prohibited from coating pots so thickly in glaze.

Sometimes you will know when something goes wrong, though, such as with one wood firing I did with Peter and Steve. It was a blistering hot day in the summer and we all came in very early to light the kiln, feeding

it with kindling that moved onto larger slats of wood for fuel. The wood is cut to the right shape and slotted into the firebox, the flames from which are pulled through the chamber that contains the pots. As it burns the ash falls through a grate and you replace the burnt wood with new lengths. The temperature rose too quickly and we heard a few bangs in quick succession from inside the kiln. Gus was summoned and he told us that a few pots had probably blown up as the moisture inside them turned to steam. 'You might as well end the firing now. No point going any further unless you want pots fired with thousands of nasty shards stuck all over them,' Gus said.

We waited for it to cool and unpacked it. Three of Peter's teapots had blown up, placed into the kiln too wet with glaze. They'd erupted into a swarm of splinters that scattered themselves throughout the kiln and collected inside bowls, cups and plates. The entire load had to be unpacked. Any chipped pots were discarded and all the broken bits brushed out of any pot deemed saveable. Disasters happen in pottery, be it during the making, the glazing, or the firing, and I genuinely think potters are very good at getting over mistakes as they're so common. We're conditioned to just brush it off and move on. The scariest firing, though, with gas at least, is the first one you ever do alone. When firing with others you have your comrades to rely on and you can problem-solve together if needs be, yet it can get hectic. Kiln firing is complicated by too many cooks and, after a few endeavours by myself, I started to revel in the process.

MASTERCLASSES WERE A constant as the years went by, and Lisa Hammond was booked for a Japanese ceremonial tea bowl lesson, amongst other demonstrations, such as showing us how faceted bottles and little rock-like store jars are made. She did the customary PowerPoint presentation in a room far too hot, full of heads tipping forward, nodding-off, followed by a day's worth of making pots in front of an audience of novice potters, all of us itching to take her secrets and try them ourselves.

The week prior to her coming, the new issue of *Ceramic Review* was released and in it an advert appeared:

APPRENTICE OPPORTUNITY
WITH LISA HAMMOND
Are you hard-working and committed?
Previous apprentices include:
Yo Thom, Adam Frew
Yoji Yamada, Darren Ellis
Start late Aug/early Sept

I replied, eagerly, stating that I was extremely interested in taking the position. She replied quickly, saying we'd have a chat on Monday when she arrived in Thomastown, and that there were about eight other applicants so far.

Lisa arrived and it was my turn on kitchen duty, which meant I was responsible for brewing tea for lunch and our afternoon break and for supplying a ready stockpile of biscuits. I previously had heard that Lisa's current apprentice, the one I might be replacing, was a fiendishly good baker and so I decided to bake a big batch of scones, to be plated with pots of whipped cream and jam, and I spent all of Sunday afternoon and night in the kitchen struggling. They ended up flat. When Lisa saw them, she proclaimed, 'Ah you didn't have to bake rock cakes for me!' It is a tale I've never been able to live down, both for trying to impress Lisa in order to win the apprenticeship, and for baking the misshapen scones themselves. We piled them up onto plates and headed upstairs for Lisa's presentation, which, as all lectures seem to go, started with the story of her life.

Lisa, like me, became fascinated by pots at an early age. By fifteen she was working with clay, and by O-levels she was skipping classes to be in the studio, telling her shocked careers adviser that she wanted to be a potter. Her first experience in a proper pottery was with Kenneth Clark, a tile-maker in Covent Garden, and next with Ian Gregory, who taught her how to build kilns and potters' wheels.

Her mother died when Lisa was only twenty-three and she used an inheritance to set up Greenwich Pottery Workshop, whilst simultaneously juggling having

children. She'd travel across the river to Covent Garden to sell her wares and made extra income by managing punk bands – driving them to festivals and letting them sleep on the floor in her living room.

Her next move was into the teaching world itself, at Goldsmiths College. This lasted from 1980 until 1993, whereupon she moved her pottery into an old train station ticket office, now Maze Hill Pottery. She dug up the hillside to build kilns and started exploring her pioneering experimental soda firing technique, a method where bicarbonate of soda, instead of salt, is sprayed inside the white-hot kiln chamber, where it turns to glass and coats the pots – eventually this would become her forte.

From time to time she travelled to Japan, meeting potters and craftspeople, living there for prolonged periods of time with her son. It's here she saw a connection between the pots she was making and those made by Japanese ceramicists; she found Shino glaze recipes and soda fired them, which at the time was an exceedingly unusual approach. Friendships were built with potters there, including one renowned maker called Ken Matsuzaki. She was shown around his kilns in Mashiko, a town famed for its pottery, meeting his apprentice at the time, Masaki Dejima, and was even taken to have lunch with 'Living National Treasure' Tatsuzō Shimaoka, himself the apprentice of Shōji Hamada – a very prestigious lineage.

She told us about her influences, of her experiences in Japan. She told us about how she takes on apprentices every few years and the benefits of undergoing such tutorship. She spoke clearly and was to the point. Her dark red hair (usually tied up in a high bun) matches the deep red clay she's known for working with, and she has powerful, strong hands that match her tenacious personality. Lisa is one of the most eminent, trailblazing potters this country has ever seen and she left an immense impression on all of us.

Once told, we moved on to the practical side of things and spent the day watching her throw bottle forms that she cut and altered, made from red and black stoneware clays, stuffed full of iron and other

metals that stained everything they touched. Lisa's hands fluently moulded the clay and it was spectacular watching someone with that much experience create in front of us. I felt a little starstruck as her recognizable forms began to come to life: pictures of them had been pinned up around my wheel for months after all.

The following day was spent making tea bowls, or more specifically *chawan*. These are the cups used in the Japanese tea ceremony. They are mostly quite short and have a wide rim, but they come in all manner of styles. Normally they sit upon a raised foot-ring and tend to be quite natural in appearance, as if they were hewn from stone. The rough black clay is cut in such a way that it resembles a cliff face, or, as Gus described them, they looked like 'the north face of the Eiger', a compliment I'm sure. The clay work is then shrouded in all manner of glazes, from Shino to plain clear glazes, which are then fired in a gas-fuelled soda kiln, which adds another dimension to them. A bicarbonate of soda solution is sprayed inside the kiln as it nears its top temperature. As it enters the white-hot chamber it turns into vapour that is carried around by the flames and, as it travels, it deposits the soda onto the surfaces of the vessels where contact is made. No two firings are alike and neither are the pots.

We watched Lisa throw a batch of *chawan*. They started as thickly walled cylinders that had their walls faceted roughly with a wire cheese slicer, the textured clay ripping and particles of grog dragging, making grooves through it. Then, she'd stretch this cylinder out from the inside, the cut areas' texture becoming exaggerated as they widened. Each pot is then removed from the wheel but with enough clay left in the base to trim a prominent foot-ring from. This is a conjunctional pedestal on which the pot sits. Once leather hard they're flipped upside-down and a foot is carved away from the excess clay using a piece of red pine cut into a sort of rough, knife shape; this wood holds a good edge whilst still being quite flexible. The foot echoes the sides of the pot and is finished as roughly as the walls, with craggy faces, sharp scratches and

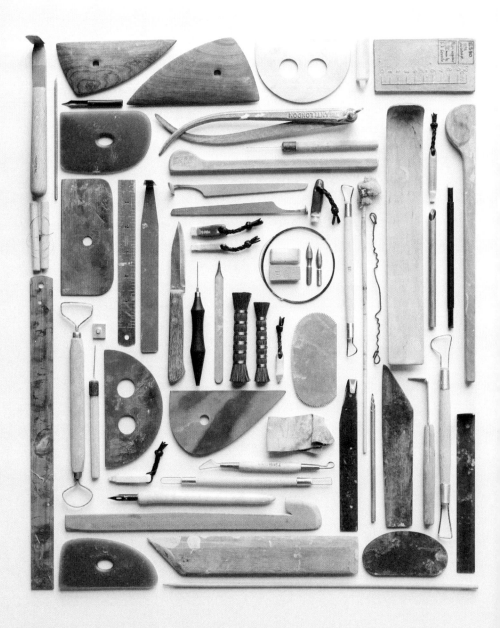

The tools of my trade. Many have been with me since the day I started, helping me throw tens of thousands of pots, and I'd be lost without them. Some tools I've made, like the wooden throwing stick and knife close to the bottom. Others have been made by my friends, like the tiny surgical trimming tools, just above my maker's marks. The ribs are used for throwing and shaping pots and the little brushes in the middle, bound with metal, are for cleaning up pots after they've been glazed.

sections of torn clay. That may sound as if it's easy to do, as if you're just stabbing and hacking at the stoneware, but I guarantee you it isn't. Not cutting a hole in the side of the vessel is a challenge in itself, as is carving the pot in such a way that it doesn't look overworked or intentional. Lisa's looked natural, even though they'd been made by hand, as if she had taken a pickaxe to a rock face and struck a pot out from the stone.

We spent the morning whittling our own pine knives and then got to work on the wheels, chipping away to create our own *chawan*. Inherently these pots are lively vessels; they aren't meant to be perfect. Each is different, unique, they're often given names and my favourites are those that your hands fit comfortably around, fingers nestling in the grooves or crevices left by the maker. This was a challenge for me in its own right as we'd all been trained to throw as perfectly as we could and now, suddenly, we were being asked to throw irregular, wonky pots. It clicked with some faster than others and I was at the back of the group. For these types of pots, so much thought is put into both how the *chawan* sits in your hands and which side of it, which 'face', should be directed to the recipient as the frothed matcha is handed from tea master to guest; these asymmetrical, lopsided pots have an allure that's found in imperfection and it's this which makes them so appealing to potter, tea master and collector alike.

I chopped away at the sides of my tea bowls and hollowed out a plinth-like foot. It wasn't bad, but I didn't manage many that weren't punctured with holes in their sides or gashes through the base. Lisa certainly made it look easy. I'd applied for the apprenticeship and part of me was half expecting her to talk about it with me; the other part hoped to avoid the topic at all costs in case she didn't want to take me on. Then, finally, one afternoon as we had our tea break outside, we had a brief conversation as Reuben fluttered around us. It ended on a positive note but with nothing set in stone. She said she'd be in touch soon and we headed back upstairs, for her to now judge everyone's pots. We all brought over the *chawans*

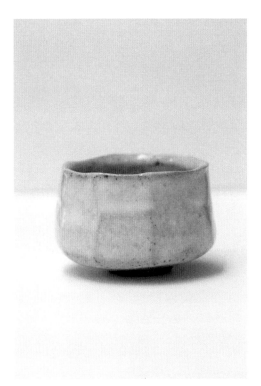

Sometimes you make pots that feel alien to you, even if they've been coated in glazes that have come to characterize you. This pot exemplifies that feeling, yet it still lives in my studio as a memento from that class with Lisa.

we thought were our best attempts. Some were large and loose, others small and confined and hard to drink from, and only a few of us had carved sufficient *chadamari*, a shallow hollow on the inside form, the tea well, where the dregs of matcha pool – a feature Lisa told us was important. Chloë came out on top; there were no other prizes, only pride. Mine was a little solid, the facets a bit too purposeful and the foot probably a touch narrow.

Alone, a week later, after arriving home from a long day at college, I saw an email from Lisa letting me know, in writing, that she'd like to offer me an apprenticeship at Maze Hill Pottery. For the second time in the space of a few years my heart leapt out of my chest. I ran from end to end in my long room, pumping my fists up into the air and grinning with joy.

EVERY COHORT HAS their final exhibition at the National Craft Gallery in Kilkenny. It's here that the offices for the college are based, alongside our sister course which was focused on jewellery. Gus would tell us that if we thought his course was strict and that the tests were difficult, it was nothing in comparison to the exams the metalworkers had.

The National Craft Gallery of Ireland is split into two wings and six of us would exhibit in each, or, in our case, six in one, five in the other, as one member of our cohort was asked to leave after the first year. Gus took us up to show us the space and told us to start thinking about how we'd like to fill it, but we weren't to exhibit here yet. First, there would be a practice exhibition in a small gallery in Wexford, a coastal town not far away. For this exhibition we were to produce functional ware with the same sorts of clay bodies and glazes we envisioned using for our final, graduation show. 'Up From Earth' was to be the show's title and we were given a week to sketch out all our ideas and designs before presenting them to the group.

I'd settled on using my white crackle glazes, together with a black *tenmoku* glaze that was unnervingly dark and glossy, like a mirror. It breaks over prominent edges, turning orange or red, highlighting the clay 147

work beneath, such as when it's coated over rims, the edges of handles and any other sharp detail. *Tenmoku* is the Japanese name, but the glazes were made to imitate Chinese Jian wares made during the Song Dynasty. These glaze recipes are almost a thousand years old and the ancient pots are just as impressive as those found these days, if not more so. Considering what the knowledge of chemistry was like back then I've always been fascinated by how these craftspeople formulated such glazes and sourced the materials. Bernard Leach brought back *Tenmoku* pots from his travels and incorporated them into the wares produced at his pottery, and since then it has remained a popular glaze, albeit one that, once again, lends itself to the vessel becoming a potter's pot through its austerity.

With my own illustrations and cross-sections now pinned up all around my wheel, like walls covered in bills, I began to make. I threw a series of lidded jars of varying heights in both *Tenmoku* black and a white crackle, together with bowls, both shallow and deep, that followed the same rule. I also included a run of inkwell forms, which were more directed at being tiny vases for single stems and flowers, and finally there would be my last porcelain bowls made on the course, coated black with a stark band of white around their rims. Looking back at photographs I took of these pots makes me wince. They're rudimentary and clumsy, the proportions are wrong, but there is, at least, some uniformity. Even the pots glazed in different ways have a subtle, stylistic choice in regard to form, my voice sounding quietly before it would soon break.

We delivered the pots, cut the foam-padded labels with our names and prices on and I, as the cohort's computer geek, helped everyone make business cards and formatted their price lists. Why do I always do this to myself? Exhibitions can be a large part of a potter's life. Some will sell most of their work at various shows a year, with half the money going to the gallery while the rest goes into their pocket. Others will attend pottery fairs, which are more casual, friendly events. Here you keep a larger percentage of the profit, yet there's normally an

I've always found it useful to sketch cross-sections. When I was learning to throw it helped me realize how to distribute the clay properly and understand how lids connect to the pots thrown for them.

initial 'buy-in' cost you pay to attend and this can to some degree be a gamble, as you never know how well the event will be attended, nor if you'll sell enough pots to cover costs. Then there's the new-age way of selling work, online, via your own store fronts that you promote through social media channels. In 2012 doing this was still quite a novelty.

Regardless of the route you take, going through the steps of cataloguing work, wrapping and shipping it, choosing prices and getting to grips with the administrative side of the job are good skills to practise. It is all quite self-explanatory and it doesn't require someone showing you each step in meticulous detail, but there is still a right and wrong way of doing it and Gus carefully guided us through the process. He wanted everyone to succeed and he'd go out of his way to help you, unless of course you didn't take things seriously. The course was free after all; they'd chosen twelve people out of hundreds of applicants, and people had been thrown off the course before.

On one occasion, a group of students were to exhibit their work alongside Gus and his contemporaries. Initials and prices were jotted on labels stuck to the bottoms of pots and Gus travelled to the gallery with everyone's work, to help set up the exhibition. He was asked by one of his fellows why one of his students' pots cost ten times as much as anyone else's. We'd all had lessons on pricing. We were all students too – none of us were even remotely known potters and, on the whole, prices are pushed up by reputation and supply and demand. I suspect that the more established potters assumed that this student thought their work *was* this valuable, spiralling into hundreds of euros for a single tea bowl.

Furious, Gus arrived back at the pottery and immediately rang the bell. 'Everyone, outside!' he bellowed from below. We all jumped to our feet and scurried out, none of us knowing what this could be about. Gus didn't keep who it was a secret. He used his name, and the offender had sat in the middle of the group, unknowingly. It was like attending a public execution as Gus made his thoughts known. Potters are proud people. You've

got to be; your work reflects you and you hope that people like it enough to purchase it. Gus was a potter, first and foremost, and a course-leader second, and after that we all took everything far more seriously. This was a real-world mistake, not one confined to the relative safety of a school-like environment where mistakes happen all the time, as is expected when students are learning a craft. None of us wanted to be strung up like that student had been.

WE STUDENTS WERE at this point all fledgling potters. I could now throw quickly and accurately, execute my own designs precisely, formulate glazes, and fire all manner of kilns. The final term had begun and each of us had already forged our own style. We were raring to go. I'd gone from throwing irregular runs of mugs, ten an hour, to being able to throw forty an hour, all of which were identical. Peter was making porcelain pots, moon jars and teapots coated in thick layers of celadon. Steve was working with colourful slips and terracotta, focusing on large vessels and a collection of functional ware, and Chloë made an installation of bulbous, hanging porcelain vases. I produced a whole range of tableware, together with thrown ink dip pens in stoneware, all clothed with a myriad of crackle glazes that were reduction fired to almost 1300°C. Gus had given us total freedom during the final term and if we needed to work late or at the weekends, that was acceptable. He'd happily order in any raw materials we requested – a ton of porcelain here, a kilo of black stain there, giant sacks of powdered minerals and tiny pots of gold lustre, which is real gold dissolved in a liquid that is then brushed onto fired pots and fired again to fuse it to the vessel.

Each workstation became alive with references, glaze test tiles and our own illustrations. We'd all become fluent with the craft and now each of us chose to pursue it down different paths. Order, symmetry and a high level of crafts-manship were the qualities I liked, and I feel that they're immediately noticeable in my work, perhaps even in the way I operate. I line pots up, handles all pointing in the same direction. The same goes for my tools. 151

Up until this stage I'd primarily been making tableware, but I had the idea in the final term to create something entirely different, a tool, used to aid my draftsmanship. I spent hours filling up sketchbooks and finally settled on making the bodies for ink dip pens, with inkwells to match. From time to time, I used an ink pen with a lovely old nib to outline fiddlier, detailed cross-sections of pots I'd draw. It made sense to make these, objects that echoed back to all those hours spent scrawling down ideas on paper. There's equally something rewarding about using handmade tools to create new pieces of art and craft, be it a handmade wooden rib to scrape away the slip on a pot or one of my precious turning tools made by the now fabled Philip Poburka, a man who has poured his life into making the sharpest trimming tools that exist, specially made to fit the measurements of *your* palm. They not only make the process feel better but there's a joy that comes from using an object made by hand by someone dedicated to their craft. My ink dip pens might not fill that niche exactly but I like using them, although they do come with the fatal flaw that, being hollow ceramic tubes, all it takes is a short drop for them to shatter – so I made pen rests too.

There wasn't a specific theme we had to follow for the exhibition at the National Craft Gallery; instead we were free to make anything we liked. We had all been so focused on tableware, as that's what the course primarily taught, so that's what ended up being the linking element between all of us. Otherwise, the variation was stupendous. I made bowls, teapots, jars, vases, dip pens and inkwells, and what I called 'palette sets', which were wooden, walnut trays I made that housed a little water-pot, a tiny pourer and a series of small palettes for mixing paint in. These were matched with a short cylinder with two slots cut out of it on either side, into which a brush could rest. Around these I pinned some illustrations I drew to explain the pots on display. They showed how the pens were fired, balanced upon a heat-resistant Nichrome rod, and how their ferrules were precisely inserted. I also drew cross-sections of teapots and technical illustrations that showed

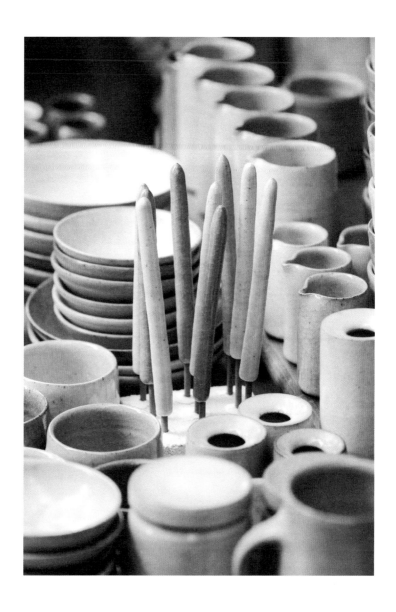

Reduction fired ink dip pens, balanced upon
inserted Nichrome rods. As the clay becomes
plastic during the firing they tend to lean,
sometimes too much. I've had a full nine become
casualties after cascading into one another.

Two pages of maker's mark ideas. I wanted something straightforward that would not get muddled and lost when pressed into the coarse clay I was using. I can't help but think they look a bit like vintage car marques.

Porcelain stamps carved with a needle's tip, and the exceedingly simple design I finally chose. I made it tiny enough to fit on the smallest facet of my bowl's trimmed foot, stamped so that it didn't interfere with the expanse of glaze above.

how they were assembled. It felt a bit like my mind laid out for everyone to see, all orderly and neatly arranged.

When we saw all the pots laid out in the gallery it was astonishing, considering where we had all started just two years before – struggling to throw two pots that looked alike. Two years of daily graft doing anything catapults you to a high level of skill, especially when you study for forty-five weeks a year and have world-class potters teaching you, showing you what's possible with clay.

My mother, father and brother flew over for the opening of 'Up From Earth', and we had a ceremonial lunch together – students and families – in one of the towers of Kilkenny Castle. Gus spoke about each student in turn, and instead of being handed over a diploma, which would arrive in the post months later, we were given a framed picture of our cohort and our teachers, Gus, Ann and Geoff. My frame was gold, unlike any of the others, resulting in my friends calling me 'golden bollocks' for the rest of the day, which wasn't made any better after winning the 'student of the course' award at the show's crowded grand opening. Then it was over; two years passed by in a flash. A craft learnt, albeit just the initial steps. A voice in clay found, together with a new, physically healthier, self.

The last weeks were spent packing at my flat and at college. We delved deep and scrubbed everything, clearing away all our belongings and depersonalizing all the work-stations, save a few secrets hidden for the next intake to find, like the previous cohort had done for us. I think one of mine still resides there, undisturbed. We were allowed to keep most of our pots; others were kept by the course for posterity's sake, while others, those we didn't want, were taken up to the kiln bay, the pot graveyard. We, the students, all swapped pots with each other, some of which I still use to this day, and every time one of these vessels is held I'm reminded of that person.

That's the beauty of handmade ceramics: they condense a person's thoughts and ideals into a vessel to some degree. After all, it took their hands, their might and their intellect to create such an object and here I am 157

drinking from a cup, clasping my fingers around a hand-pulled handle, with grooves left purposely in it by the fingertips of my friend. The lip too was shaped between fingers and there are throwing rings left travelling up the mug that have captured the motion of the pot being thrown for ever, or at least until the day it's accidentally smashed. Pots in use can't be expected to last forever and eventually, when a demise does occur, I'm always filled with sorrow, even if I can glue it back together, or have it expertly repaired by means of *kintsugi* (which is when shattered vessels are fused back together with lacquer dusted with gold or silver). But they aren't the same; they aren't in their intended state. At least I had some pleasant moments with them, but there are a number of pots I tell myself I shouldn't even use as I'd be too upset if they broke. These aren't normally the ones my contemporaries are currently producing; rather they're their old pots, relics, epitaphs of times past, ideas faded or built upon.

Peter gave me one of his thickly glazed porcelain mugs. It's squat and has a very comfortable handle. I also snagged a salt-fired variant, which he still despises to this day. It's covered in marks from the flames and has three prominent shadows on the base of the pot, as it was fired on stilts, 'waddings', like a tripod. It's still in my cupboard, stained by hundreds of cups of coffee. From Steve I have a terracotta teapot, thrown quickly and finished skilfully – he always was a show-off. It's honey-yellow, with indentations pressed into the soft clay, later filled with a green glaze that has seeped out, spilling down the belly. I swapped two mugs with Chloë; in exchange I got two stoneware pieces, the bodies of the cups thrown with her signature spirals in them. She disliked them for something I adored, which were two streaks of oxidation covering their sides. They were reduction fired and meant to be entirely pale green, yet unwanted oxygen had crept inside the kiln, marking the pair with yellow licks. They all remind me of friends I seldom see and of my time as a student.

My pots, displayed in the National Craft Gallery for our graduation exhibition, 'Up From Earth'. I can't tell you how much of a relief it was to see all our hard work in a clean, white space, as opposed to the cramped mayhem of the mill.

Greenwich

Where
I hone
my
craft

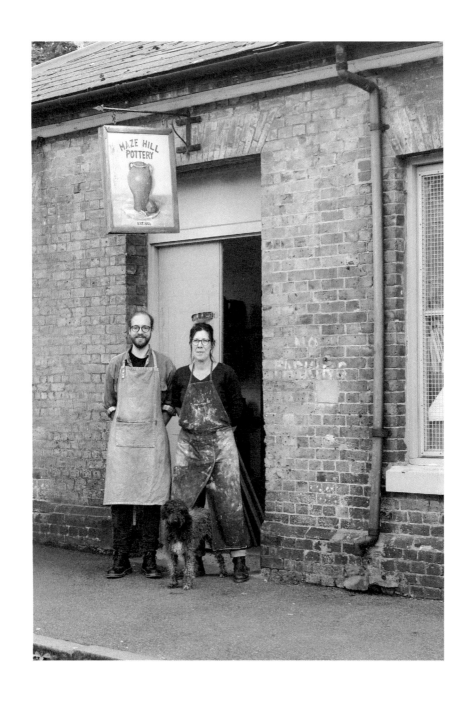

THE MOVE BACK home was hard. Despite missing London, I'd miss the friends I'd made in Ireland even more, although I didn't have long to languish as I'd begin my apprenticeship practically immediately. I'd visited Lisa's pottery a number of times before, so I knew where to go, but this time I had no idea quite what to expect. My commute was from Alexandra Palace in north London to Maze Hill in south London, then walking the two minutes from the station platform down to the workshop. It's a short building, single storey with a pitched roof, all built from yellow bricks. It was the former station's ticket office, windows guarded behind green metal grates and with an old sign swinging above the doors that reads, 'Maze Hill Pottery, EST. 1994', together with a painting of a lugged vase and a ball of clay ready to be thrown. From the outside you can barely see in, but inside is a wealth of pots, wheels and, behind that, a hidden mossy garden laden with charming defective pots now sprouting grass and flowers through their cracks. I've always felt that potters' studios reflect their character; they are, for me at least, an even more compelling sight than even the pots they make. Their tools, the condition of the place and how it's all arranged shows their mind unpacked into a physical space and I would have to learn my way around every inch of it.

Lisa Hammond's new apprentices always settle in by shadowing the previous, battle-hardened incumbent for a number of weeks. Ellie was the apprentice before me, a fierce, kind woman from Kyrgyzstan. She was limber, tall and had thick black hair held in a tight bun. She spoke softly but had a deep laugh and would spend time each day with Lisa's dog at the time, Lolly,

Lisa Hammond, Mazy and me outside Maze Hill Pottery. A home away from home, a place I still can't go without immediately regressing to my apprentice self.

Soda firing is an unpredictable process, and pots sometimes dunt
– crack due to thermal shock – or simply don't survive firings.
Lisa places the larger losses in the pottery's garden, where they
become overgrown, filling with water, snails and moss.

an eighteen-year-old mutt, a mass of wiry black hair who was living out her last days cosily curled up by the radiator, beneath where recycled clay was reclaimed, slopped onto plaster batts to dry out. I'd wait until she vacated her bed, something that only happened a few times each day, to vacuum up chunks of plaster or bone-dry clay that had fallen from the batts above. White dust, like snow, often settled in a thin layer over her black, matted fur.

I'd watch Ellie in sheer awe and disbelief as she effortlessly swept through the studio, throwing, pulling handles, then all of a sudden glazing and quickly dealing with a ton of other tasks the apprentices had to do; although, as she now had a shadowing apprentice, she had a lot more time to produce pots, since the newcomer is expected to do all of the clay reclaim, glaze mixing, cleaning, scraping, scouring and washing up. This crossover period is important as it frees the old apprentice from many of their usual jobs, which means that, whilst the new devotee learns the ropes, they can produce a backlog of pots to span the gap between when they leave and while the new apprentice is still learning how to throw the house style. This way the pots keep flowing and Lisa can keep firing the kilns.

I felt pushed to my limit. I was wedging more clay than I ever had before and I endlessly cleaned and organized the space. I was shoved into the busy inner workings of a functioning pottery and had to adapt as hastily as I could to the new rules. These few weeks spent shadowing were utterly invaluable. I can't remember ever learning so much, so rapidly, and I hung on to every word Ellie said, listening intently and scribbling down pages of notes so as not to forget the advice she gave me once she left. When it came to reversing this role three years later and a new apprentice shadowed me, I was filled with nostalgia. It's a passing of the torch, like the handing over of flowers in the Waldorf Steiner from old to new.

The old apprentice and new apprentice would sit side by side at our wheels and some days Darren Ellis would be there too. He is an ex-apprentice of Lisa's, who, as Lisa's daughter's partner, is now entwined in the

Bacon clay, that's what everyone who sees this seems to call it. The layered clay is Lisa's own red stoneware blend, shot midway through being prepared and formed from three stoneware clays, one smooth, one painfully coarse and the last highly stained with red iron oxide and manganese to provide the distinct colour. Ultimately it ends up being entirely red, yet fires to a deep, almost crimson-black packed with impurities. Potters like impurities.

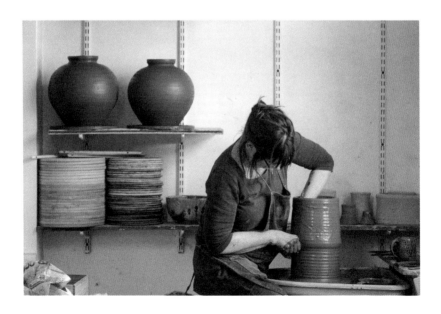

Hammond family. He kept the atmosphere jovial and would tell stories as we all threw together in a line. He's from Yorkshire, light-hearted, with strong arms and hands and a balding head, and he'd wear shorts all year round until he physically couldn't any more. He's practical too, a potter, a woodworker, a decorator, a cook, a kiln builder – he did it all. I'd sit between him and Ellie, both seasoned veterans, and together they'd prod me to go faster, change the position of my hands and suggest how I could improve or learn the shapes more quickly. It was intense but I've never had such focused tuition, and any bad habits that I revealed were quickly corrected.

Every now and then Lisa would wander over from her corner of the studio, which a lot of the time looked like a murder scene with the iron-rich red clay she used spattered over the walls and floor around her wheel. It was caked on her apron, her forearms, and a red mist clung to her, imprinting onto the stools or doorhandles. No matter how much I cleaned I could never keep on top of it. She'd idle over and watch me throw and typically say just one casual sentence: 'Your rims are a bit mean', or 'The throwing rings on the inside are way too prominent', or, my favourite, 'Just give it a bit more, ah you know! Life!' as she shook her right hand, fingers clasped around a fictitious shape.

If she couldn't communicate what she wanted verbally she'd quickly tell me to 'Get off the wheel for a second', then she'd take over, fix what she wanted changing and show me what I was doing wrong. She never spoke for long, neither would she spend an age with me, coming up with a multitude of ways to fix any errors. She knew exactly what needed altering and would frankly tell me so. If there's one word I had to use to sum up Lisa's teaching style it would be 'blunt'.

In combination with Lisa strategically pinpointing my errors and Darren's and Ellie's running commentaries on how to throw better pots, I learnt the shapes at a rapid rate; without question that was by far the most efficient period of learning I've ever experienced. I had three teachers, all highly skilled throwers, all channelling 167

their knowledge into me. It wasn't a learning curve, instead the curve was a line rocketing straight upward. I practised relentlessly and really *looked* at the pots around me, holding and inspecting them – all in an effort to perfect the pot I'd probably make the most of over the years, the classic apprentice mug, the medium mug, a staple of the Maze Hill Pottery functional range.

I SOMETIMES WONDER just how many soda-fired Maze Hill Pottery mugs exist out in the world – there must be tens of thousands of them scattered around the planet, some still in use or stashed away, a few forgotten about and an unlucky few smashed. The standard ware mug, as we called it, is the lifeblood of what the apprentices make and each apprentice must create this mug to the exact same dimensions, with the same outward bevelling rim and approximate handle. Yet Lisa does let some degree of individuality creep in, and it's this which makes the differences between mugs made by each apprentice so appealing. The way the surface of the walls is finished or how the base of a handle comes to a conclusion, whether it be a traditional swiped fish tail, or, as I did, unfussily blended in flush to the body of the mug. There was a form to follow but Lisa allowed our own subtleties to show.

I would love to be able to hunt down one of these mugs from each of my comrades and line them up altogether, to see each of our interpretations of the same object. You'd think as we all had quite strict rules to follow that they'd all be utterly identical, but in the same way that two artists wielding the same brush might paint differently, or two guitar players will pluck the same tune with different inflections, the same can be said about making pots. The shape of our hands, the length of our fingers and how tools are used will all add up to ultimately create a piece that is very individual, even if they've all been made to the same parameters. Lisa can pick up a mug made by any of the apprentices and immediately tell you which one of us threw it, which is quite a remarkable feat

considering there's been more than ten of us.

The Maze Hill Pottery mug is made from a coarse, dark-grey stoneware clay body that's mixed together in-house from various clays and some sand, a combination formulated by Lisa and refined over the years. That's the body *we* use, whilst Lisa throws with an assortment of other stoneware clays. One of the apprentice's main jobs is mixing it up, a mammoth task, especially as I insisted on wedging it all by hand as I'd grown used to processing my clay like that. It threw smoothly but with enough grit to leave your skin raw. Throwing pots over and over again, thousands of them, quickly makes the process feel like a dance, repeated and rehearsed until you don't have to think about the process any longer.

They were made from 360 grams to a height of 10.5 cm by 8.5 cm wide:

Centre the clay,
lift up the walls,
throw the rim to the pointer,
belly out the form,
undercut the base,
sponge out excess water,
scrape away the slip,
wire through,
lift away.

Once thrown, and after the pots turn leather hard, the bottom edge of each base is 'rough-thumbed' smooth, as these vessels, like many others in the standard ware range, aren't trimmed whatsoever. Then a length of clay about three inches long, a blank, which is approximately the shape of a lighter, is pressed against a scored and slipped area. The motion of attaching it is like friction-welding one piece of clay to another: it's wobbled and rubbed into place, the roughened up, slipped clay melding the two parts together.

This creates an incredibly strong join, so much so, that often when ancient sherds of pots are unearthed, the handle will still be married to a segment of wall that has been torn away from the rest of the receptacle. 169

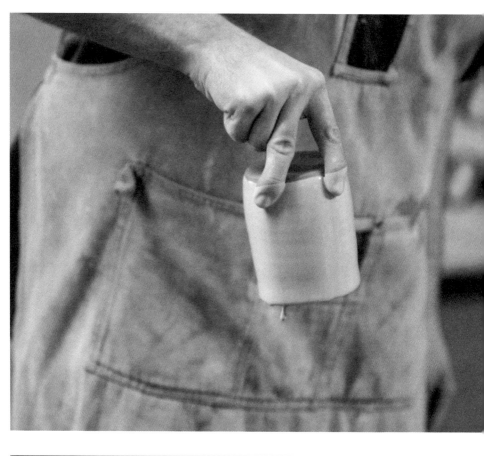

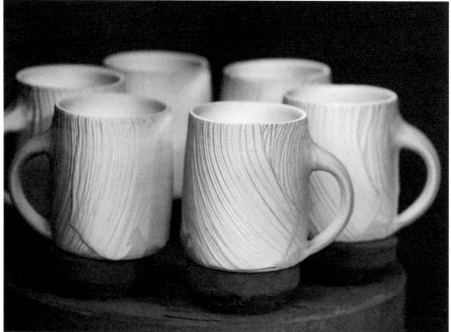

After the handle blank is secured in place and blended seamlessly into the body of the mug, it's then pulled. This is when you grip the protruding length with a wetted hand, squeezing near the top, where the handle meets the body of the mug, and pull down, the clay pinched within a closed fist. This process continues until the length is thin and fine. Lastly, I stuff the tip of my thumb into the backs of the handles, scoring three distinct grooves, one in the middle and two either side of it. The pulled handle is then looped downward towards the base of the mug, where it's firmly smeared in to attach it. It's a hand gesture not too dissimilar from that used when milking a cow.

After I'd thrown scores of mugs, most of which were disregarded as they didn't pass Lisa's scrutiny, ten or so were selected to proceed to the next step, which was raw glazing. This process brings about a problematic issue, one I'd already encountered in Ireland, which was that this fresh layer of wet slip applied to the leather-hard pot can saturate and weaken the clay, causing the pot to collapse, or the handle to crack off and fall to one side. This forces you to create work that is robust enough to survive this process and the pots I was throwing for myself, which are trimmed to be very light, would simply never survive it. Typically, raw-glazed pots are therefore more robust in nature. They're heavier, more thickly potted, and this helps them withstand the slipping procedure, followed by the brutal soda firings.

The mugs were coated in either a grey slip, which fired to a tan hue that could be orange-red or even green in places, depending on the thickness of the soda glaze that eventually latched onto it. Or they were covered in a red Shino slip that was later sprayed with cobalt oxide mixed up in hot water. I coated this in meandering swathes that settled in varied thicknesses. This would eventually melt into fluid blue tones that cascaded down the mugs, like a pot caught in the rain. Infrequently too, as a rare treat, we used a brilliant white titanium slip that fired to a dazzling yellow, which turned a striated blue where the vaporized sodium accumulated heavily. 171

The mugs are gripped with three digits around the base as they're dipped in slip to minimize the area left bare by my fingers – it's into one of these spots that the 'MHP' stamp is pressed. I always adored the mugs in their unfired state, sprayed with a purposely ill-covering layer of cobalt oxide.

My first mugs were undeniably crude, their forms askew and the handles following paths they shouldn't, as if there was either too much thought put into each one or not enough. Yet, with advice from Lisa, and the other two prodding me, they swiftly improved – even nowadays I still miss throwing this shape. So often, making and glazing pots is separated into two drastically different steps, whereas with raw glazing, making and glazing almost become one and you can do basic things, like swipe a finger through the wet slip to reveal the clay underneath, or sweep over it with a coarsely bristled *hakeme* brush – a bundle of rice straw – to create lively, loose decoration. There's something about slip that not only feels fantastic but, when freshly applied, there's this glorious moment when your pots shimmer and catch the light as if they were coated in a layer of suspended water.

AFTER A FEW weeks settling in I was getting to grips with the routine. I'd spend every morning tidying up and trying my hardest to instil my orderliness on the hectic studio, before moving on to a day of throwing or kiln packing.

Lisa had built two soda kilns. The first was Big Mother, a huge trolley kiln, the inside of which could be rolled in and out along metal tracks in the floor. Big Mother had another, more expletive name if it fired badly, as Lisa told me, smiling, as she showed me around. This kiln was really reaching the end of its life. After so many firings, the molten soda had started to erode the roof and walls and the entire shed-sized kiln was starting to sag in on itself, collapsing in slow motion. We seldom used it as the results were never any good. Wee Bear stood next to it, a much smaller kiln in terms of its internal capacity and named so after a little imprinted bear was found on one of the bricks used in its construction. It fired more consistently than Big Mother and yielded heavenly results too.

The kilns were built from a combination of bricks – heavies and insulators, as we called them. Heavies weigh about five times more than insulator bricks and are many magnitudes stronger. These weighty

blocks were positioned around spy-holes and where the soda was most prevalent. The rest was built from insulators, which are aerated and light, manufactured so they can heat up quickly, but they don't retain that heat for very long if the fuel source is removed.

The bicarbonate of soda mixture is fired into the kiln's white-hot chamber with pressurized garden sprayers. A spy-hole is removed from the wall, opening up a small gap through which the soda is fired in. This is usually done at approximately 1250°C, where it immediately vaporizes into a glass that coats everything it touches. The pots, the kiln furniture, the walls of the chamber, the ceiling and even the metal burners that shoot the flames in are affected. The pipework too can be corroded by the salt that latches onto it so we'd cover the burners in sheets of tinfoil in order to protect them. But no matter what we did, a salty, white residue found its way onto them. Soda, whilst giving striking effects to the pots, slowly disintegrates the kiln from the inside out. The insulator bricks are gradually attacked and layer after layer of brickwork is destroyed as the kiln accumulates residual soda inside. It pools in thick layers in the bottoms of the fireboxes and lines the walls as blue-green mottled scabs as sharp as knives.

I'd climb into the kiln to clean it out and this serrated crust would constantly scratch the top of my head, catching and ripping out hair and grazing my skin. It was a chamber of agony and stinging dust, and scrubbing it out between firings is truly the worst of the apprentice's jobs, especially in the summer when it held on to its residual heat.

A newly built soda kiln will give you inferior results as there simply isn't enough accumulation of soda inside yet, which means the first few years of a soda kiln's life yields less attractive work. The pots will be fine, provided you've made them successfully, but they won't be covered in rivulets of molten glaze like they will be when the kiln enters its teenage years. The stockpiles of hardened bicarbonate of soda that line the interior surfaces partly volatilize during the subsequent firings, so the more that's gathered over time, the more wondrous 173

the pots will be. After about fifteen years the kiln starts giving you beautiful and sometimes wild pots. Then, it all begins to go slowly downhill as the soda finally begins to win. The brickwork becomes unstable and chunks will begin to fall during the firings, fusing themselves to the pots beneath. Eventually whole bricks come loose, the arched ceiling sags and the perfectly rectangular spy-holes become ragged, the brick bungs barely fitting. Just as a person enters old age, so these kilns do too.

TWO WEEKS PASSED of perhaps the most intense training I'd ever undergone. My hands ached, I'd been wedging more clay than I ever had done before, and I was learning to throw new shapes, a skill in itself that's both physically and mentally draining. It was a hot August Saturday, and I was at home, having a barbecue together with a very welcome cold drink in my mum's paradisal wild garden when my phone started rattling on the table: it was Lisa.

'Hi Florian, is it OK to chat? There's been an accident at the pottery and we might need you to come in tomorrow. A kiln collapsed last night when Darren started his firing.'

Lisa had worked at Maze Hill Pottery for nineteen years by then and when she first found the place the outside area wasn't remotely usable. There was no space for kilns. Instead it was mostly an earthy slope that led up to the railway tracks that run directly behind the pottery. Lisa had a chunk bitten out of the slope, creating a flat spot for the two soda kilns. It's an idyllic site if you ignore the trains rumbling past every few minutes (you quickly get used to that), and quite unassuming save for the two chimneys of the kilns poking up over the fence.

I arrived early the following morning and as I peeked outside to look it was immediately obvious Wee Bear was in disarray. Normally it was about the size of a garden shed, with a soaring chimney jutting high into the air. It hadn't turned into a pile of rubble, like I had half expected, but the arched ceiling was sagging dramatically inward and part of the lofty chimney stack was leaning over precariously, following it.

This kiln was getting on in age and something had finally given way. Darren had packed the kiln the day before and had been firing when the accident occurred. It looked as if Darren's stack of pots inside the structure was somehow propping the whole thing up, the encasing brickwork like a veil ready to fall as soon as we removed the supports underneath. The plan was to carefully dismantle the chimney and then the caved-in ceiling to try and rescue the vessels inside, like a colossal, dangerous game of Jenga. We stood around it, moaning and donning gloves. The clean-up wasn't going to be fun.

The kiln had collapsed and with it the primary source of Lisa's income. Darren had an upcoming exhibition he had been feverishly making for too, so it couldn't have come at a worse time. That same Sunday we started the rebuild, carefully prising out undamaged pots from inside the kiln, reaching through the bloated walls, through spy-holes we'd enlarged to gain access. Then, from top to bottom, the kiln was carefully dismantled. Many sections were loose and the chimney felt as if it might keel over at any moment. It was a puzzle to disassemble and as we dismantled it certain areas crashed down. The roof finally gave way, dropping down onto the pots and even the walls beneath it were starting to waver. The swelling walls had a gap in the brickwork and we discovered that over the years molten glassy soda had snaked its way inside it, separating the courses of bricks both inward, towards the pots, and outwards, like cheeks filled with air. It was intriguing to assess the damage and together we evaluated it like forensic scientists. When the soda accumulates thickly it begins to erode any surface it touches and the guts of the kiln, down below and even inside the walls, had been eaten away, slowly, over decades.

Building a new kiln can be quick, provided you have all new bricks – but that wasn't the route we took. Lisa did order *some* new materials for the more intricate parts of the kiln, but otherwise we spent days grinding away layers of glassy soda to reveal usable bricks somewhere underneath. Thankfully, Lisa drafted in help in the

The two chimneys at Maze Hill Pottery, overleaf, Big Mother on the left and Wee Bear, the stack I built, on the right. Two roaring chambers of fire behind a garden fence: I often wondered what passers-by thought. Sometimes I caught people peeking through holes in the wooden panels, trying to work out what was going on.

175

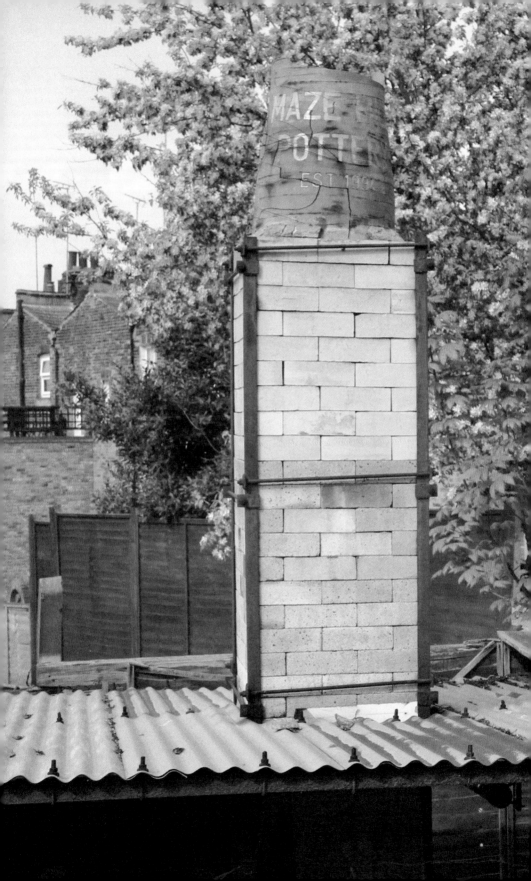

way of friends and family, and we set to work repairing Wee Bear. Much of it was a painful slog as some of us chiselled away at bricks and some sifted through the usable and unusable materials. It was dusty work and shards of soda and glaze are sharp, nasty things that stab and itch. It was sweltering hot and it poured with rain constantly, but slowly the walls started to climb back up. The flue was constructed, the fireboxes were fixed, the bag-wall inside the kiln balanced. I'd never built a kiln like this before, so in a way this was a blessing in disguise, albeit an expensive one for Lisa. I suppose it would have eventually needed to be patched up; this incident just accelerated that process.

We cut angled bricks for the arched roof and then positioned them over a wooden former, which I carefully removed whilst crouched inside the kiln, hard-hat securely on, the bricks above falling into place. I wanted to prove I'd be willing to do anything. I was up for anything and worked late into the evenings: as the new apprentice I felt like I needed to prove myself. After two weeks all that was left to complete was the chimney. It protruded above a rusty corrugated-metal roof, corroded over the years by clouds of swirling soda fumes that emanated from the kiln during firings. I was maybe the lightest, and certainly the youngest, so I volunteered to go up.

I stepped cautiously around the paper-thin metal that bent and bowed inward and chipped beneath my boots. I was shown how the chimney needed to be laid out and thereafter they'd heave up the heavy bricks, which I'd then stack, row by row, mortaring and keeping it level and learning a new skill as I went. Thankfully there was a metal frame of sorts, four corners, bent pieces of metal jutting up into the air, so the brickwork mostly just slotted in, and where it didn't, I had to cut extra slivers of brick, stuff in and slather in extra mortar, or I'd whack the frame with a lump hammer to find extra millimetres.

On the final day of construction, I was alone. I lugged the heaviest bricks up a ladder onto the roof that sheltered the kilns. It was the end of August, my birthday, it was 30°C and then the deluge began. It was

torrential and soon I was soaked. The bricks changed colour as they became saturated and I couldn't work with my glasses on, as they were doused in both water and condensation, and with them off I could barely see what my hands in front of me were doing. I was determined to finish, though, and only had the topmost courses left to lay.

I plundered the pottery, getting hold of two gigantic tarpaulins that I threw over the kiln and attached to the surrounding trees, giant pots and lamp posts. The highest part of Lisa's garden is a large concrete platform that overlooks the kiln bay. It was covered with inset metal rods and abandoned insulators and from these I was able to create a canopy of sorts to work beneath. I was drenched by the time it was strung up but at least it was dry underneath and I could continue working. I laid the last brick on top and tightened the metal frame around it. The two chimneys of Maze Hill Pottery were reunited and I scratched my initials into the mortar.

SODA FIRING ISN'T what it sounds like – no fizzy drinks are involved. Rather, the soda refers to sodium bicarbonate, also known as baking soda, the stuff you put in cakes. When mixed with water it breaks down into sodium – salt – mixed with bicarbonate. The technique seems easy in practice but mastering it is the opposite of that. The process itself begins when the kiln reaches about 1250°C. We briefly change the atmosphere from a heavy reduction into oxidation by sliding open the dampers fully; this should purge the glazes of any excess carbon, which can cause sooty, black marks on the pots. Then the soda is sprayed in. Before this can happen, though, the apprentice must first prepare some things.

A large boiler is filled up with water, into which bicarbonate of soda is poured until the water is cloudy and froths. It's stirred and I always tried my best not to spill it onto myself as the salty solution causes water to boil at a temperature hotter than 100°C, which can scald your skin terribly. It was the apprentice's job to keep the vat full of water as the process continued. It was kept

outside, near the kilns, ready to stream into gardening sprayers. I'd run back and forth from the studio with basins full of hot water, pour it into the tank and then dump a kilo of white powder into it, the water erupting.

The kiln is fuelled with mains gas and fired in reduction, and as soon as cone nine begins to bend over at 1260°C, the boiling soda solution is sprayed inside via two gaps in opposite corners of the kiln. As the soda enters the white hot, flickering environment, it vaporizes in the flames and is carried along by them. Where the flames go the soda follows, and as the fire brushes against pots it deposits the soda onto them, leaving behind a molten glassy surface on the bombarded vessels. The more directly a flame collides with a pot, the greater the soda accumulation, meaning the pot becomes glassier, the surface melting more, to the point where the clay itself can be eroded like the walls of the kiln, whereas pots that are hidden from the flames, or are packed very closely together, are shielded from the heat, meaning they're only lightly scorched.

We'd pressurize the spray bottles with manual pumps on their tops. These could be overly pressurized if you were zealous, leading to the bottle bursting and burning you. We'd each open up a spy-hole, removing the light insulating brick with one hand and setting it down. The section that protrudes, which you grasp to pull out, is only warm to the touch, whereas the other end is white hot. The bricks insulate the kiln so well you can hold them, fingers just a few inches away from a surface you can barely look at. This brick is carefully set down, ordinarily onto a slab of kiln shelf so it doesn't ignite any fallen leaves, turning them to embers, and so the dog doesn't mosey over and investigate something that only a few seconds ago was 1260°C.

We'd then take aim and squeeze the spray trigger, letting the piping hot soda solution stream into the kiln. Lisa's method was to simply aim straight, shooting the liquid in so it hit the opposing wall of the kiln, which was covered in a thick clot of soda. If you look at this section when the kiln isn't firing it looks like a waterfall, blue and green glass pools and flows downward,

all solidified in massive salty crystals. Whereas during the firing this is instead a molten mass of volatilizing soda.

There are other methods of introducing it. Some potters mix it into a paint-like solution that's brushed onto lengths of wood that are then chucked into the kiln. Or you can wrap the powder in newspaper and simply chuck it in, the packages disintegrating and the soda violently bursting. I've also seen long, curved pieces of corrugated metal filled up with powdered soda. These are inserted into the kiln before being flipped upside-down, so the soda all falls into the firebox at once, vaporizing and being caught by the flames as they travel up. All of these methods do the same task of introducing the soda, but they might cause it to travel around inside differently and thus the pots themselves might fire differently.

As we sprayed, we'd jiggle the ray so that it didn't pummel one spot continually, as doing so can bore holes in the walls of the kiln. The only thing we'd never do is spray the pots directly. If you did accidentally spray one there's a chance it could leave a streak, be it a distinct line or a puncture wound. Some potters do this deliberately; it results in pots being coated with essentially the same crust that accumulates in the kiln, only it reacts with the glazes and slips the vessels are covered in.

We'd wear thick welding goggles that transformed the whole world into a green so dark you practically couldn't see a thing. Yet when you removed the brick in the spy-hole you'd suddenly be able to look inside at the turbulent flames and at the vessels too, their outer surfaces shimmering.

As we sprayed soda through the glowing gaps, red light was cast around the kiln bay. It shone on our faces, the light fading to a deep crimson by the time it tinted our cheeks. Together with emanating light the kiln would emit white puffs of salty steam. In the summer it would dissipate fairly quickly, but in the winter it hung around like fog that wafted up the bank and clouded over the railtracks. Who knows what the train drivers thought! Lisa would tell me stories about the fire brigade being called, but that never happened during my time. 181

Each spray would last about seven minutes. Lisa firing into the front of the kiln, myself into the back, the dog curled up nearby, eyes on us. We'd spray about ten to twelve times and as the temperature increased the pyrometric cones inside would be carefully monitored by peeking at them through the spy-holes, eyes shielded with goggles, to make sure the temperature wasn't rising too quickly or suddenly dropping, which is worse.

To measure soda accumulation, we'd place rings of clay inside the kiln, next to the cone packs, rolled and textured, fashioned from the same clay the pots were thrown with and coated in the same slips. After we'd spent an hour spraying, I'd grab a long iron rod and with one hand I'd remove the brick bung from the spy-hole and with the other I'd carefully reach inside with the rod. Sometimes I couldn't even see the rings as the flames swirled around them so vigorously. The inserted cold metal poker would reveal an area just around it, like shining a flashlight into a cavern. As I pushed it in further the edges of pots would become more prominent, as would the test rings, so I'd slot the rod through one of them. They're about the size of a golf ball, and once I'd looped one I'd hoist it carefully out. Think of trying to snag one of those ducks at a carnival, carefully plucking them up with a small hook on the end of a long pole. The test ring would glow white hot on the end of the metal pole and I'd cautiously draw it out and set it aside, thankful that the still tacky soda bathing it helped it stick in place. We'd watch it cool down under torch light, as by this time it was usually late into the night; this only took a minute or two at most. What we were looking for was a glassy accumulation, so if the ring seemed dry and rough, then we knew we had to keep spraying more soda in. But if it was dripping with rivulets then it was time to stop; you don't want to spray too much in, otherwise you'd be left with a molten mess inside.

Once we'd inspected the outside of the rings, we'd crack a few of them in half to see the cross-section. Inside the ring of clay would be grey but the outermost layer would be a darker tone. This is a good

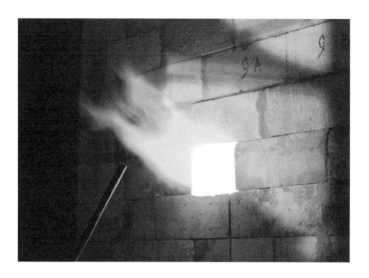

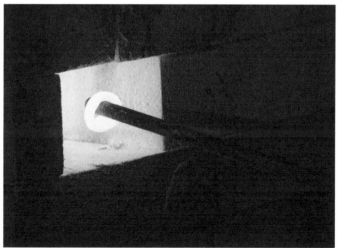

Despite looking dangerous, the fact that the ring
is essentially covered in molten glaze means it sticks
to the metal poker. Taking care where they're placed
subsequently is more important, as the white-hot
circle of clay will instantly ignite anything it touches.

The rings start life as part of a longer length of clay that is rolled over a textured paddle before being cut, sealed and squashed at the base to form a more stable section so they won't fall over during the firing. Just like with fired pyrometric cones, we could never bring ourselves to throw these away, so they live on in chains outside.

indication that the atmosphere inside had reduced properly, which meant the colour of slips and glazes would be as desired. If it was a light grey throughout we'd know that the reduction hadn't been strong enough, although at this point of the firing there isn't much you can do to fix that. Lisa, the previous apprentices, and now myself have collected the unbroken test rings over the years. I used to slot them onto the old copper soda-corroded thermocouple cables that linked to the pilot lights on the kiln's burners, creating long, heavy necklaces threaded with colourful glazed rings. I'd hang them up on Big Mother and they were of perpetual fascination to those who visited.

Once the rings were to Lisa's liking the kiln was then soaked at the highest temperature for an hour or so, meaning we'd hold the temperature steady, allowing everything inside to melt and mature. Glazes are almost like liquid at 1300°C; the watery surfaces gradually flow down the bodies of the pots, interacting with the soda, the iron in the clay and the layers of slip coated underneath too. There are so many possible interactions that can take place and, combined with the flames' movement, there's an infinite number of ways the glaze can interlace with the other materials. That's why people soda fire, as the results from every firing are different; no two single pots will ever be identical. They can be similar, born of the same family, but no two are the same. Lisa's own pots, those she made outside the Maze Hill Pottery standard ware range, were even more dramatic. Whole faces of these would be iridescent, fluxed with fluid iron and metals from the clay. Iron blossoms perforated the stoneware and glaze and, with chunks of granite and feldspar wedged in, melted into orbs of white glass set amongst everything else. It's a beautiful mess.

Once we were finished, finally, the mains supply of gas would be switched off. The spy-holes would be closed and ceramic fibre, like blankets, wrapped over any opening that could let in a cool draught. I'd remove the tin foil that protected the metal burners from the corrosive soda, and double-check the mains valve was off,

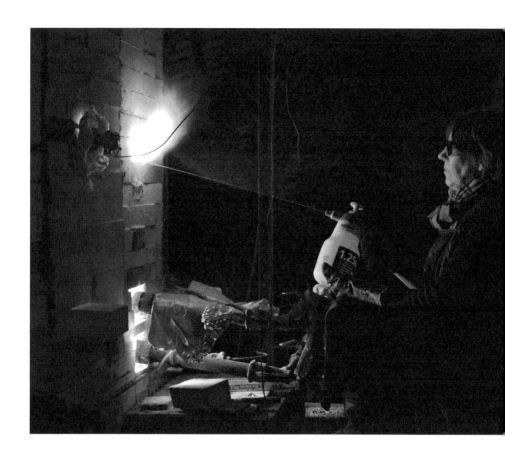

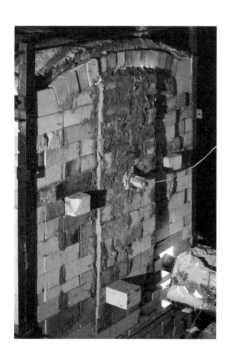

Lisa always sprayed the front port on Wee Bear, while her apprentices shot into the back. We could barely hear each other over the noise of the kiln between us, competing with the sound of the crackling bicarbonate of soda hitting the walls inside and the rushing flames. Towards the end of a lengthy firing, the brickwork and metalwork of the bulging kiln would literally start pushing outward, and you could feel the heat cooking your skin if you stood too close.

as were the burners. We tidied up, and went home utterly exhausted. Normally we'd finish well after dusk. Sometimes we'd get a takeaway, or I'd run out to fetch us snacks and a bottle of wine. The process took about thirty-six hours, yet we only had to be with the kiln consistently for the final six hours or so, and we'd fire about ten times a year.

Firing wasn't exceptionally arduous work but you had to be attentive throughout the entire process and keep checking multiple details constantly. We had to maintain a certain level of awareness for the entirety of the firing, which means that to some degree you are always on edge, checking and double-checking the kiln constantly. As soon as the gas switches off and the noise of rushing fuel and flame cease, you're suddenly at ease, although you feel frazzled, your mind ready to stop concentrating. I'd run up to the station and jump on the train back home and Lisa would drive home with the sleepy hound and we'd let the kiln cool gradually over the next few days.

Two to three days later the kiln will have cooled enough to unpack. The kiln's brick door, which is built each firing and plastered over with groggy, coarse clay to seal any gaps, hardens to a crust, so I'd flake the worst of this off, the stoneware falling to the ground to become dust, and then I'd begin prying apart the door.

I'd run inside to fetch Lisa and together we'd slowly unpack our treasure. As the travelling flame deposits molten soda wherever it surges, you can see how the flame has moved during the firing by observing the marks it left on the pots. Some pieces would be scorched and exceedingly glassy whilst others would be barely hit by the flames; we'd call these ones 'dry'. They might be a rough black or brown and it sometimes only affected part of the vessel. If the entire pot is dry then it's deemed a second, but if a curious surface has been created, say a dry patch amid a glassy sea, then it's a keeper. This makes every time you empty the kiln thrilling, as you never know what you'll get. There are disasters – pots can collapse and kiln shelves can crack, causing the neatly stacked vessels on them to cascade down, but that's rare – and occasionally 187

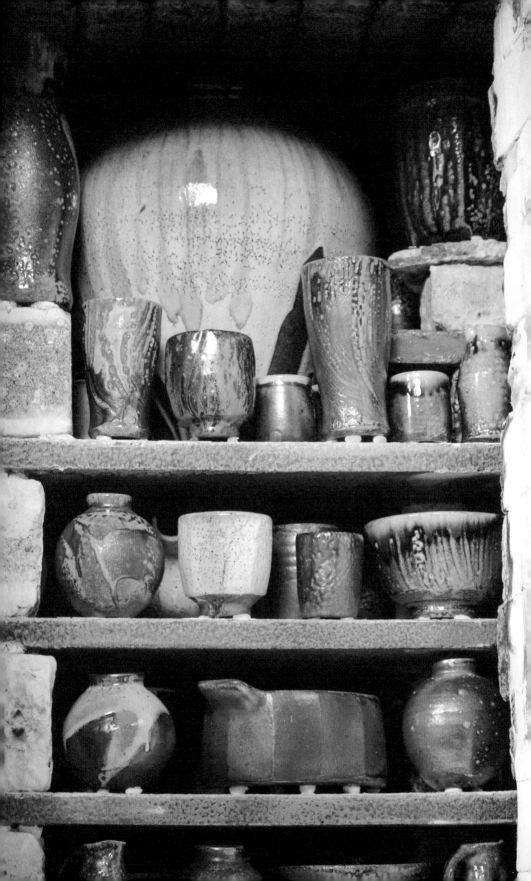

there are profoundly unique pots that look quite unlike anything else, and it's probable you'll never be able to replicate them again.

Lisa would unpack, leaning deep into Wee Bear to pluck pots off of their waddings, little feet the pieces are fired on made from a clay-like material that doesn't melt at all; they stop the vessels from sticking to the kiln shelves. I'd carry away filled ware boards from beside the kiln and replace them with empty ones, and soon there'd be a huge pile of soda-fired wares that all needed cleaning up. There were always a few pots that stuck to the kiln shelves inside, fused in place. I'd try to carefully prise them away. Most were saved, others became seconds, which are pieces with a small defect, and an unfortunate few were smashed if it really called for it – loss is a constant when soda firing.

Once the kiln was emptied, I'd begin working my way through the pots. Most only needed a quick polish around the base, especially where the three white waddings had held the pot aloft. Usually, these waddings popped off the bare clay with just a little pressure but there'd also be times they would be welded in place and I'd have to grind them away with hand-held rotary tools and meaty bench grinders, if need be. It was dusty work, the powder coating my hair and eyebrows. I'd collect the intact waddings over the months, thousands of them filling up big bowls; eventually I'd tip them out onto the floor outside, mixing them with the gravel around the kilns (at this point it was mostly made up from these little white specks). Cleaning up a kiln-load of pots might take a few hours or a few days, it all depends on how stuck the pots are. Lidded forms were the worst, as their lids are separated by waddings suspended above the jar; if these fused, I'd have to spend hours diligently drilling the wadding material away without damaging the clay and glaze of either component. The margin of error was only a few millimetres.

This – being careful – was the hardest part about grinding the waddings away, as all it takes is one mistake to accidentally scratch the glaze, making it a second in an instant. It happens to every apprentice. 189

The wicket (kiln door) removed, and all the newly fired pots proudly on display, still scalding hot to the touch, all raised upon their wadding feet. If you look carefully, you can see the paths of the soda-rich flames.

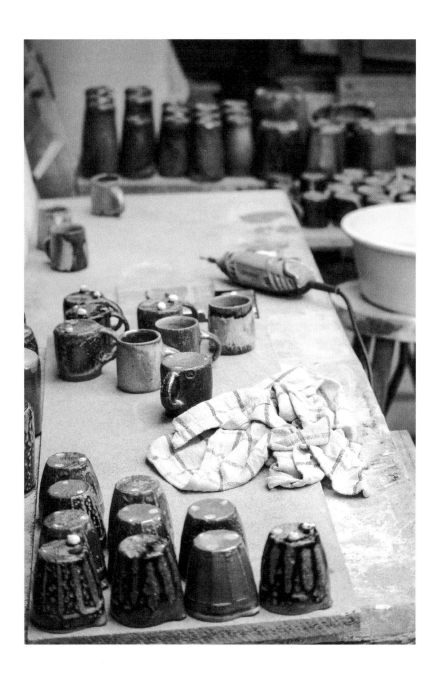

After my potter's wheel, this was the place where I probably spent most time at Maze Hill Pottery, endlessly grinding away the encrusted waddings on the bottoms of pots – feet up, arms tucked into my waist, holding on to the pot and rotary tool for dear life as I tried not to gouge lines in Lisa's vessels.

The rotary diamond-tipped drill bit would slip and chatter across the crackled glaze surface of a pot and I'd skulk inside to tell Lisa what I'd done. Beyond the pots, all the kilns and props inside would need cleaning too, another dusty undertaking, but a gratifying one. Grinding away the glassy bubbles of soda from the shelves had a satisfaction that was only matched by finally stacking all the cleaned shelves and props up together, ready to fire again.

LIFE AT MAZE HILL POTTERY went like this. Together, Lisa and I would make pots. She'd throw her own one-off pieces, the individual vessels such as vases, *chawans* and taller, handle-less teacups – *yunomi* – alongside making the more complex objects from the house-range, such as casserole dishes, oven dishes, taller jugs and a few other odds and ends.

Whilst she did that it was my job as the apprentice to facilitate her making. It wasn't only the clay bodies that I had to mix; there were also dozens of different glazes and slips we used and keeping these 25-litre buckets full was another unending task, one that involved me dragging the buckets over to a little garage about fifty metres away, where she hoarded all the raw materials, together with old pots, coils of spare element wires for the electric kilns, ancient wheels and god knows what else – even a small glass jar of yellowcake, uranium, an archaic glaze ingredient she'd inherited years earlier before such things were banned, for obvious reasons. You don't want it to leach out of the glazes and into you, nor do you want to breathe in the powder when mixing glazes with it. Basically, clutter from the pottery got hidden in the garage.

After all the usable materials had been replenished, I'd be the one responsible for cleaning up, mopping, which, as Lisa will happily tell you, I was tormented by. The cleaning was a never-ending operation for multiple reasons. First, because during the day there were usually three of us making pots; this alone generates significant mess, especially if some are messier throwers than others. Secondly, four nights a week there were

evening classes, each with eight students, beginners, the messiest of throwers. So, every morning I'd spend an hour not only tidying up the entire studio, but also dealing with students' pots, be it setting them out to dry in the sun to turn leather hard, or wrapping them up in plastic for storage in the stillages in the cramped back room.

I'm not a clean freak. My family can attest to that. But when it comes to a studio environment, I favour cleanliness. At Maze Hill Pottery I knew that at some point every day I'd have to clean, so if some reclaim overflowed down the plaster batt and onto the floor, I'd deal with it immediately. It's very easy to let a studio quickly get out of hand, and as the pottery is directly next to Maze Hill station there's a fair amount of footfall with people knocking on the door wanting to come in, normally to our dismay. But visitors gave me another reason to keep the place shipshape.

Once a journalist visited the studio to interview Lisa for a piece in a magazine, and she wrote how astonished she was by how the apprentice seemed to juggle slipping leather-hard beer cups, making lunch and cleaning up, all at the same time. Juggling *is* the perfect word to describe the life of an apprentice at Maze Hill Pottery. Your mind is constantly thinking about the standard ware range you're making, the stockpiles of clay, preparing lunch, the cleanliness of the studio, the evening classes' pots, their firing schedule, the soda firing schedule, making sure the glazes and slips are all mixed in large enough quantities, and I'm sure there are a dozen more tasks I could add to that list. You quickly become highly adaptable, switching between jobs constantly whilst leaving pots outside to dry out enough so their handles can be attached, while others await a layer of liner slip on the inside.

Finally, late in the morning, after I had made tea for everyone and Lisa was content throwing away in her end of the studio with BBC Radio 4 blaring out on the highest volume, I could settle into throwing of my own. This was the daily routine, for the most part. Once my mugs reached a suitable level – and this didn't

A batch of jars coated in slip, drying outside in the wind. The lids have a decorative circular streak around their edges, wiped in with the side of my thumb, although if too covered in molten soda you'd never see it as the glaze would flood over the decoration.

The house range was split into two colours: blue, the pots sprayed with cobalt, and tan, like this jar that shows so clearly the movement of the flames.

happen immediately, as my handles weren't good enough for a while – Lisa began letting my pots into the ranks that would be fired, which means they were deemed to be saleable. My shapes did change over time, perhaps my personality started to gradually filter into them, and Lisa was happy with this as long as they retained the fundamental Maze Hill Pottery style. As my skills improved, I was allowed to create more of the range and each time the same procedure happened. They'd be vetted, advice was given, Lisa explained what I was doing wrong, and I'd iron these problems out until she was happy.

Once the studio became saturated with pots, which sometimes only took a few weeks, it was time to fire. The vast majority of the vessels loaded into the kiln were raw glazed and raw fired, meaning they weren't bisque fired at all prior to the glaze firing. This essentially means you do the bisque firing and the glaze firing all-in-one, one consequence being that you must heat the kiln up very slowly at the beginning so as little moisture resides inside the raw clay as possible, as vessels can pop if you really push the temperature up quickly. Excess moisture inside the pots builds ups, boils and turns to steam, causing them to explode, shattering into thousands of shards.

For the first year and a half Lisa would be the one packing the kiln. I'd be outside handing pots to her and gluing waddings onto their bases. She'd be burrowed head first through the small opening as I ran around searching for the pots she yelled out for. Her voice, muffled from inside the kiln, would call out, 'Two tan mugs!' I'd fetch those and place them into her waiting hands, arms stuck out backwards, her head still stuffed inside. 'Jars next! ... Not those ones, the small ones!'

It was hectic but gratifying work, seeing all our labour laid out in a complex stack. It was best in the summer months. We'd pack together in the sun, the dog lounging next to us. Every now and then Lisa would say, 'OK, you try packing the next layer.' She'd go inside and log on to her emails, fingers tapping, trying to make a dent in the deluge of correspondence. I'd look cautiously

Mazy liked to stand above the kiln bay on the concrete plateau where the old railway transformers used to be. On days when I was standing up, pulling mug handles for hours on end, I would kick her tennis ball around the workshop until she practically collapsed.

195

inside the kiln and try to replicate her pot layouts. Once all the pieces were slotted together, I'd go inside to tell her I'd finished. She'd come out, asking how I thought my layer went before sticking her head inside to assess. After five minutes of mumbling and moving my pots around she'd poke her head back out and tell me what I'd done wrong. As time passed and I packed more and more shelves, she'd sometimes correct a few pots, or only one, and then no pots were changed at all. I'd be allowed to do whole layers by myself and, finally, in my third year, I was packing the entire kiln myself.

Packing soda kilns isn't just a matter of squeezing the pots in as densely as possible, which is the case with most electric kilns and even my gas kiln now; with a soda kiln there is so much more to consider. Wee Bear had two stacks of shelves inside, one in front of the other. Each stack was made up of approximately five layers of shelves and each shelf held anywhere between fifteen and twenty pots. This could vary depending on what kind of vessels were being placed inside, but typically about 150–200 pots in total were crammed in. Either side of the stacks of shelves was the bag-wall. This is a course of heavy bricks stacked so that there are small gaps between some of them, making holes in the wall. The bricks act as baffles, walls off which the flames are deflected. This protects the lowest shelves of pots from the flames that course into the kiln almost directly next to them.

There are two sets of burners that enter the chamber on diagonal corners, shooting the flames inside that hit the opposite wall, bounce up and race over the top shelves before all being drawn back down and out through the flue and up the chimney. The flames' path is perhaps the most important thing to consider as it's this that carries the vaporized bicarbonate of soda. This means that if you accidentally position pots on a shelf in such a way that they create a barrier, the flames will have a hard time penetrating them. You may accidentally block off whole regions from receiving the very thing that makes them special. The pots need the soda; it's what gives them life

Waffle props, crusted shelves and unfired pots disappearing into the shadowy depths of the kiln's chamber. Each pot is positioned with enough space around it not to block the path of the flames. It's easier said than done – sometimes, no matter how careful we had been, some sections might stay dry, which is what we called those areas of pots that remained uncoated by bicarbonate of soda.

and character and without it they are dull. So, as the pots are loaded in, one by one, I'm constantly thinking about how the flames will move and how the pots might be affected depending on their position. For instance, the pots coated in cobalt blue can withstand being caked in thick layers of glassy soda in a way the tan pots cannot. As a result, the cobalt pots line the edges of the shelves, where the flames are most potent, whilst the tan vessels are hidden in the middle, protected from the most voracious firestorm.

It's not always that straightforward, and understandably Lisa has a particular way she likes the kiln to be packed. It's all just a matter of gaining her trust and showing her that you can do it her way; thereafter some freedom creeps back in. It's a symbiotic relationship, a transferral of skills from master to novice, and with more than forty years' experience under her belt it must take a lot of courage and compassion to let somebody new in – let alone a dozen.

EVEN WHEN EVERYTHING was going smoothly there was still ample time to make mistakes. As potters, I think we're used to making errors. As we commit our work to a chamber that ultimately finishes the pots for us, vessels often emerge not looking like we'd imagine, and so we quickly acclimatize to failure. Pots break. We throw more. We move on.

Compare this to other crafts, where the decision of when an object is actually finished is bound to your own hand. When do you lay the final stroke of paint on a canvas? Or cut the last facet away from a hand-cut wooden spoon? There's no clear finishing line with those. Whereas with pottery there's the kiln, which is essentially a giant box-like ribbon that's cut as soon as you swing the doors open to a fired load of pots. Beyond that there's little you can do to correct things. Cracks appear, glazes can flow beyond your expectations, or can even crawl – which is when the glassy surface decides to just open up, exposing a little island of the clay underneath. The kiln has the final say, and more often than I'd like to admit it leaves me with a sour taste in my mouth. The only positive is that clay is

a readily available, inexpensive material, although

it needs a firing to make it permanent. Up until then it can be endlessly recycled – if only such a thing was possible with ruined oak or marble.

I've packed kilns badly, accidentally placing the cones in the wrong order and positioned mugs so they're touching, resulting in a fused-together mess. Perhaps the easiest mistakes to make, though, is when mixing glaze and clay recipes. All it takes is one wrong calculation, or a brief lapse of concentration, and a whole bucket of brand-new raw materials might as well be poured down the drain. The most notable error I made during my time with Lisa was when mixing up a glaze that contained rather a lot of expensive raw materials, cobalt especially. Glaze recipes are like baking recipes; there's a list of the raw materials needed that are combined and mixed with water, and they might look similar to what's below. They usually add up to 100, with the colourant tacked on at the end.

40 Potash feldspar
30 Flint
20 Whiting
10 Kaolin
1% Cobalt oxide

This is the recipe for a simple blue glaze. You multiply each by ten to make a kilogram's worth, and then multiply that by how many kilos of glaze you want. It's easy enough if you're paying attention but it's equally, excruciatingly, easy to blunder, especially when you're weighing the elements out and you're interrupted by a call, or somebody walking into the studio for a quick chat and a cup of tea (which happened all the time at Maze Hill Pottery, as Lisa's friends stuck their heads in). The conversation finished, I'd look back at my list of raw materials and have no idea where I'd left off. The general rule is to always tick off the materials you've added but one day, eventually, you will forget.

I messed up. I didn't forget to add a specific material. Rather, I copied the list down incorrectly from the original 'apprentice's glaze book', a tatty, glaze-drenched ream of pages, and added an extraordinary amount 199

of kaolin to a glaze that only needed a small amount. We didn't notice until the pots coated with it were fired and they emerged a crackly mess, the surface dry and blotchy and flaking off the pots. Lisa promptly ripped off the label I had stuck to the bucket's lid and replaced it with one that read 'Flo's Fuck Up'. 'Go and put that somewhere out of sight, it's all bloody useless,' she said.

In theory the recipe could have been fixed, but there were already 15 kilos of it and correcting it would have left us with a bucket weighing almost 90 kilos had all the extra raw materials been added back in similar ratios. We even pondered whether we could add other materials to it and then test it, time and time again, until something worked, just to see if it could be fixed – Frankenstein's glaze. But ultimately we let the water evaporate from the mixture until the glaze resembled chunks of dry earth, and then the lot was thrown into the tip, alongside dozens of Lisa's pots that she couldn't bear looking at any longer.

As soda firing is a volatile process, there's a lot of potential for things to go astray. Over the year we'd slowly let the really awful pots gather in a bin outside. Then, once a year, usually in the winter during the lead up to the Christmas Open Studio, we'd take a trip to the local tip and chuck these pots into the giant 'hardcore and rubble' container, watching them fall a dozen feet and striking the metal before shattering into thousands of shards. Quality control is an important part of a potter's life. Of course we tried to keep smashing pots to a minimum, and we never fired work we weren't happy with initially, yet sometimes the kiln has another idea, or a pot might fall from a kiln shelf into the firebox where it would become partly submerged beneath a thick swathe of molten soda.

Once you gain enough renown you need to be careful about how you get rid of unwanted wares. After all, a chef would never dream of serving burnt food, and the same outlook can be used for seconds and thirds. Lisa keeps some seconds, even those from her individualistic range which are generally more expensive. These are separate from the house-style of functional pots

Waddings don't always stay where they're put, and
excessive soda accumulation can help persuade wares
to topple. Three waddings are glued, like a tripod, onto
the base of each vessel, but they can shift, coming loose
as the pots are picked up and arranged to fill a shelf.

and were altogether more unique and expressive, thrown with black clay that became iridescent as the soda seeped into its pores. Naturally you accumulate these sub-par, but still wholly functional, pots and during the winter sale there was a shelf lined with these, with a big label above that read 'seconds'. They'd sell and soon after you'd see the same pots popping up on auction sites as 'firsts', now suddenly double the price.

So, what do you let out into the world? Is it only the very best? Or do you scratch a symbol onto your seconds to ensure the world knows what they truly are? We tried that but quickly stopped as drilling in an obvious symbol was nearly impossible on the coarse, soda-covered clays, and there are some things you just can't stop others from doing. I sometimes wish I could dispose of all the pots I made in my earliest years, yet at the same time I think there being a timeline that exists is important, an archive. I might dislike looking back at archaic wares of mine, but I could never bring myself to destroy them now.

LISA WOULD SPEAK extensively about her travels and time in Japan. She spoke fondly of staying there with her young son over Christmas once, and described all the people she'd met. Lisa had befriended Japanese potters, learnt about Shino glazes and had a wealth of knowledge that I'd constantly try and pick away at. She makes many Japanese-style pots too, infused with her method of soda firing, alongside the Maze Hill Pottery standard ware range that is more rooted in Western ceramics: teapots, jugs, jars, eggcups, mugs and large barrel-like bread crocks. As for her pots inspired by Japanese wares, she'd create drinking bowls used in the tea ceremony, *chawan*, and taller, footed cups for regular green tea, *yunomi*. She made *mizusashi*, which are lidded containers for storing cold water in, used to replenish the kettle when making matcha or for washing the delicate bamboo whisk used to froth it up. She'd throw sake bottles and tiny *guinomi* cups to drink it from, and complex stacking *jūbako* boxes, which are tiered containers set one on top of the other.

As a culture, the Japanese have a respect for handmade crafts that just isn't found in the UK, or in many other places for that matter. Their pots straddle many parts of the spectrum, from handmade vessels so pristinely made they appear as if a machine churned them out, to pots that look as if they were dislodged from a vein of metal or stone that runs deep underground. Japanese pottery was often the topic of discussion in the studio, be it questions I'd ask about the pieces Lisa was throwing or tales told of her visits during our lunchtimes. Essentially, it is a considerable part of Lisa's life and therefore it's instilled into all of her apprentices to some degree.

In 2014, not long after I started, Lisa was to travel to Japan for six weeks to be a resident potter at the Mashiko Museum of Ceramic Art. Whilst she was away, her clay-spattered place in the studio would be filled by Masaki Dejima, an ex-apprentice of Ken Matsuzaki. Ken and Lisa are old friends. They exhibit in the same galleries, they've visited each other many times, and they have an unspoken system of persistently owing each other favours.

Dejima is short and stocky and spirited. His black hair rests to one side and he giggles quietly before opening up into a loud belly laugh. He could barely speak a word of English and for six weeks it was just myself, Darren and Dejima. It was euphoric and I can't think back on that time without a smile spreading across my face. Not only was watching him at work an experience in itself – a potter, all the way from Japan, that place where this craft is looked at with such reverence – but the entire residency felt like a sitcom. Every day at the studio we'd all fall about laughing at all kinds of things, such as a technique he'd share with us, or us with him, like whipping out the slip coating from inside a teapot by vigorously flinging it between his legs, spattering the studio's green door in blobs of white. Or even just small things, like Dejima describing his dinner from the previous night, made up from bizarre combinations of foods he'd found in the supermarket, or the fact that Lisa's cat at home had made an immediate bond with him and slept on his lap all evening.

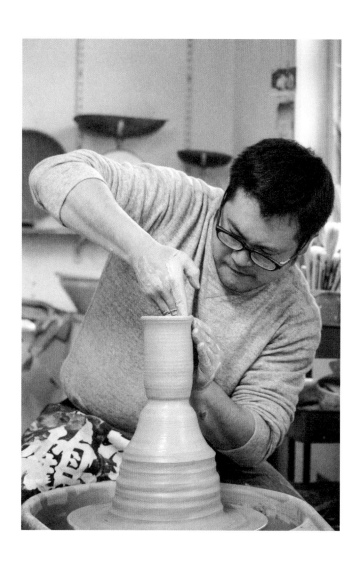

Masaki Dejima at the wheel, throwing off
the hump with the wheel spinning clockwise.

Without asking he'd help with my daily routine of tidying the studio from the mess of the previous evening's class, a morning ritual he's well versed in. 'Every morning for seven years I clean teacher's studio ... Autumn worst, many leaf.' I was glad he helped. Two sets of hands swept through the studio in half the time it would normally take me and he worked with extraordinary zeal. Most likely he was eager to get the place clean so he could get back to work. He'd started making a collection of pots that would eventually be fired in the soda kiln.

One day I made them tea and delivered it to their wheels and we chatted for a moment. Dejima told me that it was his thirty-seventh birthday. 'I'll go out and get him a cake and candles,' I whispered to Darren. 'Good idea! And let's take him out for a pub lunch too,' he replied. We returned from lunch tipsy, Dejima especially so. Sitting at his wheel with the clay spinning he just started chuckling. 'How can I do? Not possible! Too much beer!'

Have you ever tried to throw pots whilst drunk? Trust me, the two activities aren't compatible; it must be what drinking and driving is like. Both require you to use a pedal to control the speed; you have to use your hands in a synchronous way, which is done almost subconsciously, and you need to look at what it is you're doing, which in this case is throwing a vase. So really the two are identical. Only one won't result in needless deaths, only rubbish pots.

Alongside being a band of otherwise merry men, we also worked exceptionally hard. Dejima particularly so, as he had to prepare enough pots to fill and fire Wee Bear and then box all of them up and ship them home. He threw speedily, creating the shapes he was accustomed to but with new clay and coats of slip. Both Darren and I were on hand to help at any moment, to show him how the Maze Hill Pottery methodologies were executed. We didn't have to babysit him, though – one or two demonstrations were almost always enough; he was a potter after all. He'd used slips before, he just hadn't raw glazed, and making pots with unfamiliar clays only takes a few hours of adjustment, like breaking in a pair of new shoes. 205

To work in the studio alongside Dejima, a skilled thrower and hand-builder, was a privilege. As he threw, or hand-built, pots on the workbench with slabs and coils, I found myself constantly peeking over. My hands threw pots as my head watched his hands make pots. I was endlessly swivelling. Everything he did was different but the same: the way he positioned his hands, the rotation of the wheel clockwise as opposed to anti-clockwise, which in the West is the direction normally thrown in. His tools were intricate and new and he threw many of his pieces 'off the hump', meaning that each pot is made atop a much larger mass of clay that's placed onto the wheel. A small portion of that hump at the top is drawn into your hands and you can use the internal space created by two enclosed, cupping hands to roughly approximate the right amount of clay, and this is then thrown into a pot. Once one vessel is finished, sliced through and removed, more clay is coned up from the mass below, like on a conveyer belt, and the process is repeated again and again until the entire hump has been diminished. A solid lump of clay is turned into many boards of glistening, delicate pots.

At Maze Hill Pottery, and in college in Ireland too, we were generally taught to throw individual lumps of clay on the metal of the wheel head, apart from on a few occasions. Some types of lids and spouts are easier to throw using the hump method, but otherwise the bonus you get from throwing off the hump is that it negates the need for weighing out, say, fifty balls of 360 grams. Instead, you can just spiral wedge a few giant pieces, so that they're void of any air pockets or inconsistencies, and throw those, which is arguably faster.

With enough practice throwing identical pots off the hump is doable, yet with this method you tend to leave excess clay in the base of the pot so you can lift it away neatly without distorting the freshly thrown vessel. A thread is looped around the base of the pot, the wheel spun, the cordage tightens like a noose and slices the vessel off. Whereas by throwing individually weighed

out lumps, you can be more accurate and usually

there's less to trim away – but that too is dependent on the maker, of course. Some methods work for some people, some don't, and like any craft there comes a point were personal preference trumps practicality.

Dejima didn't throw all his pots on the potter's wheel; some were built from slabs and coils. He did it in a way I'd never seen before, building sideways instead of from bottom to top, like you normally see. He'd begin with a large rectangular slab. Coils of clay were then joined all the way around it and then he'd add another slab to seal the shape, so in the end it resembled a hot water bottle on its side. As he worked, he'd light a gas torch to dry out the clay and keep it from collapsing. Then, he'd flip it up and suddenly he had a large bottle shape with flat sides.

Hand-building is a task that's often visually and physically quite slow, compared to throwing on the wheel, but he broke my perception entirely. It was fast and energetic. He spent afternoons constructing complex geometric forms and angular vases that resembled mountains that were conjoined in duos and trios. He'd start by creating the base shape for one vessel, which was held together with narrow strips of tightly fastened newspaper and tape, wrapped around like tiny belts. Then he'd begin another, then another and another, moving between them as the previously moulded vessel dried out and became more stable. It was a masterful demonstration, even though we weren't being taught directly. Both Darren and I sat at our wheels, heads turned and hands still. We were transfixed.

At one point he spent an afternoon throwing mug bodies in varying shapes. He'd been watching us produce all manner of handled forms and we coordinated our workflow so we'd all end up attaching and pulling handles on the same day. In Japan, pots with handles – mugs and cups especially – aren't widely used, or at least historically they weren't. Green tea is drunk from *yunomi*, handle-less cups that have feet to elevate the pot, which is clasped from the bottom and sides with cupped hands. There's also *chawan*, lower and wider forms: small bowls with straight sides and a flat internal bottom. These are 207

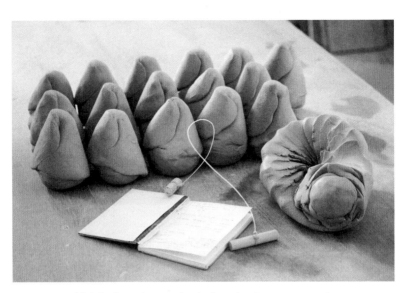

Weighed-out lumps of spiral-wedged, stoneware clay.
Neatly sealed with a round base, when thrown onto the
wheel they won't trap any air.

Dejima's hand-built vessels — pots the likes of which
I'd never seen before. Typically, ceramicists either throw
on the potter's wheel or they hand-build — he did both
superbly, leaving Darren and me awestruck.

used in the tea ceremony and, again, they don't have handles. Many Japanese teapot forms have bamboo handles that are attached via two ceramic lugs either side of the lid and travel over the pot; again, negating the need for a pulled, clay handle. Compare this to pottery from the West, where mugs, cups, teapots, tankards, the list goes on, all have clay handles, which, historically, were mostly pulled.

So, the process of handle pulling isn't, or at least wasn't, a common practice in Japan, and when you see handles on some Japanese pots they're often a little clunky and unusual, often too large or naively pulled, in my eyes at least. They just don't feel quite right – not all of them, but many vessels I've held and used. (The opposite is also true; the beauty of Japanese teaware is rarely found in this part of the world as it's mostly made by potters who have not grown up with and used these types of pots themselves.)

I showed Dejima how I was taught to pull handles and tugged a long length of stoneware into a strip. I separated it off against the sharp table edge with a snip of my thumb and then attached the blank onto the body of the mug, blended it in and pulled the final, arched shape. He got the hang of it quickly, although at first the technique looks ridiculous and feels awkward. The process looks crude, be it the phallic appearance of the clay or the tugging nature of one's hand, but you just have to get past the initial peculiarity of the technique. We all spent the afternoon pulling handles together, chatting as we worked, at least Darren and I did. By this time it was almost instinctual for us, and once we settled into a rhythm the handles flowed without much thought. Dejima, on the other hand, was truly focused on his, eyes practically crossed as he held the clay so close to his face, brow furrowed with concentration. He was adamant he'd learn and he did – his handles progressing throughout the day from thin and practically collapsing, to well-formed and sleek.

In Japan the apprentices often learn by observation. If I were in their shoes, I'd probably end up asking the master potter why they do certain things, but instead they frequently just watch and copy without

any words – Dejima did this with us. I covered the tops of my mugs in plastic sheeting as it was a particularly sweltering day and I didn't want the rims of the pots to dry out too much as the handles still needed time to firm up before I could cover them in slip. We were back in our workstations at this point and I noticed that across the room Dejima did the exact same thing after he had clocked what I had done. He didn't need to ask, even with the language barrier between us. He saw what needed to be done and followed suit.

He finally fired his creations, the pots thrown and finished with such precision yet glazed in a manner that introduced chaos to their careful character. We laid them out in the long grass and moss of the garden, displayed on kiln bricks sodden with soda, and photographed the pieces there, in the place they'd been made. Japanese forms, Dejima's shapes, only now with a new skin. I could only imagine how exciting this must have been for him.

He gave both Darren and me a pot from the firing and I still use his textured yellow plate almost every day, although I'm the only one allowed to use it. That way, if I break it I have only myself to blame.

The time came for his departure. He packed away his precious pots to ship home to Hiroshima – one day he even offered us his clothes as he needed to find more space in his suitcase for pots. Then, he was gone. It was quiet in the studio. I missed him. Lisa returned shortly after and soon her crates of pots made in Mashiko followed her back. Darren started coming in less regularly as he'd started a second job, and most days it was just Lisa and me potting away. Gearing up for ceramic fairs around the country or the odd exhibition, I continued, as ever, to learn new shapes and to hone my skills. Gradually I got faster, making pots quickly whilst retaining a certain level of quality.

At the beginning of my apprenticeship I found it hard to manage my time and to juggle everything: the classes, the pots, the cleaning. I felt constantly under pressure, a weight on me, and I was never sure where to focus my attention. I think I just needed time to adjust,

A coveted titanium yellow plate of Dejima's, made originally from a fat block of clay textured with a comb that was then stretched out on the workbench like pizza dough. It was fired with more plates above it, each propped up on wadding-filled clam shells that left permanent marks on the pot below.

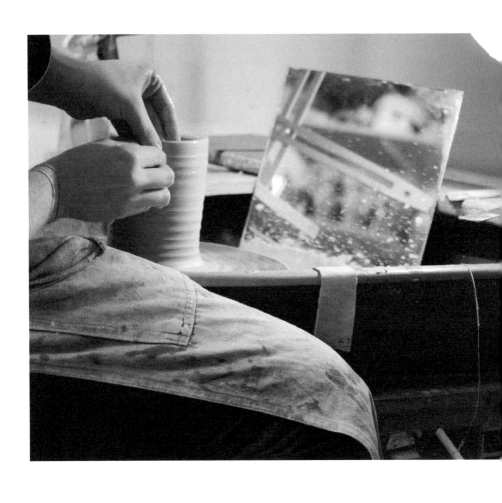

The apprentices' wheel. Ellie, Darren, I and many
others have learnt to make the standard ware range
on this workhorse. The mirror is there to allow constant
observation of the side of the vessel as it takes shape.

and who knew that it would take Lisa leaving for six weeks for me to really grasp how to run Maze Hill Pottery? A few weeks after her return she told me just that: 'I think my going away was a good thing.'

SOME POTS ARE more troublesome to learn than others, and the faceted creamers of the Maze Hill Pottery standard ware range were deceptively hard for me. The thrown forms of these pots aren't hard to make. They're just a small, thickly potted tapering cup, going from a narrow base to a wider top with a curved wall connecting the two. The rim is flicked outward with a wetted little finger that's slotted between two bracing digits from the opposite hand to create the pouring lip. They're fast to throw and once you've got out the knack of spouting it's an easy process to replicate. Faceting them, the process of removing excess clay from the walls to create flat planes, was altogether a different experience and one that famously catches new apprentices out.

Lisa facets much of her work using a selection of implements to inflict damage: knives, peelers and perhaps most notably spokeshaves, a tool that's intended for slicing the wooden spokes of wheels and the legs and arms of chairs. A spokeshave has a sharp blade held between handles jutting out either side of it. You hold the handles and carve away layers of wood with the blade in the centre, and more or less the same is true with clay, apart from one major difference: the material itself. Wood is strong, relatively. You can put a lot of weight behind the tool as you cut and the spoke or leg or beam of wood won't necessarily buckle or break. Whereas clay, which even once leather hard is quite soft, will deform as the pressure of the tool and blade press against it.

To ensure the process works, not only do you need to be supremely confident with each slicing motion, but the condition of the clay needs to be just perfect. It can't be too soft, otherwise the thrown creamer's body will just be squashed and deformed as you cut, and if the clay is too firm the tool won't slice neat long slivers away, 213

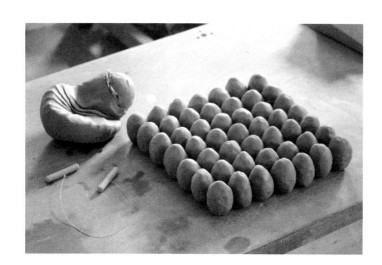

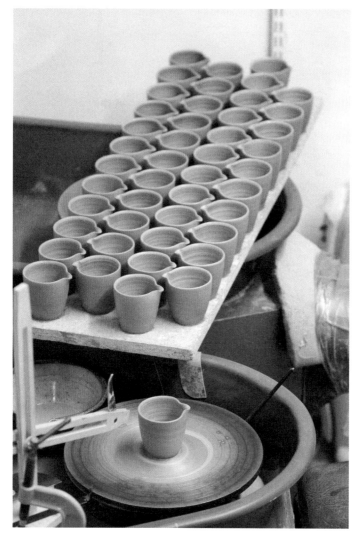

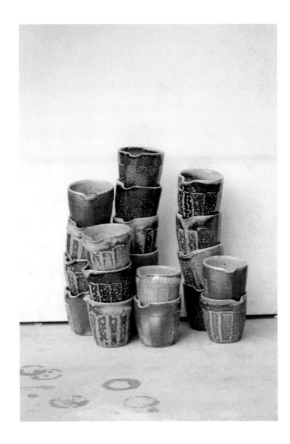

Faceted creamers from beginning to end, starting as wedged lumps, then thrown, spouted, sides cut and, finally, soda fired.

since the dry material just crumbles as you try dragging the blade through it. This means that you need to watch your pots drying with an eagle eye, but sometimes even that isn't enough.

I must have destroyed boards' worth of neatly thrown creamers. Once leather hard the little vessel is placed upside-down into the middle of a horseshoe shape of soft clay that's covered with a cloth, so that it's braced on three sides, leaving one open from which to carve it. This means you can slice the vessel and it stays put, braced, nestled into the horseshoe that holds it; without it the pressure from the downward sweeping blade would simply cause the pot to shoot back across the tabletop.

The aim is to facet away their sides to create a decagon, a ten-sided surface around the exterior of the pot. With every successful cut I'd pick the pot up and rotate it in place before shaving more away, until the entire exterior was incised and angular. Some of my cuts worked whilst others made holes in the walls, and soon I was surrounded by mounds of slices and a heap of ruined, hole-ridden pots. I bowed my head in frustration. There's no worse feeling than ruining a batch of well-made work but I suppose this is how you learn. Out of all the skills I tried at Maze Hill Pottery during my three-year apprenticeship with Lisa, faceting was the only one I never truly felt confident with. I could throw all of the forms, even the notoriously difficult, tiny leaning-back jugs that were sprung on me one day.

Lisa would issue new challenges. She'd suddenly ask me to throw a new form, handing over a fired pot as an example of the rough shape and demonstrating throwing it herself, leaving me with a freshly thrown specimen to replicate. Leaning-back jugs were the greatest challenge. They had a form that undulated in and out, starting with a gaping top that collared in before curving out to create the belly, collaring in again and finally widening at the base, a bit like an hourglass with an extra bulge in the middle. The clay on the rim was then pinched between two fingers to form a thin spot, which was then flicked out with a wetted index finger to form the spout.

Finally the whole piece was grasped either side of the lip and hoisted both up *and* back in the same motion. They looked like little penguins, beaks raised and torsos proudly puffing forward. They were hell. My first iterations looked ugly and squat, yet Lisa didn't immediately say anything. She was off working in her corner of the studio as I struggled to get it right. Darren would occasionally be throwing next to me and would give me advice, pointing at the jug and saying things like, 'I think you need to collar the shape in a bit more here', or, 'Try thinning out the rim, like this', before pinching the pot as it spun on my wheel.

Finally, Lisa would come over to examine the morning's production. 'Those two are fine, bin the rest.' Those destined for success would have handles attached, whilst the others would be piled onto the workbench, still wet, and immediately wedged back into usable clay. With the following batch there'd be twice as many good attempts and usually, by my third try, they were all more or less there, any kinks steadily ironed out.

Faceting, though, never truly clicked on the same level for me. As clay is a soft material it means that as you facet, you can actually move the tool as you slice, so in order to follow the curve of the pot this is what we aimed to do. It means that in the same motion that you're cutting down by lowering your arms, you're also rotating the spokeshave blade with your wrists to follow the shape of the pot, all whilst trying not to bash your knuckles against the wooden tabletop as the blade slams down against it. Sore, calloused spots on those impact zones weren't unusual after a few weeks' making.

There's a certain level of demotivation that comes from destroying good work. The same thing happens when attaching and pulling handles: you might have spent an afternoon throwing a beautiful batch of teapots only to wreck them with poor, ill-fitting and weak handles. This is just how it is when learning something new. If I had committed myself to it for even longer, eventually the tool would have become an extension of my hand, as happened with handle-pulling.

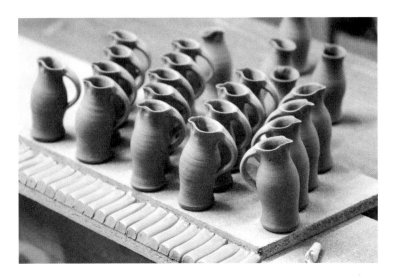

Penguins, leaning back jugs.
Wickedly tricky shapes to
make, leather hard here with
handles attached in front,
with those behind still waiting
for theirs to be pulled.

Pulling handles can make for
a welcome change of stance
after an entire day bent
over the wheel, although
you'll feel your left arm and
shoulder ache after holding
mugs aloft for hours on end.

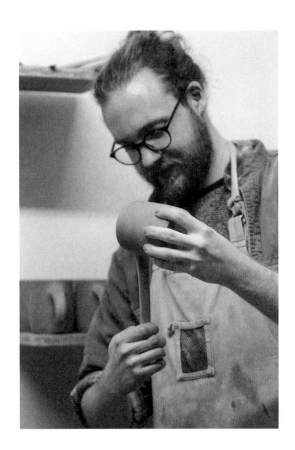

I used to despise this process and would avoid doing it at all costs as I didn't want to ruin my thinly thrown and delicately trimmed pots with a clunky, ugly appendage. But, when starting my apprenticeship with Lisa, there was just no way I could avoid pulling handles any longer, as 70 per cent of the standard ware range I had to produce was handled. So, I jumped in the deep end. I couldn't bear it until suddenly, almost subconsciously, I was watching my hands effortlessly pull long, neat strap handles. They were still awkward and without much finesse for a while, but with sheer will, and some world-class tuition, they finally went from looking crude to refined.

The creamers and faceting are among those things that almost found the light but never did. I like faceted pots, but if I explore that territory in the future it'll be pursued with different tools. Although that doesn't stop me from purchasing charming old wooden antique spokeshaves, with handles worn smooth, whenever I see them.

A FEW WEEKS after I started at Maze Hill Pottery, I began taking photographs in the studio. The idea was to document my apprenticeship but soon I started to upload these pictures online, initially just as a way of showing my friends and family what I was up to – that was it. At first, I was using my phone's scratched camera that produced blurry, almost unusable images, but I upgraded to a proper DSLR camera and my mother, who's a photographer, let me borrow some lenses she didn't regularly use.

Everyday I'd post a photograph on Instagram, together with a small explanatory caption that described what the picture showed, together with my thoughts. My images were unrefined but blogging about pottery online at that point, in 2014, was still a relatively new thing. My following steadily grew and I thought absolutely nothing of it. There were a few hundred people after two weeks and I simply used hashtags that matched my pictures, which related to the craft. I did mention to Lisa how I was documenting my apprenticeship; she was uninterested at first but very happy for me to continue snapping away. 219

Weeks later I remember coming in and telling her that I now had 5,000 people following me, much to her, and my own, surprise. A month later there were 10,000 people, then 20,000, 30,000 – it was surreal. Where were they coming from?

The importance of social media for me, and for my career, cannot be overstated. Fundamentally, it has underpinned almost everything, and has given me a means to sell my work and opened up an entirely new world of connections. It led to my having a meeting in Burberry's headquarters with Christopher Bailey, the creative director; me, a seemingly unknown potter working in a studio that didn't even belong to me. I loitered in my clay-spattered clothes in the glass-clad waiting room in the entrance hall, with high heels clattering around me as I waited to be called up. What was I even doing here? How did posting pictures of pottery lead to this? We talked about pottery for an hour and he put in an order for a large dinner set; then I left.

Instagram provides makers with an unparalleled opportunity for free promotion. All that's needed to be done is to take photographs and write captivating text to lure people in. Gaining followers was hard at the start, yet, like a snowball, it slowly gathers more mass the larger it gets. I'd sit, trawling through hashtags, liking others potters' photographs and making 'content' for hours each night, just to gain a few more followers as I slept. Occasionally it felt like one of those computer games I used to play – after all, it's all just pixels on a screen. I wrote about processes and discussed my philosophies and thoughts about the craft, which were, as a potter in training, developing as time passed. I wrote about my struggles and there was a narrative, a story that was updated each night that people could follow, detailing my life as an apprentice.

I vividly recall the moment I passed 100,000 followers, while out having supper with a friend on the South Bank one night, with all my attention on my screen rather than her. It was a visual diary that slowly developed into a means of sustaining a business and occasionally, out of the blue, people would turn up at Maze Hill

Pottery – not to see Lisa, but to see if I was there. They'd arrive without getting in touch beforehand and they came from all over the world – from the United States, Mexico, even Japan. It was bewildering and I was embarrassed to suddenly have to meet people and show them around. All those times previously, when I had visited pottery fairs to pick the brains of those who'd been in the industry for decades, only to hear that it was a hard life making, marketing and selling pots and that you'd never be able to make a decent living, and here I was, somehow building up an audience of hundreds of thousands of people. Since April 2014 I have posted a photograph or video online every single day – in some cases even twice a day – and always with an accompanying text to set the scene or describe the process. It's an inseparable, self-inflicted routine, and one that I might never be able to give up.

I am, though, a very private person when it comes to sharing anything outside the sphere of ceramics. I don't post pictures of meals I've had at restaurants, or the frothy tops of cups of coffee I'm about to devour, or cheery snaps from my holidays. I only share what relates to my job and I prefer to keep it that way. Consistency is the other major part when building an audience online, and that doesn't only relate to the frequency at which you post but also to the type of work you put out there. Niches are what lead to success – unless you're already a celebrity, of course, in which case you can post about whatever on earth you like. Embracing this world has led to so many things. Friends, events, arguably even this book. I'm sure none of it would have happened had it not been for social media, but it's a double-edged blade too, both a tool for success and a bottomless time sink. Sometimes people think that it all must be luck, and yes, I did start posting online at a good time. But I've also spent thousands of hours photographing, filming, writing and engaging with an audience, answering questions and explaining the craft, or at least, my own perception of it. Anyone who has become invested in social media like me will tell you the same thing: it's virtually a second job. 221

EVERY FEW MONTHS we'd pack up Lisa's van with a dozen boxes of pots, shelving systems and all manner of leaflets, business cards and stands to display pottery on, before heading off to a pottery fair. Sometimes they'd be outside in the sun; other times it would pour with rain, the wind whipping up the tarpaulins sheltering us, pots falling over, filling up with water and, once, I saw an entire stand blown down. Collectors would come, friends, family. You'd talk to your neighbouring ceramicists about everything, gaining a fascinating insight into another artist's life, another potter who uses the same medium, often precisely the same materials as you, only they've taken it in an entirely different direction. In the evenings we'd all sit around a fire or go to a local pub until we were kicked out. A few of these potters have been doing this for decades, meeting up a few times a year at shows all around the country to sell pots and revel in each other's company; there were dramas, relationships, fights. The pottery community is relatively small and many of the makers have grown up together. Lisa had stories about them all, and during lulls in the day she'd tell me about potters past and incidents that had occurred.

I'd slip away as soon as I was able to find the younger group of potters and apprentices; it felt like a school trip, our teachers elsewhere, us chatting late into the night. Sometimes everyone would camp nearby, as these events are often held in muddy fields; other times we'd stay in a local bed and breakfast. Lucky potters would be wildly successful during these fairs, selling tens of thousands of pounds' worth of work, whilst others might sell only a few hundred pounds of pottery, barely enough to cover the costs of attending. It must be a tough environment to be in when those around you are selling out of their pots, their stock diminishing, whilst your stand remains deserted of people and brimming with pots.

Lisa is well known enough to keep us constantly on our toes; I'd take the payments as she wrapped and chatted.

There were other days though, in ghostly quiet fairs, where we'd only make a sale or two and we'd

slowly descend into madness. Generally, these shows are quite competitive. You want your stall to stand out more than those around you and if you're a good salesperson you may be better at talking someone into buying a pot. Not only that, where your allocated stall was could have a tremendous effect on the footfall; one year with Lisa we were put right by the exit of a show and only a trickle of people made it all the way to the back. I'm shy and bad at goading someone into swapping coins for clay, and I was sure, when I started making pots (and before I began posting on social media), that this was to be my future.

Luckily, my following grew ever larger and I had emails piling up in my inbox enquiring about the pots I'd made and whether they were for sale. I steadily built up stock – some bowls and mugs and a pourer or two – and then, when I had about 70,000 followers, I set up my first 'shop update' on my website.

I was sitting on my bed with my laptop, not really knowing what to expect. I was nervous and my stomach lurched as I clicked the button setting the shop live.

One order came in. Then another, three more in quick succession and then a constant stream filled my inbox until the shop was sold out. My phone pinged with notifications, trying desperately to catch up. Five minutes flat, that's all it took to sell some forty items. People had purchased from Australia, the United States, Canada and France, and so I wrapped pots late into the night, cross-legged on my tiny bedroom floor, a spool of bubble wrap and tape on my bed, a stack of collapsed cardboard boxes and some bags of packing peanuts in the doorway. I sent them off in batches initially, tying multiple boxes up with string and carrying them to Maze Hill Pottery, delivering them to the local post office at lunch.

Lisa was as shocked as I was, mouth open as I brought the boxes inside the following morning. Could this really be how I'd sell my pots? Sold to pot collectors, fans of Lisa's who wanted an insight into her practice and, well, all kinds of people. I wonder whether Lisa ever thought I was stealing her thunder, or if she thought my 223

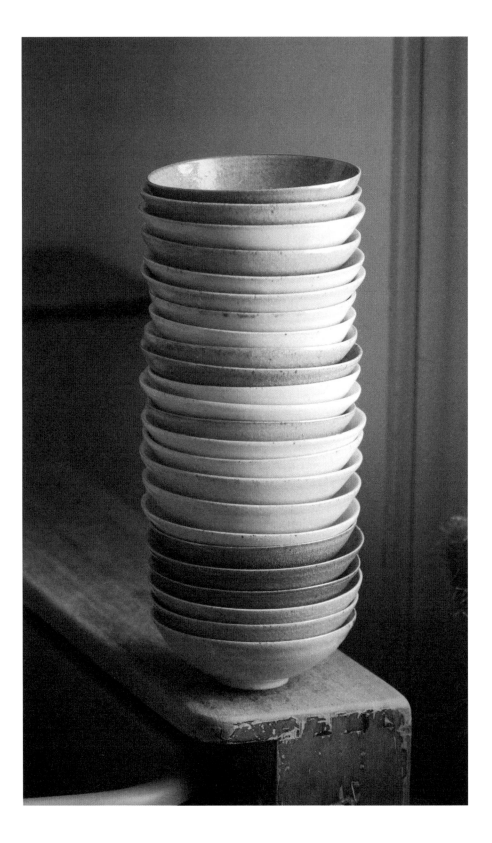

postings exploited the trust she gave to me as an apprentice? Either way, I wouldn't be here had it not been for her.

During one fair the word must have got out and in the evening I ended up having a conversation with a group of established potters around a fire, late at night, who all spelt out frankly what they thought about it:

'You'll never be a real potter doing that.'

'It's a waste of time, if people can't touch the pots, then they definitely won't buy them.'

'You're wasting hours you could be throwing pots.'

That first statement is ridiculous but it was an opinion held by a number of them. Who decides what a real potter is anyway? Who cares? I was going to reply, when Darren did it for me: 'You should really take a look at what he's doing before you pass any judgement. It's not like any of *you* lot are doing something new.'

I was grateful for Darren's support – but I did understand where they were coming from. After all, functional pots are inherently objects that lend themselves to being held and used. Wouldn't you want to hold and see the pot before you spent your hard-earned cash on it? Nowadays, though, most of us don't even blink before buying a pair of trousers online – what's the difference?

I was lucky that both Lisa and Darren supported me. In those early years, as my audience started growing online, there were quite a few instances where other potters spoke rudely to me, often completely unprovoked or after they'd had a drink. Once, the next morning, someone who had been critical the night before came over to our stall and apologized for the things he'd said. He confessed that he'd gone back to his tent and looked at everything online. 'Your pictures are quite good actually,' he admitted. 'Maybe I should take a look into making an account for myself ... I'm sorry about what I said last night.'

A precarious tower of reduction fired, crackle-glazed bowls, heaped up by me purely as a means of garnering online acclaim.

THE MAZE HILL POTTERY Christmas Open Studio was the biggest event of the year. We'd fire both Wee Bear and Big Mother in tandem, which resulted in a gargantuan number of new pots emerging and 225

filling the workshop. During my years at Maze Hill Pottery we only ever fired the behemoth Big Mother three times, always in preparation for the winter Open Studio, as it just wasn't worth using a majority of the time. The results, whilst good in places, were mostly disappointing. The vaporized soda never seemed to penetrate the right areas, and shelf after shelf would be full of seconds. The Open Studio, however, was a good chance to clear out all these seconds, as well as those that had accumulated over the year. We'd stick discounted prices on them and they'd mostly all disappear into the hands of joyful visitors.

Lisa would show her personal pots too, firsts, the good stuff, as would the apprentice, myself, and Darren. It was like a tiny pottery fair inside the studio, our pieces all thoughtfully arranged on shelves, placed on white cloths and wood, in a studio that was actually spotless for once. We didn't have a spring clean at Maze Hill Pottery, rather there was the winter wash. We'd cram all the wheels in the backroom, out of sight; all the clay was heaved out too and all the buckets of glaze would be lowered down on ropes into the damp basement. Then, the whole workshop was given a thorough blitz, mopping, hoovering, sponging down and even repainting walls and floors. I both dreaded and looked forward to the Open Studio. The clean-up was a monumental task, yet the payoff was an immaculate studio to work in thereafter.

Morning would come and a line of timely patrons would form outside. We'd be ready in the kiln bay to crack open Big Mother and wheel her out. It was a spectacle, and there was always a crowd watching us remove the bricks from the top of the door before painstakingly rolling the trolley out along its tracks, the shelves of pots slowly revealing themselves, inch by inch. Lisa would be standing in front, on stage, chatting to the crowd and looking at pots as they were unveiled. Darren would be in the wings – he was the driving force pulling the trolley out. He used a crowbar to lever it, which was stuffed through a metal bar on the trolley and into the slots on a shallow metal ladder inlaid in the concrete floor.

The apprentice's job was to help the others, backstage. I'd balance on a stool, peering inside at the top shelf of pots as it slowly trundled out, making sure nothing caught on the ceiling and keeping wobbly vessels steady. During the firing the corroded arched brick ceiling could sag in places, blocking the exit path of some pots, so a careful eye was kept on them until they were all clear. The pots chinked as the trolley lurched and there were pings and loud ringing noises as the metal components bowed and flexed. Each time we looked at one another nervously.

People packed in a tight mass watching, cameras out. It was a tense moment for us as opening a kiln can be nerve-racking, let alone doing it with an audience watching you. It's often a calm, collected period, where pots are taken out and inspected one by one, especially with soda kilns as no two firings are alike. There are pieces that are ruined by soda, those that have fused to the shelves, and those ruined by human error. When it was just Lisa and me unpacking it could be a very introspective process. We'd chat about the work as it emerged, we'd hold pots up to the light in awe, and we'd smash those that were obviously forlorn. For me it's quite a private moment, revealing one's efforts over the past weeks or months, so this experience of having an onlooking crowd does make it rather theatrical, and we'd react in ways we normally might not.

Lisa would snatch away the good stuff, hiding it for future exhibitions before someone laid their eyes on it. The rest of the day was spent cleaning pots from the kiln, categorizing them and selling wares inside. It was unbelievably busy. We couldn't move in the workshop for people, squeezed in, shoulder to shoulder, the fruity, almost sickly smell of mulled wine wafting in and out.

It's one thing to share your pots online, in photographs and videos, but displaying them in a clean physical space makes such a difference. For so much of the year, our finished pots were stored up high on ware boards, gathering dust. You might take them down but they'd still be in the studio environment, and so it was a relief to finally see them in a more purposeful way, in an emptier

Lisa directing the opening of Big Mother. She'd pluck pots off the shelves as the trolley slid out, telling those watching what she liked and what had worked well, hopefully without any unexpected disasters ruining the proceedings. Hundreds of pots fit inside this particular kiln, and she'd tell me how she used to throw enough pots each month to fill it, back when she was producing more tableware.

space, individually, not in rows or heaped up in piles. Pots can stand alone, beautiful in their own right – even primarily functional mugs and bowls, like those I display on my mantlepiece at home. In my eyes, all craft is art.

MY OBSESSIVE TAKING of photographs has meant that my entire apprenticeship is documented. The pots I threw during my first weeks as an apprentice were crude, overworked and unnecessarily fussed-over; they lacked spontaneity. Those I photographed towards the end of my apprenticeship were fluid, the handles capturing a single moment in time on their surfaces, and the pots themselves looking characterful, thrown far more quickly and to a much higher standard. After making several thousand pots I had become so accustomed to producing these shapes that I could do it with my eyes closed.

On some occasions Lisa would ask for a hand with the pots she was making, such as attaching handles onto oval, faceted oven dishes, or carefully moulding the gallery on small, hand-carved trinket boxes. We'd sit together on the workbench, shaping and carving, her emails pinging and the phone buzzing. There was never a quiet moment and things were destined to get far busier. Eventually I'd start slipping some of her pieces too, and I became more involved with her personal range, holding giant moon jars as she glazed them, arms quivering, and cleaning away the glaze on the feet of her tea ware forms. Many of the pots she makes are too large to glaze by herself and by having an apprentice do much of the dog work she can spend more time actually making pots.

AT THE TIME OF WRITING, Lisa has had twelve official apprentices. I was number nine. That's twelve separate occasions she's had to invest the time and effort into teaching somebody how to create the houseware range, together with showing them how the studio is run, the kilns fired, everything, from the ground up. That alone is a considerable feat, a passing on of knowledge that is extraordinarily rare these days.

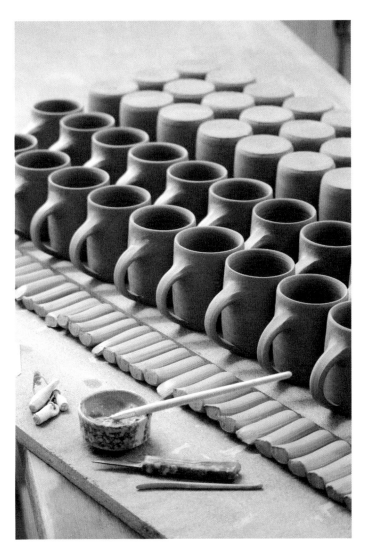

Upturned mugs, pulled blanks and freshly handled vessels. These must be dried out slowly, since attaching soft clay handles to leather-hard cups means that two consistencies are drying at the same time – and if it's rushed, cracks can form between the two parts.

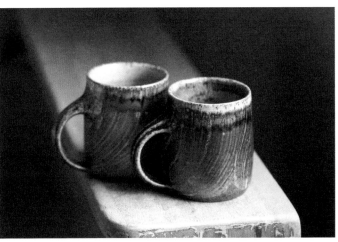

Out of the many thousands of Maze Hill Pottery mugs that I made, these two were the absolute best, a batch above all the others. I squirrelled them away as soon as I saw them.

She cares passionately about the craft and has dedicated her entire life to it. Beyond taking on her own apprentices and bringing them into the fold, she has also started two initiatives to help others. The first was Adopt a Potter, a charity that funds year-long placements for young, budding ceramicists with master potters across the country. She doesn't use this charity to fund her own apprentices; rather, those are funded from her own pocket. A few times a year the charity's trustees would come to the studio and they'd discuss the applications and decide who'd be funded. These were conversations that were always interesting to eavesdrop on, as I sat throwing pots in my corner. What makes somebody stand out? How are the younger potters matched with more experienced ones?

Initially my apprenticeship was supposed to be two years long, but as my second year was drawing to a close Lisa decided that she wanted to do more to teach the next generation. Adopt a Potter wasn't enough, and at the time universities were still offering mostly sub-par courses in regard to teaching practical skills. She and I talked about the Thomastown pottery school I'd trained at, and eventually she decided that the same sort of course needed to exist in this country. She asked whether I'd be willing to spend a third year with her, as she wanted to have someone who knew how to run Maze Hill Pottery whilst she focused on raising funds and finding a location for this school. She'd bounce ideas off me, asking about the course in Ireland and what had worked; soon she was suffocating under paperwork. She spent untold days on the phone chasing leads, the device sandwiched between her neck and shoulder as she threw. She was often away for meetings and so I was left alone to care for the place.

Before long the name 'Clay College' had been coined for the pottery school, and a curriculum created. It would teach practical, useful skills to fourteen students every two years. It was eventually crowd-funded by potters and people interested in the craft, mostly through raffles and donations, and was set up in England's pottery capital, Stoke-on-Trent in Staffordshire.

EVERY DAY I'D spend over two hours travelling underneath London on the Tube, to and from work, one of millions of rush-hour commuters. It was hot, unbearably so at times. The clay that surrounds the tunnels was once a heatsink but now it has become saturated with warmth. This earthenware clay that encases the London Underground is some fifty million years old and is found in abundance throughout the London Basin. It fires to a warm yellowish tone and you'll see buildings throughout the city – row upon row of houses – built from London clay bricks. Some houses are bright, the bricks clean or newly lain, others aged, weathered black or brown and encrusted with dirt. Hundreds of millions of bricks were being produced throughout the nineteenth century and if you start to look, you'll begin noticing them everywhere.

The rules of my apprenticeship changed in this third year. I was to be paid more and for two days a week I could throw my own pots. This was a revelation. Previously I'd been making them after work or at the weekends; it was a rare treat. When apprentices start with Lisa, myself included, you're slow at everything, be it throwing mugs or wedging up 150 kilos of clay. But after two years of relentless practice you begin to churn through these tasks, completing what would previously take a week to do as a new apprentice in just three days.

Over the previous two years I'd only made maybe two hundred of my own pieces, pots thrown in a style that I had only just started to develop during my final term in Ireland. The ideas were fresh in my mind and I ordered half a ton of the iron-rich stoneware clay body I previously used and set about throwing some angular, thin pots, clunky jars and mugs, and curved, simple bowls. The vessels were a disaster at first; for a while it felt like wearing somebody else's boots and the clay itself felt like putty. It had a smoother texture compared to Lisa's dark grey, heavily grogged stoneware that would grate at your palms and fingertips as it spun under them. That clay had started to feel like home, and this new red iron body was like a distant relative, behaving differently.

I set out to throw mugs of my own design. The shapes I lean towards are uncomplicated at heart and often, whilst concentrating on making a straight cylinder, I would inadvertently start throwing the standard ware range shapes as muscle memory kicked in, overriding what my hands were attempting to do and barrelling out the form to be more curved, against my will.

I'd tear the pot off the wheel and slam another ball of clay down. I'd try again.

Over the previous two years I'd thrown thousands of large and medium mugs and innumerable espresso cups for Lisa's soda-fired range. Now it was time to reach back into that part of my brain where a sapling had been growing. It was frustrating at first. I was so used to throwing the standard ware range that my own, finer vessels felt graceless and kept collapsing. But soon I was able to work with a speed I'd never achieved before when making my own pieces. There was finesse, too, that I had previously lacked, gained through thousands of hours of practice.

Throwing quickly might not seem important, but if there's one thing it does well, it teaches you how to work accurately and to not fuss around too much with the clay as you guide it into place. After all, the faster you can throw the more time you have for other tasks, and if you talk to any production potter, one who goes through the entire process themselves, from wedging the clay to glazing and firing the pots, then they'll probably all say the same thing, which is that throwing pots only accounts for a small portion of your time in the studio. It's just one part of a long process. Throwing can end up being a treat, the task you do for a few hours in the morning before settling down to mix up your glazes from stuffed sacks of raw materials and mopping, endless mopping.

My online shop updates became more regular, and my tiny space at home was soon half bedroom, half packaging warehouse combined with photography studio. It was all very cramped and, with hindsight, a ridiculous way of operating, but it's what got the ball rolling. 233

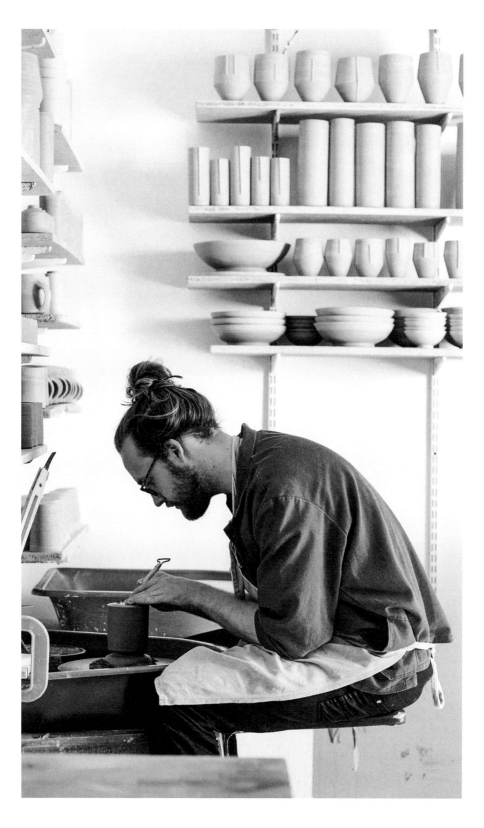

My following online continued to increase, still much to my surprise, and every few weeks I'd restock my online shop on Sunday evening, at seven o'clock on the dot. They kept selling out, all of it gone in five minutes, then two. Truthfully, I had half expected it to take a decade to work up to the point where I could sell my work consistently. The prices weren't too expensive; I just matched the amount to what other potters of my calibre and experience were pricing their work at, I didn't use any formula.

I fired my own pots in a small gas kiln that belonged to Darren, a Laser, which had an internal capacity of just under two hundred litres, which allowed me to fire about fifty or sixty pots at a time. During one of my first weeks at Maze Hill Pottery, he and I had met early one morning in south London to excavate this kiln from somebody's shed in their back garden. We ripped it out and carried it through the house, chimney and all, whacking it against every door's threshold as we passed. We shoved a sturdy cardboard box inside the kiln's chamber to try to keep the insulating fibre from all collapsing inward – it worked and somehow it survived the journey back to the pottery.

Instead of being built with insulating kiln bricks, like Lisa's soda kilns, this kiln was lined with ceramic fibre, which resembles the insulation you stuff into your loft. Inside the kiln, the lining that's exposed to the flames develops a hard, crusty layer, like a singed marshmallow that's gone cold, encasing the white-hot surging fire. The kiln had seen better days and the metal casing was rusted in places. The ceramic fibre was worn and wavering but it was entirely free, and a free kiln is something you can't pass up. The woman to whom it belonged also gave me my first wheel, a little yellow Brent, also for free, which to this day sits in my studio, gathering dust admittedly, but part of the journey nonetheless.

We set the kiln up at the pottery on some breeze blocks and Darren and I spent the next couple of days building a new roof over it to keep it dry, cutting out a hole in the thick, clear plastic for the chimney to protrude through. It had burners only on the right-hand 235

side, which meant that maintaining an even firing temperature might be difficult. The two burners poked up through gaps in the bottom of the chamber and the pipes feeding them led to two big bottles of propane stored outside.

This would be the kiln I'd use to fire my own pots. I'd pack it the day before firing, filling it with pots in white, green and dark green feldspathic crackle glazes, the same ones I'd been using in college, the recipe altered to suit the raw materials we had here. I placed the dark greens closer to the burners as they seemed to withstand the brunt of the flames better than the others did. The scorch marks suited the pots, rather than obliterating their quiet surfaces.

I'd arrive at seven o'clock the following morning. It was deathly quiet heading out of the city, and the pottery was too. I'd ignite the burners, kiln door open, then swing it closed and seal it tight. The sound of burning propane was quiet at first but over the course of the day, as the gas pressure increased, it rumbled louder and, at its peak, it sounded like a low flying helicopter thundering overhead. After the kiln was lit, I'd sit indoors, in the warmth, with all the lights off, drinking coffee and eating my breakfast. Lisa wouldn't arrive until ten – we started late and finished late – and for those few hours I'd photograph my recently fired pots in the gloom of the workshop, capturing them in the same way subjects were caught in the Dutch Golden Age of painting, swathed in darkness.

At about midday, when the digital pyrometer read 860°C, I'd initiate the reduction by turning the gas pressure up dramatically and sliding the dampers over the flue exits on top of the kiln, to throttle how quickly the exhaust could escape. The dampers were just two old kiln shelf offcuts and after a few hours of the flames sputtering up to find oxygen these dampers would be red hot, so I'd need to shift them around with a metal poker.

At about six in the evening the firing would conclude. I'd turn the gas off, the helicopter finally landing, some peace at last. I'd then crash cool the kiln from 1290°C to 1000°C by fully opening the dampers and pulling out the bung in the spy-hole. This quick cooling

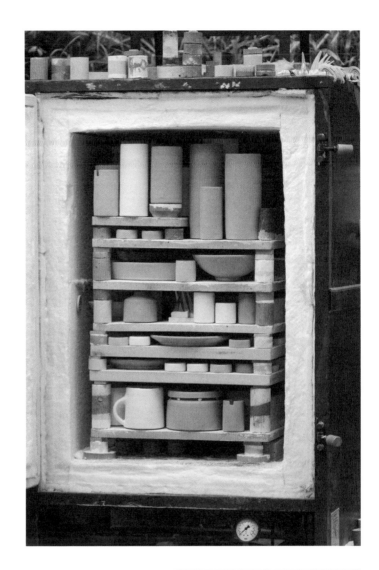

The 'Laser' kiln, fuelled by propane gas, with burners on one side only. This made it a challenge to fire consistently, needing a lengthy, gradual firing to achieve an even temperature inside.

Posting online more meant taking countless photos
and writing pages of descriptions. I've never had
any lessons in photography, yet my self-imposed rule
of posting each day forced me to learn new skills.

helps to retain colour and keeps the pots glossy, since if they cool very slowly you might end up with matte surfaces and crystals can begin to grow. By crash cooling you essentially lock the surfaces in time, at the moment they reach top temperature, the chamber white hot and almost reverberating as the flames rush around violently inside. Not that you'd ever have a clear, undisturbed look at the internal workings – you just can't do that with kilns. Rather, all of this is seen through a small spy-hole in the door. A brick cork is removed and you can peer carefully inside, dodging the piercing flame that jets out.

You can't see much after the internal colour of the flames inside transitions from bright yellow to white, so goggles are donned and, as you peek inside, you blow a large gust of air through the opening. This cools the pyrometric cones and the surrounding pots for a split second. Their outlines and forms sharpen as they darken momentarily and you frantically look in to try and spot them, replicating the cones' shapes with three fingers to remember their position and a little illustration is jotted down into the firing schedule's notes – at least that's what I do. Once the kiln has cooled to 1000°c it's clammed up. The dampers are closed and the spy-hole's bung replaced. The kiln's metal chassis contracts, a thunk ringing out as it lets out a sigh of relief.

The day after next is when the kiln can be unpacked. The cooling could be rushed if you really needed to, but I generally don't like rushing things. I'd crack the door open an inch or so, warm air wafting up onto my face, and the pots would begin to tinkle as the crackle glazes contracted further after being bathed in cool air, as if there were thousands of miniature wind chimes inside, all rippling in the breeze. The pots are always cooler towards the bottom than at the top – hot air rises, after all – so that's where I start. Snaking one hand inside to take pots out, I am careful not to touch the thick kiln shelves or props, since they retain much more heat and would singe my knuckles. Here was my first real batch of my *own* pots in a long time. It felt good to be home.

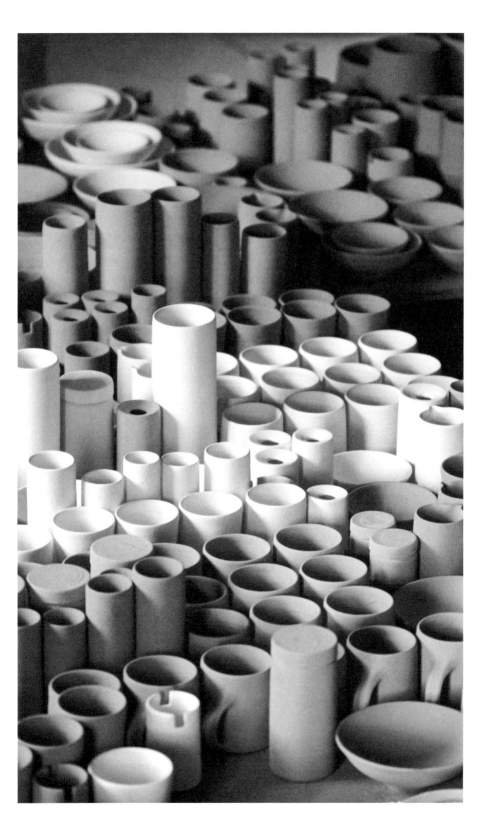

I'd spent my last few terms in college attempting to find my own voice in clay, only for the search to be put on the back burner as my apprenticeship began. I knew what I was getting into, of course, but imagine it like roughing out the story for a novel; all your notes are there, the characters are in your head, the plot, everything, but you can't sit down to write. For two years the pots had been there in my mind, or filling up pages in notebooks, and now finally they were starting to materialize into physical objects. I held one of my mugs in my hand, the glaze's surface sparkling. The handle was a little chunkier than I'd like and I could have fired the kiln slightly hotter as there were matte patches on one face of the vessel, but it was a start.

LISA WAS BECOMING increasingly busy with Clay College as it was really getting going, and Darren was away almost the entire time too. To compensate for Lisa's absence we started to take interns, to help me with the more repetitive and laborious tasks. These were commonly students, or those who were interested in a short stint of work at Maze Hill Pottery. We were inundated with applicants, which we sifted through carefully, picking a few out for day-long aptitude tests.

This is when Lisa shared with me what it is she looks for in apprentices. A person's practical ability isn't the most important factor. Of course, a basic level of throwing helps, but it's their attitude that plays the largest role. She advised me to watch and see if they observed the pots around them, as the workshop is stuffed full of handsome pieces. They line the shelves, they fill the little cul-de-sac shop and are piled high in the kitchen-cabinet as the wares we used for lunch. If they spent a day with us and didn't look at these, or ask to pick them up, or show any interest in the pots in the studio, then perhaps they weren't all that interested in ceramics. Then there were questions. If they asked a few that was no bad thing, but if instead there was a constant stream of queries, as if asked by a toddler trying to piece together the world, then that's a sure-fire way of getting on Lisa's, or anyone's,

Dipping pots in glaze was just the first step for my own wares. Thereafter, once their powdery surfaces had dried out, I'd spend days tidying them up, fettling the walls with a knife and scrubbing them with fingertips to make sure they were flat, and sponging their bases clean. Monotonous, repetitive, yet I still do it to myself. Once fired, the white will turn into a glassy grey, whereas the pinks will change into a deep, dark green.

241

nerves. She likes people who can observe the studio and what's happening and simply jump in, learning practically and lending a hand, as you don't necessarily need to know the particular details about everything immediately.

In addition, potters tend to be rather practical people. They're physically competent for the most part: being able to work cleverly with your hands is a form of intelligence in itself, and one that's often overlooked and disregarded. As a potter you don't only make pots; there's the mixing of glazes and the packing of delicate glaze-soaked pieces into kilns. We'd observe how they held fragile bone-dry pots or lifted shelves brimming with vessels and tried to get a sense of their practicality in one or two short days.

Finally, there's the person's character, and this is perhaps the most important thing, especially for Lisa's main apprentices, like me. You'll end up spending a *lot* of time together, so being able to get on is vital. Of course it's impossible to glean a full picture of somebody in such a short period, especially as there's a good chance they're on their best behaviour, but you can certainly figure out roughly where their mind is – especially after sitting through lunch and Lisa's questions, which usually went like this: 'What kind of pots do you like making?' 'Who are some of your favourite potters?' 'Are you sure you don't mind days of wedging and mixing glazes? It can be quite hard work sometimes.'

Their answers helped paint a picture of who was sitting in front of you, but more than anything what's wanted is a direct, can-do attitude and a willingness to learn. We'd get them to throw medium standard ware mugs, not as part of the production itself but as a means of practice. I'd be pulling handles all day as they threw and sometimes I'd time them as they made, calling out when the centring should be finished, when the walls should be pulled up and the pot shaped in an attempt to get them to throw more quickly. For those who were successful, at the end of their internship we'd fire a few of these mugs for them, which were even stamped with the coveted 'MHP' seal, pressed into the soft clay on the best they made.

This shadowing was a good opportunity for me to learn how to show someone the ropes when the time finally came for a new apprentice to be chosen. This, together with my descriptive online posts that detailed processes and teaching evening classes for three years, made showing people how to make pots, and how to approach talking about it, feel rather natural. I'd had so many good teachers myself over the years and each one gave their own perspective on the craft. Yet, I still wanted to create the pots I had set out to create after graduating from college in Ireland, only now I had an apprenticeship's worth of practice behind me. Thousands of pots, tens of thousands even. Was I approaching ten thousand hours yet? I must be close, if not well past that. In the world of pottery is that even enough? I remember one potter telling me, 'A potter's first sixty thousand pots are shit.'

If that's the case I must have many more to throw yet.

AS THE FINAL YEAR quickly sped past, I found myself throwing boards' worth of pots every day, for Lisa and myself, more or less effortlessly save for the few errors that always creep in. The shapes were becoming second nature to make, as was the raw glazing, and finally I could pack the soda kiln almost entirely alone, although Lisa still had the final say. One lunchtime, as I was cutting batons of carrots to be dipped in hummus, Lisa ran an idea by me. She always gifts something to her departing apprentices; for Darren it was enough bricks to build a gas kiln from, and for others it was a big, expensive pot of hers. For me, she suggested plane tickets to Japan, and, more specifically, the chance to spend time with her friend, and master potter, Ken Matsuzaki in Mashiko.

Ken was apprenticed with Tatsuzō Shimaoka, who himself had been apprenticed with Shōji Hamada. Hamada and Shimaoka were key figures in the *mingei* folk craft movement. Yanagi Sōetsu, a philosopher who found beauty in everyday objects and crafts, especially those made by unnamed craftspeople, spearheaded the movement in the 1920s and 1930s as a rejection of Japan's rapid

modernization. He idealized the people who spent their entire lives focusing on a craft without ever receiving overwhelming recognition for doing so, an idea I fell in love with when I first started making pots and read about the history of Bernard Leach. These objects should be cheap, used in our daily routines and characteristic of the areas they're made in. Sōetsu found a friend and partner in Hamada, who both influenced and was influenced by Bernard Leach.

Ken Matsuzaki set up his own charity, called the Mashiko Potters International Association. Its aim is to connect the potters of Mashiko with the rest of the world, be it through exhibitions, apprenticeships, or travelling with a younger generation of potters to see ceramics internationally. In fact, a group was due to come to Britain soon: Ken would lead a band of promising Mashiko ceramicists for an exhibition, and ferry them around the country visiting famous potteries. Lisa would be helping to organize this trip. Ken and Lisa help each other out and have an unspoken agreement that the other can ask for a favour when needed. Lisa agreed to drive the group around the country in a minibus for a week, and in return, she would ask Ken if I could do a six-month apprenticeship with him.

The visitors arrived at the airport laden with suitcases and bags full of pots. They looked exhausted. I ran out and ushered them into the van, taking their bags and stacking them neatly in the boot. I met Ken, we bowed and shook hands. A clash of cultures – a shake and a bow, a bow and shake. We all piled in and set off to the first stop on our pottery tour, Goldmark Gallery in Uppingham. This is a small market town in Rutland where the potters would be exhibiting their work. Upon arrival they all suddenly disappeared and changed into colourful, traditional silk kimonos. As the show went on, and when the countryside folk arrived dressed in boots, caps and padded gilets, they must have been quite surprised to see an array of striking Japanese vessels, together with a party of kimono-clad potters. I felt as if I was in another country, especially since we couldn't communicate too easily.

Potters have a universal language, though, it seems. Clay connects us and we can appreciate each other's pots and describe the features we like just by running our hands over them; we simulate the movements used to create them, as queries, to understand how certain parts were made.

All the potters' work was sublime, and it varied greatly in style from maker to maker. First was Natsu Nishiyama; she made rock-like sake cups and pourers that were created by slamming a stone against a flat piece of clay on the ground. This indented slab was then moulded into shape, and protrusions, like spouts and feet, were grafted onto it. They looked alive, as if at any moment they'd flex their legs and start lurching across the table, hence Ken nicknaming them 'sake-monsters'.

Taketoshi Ito made intricate pots the likes of which I'd never seen before. They were coated in shadowy, metallic blacks and resembled gothic architecture, incised with spines and pointed arches that repeated around the rim like the spokes of a wheel. Vaulted segments spanned the vessel, and some even had what could be flying buttresses. They sat delicately upon their plinths, almost floating since they were as light and fragile as an eggshell – a cathedral condensed into a vase.

Yoshinori Hagiwara was a fifth-generation potter who made traditional Mashiko-yaki, Mashiko ware, his pots coated with chocolatey brown and mirror-like black glazes. Some had swathes of yellow *kaki* (persimmon) glaze and others were lined with a blue *nuka* (rice husk ash) glaze in rows trailed carefully through it. His pots were functional and curvaceous, humble objects with obvious uses that begged to be held.

Shikamaru Takeshita threw large angular vessels and square plates, known as Nanban ware. These are wood fired but not to a particularly hot temperature, which means there isn't much molten ash coating the tableware, rather what's left is only the scorched areas the flames have licked. They're both eerily conventional in shape, yet with a modern undertone I can't quite pin down. Angles creep in, distortions too, and this was emphasized 245

in an exhibition I'd eventually see of his in Mashiko, where his work was all laid out on industrial metal surfaces. He remains one of my favourite potters to this day, especially in combination with the flamboyant spectacles he'd wear.

Lastly, there was Toshihiko Takeda, a person who made the conscious effort to connect with me even though we couldn't understand one another. He smiled kindly and engaged with us in a wholly gestural way, exaggerating facial expressions like a mime in order to communicate, along with a few broken English words. I immediately felt as if we'd have got on had circumstances been different, and much to my surprise he even gave me a pot right after we met. His ceramics were simple in shape, the clay pressed against fabric covered in white slip that impressed itself onto the surface of the brown stoneware, transferring the texture, resembling that found on a book with a woven cover. Over this surface he'd delicately paint black and crimson distorted arrowheads, almost like the Starfleet insignia but stretched to envelop the vessel walls.

All their work was different, as you would expect in the sphere of ceramics, where so much is possible due to the sheer number of techniques and materials that exist. Yet, in Japan, creating work that is wildly different is a little bit unusual. It tends to be that the potters make a similar style to the pottery town they work in. In Shigaraki most potters create vessels that are wood-fired in *anagama* kilns (*ana* meaning cave, *gama* meaning kiln). These are ancient designs, built from brick in curvaceous shapes, generally up the side of a hill, following the slope. In Bizen they wood-fire too, yet the pots tend to be reddish in tone and are strewn with marks caused by *hidasuki*, straw wrapped around the pots prior to firing. This combusts in the kiln and potassium from the rice straw deposits itself onto the clay, vaporizing and leaving orange-red marks, shadows from where the straw once lay.

In Seto, the ceramicists use a very white clay body and a mixture of glazes, the most notable being *kiseto*, a muted yellow tone that settles into the grooves of pots as it floods down their sides. The clay work is often

incised and blotches of green are daubed over it, which melts and glides as it's carried by the yellow beneath it. In Mashiko the potters use rich glossy browns, blacks and blue-greens, these glazes coated onto a locally dug stoneware clay that I'd soon have my hands sunk into. Pots there tend to be quite thick and functional, with swirling patterns and overlapping lines.

All of this is to say that tradition is still important in Japan, and venturing out and creating pottery that's completely dissimilar to the area you work in is unusual – or at least it used to be, although it is beginning to change. I asked Ken about this, and also what he thought about the craft in the UK, and he said that he loves coming here as this same level of tradition, of sticking firmly to your guns, doesn't exist, which means there's a level of divergency in what's created that doesn't exist in Japan. We aren't beholden to our roots to the same degree. It's both a blessing and a curse, though, I think. The sheer level of craftsmanship in Japan remains so high because of tradition, yet it can also stifle creativity. This is exactly why Ken is so driven to make links between the East and West, for younger potters especially, so we can experience each other's worlds and hopefully build upon them.

Interestingly, Ken doesn't abide by the normal rules and he stands out because of this. Beyond his exceptional talent on both the potter's wheel and when hand-building, he creates work in the style of Bizen and Seto, he makes Oribe pots and Shino vessels and even soda-fires, like Lisa, but with wood as a fuel as opposed to natural gas. He uses decorative brushwork, he facets and carves the clay with chisels, there are lugs and protrusions and even lacquer-ware lids. Clay forms are textured and torn, hollowed out and twisted. Simply put, he hasn't restrained himself. He's looked at Japanese ceramics as a whole and has tried his hand at most of it, combining these styles in ways that no other potter has. This makes his approach rather unconventional and I'm sure there are ceramicists in Japan who question why somebody who lives in Mashiko makes Seto-style pots, but he doesn't care. 247

The following day we all climbed back into the minivan and set off to our next destination, Stoke-on-Trent, for a workshop where all the Mashiko potters, Ken included, would demonstrate and then teach a masterclass. It was cold. We wore thick coats, hats and gloves and I joked to Ken, as British as I could be, about the typical bad weather we have here. He replied, 'You will need gloves in Mashiko! January is *very* cold.'

We arrived in Stoke and set up the demonstration areas, laying out tools and clay and lining the wheels up before heading back to our hotel. I was on hand to help and dashed between the potters aiding them as I could, phone open and ready to translate at a moment's notice. In the afternoon we toured Stoke-on-Trent. We saw the mountainous bottle kilns and even clambered inside one, much to the delight of the Japanese potters. Next came a few hours in the World of Wedgwood Museum, their faces pressed against the glass cabinets, looking at the pots and tools and machines used to propel British ceramics during the Industrial Revolution – the museum staff hurrying us out as it was closing.

I hopped on an early train back to London as somebody needed to be at Maze Hill Pottery to ensure the evening classes continued smoothly. I bid farewell to the group as they set off to St Ives to visit the Leach Pottery – a pilgrimage all Japanese ceramicists make.

'I'll see you in Mashiko in a few months,' I shouted, as the van drove off. I waved and the windows were full of fluttering hands waving back.

THE END OF MY apprenticeship was fast approaching and two worries arose within me. I hoped that I'd leave with enough skill to be able to run my own studio, and that I had passed on enough of my knowledge to my successor. There's a certain level of pride, a final passing on of skills, of tradition, that suddenly hit me. My replacement would become another link in the chain of Lisa's disciples. The last few weeks were quite sombre. It's hard leaving a place you've become so engrained in. There wasn't just Lisa, there was Darren and the evening

A tall bottle kiln in Stoke-on-Trent, with Ken Matsuzaki, Lisa Hammond and company for scale.

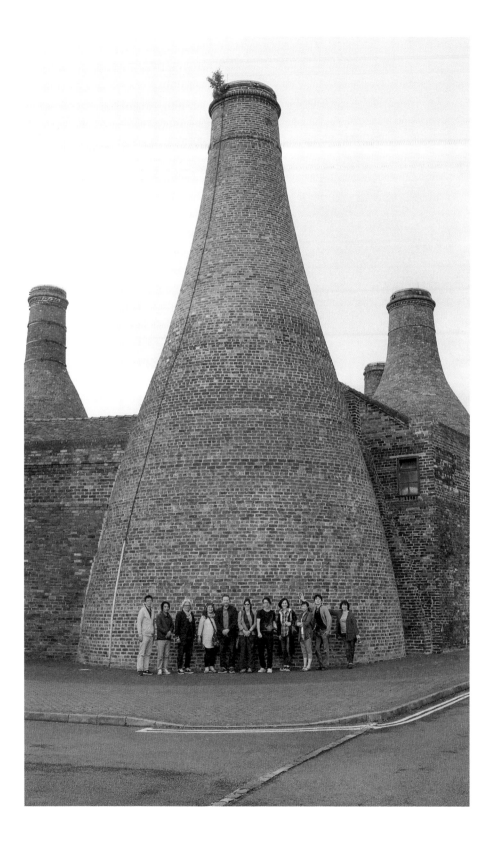

class students I had taught for three years now. Many of my students had been with me from the beginning, eight people of all ages at their wheels in the workshop, making pots for projects I'd think up or simply throwing whatever they liked, from gravy boats to spittoons. The classes ran for six weeks at a time, and the idea wasn't so much to create and keep ample amounts of pots, rather it was about instilling a certain level of skill. At the start most of them were abysmal, but the glee I saw on the faces of the students when they first came to the evening classes was infectious. Suited women and men, sleeves rolled up, trying something new, would drift back to their childhood as their hands sunk into the clay. They'd laugh, and joke, and they'd be smiling from ear to ear as they got progressively messier. A few advanced frighteningly quickly, such as one friend, Mark, a skilled leatherworker, who tried his hand at throwing pots. He applied the same care and concentration used for handcrafting expertly made purses and bags, but with a medium he wasn't used to working with. Yet, as a craftsperson, someone with a trained eye and serious attention to detail, he learnt at an astonishingly fast rate and his pots, even after just a few, short lessons, matched what I'd been producing after a few months of practising back in school.

Others never really progressed past mugs, and as months passed, and certain students kept coming back, the classes became more relaxed. One of them asked if they could bring a bottle of wine with them to share with their classmates, and the classes quickly turned into both an educational and social function. They all took me out to the pub after our final class and presented me with cards and presents. I'd miss them all a lot.

But most of all, I'd be sad to see less of Lisa and Darren. I'd miss the routine, our lunchtimes, batons of carrots, homemade coleslaw, constant teatime and the glorious process of raw glazing pots; swiping fingers and coarse straw brushes through layers of wet slip. I finally felt like a proper potter producing Lisa's wares, with real

hand-built brick kilns outside and riveting firings

with actual flames and a sense of danger. No longer was the kiln hidden in a room I wasn't allowed in; I was inside it, packing it, firing the gas and scraping the chamber clean after each firing. This apprenticeship with Lisa forced me to learn a whole style of making pottery that I probably would have never attempted otherwise, nor become so practised at. The joy is that all the skills learnt here are transferable, all of that time spent learning how to raw glaze, pull handles, to throw rapidly and accurately and even load soda kilns, will all be useful in my own practice, even if it isn't exactly the same.

I planned on living in London after Japan, so I never truly said goodbye to Lisa. I'd be back and we'd stay in touch, like most of the apprentices do. It's always a joy returning to Maze Hill Pottery – it hasn't changed much, save for the colour of the window frames and doors, the old faded green paint now plastered over with a layer of blue: a shock to my system every time I see it. The floors inside have received a fresh coat of paint too, probably to hide the areas I'd worn down after three years of mopping twice daily. It's a home away from home, a place I immediately feel comfortable in, even though new apprentices have been and gone and made the place their own, changing where tools are kept and hiding my mop and bucket.

One day soon Lisa might have to move and when that happens, Maze Hill, Greenwich and south London will lose something precious. She's the only soda-firing potter in the capital and she's a pioneer for pottery and crafts as a whole. She's done more for teaching the next generation of ceramicists than anyone else I can think of. At times she can be blunt, she'll admit that herself. She isn't fazed by telling you what she thinks or what you've done wrong, but she cares, wholeheartedly, about the passing on of skills. One day, if I'm able, I hope to have a soda kiln too, so that I can channel all I've learnt with her over those years. Each time I fire, instead of filling a little sake cup with red wine to be placed onto the wickedly hot kiln for the 'kiln gods', it'll be for her, for Lisa.

Mashiko

Where
I cross
the
world

The whole of Mashiko was trim and tidy like this.
On Sunday afternoons, as I explored, I'd see townsfolk
cleaning laybys, clipping communal hedges and
planting flowers. People's gardens spilled onto the
streets and everything, even the disorder, was orderly.

THE FLIGHT TOOK longer than expected. We were headed straight into Super-Typhoon Lan, which meant the plane had to loop around, killing time until the storm had drifted safely past the airport. The plane finally approached Tokyo, buildings stretched out as far as my eyes could see, and I pressed my face against the window to take in as much as I could, skimming over the ocean of crosshatched roads, walkways and power lines. The skies were blue now and the remnants of the storm system slowly crept away into the distance, casting immense black shadows over parts of the sprawling metropolis.

It was October, and as we landed I saw tufts of red and yellow trees amongst concrete. I made my way through the hectic airport, with vending machines flashing and buzzing and even speaking to me in robotic voices. I reached security and patiently waited for my cultural activities visa to be processed. After ten minutes I was handed a laminated identity card, followed by a warning that I had to keep it on me at all times otherwise I could be fined. I shuttled into the arrivals lounge and straight away spotted Ken, with his flowing white locks, and Doi Tsutomu, his apprentice, whom I'd heard so much about. He was currently seven years into a ten-year apprenticeship, which put my three years with Lisa into perspective.

Doi stood with his fantastic crown of black hair that radiated outward in a sphere from his head. He was the same height as Ken, but I could never put an exact age on him, even though I'd spend nearly every day with him for the next six months. He was slight, quirky, and had a smile and laugh that were contagious – at least they were in the rare instances they made themselves known.

The drive from Narita Airport to Mashiko takes about two hours. It's a trip we'd end up doing dozens of times, as heading into Tokyo for business was a relatively common occurrence. Doi drove us as we spoke slowly with the aid of an app on my phone that translated back and forth in a droid-like drone. It could even translate text if you pointed the camera at a book or a menu, the Japanese kanji script suddenly transforming into the English alphabet on screen, jittering and changing and frequently spouting utter nonsense. The gist was often all I needed, although at times Doi and I would communicate mainly with our hands – pointing at things, waving, pinching fingers together.

We skirted around mountains, drove through verdant valleys and followed paddy fields that rippled as the wind fluttered over them. I started to see a few rundown industrial warehouses and chimneys poking up too; even smashed kiln shelves and potsherds began to become evident on the sides of the roads. We must be approaching Mashiko. If St Ives and the Leach Pottery was a Japanese potter's place of pilgrimage, this would be mine.

We passed by a gigantic figure – a bear? It was brown with a white belly and a wide yellow hat that stuck out from behind its head. I swivelled round as we drove past. It must be three-storeys tall and, most notable perhaps, as I'm sure anyone who has seen it will know, is the fact that it sits on a voluminous pouch, its testicles, like a stool, out of which juts a long, weathered erection. It's a ludicrous sight. Utterly ridiculous in fact. It's the mascot of Mashiko, a towering *tanuki*, a Japanese racoon dog and a prominent creature found in Japanese folklore. Towns have differently dressed *tanuki* that come in various colours and poses, and Mashiko's just happens to have the largest testicles you've ever seen. Held aloft in his outstretched hand is what looks like a barrel-sized *yunomi*, a foot-ringed and handle-less teacup, a handmade pot. You'll find miniature souvenir versions for sale all around town, little lopsided racoon dogs in yellow, brown and white glaze. I have one sitting in front of me right now as I write this, head tilted to one side, peering at me with its three eyes.

Mashiko's terrifying and vulgar mascot. My big regret is not taking a photograph with it – or rather, with him – as I saw everyone else do. The painted plates to his right say simply 'Mashiko'.

Finally, the car turned into a small carpark. A ginger cat sat and watched us pull up beside a long two-storey block of apartments. This was where I'd be staying, the accommodation funded by Ken's charity, Mashiko Potters International Association. I wouldn't be the first visiting apprentice staying there. We got out and Ken pointed over at a rusted old bike propped up in the communal rack. It was painted black, although that was flaking off in places, and there was a vintage metal dynamo bike light attached between the handlebars and a deep basket too. 'You can use this to ride to the pottery,' he said. 'The key.'

He dropped a tiny metal key into my hand. It was smoothed all over, presumably after many years of use or going through the washing machine one too many times. How on earth would I manage not to lose it? I thought, as I stuffed it into my back pocket.

We carried my luggage in, two heavy bags and a wheeled suitcase. They showed me around, which took all of two seconds as the flat was minuscule. Doi disappeared, back off to the pottery no doubt, and Ken told me we'd go to the supermarket next. We climbed back into the car and drove the few minutes' journey through tightly walled roads past austere homes with immaculately trimmed box hedges. I heard the supermarket before I saw it thanks to a jingle that rang out from speakers on its façade. I still sometimes find myself humming that song and singing the slogan, even though I haven't a clue what it means.

Slowly we waded through the murmuring aisles. Everything was new and different; screens and speakers hidden amongst packets of ramen noodles spoke to us as we walked by and I must have asked Ken about thirty times what various items were. In most cases he couldn't even tell me – not because he couldn't explain clearly but because I simply didn't know what they were. We eventually located milk, cereal, cheese, ham and apples. Bread could only be found in thickly cut white slices that were soft, light and perfectly uniform in texture, six slices to a bag. I got three packets. My outings to the supermarket never became routine; everything remained exciting,

and I felt just like Dejima must have when he was telling us about his experiences in English supermarkets.

I would gradually taste my way through new delicacies, trying all the instant ramens in exuberant packaging, the perfectly shaped deep-fried fish and the freshly prepared sushi, which was always heavily discounted by the time I arrived late at night to pick up my evening meal, so that became my staple. The most notable surprise was what looked like a doughnut. It appeared as if it was coated in icing sugar and I expected it to be filled with red bean paste. After finishing supper alone in my apartment at the end of a long, busy day, I took it out from its bag, ready for something sticky and sweet. I sunk my teeth into it and my mouth was filled with spicy curry sauce. It was delicious.

My pocket-sized apartment consisted of four rooms, or rather, two rooms and two closets. There was the bedroom, which had a thin glass sliding door that led to the balcony outside, which is where the washing machine was. The bedroom's floor was covered in a number of supple tatami mats, made from woven soft rushes. These spanned the entire floorspace but there was a Western-style bed in one corner, although it was slightly too short for me. Above the bed was a large heating unit, an object that I'd soon come to worship and spend practically all my time beneath, as the winter months rolled in and the room became an icebox.

The kitchen was petite but well equipped, with a metal hob and a grill-tray that slid out. I had a ready supply of handmade pots, obviously made at Yuushin-Gama, the name of Ken's kiln and therefore his pottery. The countertops were all a little low, which meant that when I cooked supper, which was rare, or filtered coffee, which was frequent, I'd always be slightly stooped over. A small toilet cubicle led off from the kitchen, as did the bathroom, which was clad entirely in white plastic. Being inside it felt like being inside a pod spinning around in space on one arm of the International Space Station, that or being inside a sauna, as the tiny room filled up with clouds of steam as I showered and I could 259

All the manhole covers around town were illustrative.
Pots, birds, flowers and trees, telling a tale of the town.

barely see a thing. I climbed inside the extraordinarily deep bath and shower combo and tried to stand up straight. My head banged against the ceiling, my knees still bent. I'd be having stooped showers too.

Looking down at my feet I noticed I had already broken one of many rules I'd quickly get used to: there was mud from my boots trodden over the mats. I ran back to the *genkan* at the entrance of the apartment and deposited my shoes into this section of floor that's lowered into the ground. You always take your shoes off before entering a home, which is a good thing as a potter, because we've often got dust- and clay-covered boots. The doorbell rang. It was Doi. He simply pointed outside at a tiny white truck; he was here to pick me up on our way to have supper at Ken's.

We drove the short trip through Mashiko, down the high street, which on both sides is lined with rows of pottery shops, selling mostly finished, glazed wares, together with a scattering of clay and tool suppliers mixed in for good measure. We passed over a little stream and through some bare paddy fields before crossing a quiet junction and following a winding road upward that passed the pottery of an almost mythical figure, Shōji Hamada. Both Hamada and Tatsuzō Shimaoka, with whom Ken was apprenticed, became the first two 'Living National Treasures' of Mashiko during their lifetimes – an inconceivably important title that recognizes people who've dedicated their whole lives to the practice of traditional Japanese crafts, or, as it's officially put, to being 'Preservers of the Importance of Intangible Cultural Properties'. Being made a Living National Treasure even comes with a subsidy of two million yen per year, which is around £12,000.

Even in the dark, Ken's pottery and home were pretty impressive. The front is protected by a stone retaining wall with a driveway that snakes up to a sizeable, ornately covered open garage. There must have been ten different structures in total, from the workshops and kiln bays to the house itself, perched up high above it all. There were walkways weaving throughout, and behind all of it was a vast canopy of trees that were just beginning

Shōji Hamada's wheel, a device I had seen operated in
old black-and-white films. It's spun by way of a rod being
inserted into one of the holes around the circumference
and turned, faster and faster. Once enough speed has been
gathered the rod is set aside and throwing can commence.
Back in Thomastown, Geoffrey had told us about 'fingering
Hamada's hole', and that's just what I went ahead and did.

to take on fiery hues. They loomed over us and cast long shadows. We trudged up the steps towards the house, past the corrugated metal kiln bay lined with at least twenty bottles of propane that fuelled not only the house, but all the gas kilns too, and finally, up the final flight of flagstoned steps to Ken's home. There was no *genkan* here. Rather we took our shoes off outside, leaving them there, and stepped up through the rattling sliding door into the dining room.

Ken's family was there, his wife, Yoko, his daughter, Reiko, and his grandson, Gaku. His daughter speaks fluent English, which was very convenient when more complex discussions were had. I'd end up spending dozens of hours during my time there simply listening to conversations in Japanese, but tonight was not one of those nights. We had mouth-watering sushi served on large, handmade, cragged platters, with slices of crisp lotus root layered with cheese and ham and baked to a crust in the oven. After supper I gave them some gifts, luxurious chocolates, fancy biscuits and a children's book my stepfather wrote that has been translated into Japanese, which went straight into Gaku's rice-covered hands. I thanked them for having me, and I promised I wouldn't be too much trouble.

Afterwards Doi drove me back, his phone blurting out that I needed to be at the pottery by eight o'clock tomorrow morning. I ambled up the steps into my tiny flat. Sitting on my bed I looked down – I had forgotten to take my shoes off again. I traced my muddy footprints back to the door, sweeping the dirt back as I went, and readied myself for a welcome night's sleep in my small bed. The room was bathed in green and red light that glimmered through the curtains from a ramen restaurant on the other side of the carpark and I slowly faded off to sleep.

THE LAST STRETCH of road to Ken's pottery was lined either side with ditches, outcrops of bamboo, frothing streams and a few other potteries. Then it all suddenly became quite different, with a few ramshackle dwellings with hordes of collected junk, propped 263

up with makeshift walls, ceilings and extensions, all fashioned together from corrugated metal and sheets of plastic fastened to one another. I swung the bike up into Ken's and found a place to park it beneath the awning of the kiln bay, next to a small rustic building that stood on one corner of Ken's property, like a guard tower. It was assembled from large stone blocks with an elaborate tiled roof; upstairs the precious fired pots were stored and below was the photography studio.

I was the only one there, early of course. I'm always early. Even when I try to be late for things I end up being on time. Punctuality resides in my bones and so I sat down and waited, perched on a short retaining wall next to a potted, almost dead, lotus plant, right in the middle of the grounds. Opposite where I sat was a grassy outcrop. It was a sizeable mound, covered in leaves, with a few tall pine trees shooting up through it. Through it? That was strange. Is this where all the swept leaves are piled? I walked over and brushed a few crisp yellow and red leaves away and almost sliced my finger. Hidden underneath a layer of foliage was a mountain of pottery shards, some practically whole, others chipped or smashed in half. There were Oribe greens with shimmering, water-like surfaces, crusty wood-fired vessels that glinted with a golden iridescence, *yohen* pieces, touched and marked by the flames of burnt wood and charcoal during the kiln's firing. There were Seto wares of silky yellows marked with dollops of green and all manner of other pieces that I couldn't recognize, all broken, mingled and now mixed with the autumnal leaf fall. I know potters smash pots that don't make the grade, but I'd never seen anything on this scale.

At Lisa's we'd have to periodically get rid of our shards, but as Ken had enough land, he simply kept smashing his pots in the same spot and over the years the mound had slowly grown to be a few feet tall and a dozen feet wide. He hadn't chosen some secluded area for their grave; instead the pile was right in front of you as you entered. You couldn't miss it, apart from when it was covered in leaves, obviously. I never asked Ken

As a westerner, living in a country where bamboo forests simply don't exist, observing their dense darkness, and how they cascade at their boundary and sway in the wind, felt quite moving.

Strata of Ken's wares, sometimes destroyed by choice, sometimes by accident, overleaf. Over-fired, slumped bowls were lobbed here immediately, as were Oribe plates shattered to pieces having stuck to a kiln shelf. Earthquakes also played their part on occasion.

264

why he decided to smash his pots there, perhaps it was for convenience's sake – but I have a theory. I think it's a monument and a message. To any potter, acquaintance, or anyone who stops by. It shows what Ken has been through, what it takes to get to that level, and it shows his everlasting journey of improvement, of being self-critical.

I later found out that much of the shard pile had been caused by the Tōhoku earthquake in 2011. At a magnitude of 9.1 nothing was safe, let alone fragile pots, and all those vessels stored on the floor to ceiling shelves in the tower broke, cascading to create a thick carpet of shattered ceramics. All the pottery on the ware boards in the studio suffered the same fate. Kilns tumbled, houses collapsed, people were killed. I can't imagine going through such an ordeal, the ground trembling beneath your feet, walls and ceilings rupturing, and leaving marks that last generations.

The tsunami that followed that earthquake caused a disaster at the Fukushima nuclear power-plant, and the fallout from this was dumped all over Mashiko. This meant that local wood couldn't be used for firing kilns and vegetables grown couldn't be eaten as the soil was contaminated. To this day, Ken still sources his wood from elsewhere – he made clear that the radioactive wood ash created ends up being highly concentrated in the fired glazes. As I was standing atop the heap of shards, inspecting a piece in my hands and exhaling clouds of hot breath into the frigid morning air, Doi turned up.

He hopped out of his car and pointed over at a cramped alley between the kiln bay and Ken's covered parking spot. I followed him. We squeezed past twenty silver bottles of gas and there, lining the walls and hooked up on nails, were tools. He handed me a rake, a big green plastic bag and a scoop. We walked up some stairs; these were quite grand and curved up the hillside. Little stacked stone pagodas were hidden either side of us amongst the autumnal plants, together with pots, both broken and whole, sitting snugly in moss and mulch. There were also rows of molten pyrometric cones, their glossy white

spines poking out from the moss that enveloped them. I saw cones like this throughout the town, on walls, tucked on windowsills and even in the aggregate that made up the gravel in some areas. At Maze Hill Pottery I'd unpack them after each soda firing and place them in lines on a lichen-encrusted ledge, and I was glad potters here couldn't bear to throw them away either.

Once at the top we walked around another building. This was the guest house, which was very traditional, a room within corridors lined with paper walls and sliding doors. We went through a wooden gate and into Ken's private garden. Leaves were everywhere, thick on the ground, and for the next three hours we swept *every* single one of them up. Beginning in this garden we worked our way back through the grounds, down the stairs, around the metal kiln shed, towards the car shelter, through various walkways, the kiln bays and the drive that led into the property and, finally, the moss garden that lined the retaining wall at the front of the estate. This was the hardest section, as the leaves would imbed themselves in the moss and many had to be gathered up by hand. Every now and then one of us would take the green sack stuffed full of leaves, which had already been climbed into and stamped down numerous times to squash them, over to one of the wood kilns, to be emptied. We'd attempt to burn them but they were normally so damp we'd have to light a gas torch and force the leaves to ignite, the smoke thick and pungent. The ash would be shovelled out later and dumped over the road, where it cascaded down into a root-riddled gully.

This process lasted the entire autumn. We did it every single day until there were absolutely no more leaves to incinerate, either on the ground or in the trees. Yet even with bare trees all around us, a few hours in the morning were always spent cleaning. We worked together at first but eventually we parted ways and started at different points. I'd plug myself into music or an audiobook but Doi never would, and for hours, in progressively declining temperatures, we'd rake up millions of leaves and shove them straight into the kiln. 269

I'd never had a job where I worked outside and I both loved and hated this task. The crisp cool air, the golden light and my favourite story filling my ears caused the physical work to take a back seat. Then there were the days it rained and we'd be raking up leaves, mud and the sludge they created when all combined. We'd be soaked afterwards and would retreat back into the pottery to huddle around the log burning stove, which after a certain point in the year was lit practically the entire time, filling the pottery with the glorious sounds of crackling embers and sometimes a bit too much smoke, but at least we were dry.

One morning as I was sweeping, I heard a roaring sound from down by the kiln bay and I hurried over to see what was causing the racket. It was Doi and he had a leaf-blower. My heart leapt with excitement. Why hadn't we thought of this sooner? And so, for a few days, this was our new strategy and it was blindingly fast. We'd take turns operating the blower whilst the other one filled the sack up and carried it off to the kiln. Then, one morning, whilst Doi was blowing the leaves out from beneath the cars, Ken came down from the house. He always started an hour or two later than us. I heard the two bickering from afar and looked over; Ken was gesturing at the cars and pointing at the leaf-blower and Doi looked rather taken aback and apologetic. As Ken came down the steps to the pottery he said to me plainly, 'No more blower,' then shut the sliding door behind him. I swiftly ran up to see what had happened and looked at Doi and the cars. They were coated in dust. That was the end of that.

The tasks thereafter, during the day, were relatively mundane for a while although still challenging. Above the workshop was another room. Wooden steps led up to a raised porch and a large sliding door, and inside was a storeroom of sorts. It was there that all the pots were brought to be wrapped and processed for shipping, labelled for exhibitions, or measured and catalogued. It's also where Ken met clients if they came for a formal visit, Doi and I arranging a gigantic red-and-black lacquer tabletop and chairs in the middle of the room and

carrying down steaming pots of tea and bowls of intricately made sweet snacks.

After sweeping, my first few days were spent in there with Doi, as were our evenings, wrapping pots and stuffing them into their purpose-built *tomobako*, the wooden boxes you often see accompanying Japanese pots. They're perfectly and precisely made; the wooden lid only fits in one orientation, and as it falls satisfyingly into place you can feel the air being pushed out of the join. Potters sign the lids with ink brushwork, noting what's inside, then, on one specific corner, a red ink seal is stamped onto the wood. In this case it showed that the pot inside was made by Ken Matsuzaki. We'd sit cross-legged on cushions, wrapping pieces carefully in layers of foam, folding paper covers for the *tomobako* and then wrapping those too. If you've ever experienced Japanese wrapping you'll know the level of precision and beauty I'm speaking of. The room was cosy and warm, the heater flooding me and Doi in hot air, and we'd both find ourselves dozing off as we worked, heads nodding forward before jerking awake.

For three long nights running, from seven to about eleven o'clock, Doi and I worked tirelessly preparing these boxes. Each one had five compartments for five different pots and there must have been eighty of these in total. They were to be gifts from an employer to his employees, and before they could be delivered they would have to be blessed at a local shrine in Mashiko – a spectacular ceremonial experience that I was very lucky to attend.

There must have been some kind of miscommunication, though. There's no doubt in my mind that Ken and Doi were a well-oiled machine, but that's not to say there weren't some cracks at the seams, and I'm glad some things are universal; Lisa and I certainly hadn't always seen eye to eye or listened to each other properly. Doi instructed me to wrap each pot so that it couldn't rattle about, then around each pot in its cubbyhole we laid out beautiful crosses of paper and foam that were tucked into the corners to hold the vessel tight. Five pots per box, with eighty boxes to get through.

On the last evening, our fingers sore from pressing and folding paper, the sliding door crashed open and Ken came in, kicking his shoes off. A discussion quickly took place, hands moving, questions, queries, I couldn't tell. Ken turned and left, just as soon as he had arrived.

'What happened?' I asked. Doi reached for his phone and tapped something into his translator: 'They don't need to be wrapped at all ... Now we must unwrap.'

ON MY VERY FIRST day at Ken's, at three o'clock sharp, an intercom in the pottery sounded. It took me by surprise as a robotic Japanese voice suddenly broke the calm of making – Ken has an intercom system set up at various points to communicate throughout his many studios and the house. We put our shoes on, slid open the door and made our way up to the house, where the shoes came off again. I must get some without laces, I thought, and we stepped inside.

We sat down in silence, at first I didn't know what for. I hadn't understood what was said on the intercom and I simply followed what the others were doing as they beckoned me to come with them. Ken disappeared for a moment, rummaging in a box, and brought out a beautiful cup, a *yunomi*, a teacup made for daily use.

This one was wood fired and is a prime example of a quality called *yohen*, the translation of which is 'changed by the fire', referring to the golden effect that shrouded part of the pot caused by a sustained and strong reduction during the firing. *Yohen* can also refer to pots placed in the front section of the kiln. Here, as the wood is piled in, the ash builds up in thick layers as the temperature gradually rises and more wood is burnt. Once the internal temperature is hot enough the ash itself begins to melt and stick to the pots, leaving dramatic fiery marks as it bathes them in glaze created from cinders, in combination with the glazes and slips already present on the pots.

The *yunomi* Ken was holding was stoneware, gold in places and spotted with tiny pinholes pricked through the thickly applied slip; these aren't defects in the eyes of Japanese potters and are favoured by tea

The Yohen Shino *yunomi* I drank my green tea
from each day, clasped between my hands,
the cup providing much-needed warmth.
An object precious beyond comprehension,
one I hope to spend the rest of my life with.

Despite the cold, all I needed was a sunny spot
to sit in for lunch, whereas Kombu was always
on the lookout for the warmth of a human.

masters. There were faint echos of white brushwork beneath the black and gold and inside the vessel the base shimmered, like when you look into a deep well full of coins that catch the light. These metallic dots sparkle as the tea is poured in, causing the liquid to constantly flicker and glint. 'You will use this cup,' he said, as he placed it in my hands.

Thereafter, every single day at teatime, Ken's wife Yoko would place the designated *yunomi* and Doi would fill it with tea. Doi had his own specific cup too. The form of my *yunomi* also happened to be the one I'd spend months making – I would throw hundreds and hundreds of them with several types of clay.

I HAD VIRTUALLY no social life. In fact, perhaps my most sociable, intimate moment each day was when Kombu, Ken's small black cat, came and napped on my belly in the sun, opening and closing her sleepy eyes as she stared at my boiled egg, yet to be taken out of its shell.

Every day throughout autumn and winter, until it got so desperately cold that being outside was essentially impossible, I'd eat my lunch on the wooden steps that led up to the packaging room. The wooden porch was always sunlit and there I'd bathe in the rays as I ate, wolfing down my sandwich made with slices of bread that were far too thick. By no means was it warm outside but as long as I stayed in the sun it was acceptable, plus I could connect to the house's wireless network from there.

Our approximate routine went like this. Work began at 8 a.m. sharp, and we laboured solidly until midday. Lunch lasted an hour, then we continued. Most days, but not every day, we'd stop in the afternoon for a brief tea break, either up in the house or in the studio if we were busy. The intercom would sound, Doi would hurry out and then return with a laden platter. Each day the tea was brewed in a different teapot, some stained from years of use and chipped and even more beautiful for being so. The vegetal smell of green tea followed him into the workshop as he carried the red-and-black

lacquer tray in, on which was also a little decorative bowl that contained an assortment of treats.

At 5.30 p.m. we stopped for our supper. I always knew when it was nearing that time as at five o'clock a chime rang out across Mashiko from giant speakers on the town hall. It was an eerie tune that echoed throughout the trees and over the hills, mainly to alert the children that it was time to go home, but historically it also informed those toiling in the paddy fields that their shift was over. These songs change from place to place, the exact timing too, but it was a constant.

I'd cycle home, hastily put together something to eat, or just purchase discounted sushi, as became the norm, then at 7.30 p.m. I'd cycle back to the pottery and we'd work again until late in the evening. We did this six days a week, with Sunday off to recuperate. On this day I'd wash my clothes, my hair, I'd do a sizeable food shop and then I'd routinely, helplessly, crash. Sometimes I'd explore Mashiko in the afternoon, after I'd done my housekeeping. I'd visit all the pottery and tool shops before stopping off for my Sunday ritual of cake or *mochi* from a shop just next to my apartment, and after a while all of this started to feel very normal. I'd found a new routine.

AFTER A WEEK of sweeping all morning and wrapping all day and long into the night, the first proper task was given to me – I was to grind the bases of pots.

This is a task that occasionally needs to be done to vessels that are wood fired, salt fired or soda fired. Some of Ken's green Oribe pots that are gas fired need it too, as, when thickly applied, glazes can run down the pots like ice cream melting in the sun. If the glaze runs beyond the pot's base it floods onto the kiln shelf, and once cooled this fluid glaze sets, welding the vessel in place.

If a pot does stick firmly it can be difficult to remove it without causing damage, so you can use tiny props, waddings, to raise the pot up from the shelf, which creates a layer of protection. For more defence you can brush a layer of coarse alumina hydrate and kaolin

onto the kiln shelves, mixed half and half. You'll find dozens of other recipes for this substance; I've seen some that contain flour, woodchips and even rat poison – I've heard of waddings being eaten off pots awaiting their turn in the kiln.

Ken's mixture is patted into three-pronged moulds, setters, which more or less do the same job as waddings but are more flexible and are potentially reusable too, as long as they don't become too encrusted with glaze. In one way it's the kiln shelves we are trying to protect as opposed to the pots, as they are expensive pieces of kit, especially the wafer-thin silicon carbide ones Ken had dozens of. Nonetheless, even with these precautions, the pots raised up on waddings or setters, like houses on stilts to protect them from flooding, can, and regularly do, still stick. The glaze on the underside can be superbly sharp once plucked away from the kiln shelf. It's as keen as a razor's edge and the waddings need to be ground away and the pot bottoms polished smooth.

Thankfully, grinding is one skill I had mastered. Soda firing makes you accustomed to this process and I must have cleaned the bottoms of thousands of pots during my apprenticeship with Lisa. So grinding the bases of hundreds of Oribe green plates wasn't necessarily difficult, but it was almost implausibly labour intensive, as you cannot take your eye off the task at hand for even a second without potentially damaging the pot or injuring yourself. I sat on a chair outside, rotary tool grasped tightly in my hand, or using the angle grinder tied with plastic straps to a crate, a death-trap, concentrating for hours at a time. The area around me was covered in a layer of fine dust, microscopic shards of glass from both the polished Oribe glaze and the remnants of the waddings themselves. When I finally got home my hands felt like they didn't even belong to me, disconnected, shaken to the core and aching after eight hours of clenching a quivering rotary grinder as firmly as I could – I did this for days and nights straight.

My knuckles were cracked and covered in powdered glass dust that dug into my pores, and

I spent long evenings patting clay setters into these moulds, carefully prying them out with a sticky ball of clay, and piling them up to dry. Despite careful grinding, it's near-impossible to get rid of the setters' imprint entirely – best to embrace them as marks of the process, notches in the glaze.

even after washing them multiple times the stubborn embedded particles remained. It would gather in my beard and hair, although the area my masks concealed – I was wearing two – remained unsullied, leaving my beard white all over save a circular patch of blond tufts around my mouth and nose. I kept going, filling green crates with the polished plates until I could hardly focus any more and then, finally, a new task was on the horizon. Doi stepped out of the workshop at five o'clock. The sun had set and shadows filled the courtyard, my fingertips now twitching in the cold. They must have been sick of hearing my drill bit skittering for days now.

'Go home! Tomorrow – clay,' he said, pointing off into the distance. 'What time should I come back tonight?' I asked, expecting the usual evening shift. 'No tonight, tomorrow!' I had the night off? For the first time in almost two weeks? I was ecstatic and rushed home to actually cook a dinner of my own rather than indulging in discounted blocks of rice and fish. Was Doi's English improving too?

WE WENT ON our first outing on a crisp autumnal morning, after Doi and I had completed a very rapid sweeping and cremating of all the newly fallen leaves. Together we loaded the back of the comically tiny white Kei pickup truck, throwing in two rusted wheelbarrows and shovels before hopping in. Inside, Doi and I were knee to knee. He switched the heating on to the highest setting, blasting cold air out onto our faces until it eventually starting sputtering out warm air. Somehow, Doi was still only wearing a buttoned-up shirt, and he wouldn't end up changing his uniform until it practically snowed. Once the cabin was warmed up, we set off. It wasn't freezing yet; the weather was certainly wintery but I can't remember any autumn that was as bright – long shadows and golden rays make up many of my memories from this time.

The land around Mashiko is rich with clay. As a town it has been producing wares specific to the region, Mashiko-yaki, Mashiko ware, since at least 1853, when Ōtsuka Keizaburō constructed the first kiln 279

during the Edo period. Ancient pots and figurines from the Jōmon period have also been found in Mashiko that date back some 16,000 years. *Jōmon* means 'rope-patterned' – these pots from bygone times were often decorated with pieces of coarse twine that were pressed and rolled into the pots, leaving highly repetitive markings that encircle and spiral around the vessels. It was a technique used by Ken Matsuzaki's teacher, Tatsuzō Shimaoka.

We soon arrived at a dilapidated locked gate in the hills outside Mashiko. From what I could gather it was an old clay mine and industrial pottery. Doi pointed at the ground, where the earth had begun to turn white, flecked with yellow, and said plainly, 'Clay!'

We were greeted by an acquaintance of Doi's, who let us pass and we drove the truck as far up the lane as possible. We came to a halt by a thicket, surrounded by deep puddles of white slip, the slurry created when clay becomes saturated with water. Amongst the brilliant white puddles on the ground were flecks of bright ochre, both imbedded into the white and dusted over it, like icing sugar. It's this that we'd come for. We wheeled our barrows through spiky shrubs and through pools of murky yellow and eventually we came to a steep hillside that was dug away in places. The terrain felt alien, as if we had stepped onto another planet. To our left was a dense bamboo forest. This was the first time I had seen one, and I wandered over to it. They're eerie; all you can see is green lengths fading into black, and the long nodules and blades lean out, as if it's a room crowded with far too many people.

Doi's friend shouted something at me as I got close to the surging shoots. He gestured for me to come back and Doi said something along the lines of, 'Don't go, boar!' He wasn't wrong. There was the loud sound of rattling as lengths of bamboo clattered and the undergrowth rustled in front of me. Suddenly I could hear them whining and grunting just metres away, hidden amongst the green and in the ditch that ran alongside the bamboo. I stomped back as Doi gestured first at the ground and then at the wheelbarrows. We began shovelling.

Chimneys on the kiln shed, poking out through walls and roof.

281

The earth didn't dig up too easily at first; much of the clay was intertwined with roots so we had to delve down deep before it started to cleave away in larger clumps. I caught the strong scent of metal and damp earth as we dug. Whilst we worked our friend continually lobbed stones into the forest in the direction of the boar. We could still hear them as we excavated and I felt as if the others were slightly on edge – I know I was.

Soon our wheelbarrows were brimming with clay, like open chests full of plundered yellow gold. This was a white stoneware clay, filled with impurities and large fragments of yellow iron ochre. We returned to the truck, our laden barrows' wheels now sinking into the ground, deep into the soft white slip, and began to heap the cracked dry earth into the rear of the pickup. We repeated this process five or six times until the back was weighed down and thankfully, as we toiled, our guide stood guard the entire time, sending a barrage of rocks into the bamboo, the stones striking the wood, bouncing and ricocheting off a dozen branches before falling to the ground with a thud.

In a short time the truck was full. We said our goodbyes, the man disappeared back through the bushes and we drove home. Whenever Doi and I went out on an excursion, at some point he'd stop off at a vending machine along the road. You can find them in the middle of nowhere, such as this one that was surrounded by steep banks of towering bamboo on three sides. He reached into a pocket and pulled out a few coins and asked what I'd like, or at least gestured at the machine and implied so. I opted for black coffee; Doi always chose sweet tea. We climbed back into the cramped truck, my puffy yellow worker's jacket practically swallowing the entire compartment. I expected Doi to insert his key and head back to the pottery immediately but instead we sat there, in unbroken silence for half an hour, sipping and warming up.

On our return, Doi showed me where a pile of wooden fence panels lived, and whilst he backed the truck up to the kiln bay I placed the panels flat on the ground in a long row, where he'd indicated. We shovelled

out the white and yellow clay onto these and spread it out evenly, so that none of the pieces were crowded together closely. We needed it dry to the core before the process of refining it could begin. It was forecast to rain that night so as we left for the evening, we slung tarpaulins over the clay – during the following days we'd uncover it whenever the sun shone.

This had been the easiest clay-gathering expedition I'd ever been on. In the past when I'd scavenged for clay it had always been a bit hit or miss, the clay riddled with too much mud and other impurities, or it was all earthenware, which meant it wouldn't fire up to the temperatures I like without turning into a puddle of glass on the floor of the kiln. (London clay, whilst good for making bricks with, is predominantly earthenware, and in the few instances during my time at Maze Hill Pottery that we sourced some, or were given some, we only ever used it as a thick slip to brush onto the outside of pots, with typically unsatisfactory results.) Ken inspected the clay with us, crumbling it in his hands. It had been drying for a week and now the yellow iron ochre was accompanied by fallen red and orange leaves.

'Now we crush,' he said, as he waved at a machine I hadn't taken a good look at yet. It was essentially a giant mechanical pestle and mortar. An immense granite basin sat below a machine-driven arm with a solid pummel on one end, which was hoisted up and allowed to crash back down. It was loud and rhythmic; a pulsating metallic sound rang out as it sprang to life, followed by a boom as the pestle fell, crashing against the stone, the impact echoing throughout the area and shaking the ground.

Manning this machine was to be my task for the following week, refining chunks of clay to pulverized dust, with a stern word from Ken never to allow the pestle to directly strike the granite mortar, as it could fracture. I immediately got started, climbing up onto a crate and coaxing the craggy lumps beneath the path of the hammer, shattering it as I started the process of reversing millions of years of geological time. I'd be turning 283

Our dug spoils, powdery clumps of clay that were checked each day, turned, kept dry and finally pulverized into a coarse dust. Some batches were more golden than others, but eventually it would all amalgamate, once blended through the pug mill.

decomposed rocks into powder, which would eventually be fired into a solid, stone-like state again.

I'd fill up a wheelbarrow's worth of the clay we'd dug, picking out any leaves, twigs or bugs that had made their home in it over the previous week. I heaved the clay up steps to the crusher that was beneath the kiln bay. All of the kilns were covered by one extensive ornate tiled roof that travelled up the hill at one end. Much of the ascending section covered a three-chambered brick *noborigama*, which translates to 'climbing kiln'. These are commonplace here, built either on the hillside or even partly into it, at an angle, which helps the flames to be drawn through it. The machine lay sandwiched between piles of kiln furniture, pots that had split open during the firing and other heaps of organized junk.

I shovelled the chunks of crumbling clay into the mortar and switched it on. As it pounded away, I'd carefully use a stick to nudge the larger lumps into the middle, directly beneath the fall of the hammer, the fine powder gradually curling up around the sides of the mortar like a wave about to crash back down. One wheelbarrow's worth took maybe ten to fifteen minutes to crush properly and I had many, *many* to do in total. Then I would scoop up the processed powder and place it into another wheelbarrow before carting it over to a gigantic screen sieve, where the powder was rolled backward and forward and shaken violently over the mesh until all that was left were shards of bark and a multitude of tiny pebbles. Under the sieve was a metal hopper that directed the crushed clay straight into sacks I'd carefully position beneath. Once the sacks were stuffed full of powdered clay, I'd seal them and heap them together under the kiln bay's roof.

It was a loud and dusty process so I wore a mask and gloves, too, in the bitterly cold mornings, and a pair of headphones. These were my saving grace, as not only did they muffle the sound of the machine, which clanked and jittered noisily as the metal arm components span and the engine whined, but once again they gave me music and stories to help pass the time.

For generations potters haven't typically inhabited cities, and perhaps for the first time I really felt like I understood why that was. Not fifteen minutes away from Ken's pottery is a source of usable, high-firing stoneware clay, which he can dig up freely to process and use for his pots. There's a synergy here that I adore and it's something which I regularly find myself thinking about. Being able to find functional clay that's sourced so locally to where you live adds something else to your pots, a narrative beyond just the creation of the vessels by your own hands. Ken's using the same clay that craftspeople have used for sixteen thousand years or more, instead of just purchasing sacks of raw materials that are shipped to your doorstep from another part of the world. It's right there, in the ground, and he can dig it up and use it. I really wish I could do the same thing in London – I think ultimately that'll be what pushes me out.

The following week was spent processing all of this finely powdered clay into usable material, soft and ready to be thrown with. We hauled the sacks of crushed and sieved clay onto a lopsided cart with punctured wheels and trundled it into the workshop, which I had only spent a few moments in thus far. The studio isn't vast but it is cosy, a space perfectly suited for one industrious potter and their apprentice. Two wheels are set into a raised wooden platform suspended above the floor. The heads of these wheels are level with the surrounding stage and the motors and chassis of the wheels are dropped below it, in gaps specially cut out that can be covered with a wooden panel when they aren't needed, hiding them away.

When you are throwing on these wheels, you don't have a chair or a stool to sit on; rather, Ken sits on a pillow placed directly on the decking. On the left-hand side as you enter the workshop are the two wheels next to one another, one powered by electricity, the other powered by rhythmically kicking a large wooden flywheel in order to keep it turning: this is a traditional momentum kick-wheel.

In the right-hand corner is another standalone
kick-wheel, which is the one that I'd eventually

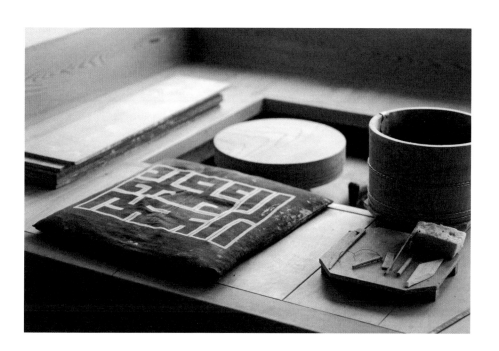

Ken's spot. It felt like a shrine, and each day Doi would
clean and lay out the tools, plump the pillow and fill up
the hinoki bucket with some warm water to throw with.

spend hundreds of hours learning to use – it was my new ride, although I didn't know this yet.

Purposely, there was nothing in the middle of the studio. This way a diverse range of tasks could be performed there, just by swapping equipment in and out depending on what you were doing. The floor itself was made up of rows of stone blocks, sandwiched together with courses of black brick. On two walls stood floor-to-ceiling bamboo stillages, stacked full of ware boards lined with pots, which smoothly rolled over the round beams of bamboo as opposed to the square batons I'd used in stillages back home. As I walked in and looked up there were also stillages overhead, hung from the ceiling, again, chock-full of pots.

It's a scary moment when you're inside working and suddenly the earth starts to tremble beneath your feet and all the ceramics in the room begin shaking too. It happened a number of times, small earthquakes only, but Ken and Doi didn't blink an eye, even with all the pottery rattling and clinking together above them, tens of thousands of pounds' worth. Were they just that used to it? I would sweat, my heart's pace quickening, but somehow they sat very calm and collected, neither of them lifting their heads up from their work.

We trundled the clay inside and filled two jumbo plastic paddling pools with the powder, with the addition of some sand to the mix to give texture to the clay. Then, in dozens of trips, we gradually saturated the powder with water and mixed it roughly until it had the texture of poorly incorporated bread dough. This was scooped out and hurled into the mixing chamber of the pug mill. The clay logs that were extruded initially were rough, torn and practically fell apart in our hands. Each was about a foot and a half long and we stacked them up in a pyramid that grew ever higher. After all the clay had been run through the machine once, we whirled it through again and again. Each time it become smoother and less crumbly and slowly it started to resemble proper, usable clay, the

particles knitting together and becoming smooth.

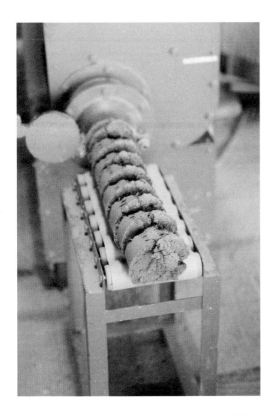

The clay would crumble in your hands at this stage, yet after being run through the machine a dozen times it knitted together and the logs became uniform.

Doi and I continued working long into the night, both of us becoming bleary-eyed, our limbs moving slowly and yawns echoing between us. The pug mill wasn't great at squeezing through every last inch of clay so we'd take turns, one person loading the machine up with hunks of partly processed clay and then slicing away the newly pugged logs to place atop the ever-growing pile. The other person would use a stick to push the reluctant clay into the rotating blades so it snagged and was dragged through, pushing it out the nozzle. It's a dangerous task if you become distracted, or drowsy, as if the stick gets caught on one of the powerful spinning blades it could quickly get pulled in and crunched to splinters.

Doi was poking at the squelching earth being sliced up with a stick, forcing it into the blades, and I saw him dozing off in the same instant, his hand following the stick into the mouth of the machine and into those grinding teeth. I quickly pulled his arm upward. He blinked in shock; no words came out but he continued to blink his eyes very purposefully in order to wake himself up. We swapped jobs after that.

I WAS SUMMONED to the pottery studio for the next challenge. Ken handed me a few objects – some bamboo, a devilishly sharp knife, a hand-drill, a wad of sandpaper and a mixture of short wooden slats. He then gave me three tools. A *tombo*, which translates as 'dragonfly', is a bamboo tool that is essentially a crucifix on a stick. The vertical stick measures the internal depth of a pot and the horizontal strip of bamboo dictates the width. This is lowered into thrown forms and when the clay matches both depth and width, it ensures that each pot is the right size. Next was a longer wooden tool, a *gyubera,* meaning 'cow's tongue'. This looked like a long, flat wooden spoon but with a very specific curve sanded into the spoon section, it's lowered into the base of the *yunomi* as it spins and it's pushed into the bottom of the cup. At the same time, from the outside of the partly formed *yunomi*, fingers are pressed against where this tool rests on the

290

inside, which causes the shape to transfer perfectly onto the interior form of the tea cup. Lastly, there was a rectangular wooden rib with one sharpened end – simple, thankfully. 'Make your own, then come back inside.'

I couldn't begin learning how to throw *yunomi* until I'd crafted my own tools, an ethos that has followed me since my years at school. My imitations weren't bad; potters often make their own tools and I'd had years of experience whittling and constructing all manner of other implements to aid the making of my own pots. I went back inside and showed the finished items to Ken. He pondered over them. The *tombo* passed, surprisingly, as did the rib, but the curve of the throwing stick wasn't quite right. He pulled out an even sharper blade sheathed in bamboo and expertly corrected the profile. 'Now, you are ready,' he said.

UP UNTIL THIS I'd only ever used an electric wheel, one that spins more quickly the harder you press down on the pedal. A kick-wheel was something new. I know how to throw pots, but now I'd have to learn an entirely new way of operating the machine itself. The kick-wheel consisted of a relatively narrow, small wooden momentum wheel at the bottom, which is the section that's kicked in order to spin it. This was unlike other kick-wheels I've seen that have an expansive, very heavy, concrete flywheel below – one you can kick and really build up a lot of momentum with. Comparatively, the wheel I was going to use was light and didn't hold its momentum for very long, which meant that when centring the clay and pulling up the walls of the vessel initially, the flywheel needed to be kicked an awful lot to keep it spinning: the friction imparted by your hands to centre a large mass of clay slowed it down in a matter of seconds. It's hard work, but as with any physical task your body adjusts.

The bottom of the kick-wheel is attached to the top section via a column of four struts of wood around a central metal beam, all of which is then wrapped up and hidden by thick twine. The wheel head itself, the part pots are thrown on, is a thick slab of wood 291

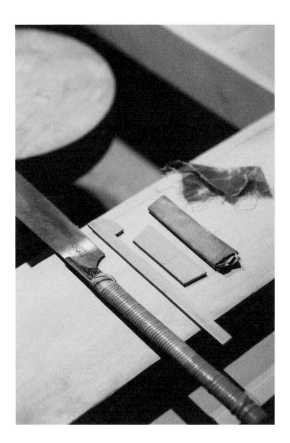

Before learning to throw on Ken's kick-wheel, I first had to craft my own tools. It felt like a ritual. This was a minimal set, compared to what I was used to throwing with back home. Many were the same but different, bamboo instead of metal, string instead of wire.

sawn into a circle. It's raised higher than usual, which keeps you from leaning forward and hunching over excessively, something my back would thank me for later.

The kick-wheel had a raised wooden structure built around it on three sides, almost like decking. You walk in from the front, skirt around the wheel, and sit down on a plump, dusty pillow placed on the framework. From here you can easily position your tools and your bucket of water, and your ware boards can slide easily on and off either side of you.

Ken sat down at this wheel set aside from the others as Doi prepared a large block of yellow-tinged Shigaraki stoneware clay. He spiral wedged the lump, which seemed encrusted with sand, grog, rocks and flecks of something I couldn't quite figure out. He handed the beautifully spiralled clay to Ken who slammed it onto the wooden wheel head, perfectly in the centre. He patted it in place, sealed the bottom of the hump to the wheel with a wet finger run against where the two components meet, like caulking between a bathtub and a tiled wall, then he began to show me how to make a *yunomi*.

The hump of clay is quickly centred, then the top portion is segmented off and thrown into a cup. Once it is sliced away and carefully lifted to one side, more clay beneath is coned up, another segment portioned off within your hands and another cup thrown. Ken demonstrated the process from start to finish perhaps three times, his hands moving articulately.

The whole block of clay is roughly centred first, so that the spinning hump doesn't have any excessive inertia that could draw the pot atop the mass off-centre as it's thrown. A portion of clay is clasped between the hands, and Ken made it clear that you should remember the position of your grip every time you do this, so it can be replicated for each cup and a specified weight of clay used each time.

This top portion is centred properly and thereafter it's thrown like any normal pot would be. He plunged his thumbs into the middle of the centred lump to open it up and form the base; next the walls were shaped 293

until it matched the dimensions set by the *tombo* tool I'd just made. Once the rough shape is more or less right the finishing procedure can begin. The throwing stick I'd made, with its particular curve, is lowered into the vessel to finish the interior form. On the outside Ken's fingers pushed against the wooden tool so that the curve transferred perfectly. I can't overstate how important this was to get right, and, in the days following, and after hundreds of cups had been thrown, Ken would destroy any that weren't up to par – in most cases it was because I hadn't thrown this interior curve correctly. 'Only those four – you can destroy the rest.'

Once the inside of the pot was formed Ken collared in underneath the vessel to create an area where the foot-ring could be trimmed. Essentially this was a thick disc of solid clay beneath each pot; the extra material here also creates a point to easily lift the vessel away from. The outer walls were scraped clean of excess slip and the rim was bevelled outward to an edge before being smoothed over with a long chamois leather, softening it into an ergonomic shape that nestles into the corners of your mouth. To remove the finished pot a string is slung around the base and wrapped around it, whilst the wheel is stationary. Then the wheel is spun, which causes the thread to tighten like a noose and slice through the clay, separating it from the hump in a clean horizontal cut. It could then be delicately plucked away and set aside.

My core skills were there but they had to adapt, and they did, as did my right leg which quickly, and painfully, became accustomed to kicking a spinning wooden-top for hours each day. This was the most fundamental difference. An electric wheel is constant; it spins without having any real impact on the vessel at hand, unless you change speed very drastically very suddenly. Whereas with a kick-wheel the speed fluctuates constantly, and you must throw according to it. When you kick the wheel it jars the whole structure for a second, the spinning wooden contraption and the clay move, so you must hold the piece in a way that braces it for that moment of impact.

And when kicking the flywheel to do this job you engage your whole body. You balance as one legs kicks out, your core engages and you need to hold yourself steady. It's hard. You have to focus with your entire body, not only with your hands and arms.

I went from completing an array of menial tasks to throwing on the kick-wheel for ten to twelve hours a day, for two weeks continually. My right leg ached relentlessly most days, but my *yunomi* got better and I learnt to throw faster. I also learnt what those unrecognizable chunks in the clay were after a few sliced and jammed into my hands – to my surprise they were shards of bark, chips that later burnt away when the pots were fired, leaving little cavities the glazes pooled into.

I was throwing the base forms that Ken would later facet and trim the feet on, and after a week or so he decided my pots were good enough for his own production, cups that would bear his maker's mark. 'You're natural,' he said, smiling, 'you understand the rhythm!' He handled the cups and felt the cross-sections between two fingers. I've *never* been more elated.

As the days flew by I'd be given different clays to throw with. Some were lovely, smooth as butter and threw to my exacting command. Others were horrible and 'short', which is what potters call clay that lacks strength and simply cracks and splits as it's worked. The walls of these *yunomi* would fracture as I stretched them out and Ken and Doi spent more time than they would have liked backfilling these indentations. I also finally used the stuff Doi and I had collected from the mountainside and painstakingly processed into a usable clay. It wasn't the closing of a circle yet – these pieces still had to be glazed and fired – but it felt marvellous creating pots from clay that I'd dug, processed, pugged and bagged up myself.

One icy evening, after I'd cycled up the hill and was warming my hands by the log fire inside, Ken kindly let me throw ten cups to keep for myself. I could even trim their foot-rings too, which would be another entirely new skill to learn on the kick-wheel. We sat with

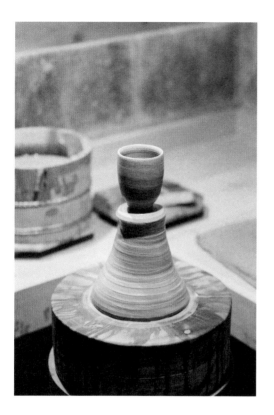

Two shots of the same spot, the kick-wheel I learnt to use and a hump of clay, all of which would eventually be used up and thrown into tea cups atop the mass. Once exhausted, all the freshly thrown *yunomi* would be transferred to the stillages, to turn leather hard before Ken finished them.

the leather-hard pots in front of us, walls thin but with deliberately thick bases from which to turn an elegant foot, like revealing a defined sculpture from a block of marble. Ken demonstrated how he did it, saying how it looked like the node between two internodes on a shoot of bamboo. Then he told me to give it a try and shuffled off in his destroyed shoes, the backs bent inward, crushed against the sole, a pair of trainers turned into slippers. He left Doi and me in the workshop and slid the paper door closed. He'd do this quite regularly. I'm sure Doi knew what was happening but he'd often come and go as he pleased, leaving us to get stuck in the tasks at hand.

My cup's foot-rings held the pots up but they lacked the elegance Ken's had; the proportionality wasn't quite right and the surface of the clay felt overworked compared to the thrown walls above it. This particular clay was relatively short, which meant it left the surface with an almost rippled quality, as spiralled fractures resonate from a central point. The clay is meant to do this; it's a quality exploited purposefully and Ken had total control over a surface that wants to be pulled apart as it's trimmed. He knew when to stop fiddling and fussing over the clay, whereas I carried on. I didn't like them at the time but Ken insisted I bisque fire them, just in case, and thank goodness he did as eventually I would end up accidentally smashing a board of my own work and these cups filled the void created. To my surprise they fired gloriously. I've kept a few and they remain very precious to me.

THE WEATHER BECAME colder and colder, yet the golden light remained, warming my skin when I was outside sweeping up leaves. Ken was preparing for his fortieth anniversary exhibition at Keio department store in Tokyo. In Japan, potters and other craftspeople often exhibit in department stores, many floors up above the bustling streets – these are honourable places in which to show. The work is often displayed on felted surfaces, in long rows and clusters, in carpeted rooms, as if somebody had taken a boardroom in a corporate office and decided 297

that it was now a gallery space. Each pot is displayed alongside a little slip of paper, slid into a clear plastic display case, that has the name of the object written on it and the price, too. These exhibitions felt like shop displays, and perhaps that's more what they're akin too – or perhaps it's just my trained perspective. Gallery spaces back home and in Europe tend to be clean and white, with the pots shown sparingly, whereas this space Ken was to fill had no windows and only long fluorescent lights blinking from the ceiling. During my months in Japan, we saw a few shows just like it by potters of quite extraordinary fame, and even an exhibition of Dejima's too, Ken's apprentice of old – yet I couldn't get the image out of my head of showing my pots in a sparse side-room in Brent Cross.

We spent long nights in the packing room above the pottery studio filling hundreds of *tomobako* with pots. These were gifts to be given to each person invited to the opening night – a small *guinomi*, a sake cup, every cup in its own special wooden box that was signed and wrapped in beautiful traditional *washi* paper. These cups were soaked in giant vats of tea in the workshop, propped up on the scalding log burner. We piled them in, making sure they were submerged under the liquid and tea leaves, and left them to stew. Slowly their surfaces became slightly brown, and almost pink in places – I'd never seen this done before. Once they were deemed sufficiently stained, we'd thoroughly wash them, scrubbing any scum off and setting them aside to dry. They smelt sublime and looked it too. Each was carefully thrown and had a small, delicately trimmed foot, swathed in a flesh-coloured glaze with white flowing strokes radiating out like petals.

Doi and I loaded everything into Ken's car, all the pots safe in their perfectly sized wooden boxes, and drove to Tokyo. I was there to keep him company, and carry boxes, I suppose. Ken didn't always come with us, or sometimes we'd meet him there. We talked through the apps on our phones and we stopped at service stations to eat hot meals together. The journeys were long – several hours there, several back, and more if the traffic was

bad, which it normally was. These days were exciting in one way at least as, after dropping off the goods, we'd make our way to galleries throughout Tokyo and I'd gape in awe at the pots in glass cases held down with fine fishing line to stop them toppling over during earthquakes. London felt minuscule in comparison, or at least simple. Here there are a few bridges and tunnels, but in Tokyo there are roads above roads above roads, with a tunnel underneath and a winding walkway snaking its way through all of that. I felt tiny and lost, but Doi knew his way around.

The weekend came and finally, after all the pots were positioned and the names and prices were pinned by each, a battalion of white-haired, elderly ladies came in. They were armed with flowers and branches, water lilies and bows of foliage. They had tools too, those for clasping branches in certain ways and for snipping them to length, and watering cans with long spouts like an anteater's tongue. They were here to practise *ikebana*, the ancient Japanese craft of flower arranging. They split up to tackle the smaller arrangements, positioning plants so that they sprang up and out of the vessels with as much vigour and character as the pots had. Then, when it came to the larger pieces, they'd come altogether and take turns positioning and repositioning the flowers. They'd all stand back and point at the parts that worked and those that needed altering, deliberating on how to make the flowers and vessels work in harmony. It's one thing to stuff a bunch of flowers in a vase, but to create beautiful assemblages of blossom which move in dramatic ways that are obviously artificial, but seem as if they're still in a meadow of wild flowers – frozen in time yet somehow catching the wind – is truly an art form.

Suited figures filled the gallery and a little, pristinely wrapped box containing a tea-soaked *guinomi* was gracefully handed to each person as they left for the banquet hall on the same floor. I had asked Ken what I should do throughout the evening. He instructed me to talk to any foreigners and take photographs. There were no foreigners, so I skulked at the back and snapped

away at Ken, the crowd and the pots. There were speeches, culminating with one by Ken, after which everyone rushed to fill their plates with steaming hot food. I tagged on to the end of the line and made up a plate of cold tempura and looked for somewhere to sit, but all the tables were packed and roaring with loud conversations that I did not understand, accompanied by the chinking of tiny, adorable glasses of beer. I wandered over to the window and gazed out as I ate with the room reverberating behind me. The room was heaving, the city a gyrating sprawl of lights and noise, and I felt quite alone.

As the exhibition continued for the next couple of weeks we'd spend the odd day back in the city. Either we'd all be present at the show or the three of us would venture out to galleries or to see sights – including the unmissable Mingeikan, a museum, or temple really, for the *mingei* movement, for Japanese folk crafts. The beautifully crafted wooden building is surrounded by modern houses and pronged metal fences and it feels tremendously out of place, but inside it's a marvel. The wooden floors gleam from slipper-clad feet shuffling over them. There are cabinets of pottery, lacquerware and textiles, with silky hanging kimonos and wicker baskets enveloping perfect, imagined shapes. Ken showed us around and pointed to pots he knew and liked. That evening we met up with Dejima and the four of us, Ken, Dejima, Doi and I, all went for ramen. We sat and drank together and life felt normal. The language barrier was broken as both Ken and Dejima spoke and joked in half-broken English, and for the first time in a long time I didn't miss home.

THE MORNING LEAF sweeping ritual was more demanding now as the leaves starting sticking to the frozen ground, tiny pillars of ice protruding through them: *shimobashira*, frost-needles, as Doi blurted out early one morning as they shattered satisfyingly while we swept over them. Kombu must have enjoyed this sensation too, as she trod gingerly through the frost, staring down at her paws. And Doi finally put a jumper on.

My daily task of making *yunomi* teacups came to an abrupt end when Doi waved, ushering me over to the pottery, where Ken was waiting. 'Today, you make plates,' he said, almost theatrically.

Plates aren't a form I've thrown many of in my life as a potter, which might sound counterintuitive considering it's one of the shapes you'd think a potter might throw thousands of. I had made them in Thomastown, but it was only ever in week-long projects or in very small batches. The thing with plates is that they eat up an extraordinary amount of space in the kiln. To fire lots of them you need plenty of kiln furniture, shelves primarily, which isn't cheap. In the same space you can fire six to eight dinner plates you can fit thirty mugs. Therefore, they become rather costly objects to create en masse, as you need to fire the kiln many times or purchase a *very* large kiln. Even whilst I was Lisa's apprentice, we only ever made a handful of them.

Unlike with mugs or bowls – objects my hands can create almost purely on muscle memory alone – I need to think when I'm throwing plates. For Ken's production I wouldn't be creating them in any conventional way either, as I was only allowed to use the kick-wheel when producing pots for him. He said that apprentices should learn using a kick-wheel before starting to use an electric one. The plates I was to make would be about eighteen centimetres across, with a flat bottom and a thick rim that protruded at an angle about six centimetres into the air.

These moments always felt like I'd passed some unknown threshold and was ready to take the next step in my training. This wasn't just a matter of throwing a dish from one single lump of clay. Instead it was a multi-stage process, as trying to throw a plate conventionally using a kick-wheel quickly leads to problems. A lot of pressure and force is needed to squash a thick lump of clay down into a disc. With an electric wheel this is easy, as it spins constantly as you push the clay into shape. But with a physically spun wheel, the process of pressing the clay down causes the momentum of the wheel to

swiftly diminish – it would be infuriating to even attempt it – which means that another method is utilized.

The first step is to create a bed of clay on the wheel, onto which throwing batts – the small, wooden platforms pots are thrown on – can be attached. They can be lifted away without having to touch the plate itself. This is useful, as trying to lift a soft, freshly thrown plate off the wheel with just your hands is something I've only seen a few *very* talented potters do successfully.

To one side of the wheel lie many long coils of clay stacked in a neat pyramid, next to which is a rough circular block about thirty centimetres tall that is sliced copious times from top to bottom into discs, each about one and half centimetres thick. Think of a stack of pancakes.

You begin by laying out one of these discs onto a wetted throwing batt. This is our tray on which the plate will be thrown. You measure the diameter with a wide *tombo*, our dragonfly measuring device. A potter's needle is held in place, then the wheel is spun, scoring a line that becomes a perfect circle. This means you don't have to prepare the clay for this section initially in a very accurate way, as attempting to make a faultless cylindrical block of soft clay is very time-consuming and unnecessary. Instead, Doi just roughly hammered out a large mass, which just needed to be a touch wider than actually required. The excess clay beyond the circle is then removed and the outer circumference of the circle is scored with a serrated kidney, before slip is daubed thickly over it.

One of the clay coils is then snaked around and attached to the outside, around the edge, so that it encircles the disc. It's firmly pushed down and blended into the base section, and finally this coil is thrown into what becomes the thick outer rim. This section is angled outward and then the whole vessel is tidied up, a wire is immediately slid beneath the plate to separate it from the wooden throwing batt and then the batt, along with the in-situ plate, undisturbed, is lifted away and set aside to firm up slowly to leather hard.

Then another batt is placed onto the bed of clay and another plate is made.

I enjoyed learning to make these plates even more than the cups. Despite being more complex in many ways, they were easier to create, or perhaps Ken just didn't need them to be as exact as the *yunomi*.

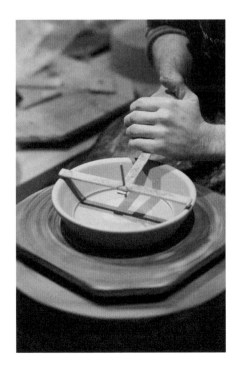

That might sound complicated, but it isn't. Although it combines both throwing and hand-building techniques, it's a fast, seamless process and Ken was surprised by how quickly the technique clicked with me, as was I, which meant that I ended up throwing hundreds of plates over the coming weeks.

> Lay down the base,
> encircle the coil,
> throw the flange,
> form the lip,
> scrape away slip,
> glide a wire beneath.

Although they are by no means finished at this point: the outer flange is left purposely thick, as once leather hard it is faceted with a sharp metal gouge. This part was difficult and I had flashbacks to the ranks of creamers I had cut holes into with a spokeshave at Maze Hill Pottery. This time, thankfully, it came more easily. The grooves cut were straight, one after another, all the way around the rim. It almost resembled a pie dish. Once all the flutes were cut, the area where the gouge met the plate was cleaned over and then they were set aside for Ken to finish.

Soon the floor of the pottery was littered with dozens of freshly thrown plates in long rows. That's where they were stored, down low where there's little to no draught and the heat from the log burner rises above them. By the end of the day we could barely move as plates covered practically every usable surface. The floor was blanketed in dishes on their square batts and we cleared narrow walkways between them, so we could get from the water supply to the tools and back to the wheels.

Once the plates were leather hard, Ken expertly trimmed their bases, the coarse clay tearing as the tool's blade shaved through it. Finally, he'd sign each, scratching his maker's mark deep into the stoneware, three lines intersecting, the pot eternally marked by his hand, although more often than not it is hidden by glaze or molten ash. Despite that, they are still

Newspaper is used an awful lot as a tool for slowing down drying. I now use dry cleaners' plastic, one roll of which will last my entire life, I'm sure.

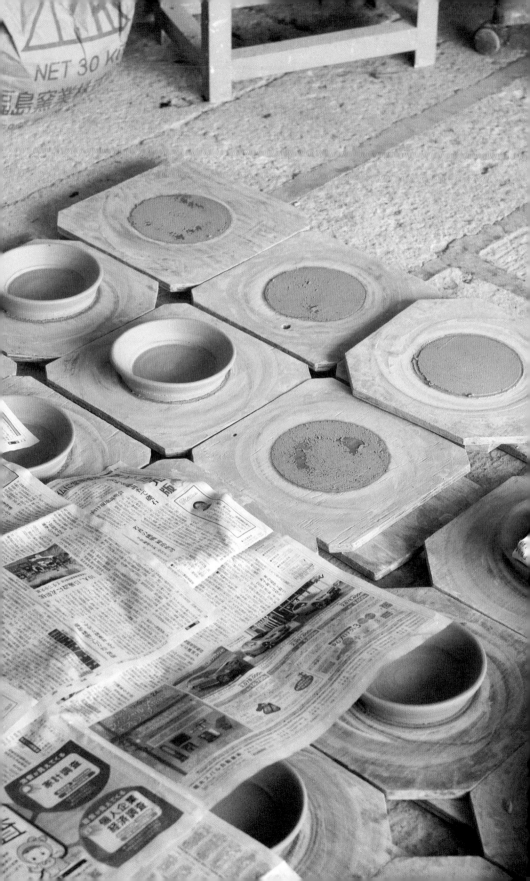

unmistakably his pots. That's where I wanted to get with my own work – for it to be immediately recognizable as a vessel made by my hands, and nobody else's.

The question is how do you get to that point? Is it by making work so distinct that it can't possibly be produced by anyone else? Or is just by becoming so renowned that the majority of people simply identify it with you? My work is uncomplicated. I use consistent, uniform glazes, throw straight edges and trim sharp lips. I don't decorate or glaze in a complex way and my aim has, up until this point at least, been to make pots that I can see myself happily living with. These happen to be rather plain, minimal and straightforward pots. So, how on earth do you make them stand out? Do the shapes need to be new, experimental and unlike anything else? Or do you hold fast and create the same style of pots for a prolonged period of time, so people become accustomed to them? If you live and breathe your style, write about it, photograph it and live with it, it soon becomes like a second skin, but I never set out with a particular style in mind. I didn't pre-emptively create designs I'd follow. Rather, they've developed with me, they've changed as my skill has grown and, nowadays, I'll sometimes throw a pot and it immediately doesn't feel like one of mine. Which is strange, considering it was made with my hands, my tools and coated in my glazes.

PACKING AN ELECTRIC KILN for a bisque firing and then glazing all these plates was our next task, which would be followed by firing them in a large gas-fired trolley kiln. The gas kiln was huge, surrounded by thick steel and insulated with layers of softer, insulating bricks. The kiln's door was unlocked by twisting a large metal wheel, like one you might find on a submarine hatch door. Once the door was swung open, the kiln's brick floor could be wheeled out: this way you can pack the innards from all angles, which allows for more flexibility. Through some pipes in the wall it was fuelled with propane gas, which connected to the same gas supply the house was heated with.

First, though, the pots had to go through the electric kiln, which was outside. That kiln was incredibly deep – think of a cavernous treasure chest – and both Doi and Ken would disappear inside as they bent over it to place pots on the lowest level, their legs and rear the only things visible. Quickly Ken realized it might be easier if I did this as I was a little taller, so I spent an hour bent over loading very fragile, bone-dry plates into the kiln as the cold wind kept flinging my long hair into my face. The kiln would be fired automatically overnight, the plates becoming porous and hard and some of the organic matter, like bark, burning away, leaving small voids in the stoneware.

Coating all these pots with copper Oribe glaze was a mammoth task. There were enough pieces for two firings in the hulking trolley kiln and we worked continually for a week, without a Sunday off, in order to prepare all the pots for the glaze firing. I'd heard the Japanese work ethic was prodigious but I hadn't expected it to be like this. Ken and Doi were a sedulous pair, a symbiotic duo who rocked out unfathomable amounts of pots, and observing this operation from the inside was eye-opening.

Oribe means green, but Oribe isn't really just a colour of glaze, it's a style of making in itself. These pots are called Oribe-yaki and there's a long history behind them, dating back to the sixteenth century, albeit contested at points. For hundreds of years only certain types of pottery could be used in the ancient tea ceremony. A pivotal figure and authority on the 'Way of Tea', Sen no Rikyū, used primarily raku pottery, Raku-yaki. These pots were fired with charcoal, before being torn out of the kiln, white-hot, and allowed to cool naturally in the air. (It's the same technique that lured Bernard Leach into the fray.) These vessels are usually black; they can be metallic with hints of red, and look as if they've been cast in bronze or knapped from a chunk of obsidian.

Furuta Oribe, a disciple of Sen no Rikyū, forged his own artistic path, and in doing so he supposedly came up with the green Oribe glaze we know these days. It's coloured with around 5–6 per cent copper oxide 307

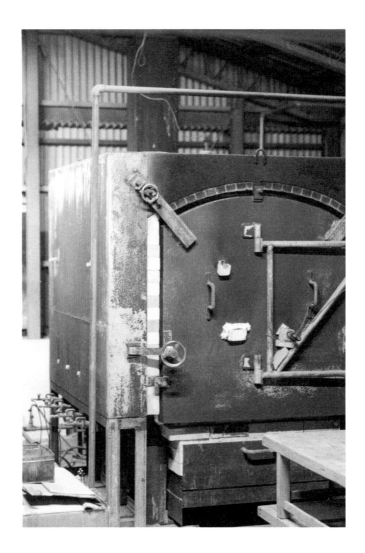

The trolley kiln, the inside of which rolls out along tracks
in the floor, meaning that it can be packed from all sides
and larger works can be lifted in, hence the crane above,
just out of shot. To operate the dampers on the flue I'd
have to squeeze past all the burners, my stomach drawn
in to avoid accidentally turning a valve.

mixed with wood ash and various other raw materials and it is intensely green, like an emerald. It's also *very* fluid and doesn't stay put on pots where coated thickly. Instead it moves, shrouding the form, almost acting like water at the highest temperatures – hence all the hours I spent grinding the bases of mischievous plates.

Oribe is beautiful but very hard to work with and isn't really only limited to green. You'll find black Oribe, red Oribe and plain, Shino Oribe. The rules aren't so defined and, like I said, the history itself is debatable. Now, if only it were as easy as coating pots in just the green glaze, but I haven't even mentioned the other, equally important side to it, which is the decorative iron brushwork. Some pots are simply gloriously green from top to bottom, whereas others are patchy; the green envelops some areas but not others, and in those patches are layers of white slip and decorative iron brushwork.

In order, from start to finish, glazing Oribe-yaki went as follows. The bare, bisque fired pots, the canvases, have areas designated for brushwork, which involves drawing a pencil outline around an area, or you can simply do it by eye. Over these zones a layer of white slip is brushed, then, onto this, some strokes are brushed over using a bright yellow iron pigment. Ken deftly paints flowing lines that resemble flowers and their leaves. These areas are then covered in a transparent glaze and, finally, that's daubed over with wax, to mask it all. At long last the pot is dunked into Oribe glaze in varying layers of thickness and strengths of copper oxide. Some freshly dipped pots, still wet, are sprinkled with the ash made by burnt rice straw, which settles into the wet glaze and momentarily makes the pot look as if it has a layer of fur, although once fired it'll transform into an additional layer of glass that is extremely fluid and creates luscious, long blue highlights that streak through the green. It's quite a process. Now imagine doing that for several hundred pots, not to mention the hours spent roughly sanding the bisque ware prior to glazing, and the clean up with a wet sponge they might need afterwards, to remove glaze from the foot. 309

We'd set up in a row in the studio, each of us working on a different step before handing the pot to the next person, who'd complete the next stage, like a production line in a factory taking pots through one machine on to the next and onto the next. We used upturned plastic crates as trestles for the ware boards and sat on swivelling office chairs, the fabric worn thin in patches after years of doing exactly what we were doing. It was meticulous, laborious work. Ken helped, but he also disappeared sometimes, leaving Doi and me to daub wax, sand pots and tidy up the freshly glazed surfaces. There was some respite, though, in the form of music. Ken had an old iPod plugged permanently into some speakers, but … we listened to the same playlist for the entire six months I was there. I can still remember almost everything on it, be it The Beatles, which I liked, or some awful jazzed-up English Christmas carols, which I'm not even sure they knew were Christmas songs. You can imagine my horror at hearing them on repeat, week in, week out.

After a week of this my hands were in tatters, my nails cracking and my fingertips splitting from constantly being dunked in glaze or water and then dried again, hundreds of times a day, then rubbed against coarse clay. They were cut and I had calluses in places I didn't know they could appear, presumably from all the sweeping of leaves in the mornings. My knuckles bled as I bent my fingers and I ached all over. I could barely function I was so exhausted.

We'd both fall asleep in mere moments at lunchtime and I think this is what led to my smashing a board of Ken's pots while moving them from stillage to the crates on the floor. The board twisted in my hands, my foot angling off balance, and I sent the whole lot flying onto the stone floor. They turned to dust, fragments spilling over the ground. I don't think I've ever been as apologetic about anything in my whole life, but it's difficult when you aren't entirely sure they know how sincere you're being, so I kept going. Ken could see we were both on edge and gave us Saturday afternoon off, and Sunday too.

Doi and I spent many hours here, surrounded by Sapporo
crates, glazing, waxing pots' feet, sanding vessels and
washing bisqueware, all in companionable silence, separated
by language, side by side. I'm sure an ice-cold beer might
have helped make these repetitive tasks a little easier.

THAT WEEKEND THE temperature suddenly plummeted and it began to get uncomfortably cold. A single, sliding glass door doesn't do much to retain the heat, so I drew the thin curtains across the windows and climbed into bed fully dressed, with my coat and gloves on and with a hat my mother had knitted pulled tightly over my head. I tugged two floral duvets over and then tucked in a fleecy blanket, not before dragging my bed so it lay directly underneath the heater mounted on the wall, which I left on all night, gently blowing warm air on my face, the only exposed skin.

I awoke, the walls trembling around me. My bed was rocking and the sliding door that separated the bedroom and kitchen was rattling violently, as if being shaken by an intruder who had failed to understand the nature of such a device. The stuffed cutlery drainer threw itself onto the floor and I had a hard time sitting up as I'd wrapped myself so tightly; even standing upright was a challenge. I grabbed my phone and hurled myself outside, front door open, building still swaying, down the frozen steps into the carpark. The earthquake didn't last long. The floor kept oscillating for a further thirty seconds or so and then there was a ghostly silence. I was the only person outside. I checked my phone: it was midnight. With further searching online, I found that a 5.9 magnitude quake, emanating just off the east coast, was already being reported. I waited another minute and the silence persisted, so I timidly crept back inside and tried to go back to sleep, only now my heart was racing, adrenaline coursing through me.

I overreacted, obviously. No one else had run outside, and when I asked Ken about it the following morning, he said he had awoken but didn't think anything of it. Over the past few months there had been very regular, weak earthquakes but this was something else entirely; I had felt in danger. I've lived in Britain my whole life, and earthquakes hardly occur – and if one does strike it just about causes a window to rattle the same way a rubbish truck rolling past your house might. The thing you have to remember is that in Japan earthquakes are

just so common, they're like heavy rain or a particularly windy day, the timid ones at least. They'd hit when we were in the studio, the pots above our heads rattling unnervingly on the bamboo stillages, or they'd strike as I ate my sushi and watched television during my dinner break, the room palpitating and my socks swinging as they dried outside on their hanger. Some occurred that I never even noticed. I'd arrive at the pottery and Doi would ask me if I felt that one ten minutes ago, but I rarely did when I was cycling, as apart from swinging power lines there isn't much to indicate that a puny one is occurring, and the cycling motion is enough to completely negate it. Although once it did sort of feel as if I was riding on jelly for a second, and at that same moment all the birds around me suddenly flew up into the air.

The most surreal moment occurred during a visit to the supermarket one Sunday. I was browsing the sweets section and weighing up whether to get chocolate-covered almonds or wasabi-flavoured chocolate bars. There was a tremor and suddenly my pocket burst into life, my phone vibrating and shrieking at me. I always kept it on silent, so this was unexpected; moreover it wasn't only *my* phone squealing but the phones of every single person in the entire shop. It was a tsunami alert. I swung my head to one person, and the next; they were all looking down at their screens too. Then the shaking ceased as quickly as it had begun. They all looked up, unfazed, and continued with their shopping, as if nothing had happened.

Japanese people are used to earthquakes, and there are constant reminders of what's possible everywhere you look. In Ken's dining room, where we sat most afternoons for tea, a colossal gouge travels horizontally across the middle of the walls, an awful memento of the terrible 2011 Tōhoku earthquake that killed almost twenty thousand people. My apartment block was covered in cracks, although I didn't realize exactly what they were at first. The outer walls had sprawling fissures across them, although they'd all been filled in and carefully painted over with straight white lines. I never got

used to the earthquakes, and I can only imagine the horror of those that destroy towns and take lives.

I returned early on Monday morning. It was time to fill up the gas kiln with all the Oribe glazed wares. We wheeled out the trolley kiln, me pushing, Doi pulling; it was heavy and we put all our weight into it. If it was that hard pulling it out, how much harder would it be to push it back in once laden with hundreds of carefully positioned pots?

We marched back down to the workshop, past the immaculate hedge from which I teased fallen leaves each morning. (Although they'd stopped falling now, finally, thank goodness.) Our task was to bring all the pots up to the kiln shed, and so we precariously carried packed boards up, held aloft on our shoulders. You get good at doing this as a potter, balancing long wooden planks stacked with vessels of all shapes and sizes. As the plates were coated in fragile glaze we could only manage five to a board, so they weren't too heavy. With a bent wrist the board is held in the middle, aloft, at its balancing point just above the shoulder, leaving the other hand free to manoeuvre the board around corners, open doors, or steady a pot that's shaking a little too much. You can't rush this process and Doi and I steadily flowed back and forth, slowly walking our way up and slotting the boards into the stillages in the kiln shed before running back down to fetch another.

Loading the kiln was easier than I had imagined. First a layer of pots, then props were positioned on each corner, then another layer of shelves; this continued until it was nine tiers tall. Each kiln shelf is coated thickly in a layer of kiln wash, which doesn't melt during the firing and essentially creates a protective film so any excessively fluid, unruly glaze doesn't flood onto them. The kiln wash, whilst still wet and sticky, has coarse alumina hydrate sieved over it, which embeds itself like sugary hundreds-and-thousands sprinkled over glistening fresh icing. This acts as another layer of protection for the shelves and the pots. Finally, each pot is placed onto a three-pronged setter, made of the same material as the wash, only with less water and so more malleable.

As we packed the kiln, each *yunomi* had one of these setters slid underneath it; the plates didn't. Whilst the precautions might seem obsessive, they're absolutely vital: I didn't want to spend another week grinding the bottoms of glazed plates. Doi showed me what to do and I followed suit. He was meticulous, pointing at where I should place pots and telling me, 'No, no, no,' when I placed them incorrectly. Ken would peek his head in and check on our progress but it didn't take long, the shelves layering up rapidly. When all the objects going in are more or less the same size it's just a matter of cramming in as many as you can, like stuffing a sleeping bag into its case.

Once the trolley was fully loaded and brimming like a bucket too full of water, Doi and I very slowly nudged it back inside the chamber, months of hard work. Millimetre by millimetre, we pushed as Ken paced back and forth and around, checking pots, holding on to shelves and directing us. With the trolley finally inserted, we lit the burners before swinging the door closed and sealing it tight. It was quiet; some forgotten leaves rustled outside and the low drone made by the burners was just about audible.

I cycled home as normal, picking up supper: *nigiri* and my favourite things in the world, *inari*, which are sweet, savoury tofu pillow cases stuffed with rice. (Ever since leaving Japan, I've tried to find some that taste just as delicious but to no avail yet.) I hopped back on my bike, bringing with me just my usual gear – keys, wallet, a clay-covered phone and my wifi modem that followed me everywhere I went. I zipped through the numbing air, through backstreets and skirting around paddy fields. I was full of rice, and the bumpy cycle back to the studio was always a struggle after supper, like getting out of bed twice in one day. I parked and Doi was there, waiting. I followed him back up to the kiln shed and he sat down. 'We stay night,' he said. 'All night.'

That was a shock. I didn't mind, of course, and I didn't complain – that was why I was there, after all. To be honest I hadn't thought much about actually firing the kiln. I imagined that perhaps it would sit on a low 315

temperature by itself, candling overnight, but of course not. Even so, some kind of warning might have been helpful. Immediately I hopped back on my bike and raced home to pick up more supplies. I also bought a hefty bag of sweets for Doi – this was a tip I'd been given by Suzanne, a previous visiting apprentice. We sat in deck chairs in the corrugated metal shed, facing the kiln as if we were sitting in cushy armchairs facing a fireplace. You might think it would keep us just as warm, but it didn't. The temperature increases very slowly and, before it warms you, it needs to warm through a thick layer of brick and metal.

Time passed slowly until midnight. We read, we jogged on the spot, and even ran laps inside in order to stay warm. Then Doi showed me how to operate the valves to increase the gas pressure and how to position the dampers to alter the reduction.

All the data, such as the current temperature, the gas pressure and the damper positions, was measured and noted every half an hour on the dot, a little alarm beeping every thirty minutes causing us both to suddenly jolt upward from our slumber. We took turns. As the temperature outside dropped below freezing we tugged our chairs closer to the kiln. We even leant against the metal, feet propped up close to the burners in an attempt to warm ourselves up.

At midnight Doi disappeared, lifting up the sliding garage door and letting it clang down behind him, sealing me in. I clambered up and jotted down the temperature and gently turned the valve to release just a touch more gas. The door behind me was abruptly flung up and Doi stood there with a lacquer tray, loaded with two substantial plates of steaming soba noodles, fried eggs and a giant teapot of green tea with, of course, our chosen *yunomi*. We joyfully ate our midnight meal and Doi explained how every six hours when firing, Ken or Yoko would cook a meal for us, even in the dead of night or as the sun was rising in the morning. We were both drowsy after eating and we dozed with the kiln now roaring in front of us, exuding

warmth. Night crept on and frost began to creep

My cycle commute through town took fifteen minutes. Small landmarks made it memorable, such as this red ladder, or passing the local Shinto shrine, or the white-haired man sitting on a tiny wooden stool, puffing away on a cigarette, who always nodded as I passed each morning.

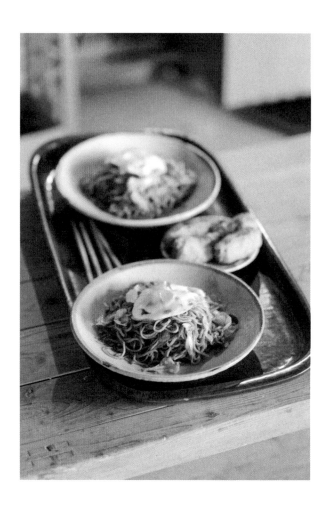

When firing kilns for days straight, meals become
the one thing you look forward to. I couldn't sleep
properly, I was always either too cold or too warm,
but at least the food was piping hot and delicious.

beneath the rolling shutter and across the concrete floor. We squeezed up closer to the kiln, practically hugging it.

By morning the kiln was 1000°C and the reduction had long been set. We were now starving the kiln of oxygen and bright green flames were gushing out from the spy holes, enveloping the brick bung that could barely contain them. The emerald colour of the flame is caused by the significant amount of copper in the glazes and it bathed the room in green, flickering light. I hoped everything was behaving inside. Hundreds of *yunomi* and plates I'd thrown and that Ken had finished were now covered in fire, and even though they weren't my pots, my involvement in their production made me feel at least like a stepfather to them. We had initiated the reduction atmosphere in the early hours, pushing the damper over the flue slightly, throttling it, and adjusting the passive damper at the back of the chimney – a hole filled with a hodgepodge of tiny slivers of brick that could be moved around, or an individual piece removed, to further influence the strength of the reduction. An eggy sulphuric smell poured out from the hot chamber and we now camped a few paces back as the metal was far too hot to touch. We slept fitfully through the early hours.

I woke again to the shutter rolling up and dropping back down behind Doi as he left. The noise from the kiln had grown to a trembling bellow. The shutter opened and closed again. It was now 6 a.m. and Doi held another glorious tray of hot food. Tea was accompanied by stacks of toasties, cheese squeezing out from the crusty edges. I took a bite and was surprised to find it filled with macaroni, a pasta toastie. It was piping hot, at least, and warmed my numb hands. After a few months now in Japan I wasn't surprised by the food any more. I liked the strange combinations of Western cuisines they seemed to enjoy and we both tucked in as I tried, unsuccessfully, to explain why pasta in a sandwich was weird.

Alongside the ranks of pots in the kiln, we'd also packed a dozen miniature clay baskets, constructed from a small slab of white clay with a handle that looped over the top. Cradled in each basket was a test tile coated 319

in Oribe glaze and as the temperature approached its apex, we began to pull these baskets out from the kiln. Ken was with us now; the firing had reached a critical stage, where preventing it from getting too hot was crucial, as these glazes start to boil at 1260°C, resulting in a glassy veneer that not only runs off a pot like water but it also causes thousands of tiny bubbles to appear on its surface, most of which will shatter, covering the vessel in tiny, razor-sharp green craters. We lessened the reduction so the flames didn't hit Doi and his long metal poker, which he delicately threaded underneath the clay basket's handle, hoisting it out.

It was white hot as it exited, a spot of light in the shadowy room. He dropped it into a container of water, which erupted, boiling around the tile as it gurgled to the bottom. A moment later Ken fished it out, still warm to the touch. We inspected the colour of the glaze and how molten it had become. They weren't quite ready yet and we kept this game up for a while, pulling tiles, dunking them, checking the results like little film negatives and watching as the green glaze gradually deepened in colour, spreading out across the tile like melted butter on hot toast.

Finally, forty-eight hours after lighting the kiln, the results were satisfactory, and the gas was switched off. The roaring, tumultuous flames inside settled and suddenly all we could hear were the crows calling rudely outside. Silence. It always feels wonderful after firing a gas kiln all day. We clammed up the spy-holes and slid the damper over the flue so no cold air could flood inside and wreak havoc. It was late on Wednesday and we'd be opening up the kiln on Sunday 24 December, Christmas Eve, the pots like presents under a tree.

FOUR DAYS LATER, we cracked open the kiln. The metal pinged as tension in the door was released – kilns expand as they're fired and unnerving noises often ring out when they're opened. A wave of very welcome hot air engulfed us and inside the glassy green *yunomi* and plates glimmered, clad in an emerald glaze with bursts

Doi, threading a metal pole through a tiny clay basket's
handle, somewhere deep within the white-hot chamber.

of iridescent iron brushwork that caught the light. We wheeled out the trolley, the pots barely rattling whatsoever now, compared to how precarious they were when being wheeled in – clay and glaze had set, setters slightly fusing to the stoneware body.

We unpacked the kiln, carefully snapping off the setters beneath the pots and separating them into two piles, those we could reuse and those that were no good. The pots themselves were crammed onto wooden planks and all the kiln furniture was neatly stored away. We glued the test tiles onto a wooden board in sequence, together with timings and other notes scribbled around them, and it was hung on the wall, joining many others like it in the kiln shed – infographics, notes to aid firings in the future and as a means of keeping records.

Now the next stage could begin. We dragged a bulky metal container out from behind the kiln shed – I'd been sweeping around it for months but never knew what it was for. Doi fetched a long hose and slowly filled it with water, while we piled pots into the tub. It was beautiful. The golden winter sunlight reflected off the surface of the water and the submerged green jewels beneath, all of it shimmering together. The water saturates the glaze, which is crackled in places and still somewhat porous, and they'd be left like this overnight, readying them for the next step.

Christmas isn't *really* celebrated in Japan, hence our working on the day, but the shops were at least selling special festive food packs – sliced turkey, roast potatoes and even Brussels sprouts, all sealed in a neat little container. I had to get one, didn't I? Waiting for me at home were a trio of parcels, presents, mainly in the way of chocolate, books and thick woolly socks, one from my family, another from Lisa Hammond and a third from one of my oldest friends, Kate.

Once the pots had steeped in water overnight, they were carefully transferred in batches to a vat of weak hydrochloric acid. Since the pots were already saturated with water, the acid only touched the very surface of the glaze, instead of being pulled fully into it.

Shibunuki is the name of this process, wherein the pots are immersed in acid for thirty minutes. The acid erodes the oxidized residual copper found in the surface of the glaze and changes its colour, turning it from cloudy and muddy to a bright, brilliant green. The dark greens lighten up, becoming more transparent, and those Oribe pots that had rice ash sprinkled on them would explode into vibrant blues after being submerged. I removed them from the acid and then thoroughly washed them with the shower-head in one corner of Ken's studio, scrubbing each one vigorously. Some needed two, or even three rounds in the acid before Ken was satisfied, and I spent two days and nights soaking, scrubbing and drying the newly fired pots.

Finally, I polished their bases, boarded them up, and slid them into the stillages. They gleamed, at last finished. Months of work complete and another new way of making pots added to the repertoire. It dwarfed anything else I'd ever done in terms of the number of processes involved. Oribe pots may look simple and often spontaneous in terms of decoration, but they are exhausting. The number of steps, the glazing, the soaking, the scrubbing, made even soda firing feel undemanding in comparison. I told Ken I had finished and he followed me down to the workshop.

He inspected them, handling the cups and plates and peering into the glazes. 'Good,' he said, as he reached over to one of the *yunomi* and handed it to me. 'Yours.' I grinned and thanked him. 'What's next?' I asked, at once wishing I hadn't.

Next to the guest studio was one last little outbuilding. It was narrow and had long sliding wooden doors across its front. I hadn't really noticed it before, thinking it was just another storeroom, and it turned out I was right, although it wasn't full of clutter or tools or boxes. Instead it contained at least a hundred lidded plastic buckets, some large, others small, stacked one on top of the other in seemingly no order, like a plastic Giant's Causeway shoved into a closet. I stepped inside and was surprised by just how warm it was, I could feel the heat rising up through my boots. Ken laughed at my confusion. 323

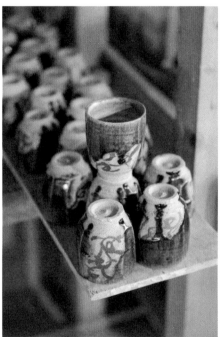

Washing *yunomi* in weak acid after bathing them in water all night. This erodes oxidized copper on the surface, lightening the colour. Despite using gloves, a full day spent dunking pots would inevitably soak my hands a few times, leaving them itchy and raw.

'Heating in floor,' he said, 'so the glazes don't freeze.' Had I just found my new lunchtime spot? Surely I could find a little nook amongst the buckets to eat my sandwich and egg and nap in?

All the buckets had to be lifted out, checked, duplicates amalgamated and sieved back into a usable state. Old and forgotten glazes were thrown away, new labels made, and I cleaned about sixty buckets, spotless. The water in them started to freeze soon after they were removed from their cosy abode and I wish I had taken a photograph of this, of all the blue buckets arranged outside in rows, Ken and Doi going through them systematically and chucking anything to me that needed to be rinsed. It took all day, our hands were frozen, but finally I lugged the last 20-kilo bucket back into the warm room, the glaze swishing inside. We'd do this same, annual sort-out at Maze Hill Pottery, consolidating all the glazes we'd inevitably mix and eventually be overrun by.

That evening we drove to Utsunomiya, the capital of Tochigi Prefecture, for dinner out. It's a city famous for *gyoza* dumplings, a treat that Dejima always spoke so enthusiastically about. All of Ken's family came, Doi too of course, driving us, and there were members of his charity, Kumiko and Takashi, both of whom had helped tirelessly to figure my visa out. Ken gave them both a gift. Bundles of neatly wrapped fabric around something cup shaped. They were unwrapped and inside were two sparkling Oribe green *yunomi*. They twinkled, the green containing shimmers of red and purple and even yellow, like a slick of oil. 'Florian's cups,' Ken said, 'ones he threw.'

'Pots made by Ken Matsuzaki and Florian Gadsby!' Takashi said gleefully as he held his to his chest. Kumiko and Takashi joked about how they must be priceless objects and then the meal began. I let a smile creep over my face. I was beginning to feel more at home, like I was part of something, even if it would only last for a brief six months. The sake kept flowing and bowl after bowl of cold soba noodles arrived, which we'd dangle into hot meaty broth before slurping them down. 325

Our final day of work before breaking for the holiday was spent cleaning up. We washed Ken's house, scrubbing the wooden panels on our knees with bristled brushes – at least that kept us warm. It revealed the hidden colour beneath, peeling back green lichen that had grown over the boards of wood. We then shifted our focus to methodically tidying the studio, digging out the pits of scraps beneath the raised-up wheels and vacuuming the place within an inch of its life.

I was carefully dusting all the wooden beams that made up the paper windows and doors, making sure I didn't poke holes in them, when the intercom suddenly buzzed into life and a staticky, android-Ken blurted, 'Floriaaaan! Teatime!'

Shoes off, I stepped up into the snug dining room and as we sipped green tea we had a long discussion – it seems plans had changed. Ken would be travelling to Chile for the whole of January to teach masterclasses, cleverly escaping the excruciating cold that would soon descend. Initially, we had planned that during my final month in Mashiko I would make Oribe glazed pots of my own, to be fired and exhibited. Instead, I would do it in January, whilst Ken was abroad. This meant that over my break I needed to plan what to craft, and how many pots I needed to make. At least this gave me a distraction of sorts. I had no idea how many pots I'd have to throw to fill the kiln, so after tea I walked down to the kiln shed, tugged out the trolley and measured everything: the interior space, the width of the kiln shelves, even the various 'I'-shaped props that support the shelves.

Ken summoned Doi and me to say goodbye, handing us both heavy plastic bags full of cans of beer and apples. Fruit is a customary gift in Japan, and they were perfectly round and red and crisp. I'd seen melons in the supermarket that cost the equivalent of a week's salary, and plump strawberries that looked as if they had been cast in a mould and painted meticulously by hand. It was all well out of my budget. We all bowed to each other, said farewell and went our separate ways.

Ken's guest studio, door set ajar to let fresh air in to help dry the pots within. Boots were forbidden inside.

I'D LIKE TO SAY I spent my holiday travelling Japan, visiting Shinto temples and sampling wafer-thin *fugu*, but that wasn't the case. After months of working harder than I'd ever done in my life I was beat. Instead, I spent the holidays cycling around Mashiko, scrutinizing even more pottery stores, trying a handful of small restaurants and cafes, looking through the most phenomenal antique shops I've ever seen, and *tried* to relax. I was meticulously planning my firing, loading up three-dimensional modelling software and creating a scale mock-up of the kiln. I made crude placeholders for all my pots from the dimensions I kept scrawled in my notebook; that way I could drag and drop them into this digital kiln, manoeuvring them as necessary to figure out the most efficient packing. I needed to make exactly 450 pots.

I couldn't wait to begin work at the pottery again, and we cleared out the guest studio ready for my month-long making marathon. There wasn't much space inside and I'd have to use a slab roller as my workbench, but at least I had an electric wheel; what a treat that would be after three months of kicking a revolving wooden-top. Now all I had to do was press my foot down and it would spring to life.

I was going to continue making the style I'd been cultivating since studying in Ireland, yet now made with Japanese materials and glazes. Ken had asked me to prepare a few different designs for the iron decoration coated over the Oribe pots, which scuppered my plans of keeping everything plain – clean vessels shrouded only in layers of green, letting the forms sing, which is what I had intended to do. This almost felt like an exam. I had been assigned a task by Ken and I wanted to perform well. I was to pay for the raw materials and the finished objects would ultimately be mine.

After my virtual kiln was finalized, I took ink to paper, churning through dozens of ideas for the iron brushwork that accompanies the Oribe. I found myself naturally recoiling from it. I've never been into surface decoration in my own work, patterns especially. I prefer things to be straightforward, and this was the

opposite of that. I painted tests. There were crosshatched marks, radiating flecks and cubic arrangements, but nothing felt like it identified as mine. I knew this batch of work would be a unique collection but it still needed to reflect my aesthetic, as otherwise what was the point? I didn't just want to imitate the work Ken was making. I wanted to throw forms to my liking that would be clothed in somebody else's glazes. I felt like a beginner, one at the start of their creative path. I was adding inky ornate florets to illustrations of my pots and it felt as if I was trying to mix water and oil: nothing worked. Ink-strewn paper lay around me, covering the tatami mats. This wasn't in me at the moment.

FOR THE NEXT MONTH it would just be Doi and me. On the first day we went together into the concrete bunker that was a few metres away from the workshop. It resembled a colossal kennel. This was where all the clay was stockpiled. It was dank inside, and lined on three sides with thick stone shelves. I was to use a coarse Shigaraki clay, the same one that contained unwanted bark, tiny pebbles and all kinds of surprising impurities. It wasn't that bad, save for when a furiously spinning chunk of wood imbedded itself under a fingernail, but that only happened once. There were all kinds of delights in there and I could have spent an hour looking through the different clays, poking them and making test pots, even smelling them. There was an especially precious-looking bundle that Doi told me was the last batch produced by a master clay-maker. He had died a long time ago and used to produce clay for an exclusive group of potters. You couldn't just buy clay from him, instead he'd choose his clients based on their work and fame, and only then were you allowed to purchase his clays. Ken later explained that this clay, which was still soft, had been aged for ninety years.

I filled my arms with stoneware, Doi too, and we walked the short distance to my temporary studio. The clay was deposited in a neat stack and Doi, through using hands and two words, said he'd be working

in the workshop next door, and that he'd bring me tea and treats at three o'clock. As he left, I noticed two little dried up beige lumps on my wheel, deliberately piled up on each other in the very centre. I followed him out and asked him what they were and, excitedly, he replied, 'Ah *mochi!*' This is a tasty chewy substance made from pounding rice until it comes together and forms a bouncy paste that's traditionally made and eaten in the New Year in the hopes of good fortune for the year ahead. I picked one up and tried to take a bite. It was as hard as stone. Doi laughed and said, 'No-no! Lunchtime, we eat.'

He took the *mochi* and strode off and I took up position on the floor, spiral wedging clay ready for the wheel on a wooden board. Lumps of 300 grams were weighed out and I started throwing mugs, an easy form to get back into the swing of things – to warm cold hands. I'd forgotten a wire, needed to slice the pots off the wheel with, so I put on my coat and went in search of Doi. I slid open the workshop's door to poke my head through and there he was, asleep, curled up on a chair next to the crackling log stove. I was sure I could find the wire myself. Doi worked hard, unfathomably hard. He was the engine under the bonnet keeping the whole operation functioning smoothly, and whilst Ken was away, Doi could take it as easy as he wanted.

After I'd spun a board's worth of mugs and prepared clay for another, Doi popped his head in. 'Lunchtime!' he said, leaving the door open and jogging back to the workshop. He had placed the *mochi* onto the scorching hot metal of the log burner and it had ballooned up, tripling in size. We tore segments off, dipping them in soy sauce he had pooled into a shallow Oribe dish. It was delicious, partly singed, thankfully soft and chewy now, like a toasted, savoury marshmallow. By means of a conversation via the translating app on my phone I found out that this was a New Year's tradition. Shinto monks from local temples would prepare *mochi* and deliver it to all the local potteries, placing them on the wheels. People don't lock their doors around here – in fact I don't think there was even a lock on the workshop's door.

The monks just waltz from house to house, door to door, wheel to wheel, placing their offerings of good fortune.

We finished the *mochi*, our teeth sticky. Doi put his feet up and closed his eyes and drifted off to sleep and I shuffled back to my work. I told myself I wouldn't nap during lunchtimes as there were pots to be thrown, but five minutes later my eyelids were drooping and I couldn't stay awake. I propped my feet up on a stool in front of the electric heater and leant back in the swivel chair and for one glorious hour I slept, as we both would, every day for the next month.

Even though Ken was away, we were expected to keep to the usual hours and maintain the tidiness of the grounds. We'd sweep together in the mornings, which at this time didn't take long as the trees were basically entirely skeletal and, as the temperature was so low, we couldn't bear being outside for long. Once that was done we'd go our separate ways, running to our respective studios to thaw out in front of our heaters. I'd spy Doi going back and forth to the heaps of wood all day to fetch more logs for the fire, and occasionally we'd ask each other for help, or pop out for an errand as a pair. This is how it continued throughout the month, and – perhaps most wonderfully of all – we didn't have to work in the evenings.

Weeks merge when spending twelve hours a day making pots, teapots, bud vases, bowls, with the hope of shipping much of it back home to sell in order to fund my future studio. The little workshop filled up and a puzzle began where I had to constantly arrange and rearrange the space in order to squeeze more pots in. As the studio became more saturated with pots it became humid inside, sticky and wet as all the clay slowly dried out. A few times a week Doi would come down at teatime and we'd sit and have tea together as he looked over what I was making or sat, enraptured, as I pulled handles on mugs and jugs.

Doi had my schedule pinned to a wall and damned well made sure I stuck to it. I'd finished throwing at this point and all my pots had been slowly drying in the studio, the moisture gradually evaporating and, 331

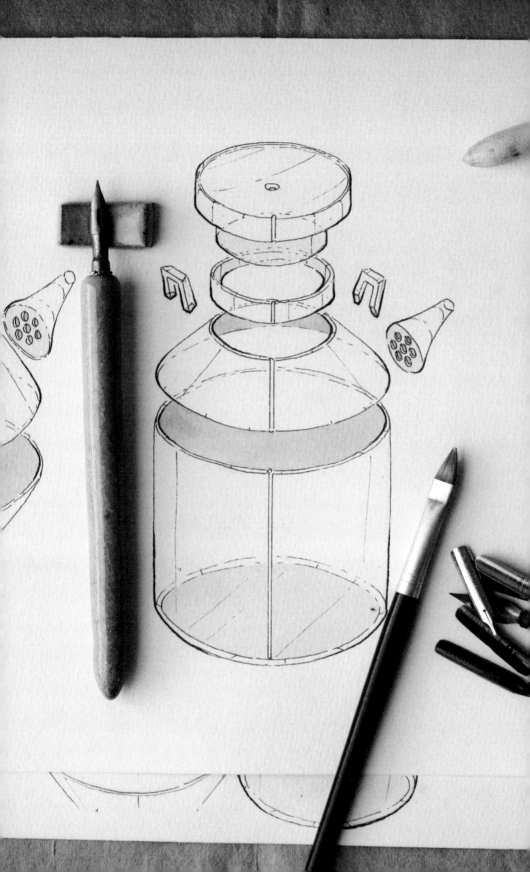

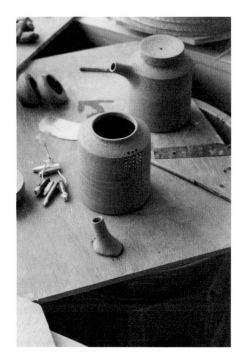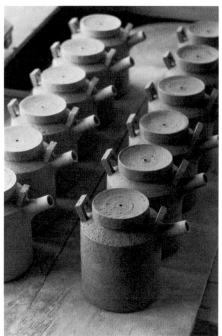

The illustration makes the construction
seem far more complicated than it really is.
In reality, the body, lid, spout and lugs are
the only components – the lugs being the two
loops of clay that are joined to the body,
hooks onto which akebia handles are woven.

combined with the heater that was constantly blaring, it felt like a tiny, tropical environment inside. But now that was over. Today's task was packing the electric kiln outside for a bisque firing. I brought my pots out, stacked and piled them as densely as possible, and then told Doi it was ready to be switched on and fired to 1000°C. My first batch of work was under way and Ken was back tomorrow too.

As I began tidying up for the day the snow started. It fell on the compound gently at first, the flakes sparkling in the light cast by a lamp that shone in the middle of the estate. Then it got heavier, barrelling over the forest and settling quickly on the earth. I spent the evening walking around, photographing the fairy-tale landscape as snow stuck to abandoned pots in perfect, smothering cloaks. It twinkled as I wiped the fluffy powder off my bike seat and it took me forty minutes to get to the supermarket. It covered my glasses if I wore them and stung my eyes when I took them off.

I'd almost reached the shops, cycling excruciatingly slowly along the pavement as the roads were crowded with stationary cars. I came to the town hall and there, in the middle of the road leading into the carpark, was an old woman. She had fallen, sprawled and motionless, covered only in a thin film of snow, which I hope meant she couldn't have been there long. I dropped my bike and rushed over. She was wailing but it was barely audible in the blizzard, her face pushed into the mounding snowfall. Visibility was so poor she could have been easily missed and nobody in their cars had seen her. I asked if she was OK and she clasped onto my shoulders, trying to lift herself up. She was sodden and moaning and I couldn't understand a word. I frantically waved at the cars beside us and a suited man pulled over and dashed out, slipping on the snow. We helped her up and I put her spilled shopping back into her fallen bags. I was no help any more: two other people were with her now. I tried to tell them how I had found her but it was lost in the din. My bike was partly swallowed in a drift and I wrenched it out and continued to the supermarket. I stepped inside, dripping as the

snow melted off me, and picked out supper. Such a day, and journey back, deserved a big tray of sticky *inari* rolls.

The blizzard had ceased by morning. It was quiet outside, and a quick glance through the curtains confirmed that everything was covered in a thick expanse of snow. Mist clung to the ground and the sun was just about breaking through, rays igniting tiny droplets of ice suspended in the air. I packed more food than usual, warmer clothes, chargers for my phone, and set out on my expedition to the pottery, pushing my bike through deep sheets of fresh, undisturbed white. I felt like a character in a Studio Ghibli movie trudging through a wintery landscape. Snow had settled on the reeds in the canals that criss-crossed Mashiko, hovering over the frozen water like tiny plump white islands.

At the pottery, for a while at least, the clearing of snow replaced the ceremonial sweeping of leaves. Afterwards Doi and I would set a roaring fire inside the studio, sitting by it until we had dried out, feet thawing, palms rubbed together vigorously. The snow had curled off the roof and almost directly onto the electric kiln that had been firing my pots, which somehow finished, thankfully, unaffected. Ken and Yoko had arrived back at Narita Airport the previous night. It had taken them ten hours to drive home, and as they slept, Doi and I spent the rest of the day shovelling snow. We clambered around on roofs to push the worst of it off, disturbing glacial panes that would glide off the roof. We'd shovel all of it into the back of the Kei truck, into which we'd shoved two fence panels to stop the snow from cascading out over the sides. Once it was full, Doi drove it over to a ditch opposite the pottery and hoisted up the trailer, the snow tipping out with a loud rush into a small gushing stream that ran beside the road in a deep gulley.

THE ROUTINE IMMEDIATELY returned to normal, despite the inundation of snow that made every job that much harder. It didn't stop us, though, and work sprang back into a rapid pace. Early the following morning

The sweeping of leaves was replaced by the shovelling of snow. Doi and I would spend hours each morning clearing Ken's ground, creating pathways, shaking bushes and pushing it off roofs. It was exciting, for a day or two, but we quickly missed our old routine.

I flicked through images on my phone and showed Ken and Doi my three-dimensional kiln plans, as well as all 450 pots I had physically produced, stacked neatly in rows in the guest studio. They both stood transfixed by the pictures of the kiln plans – I may have gone overboard with that.

'I've never seen anything like this!' Ken proclaimed, followed by, 'Amazing!', and many utterances of *'sugoi'*, a word I'd heard a lot during my short time in Japan; it is used when you're awestruck. A few minutes later, after some discussion with Doi, Ken decided that as well as firing a kiln load of Oribe glazed pots, I should throw more for another kiln of Shino glazed pots too – I was lost for words. I preferred the world of Shino glazes and hadn't expected to actually make any myself. I'd have to begin throwing again – I needed more pots. I went and measured the internal diameter of the gas kiln situated next to the trolley kiln we'd previously fired. In any normal situation, in your own studio, this isn't necessary when producing multitudes of functional pottery – if there are any leftover pots you can save them for subsequent firings. But here, in Mashiko and with Ken's kilns, I was only doing two firings. I didn't want to waste his materials, his precious clay and glazes and propane gas.

Shino ware means 'white' ware. The first records of Shino-yaki are from around 1600, during the Momoyama period. At this time a decadent style emerged, with objects coated in gold and lacquer as a means of displaying wealth and power. At the same time there were pots made that embodied opposite qualities, such as Shino-yaki. These pieces resembled stone and personified imperfection. Some potters have a knack for making work like this – pots that seem almost effortless and crude. They balance both spontaneity and premeditation and it takes years' worth of practice to get it right.

Shino reportedly was Japan's first white glazed ware, made from local materials from the Mino and Seto areas, two important pottery-making regions just like Mashiko. There a white feldspar was found that was mixed with clay and with that the first Shino glazes were 337

formulated. The glaze recipes tend to be very basic in composition, being made up of varying types of feldspars and clays. What creates notable differences, though, is the size the particles are ground to, together with the firing schedule followed and the iron pigments and types of clay used. As connections between potteries in the East and West were made, the popularity of Shino wares soared across Japan and the rest of the world, and the allure of these glazes, and how to replicate them, remains a hot topic of conversation to this day.

When applied thickly, some Shino glazes create fatty white washes that can be quite globular and unctuous. When coated thinly, the iron-bearing clay beneath begins to burn through, turning the white red or brown. It's a process that can be unpredictable and the making process echoes that. Ken's tea bowls, *chawan*, are thrown loosely. He lets the clay undulate and alters it as spins, knocking seemingly arbitrary irregularities into the vessel with great skill. Ken liked to quote Picasso when doing this: 'It took me four years to paint like Raphael, but a lifetime to paint like a child.' They look natural and their surfaces are often accompanied by iron brushwork, sometimes floral motifs, other times simply a wash or a few gestural flecks of the brush; the possibilities are endless.

Imperfection isn't a quality I'm very good at embodying in my own work, and nor do I think I ever will be – although I suppose a midlife crisis could perhaps change that. It's fascinating when you see a potter suddenly change their style, like when your favourite band release an album that sounds completely dissimilar to anything else they've ever recorded. It's a rare event, but it does happen, and it doesn't always work.

The kiln I'd be firing them in had thick walls in order to aid the process of firing Shino wares, as they require a very slow, controlled cooling period. Ken spoke excitedly about this as he showed me the kiln, and gave me a brief history of kilns elsewhere in Japan with walls some two metres thick. This helps the kiln to fire back-wards in temperature, so to speak, by itself, as the

bricks naturally lose their heat. Whereas with Ken's thinner-walled kiln, we had to fire it manually down, lessening the gas pressure as we went, guiding it in for a controlled landing rather than just switching it off mid-flight. If we did turn it off suddenly, the temperature would plummet too quickly and the colours Ken was seeking wouldn't transpire.

I only needed a week to produce the 150 pots for the thickly walled kiln, as it was considerably smaller than the trolley kiln. The plan was to fire both the Oribe pots and Shino pots at the same time.

Ken popped his head in through the sliding door and said, 'For the Shino firing you should throw some *chawan*, *yunomi* and *guinomi* [sake cups].' I hadn't planned on making any of these. Whilst I was in Japan and using local materials, I didn't want to simply emulate the pots around me. I had seen a few comments on Instagram asking why I wasn't making Japanese pots. Why wasn't I making *chawan* and *yunomi* and sake cups and bottles? The answer is clear, in my mind at least; if I did that, then I'd be doing nothing special, new or different. I'd just be making poor imitations of pots I didn't really understand. They aren't part of my heritage or my culture and I'd just be another foreigner trying to replicate them for no real reason, or doing so just because it's popular in the West. Instead, the idea was to make the pots I'd already been making – bowls, mugs with handles, teapots and jars, my predefined forms, those that I'd been continually fashioning in my style, but this time they'd be wearing new clothes.

I had been taught how to make *yunomi* by Ken, for his production, but they aren't a form that'll ever find a permanent place in my repertoire of pots. I love Japan, I adore their appreciation of tradition and craft and I use some very special pieces at home, to this day, but I never want to try and copy them myself. In the West, creating Japanese-inspired pots is an easy route to go down. They're popular, and there are many buzzwords, such as *wabi-sabi*, a traditional Japanese aesthetic that embraces imperfection, that are latched on to in order to 339

propagate an image and sell bad pots, wobbly vessels, made without care and pushed by large Western corporations who claim that, because they're *wabi-sabi*, everything is fine and dandy.

In many instances I think it's inappropriate, a misuse of the word, and I have similar feelings about Western potters who have no honest experience of Japanese culture creating traditional tea ware simply because they like the pots and they're popular. It is, however, more complex than that, and I think people should really ask themselves why they're making certain objects. Collaboration, a mixing of ceramic cultures, young makers mingling together and experiencing the world of pottery together is one thing. But actively taking a culture's wares and mimicking them yourself if you haven't made an effort to visit the country, to meet potters there and to learn about the traditions, makes the imitation feel lifeless, joyless and pointless.

Whilst Ken had asked me to make some Japanese-style teaware, I resolved that they would be a one-off, a page in my history as a potter, an endnote in my education, as that's where I was at this point, embarking on the final months of my formal pottery tuition. I had watched Ken throw *chawan* a number of times, atop a hump of clay, using his kick-wheel, the walls wavering, curves and ledges forming, the pots looking as if they might collapse at any moment but somehow surviving. The clay could resemble chiselled stone or carved wood, or even a hunk of soaking, fluid clay, held in suspension.

Together, myself throwing at the wheel and Ken to one side, I threw a batch of *chawan*. He described why he does certain things, how he holds his hands as he throws to create the lumps and bumps and irregularities. It felt alien, this idea of deliberately allowing wobbles to reveal themselves and become a critical part of each pot. I've always tried to craft to a high level of finish and trim pots within an inch of their lives. That's how I like to make them and this, throwing a gyrating, teetering bowl, felt so distant to me. Ken liked a few of those I fashioned, as

did I, one in particular with a flat side undercut

by a fissure, like a chunk of flint with a facet knapped off it – a lucky accident.

The following day he came back to sit by me again as I trimmed them. This is done both conventionally, with looped trimming tools, and with a piece of sharp wood that's used like a paring knife to cut strongly defined angles to form the pot's foot. Again, he guided me, revealing what he'd do to certain forms and why, but also saying that I have to do what inherently feels right to me. Tea bowls have a face, a prominent side, sometimes intentionally made or accidentally found, and when the bowl is passed around from person to person during the tea ceremony you hand it to them face first. So, as I was trimming, Ken reminded me to envision where this face might be, what part of the wonky pot is asking to be held or looked at and which sections need to be carved and altered. It was fascinating to see his approach. I always thought *chawan* were born out of a single moment, defined by chance, but a lot of thought goes into each one and we hadn't even got to glazing yet. I finished them, together with the remaining pots needed for the Shino firing, and packed another electric kiln for a bisque firing to 1000°C, to harden the pots and make their body sponge-like.

I had known I would be holding a kind of exhibition in Japan but the details of it were still unclear. Half of me expected it might be in a department store in Tokyo, many floors up in a little carpeted nook. But instead, Ken informed me it would be held at Kanoya Gallery, a local showroom housed in an enchanting traditional wooden Japanese house. It was well kept with a walled garden through which visitors stepped over large flagstones set into a sea of pebbles that led inside. Amongst the gravel were mounds of moss, and boughs of trees drooped down that in the spring were heavily laden with pink blossom. Then, you'd step inside the gallery, into two rooms that would soon be filled with my pots. Ken Matsuzaki exhibits here, Tomoo Hamada too, the grandson of the *mingei* master potter Shōji Hamada. I was left stunned after hearing that. I had an awful lot to live up to. 341

Kanoya Gallery, the location of my first solo exhibition, and some of my bowls, swept over with iron pigment using a bristly straw brush, that were shown there. They were worlds apart from my usual, uniformly glazed pots, but they were some of my most successful Mashiko wares.

The wary making of these *chawan* wasn't finished yet. Once all the pots had been bisque fired, we sat one evening with these asymmetrical tea bowls laid out in front of us. We studied each pot, examining the shape and how it rested once placed; a few didn't fit perfectly flat. Ken spoke about how each pot would inform how he'd apply the Shino glazes and slips and that no two were alike. I thought about each and took in as much of what he said to me as I could, before using brushes to coat on slip, glaze and washes of iron in copious layers and combinations.

I felt as if he didn't want me to do exactly as he was suggesting, so I took his recommendations and tried, as best I could, to put my own spin on it. Next to all my other neatly lined up pots, these bowls felt very alien.

Then the glazing commenced. Four days and four nights straight, our roles reversed this time. As I decorated Oribe-yaki with iron brushwork using straw brushes, Ken and Doi would wax over the areas I defined with a pencil. I felt like an imposter. Ken is a world-renowned potter from an unparalleled lineage and here he was, helping an apprentice for almost a week straight to glaze his pots. I honestly imagined it would be just Doi helping me out. This is a task that's so easy to do badly – like attaching a terribly formed handle to a fantastically thrown mug. Good work can be ruined in a second of distraction. I think he was there to guide me through it partly for that reason, to ensure the standard was kept high, as ultimately, had I missed a step or applied the wrong glaze, it would have all ended in disaster. Or perhaps it was to get the whole palaver over and done with as quickly as possible, so he could return to his routine and get all my bloody pots out of his studio.

WE WORKED LIKE machines, glazing pot after pot as darkness fell on us. I felt bad for making so many mugs and bowls and irksome little lidded jars that were finicky to glaze. We sat in a row – I'd glaze the outside and pass the pot to Ken, who'd glaze the inside and would then pass the pot to Doi, who sponged the bases clean. 343

It was quick and efficient and over that week I tried to work during my lunchtimes too, but I couldn't last. At midday I fell asleep in the guest studio, where I hid to escape the cold. I napped with my booted feet propped up next to the red-hot storage heater and awoke soon after to the smell of burning rubber. My right boot had started to melt.

On the final day of glazing, as we sipped tea during our break, I asked Ken about the kiln schedules for both firings. They're operated entirely by hand and Doi and I would have to be with the kiln firing the Shino wares for 150 hours, and the trolley kiln for about 50. You can purchase gas kilns that fire automatically, but they cost as much as a brand new, expensive car, so I asked Ken, who has a few nice cars, if he'd ever consider getting a programmable gas kiln. His answer was quick, and straight to the point, as always. He looked over at Doi and said, 'He is my program.'

Ken continued and spoke of how when he was young, he'd fire these kilns entirely by himself for a week straight. Adjusting the settings, sleeping for a few moments, adjusting it again, and so on. I couldn't quite believe it, the dedication, the self-sacrifice, everything. He deserved to not really be involved in the firings any more, hence why they were a task given over to the apprentices as soon as they were trusted enough. Firing has its charm, wood firing especially so. Timber is thrown inside and smoke billows out and the kilns often require teams of people working – friends, and young, visiting potters who want nothing more than to experience the process. Yet gas firing quickly loses its glamour – not the results, of course, but the process itself. Rotating a few valves and altering the damper only remains engaging for so long. They're pretty much just electric kilns with flames that protrude through the gaps beyond a certain point, and if one day I have an apprentice you can be sure they'll be the one firing the kiln.

I lugged my pots up to the kiln shed, all six hundred of them. I smashed a few of my own vessels. They were carried up on my shoulder and I noticed one pot wobbling a little too much and, in my attempt to

Switched on all day, this heater kept my studio cosy throughout the winter, and also destroyed one of my boots one lunchtime after I fell asleep with my feet propped too close. The leather around the front of the boot split, looking as if a sharp claw had torn it, and I woke up to an acrid smell filling the room.

345

Red wax masks iron brushwork underneath,
as the grey Oribe glaze is dipped over the pots.
After being reduction fired, these would become
emerald green with flowing metallic decoration.

save it, to stabilize the rattling jar, I sent all the others flying to the ground. Ken was more distraught than I was and quickly ran to retrieve a few *yunomi* I had previously made and trimmed and forgotten about.

I placed my laptop on the desk next to the rolled-out trolley kiln, the screen showing the virtual kiln pack I had constructed. We started with the Oribe pots. In the program I lifted all the shelves away to reveal the lowest tier, and we began to pack, looking at the layout on the screen, then replicating it in real life. It was easy, and Ken and Doi spoke in high-spirited, happy tones to one another as they followed the guide: perhaps I'd finally shown them something new. The Oribe pots were placed on the setters to protect them from fusing to the shelves, and we even bathed the bases of some pots in mounds of white ash. I wasn't sure what Ken was doing when I saw him heaping it initially, piling coarse white powder around a cup like a bank of snow around the base of a tree.

'It turns the clay orange – decoration!' he said. He waved and said something to Doi who dropped what he was doing and ran off to find something. Out of breath he came back, holding a *yunomi* that was flashed an orangey-red around the base where this ash had been. During the firing it volatilizes, colouring the bare clay. I liked it. It looked like singed toast.

The rest of the packing went smoothly; the plan helped tremendously as some of my shelves contained a multitude of shapes of pots. The only tricky bit was balancing my narrow cylindrical vases on the setters on the top shelf. They wobbled precariously even after we'd secured them; how on earth would we push the trolley back inside? Doi raised a hand, an idea! Once again he ran off and this time returned with glue. We stuck the setters onto the vases; they stood still. Ken smirked and said, 'You better hope there's no earthquake.'

My heart sank, of course. I just had to hope one didn't strike, and suddenly the perils of making pots in such an environment dawned on me. I hadn't felt this way about any of the pots we had fired so far, but now 347

these were my own vessels. I'd poured a month into creating this body of work and it was all going to be locked into a colossal metal chamber and flooded with flames. Not only that but at any second the ground could quiver and send the whole lot crashing down. At that point, my pots would be the least of our worries.

It took us fifteen painstaking minutes to wheel the trolley inside its housing. The pots were a strange mixture of grey powdery glaze, that's the colour the Oribe is before it's fired. They were covered in patches of bright red wax and had streaks of white where washes of Shino lay beneath. They are matte and dull but soon they'd shine like emeralds with decorative metallic iron brushwork in places, both fluid strokes done quickly with a *hakeme* brush or more detailed crosshatches and flecks, done using the tip. The kiln was full, the burners lit and Ken hurried me in front of all the pots, grabbing my camera. 'Careful of the flames!' he said as he clicked away, head hidden behind the lens.

The Shino pots appear red and brown before their firing, with matte, powdery surfaces. The gas kiln for the Shino pots was a deep trunk shape, so we'd step onto a raised metal platform and from there we could bend over inside to lower pots onto the lowest shelves. They were spaced generously in comparison to the Oribe vessels in their kiln. Ken stated the pots needed room to breathe and mentioned how they shouldn't overhang the shelves either, as if a pot spends 150 hours directly in the path of an angry flame it's not going to endure the firing. The kiln was packed and thanks to my accidental smashing of a few more pots there were a few pockets left on the top shelf, which Ken filled with six tea-stained sake cups. We lit the kiln, two burners either side gently glowing as the gas ignited, then the lid was shut and some ceramic fibre was stuffed into a few gaps around the aged kiln to seal it.

It's a complex firing, as made obvious by the intricate kiln firing charts. In one of the desk drawers in the kiln shed was a trove of scrolls. They looked like rolled up treasure maps, the paper worn and yellow,

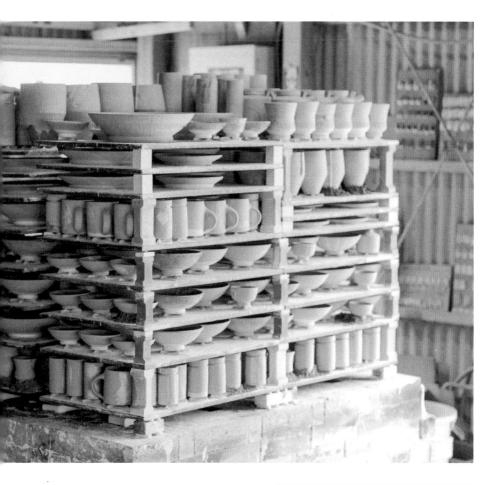

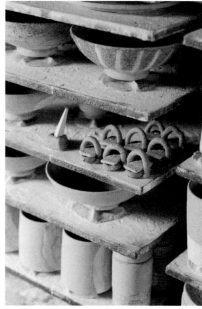

Four hundred and fifty Oribe pots, minus
a few I accidentally broke, neatly packed
into the trolley gas kiln together with
the tiny, tile-carrying baskets that are
carefully lifted out during the firing.
All of this was then gently pushed,
bit by bit, back into the chamber of the
kiln before the door was sealed tight.

The chest-like Shino kiln we fired in tandem with the trolley kiln full of my Oribe pots. We packed this in a fraction of the time, but fired it for six straight days and nights – it radiated heat like a campfire.

frayed at the edges. As the drawer pulled open all I saw were the tops of them, dozens upon dozens of circles and holes within, as they were all slotted in lengthways, side by side. Unfurling one revealed six landscape pieces of graph paper taped together to form one extraordinarily long piece of graph paper, and along this lengthy expanse of tiny squares was the journey each firing took. A line rose, following the temperature increase, and then traversed roughly horizontally, falling, climbing and jumping in places, before finally sloping down; all of which was accompanied by a scrawled commentary. They were both fascinating and confusing and it took me going through a whole firing schedule to begin to understand them, and even then I was only scraping the surface. The wealth of knowledge in these pages: there must have been sixty scrolls altogether, almost ten thousand hours of firing. Stashed together, they were a vault of information that I spent hours looking through and translating from Japanese to English with the help of my phone.

The pots for the Shino firing had been glazed more expressively – I purposely left drips of glaze and didn't worry too much about overlapping surfaces or droplets that ran onto the foot rings. Ken had suggested I shouldn't clean them up too much after glazing, so once again, I left these vessels messier than I usually would. Even my own forms, the teapots, bowls and mugs, were left roughly glazed. It would be amusing to see how they looked against my straight-sided forms, as usually Shino pots themselves tend to be more organic in nature, thrown loosely and trimmed accordingly.

It was late in the day by the time the two kilns were finally lit. They followed different firing schedules and required individual approaches. Their reduction atmospheres would be initiated at different times, and periods of oxidation would also be introduced at certain stages. I understood the basics of what needed to be done but without Doi and Ken firing with me I would have been utterly lost; really, I was just tagging along for the ride. Gas kilns are particular things: each handles

One of Ken's firing charts with lines following the temperature, damper position, and other jotted notes. Every single alteration to the kiln had to be noted, no matter how minor.

differently and fires differently, and they have their own peculiarities. You may know how to operate one gas kiln perfectly but, whilst those skills are transferrable, there are always some things that can catch you out when firing an unfamiliar kiln.

We had a few hours to kill before the six-day shift began. This would be the longest firing I'd ever done, so I cycled home and packed as many supplies as I could force into my bag, together with some changes of clothes and extra layers to fend off the cold. Then, I stopped by the supermarket to pick up a sack of snacks and sweets, for myself and to keep Doi happy, as I knew he probably wouldn't get any for himself.

This round of firing was much like the last. Every six hours on the dot we'd take turns fetching a hot meal from the house, at twelve and six, day and night. Udon noodles, pasta toasties, piles of rice with fish and chicken on top, accompanied always with little steaming bowls of miso soup and pickles and vast quantities of green tea. It would have been a healthy diet had it not been for all the chocolate in-between. The first night was the coldest but as both kilns were now heating up, we could sit between them, warmth swaddling us from either side. We seldom talked and there wasn't always much to do, simply adjusting the damper and passive dampers to control the strength of reduction, but eventually we started to remove the tiny clay baskets from the Oribe kiln to see how it was progressing. In the daytime we'd help Ken with a multitude of tasks and the daily sweeping continued. I kept a timer on my phone that would sound every half an hour and, as soon as it buzzed, we'd both scuttle up to the kilns to check on them. Other times I'd be left to babysit the kilns alone, when they were at an easy stage to manage, as Ken and Doi were off doing jobs of their own. Mostly though we stayed with the kilns.

As they reached their top temperatures, instead of huddling right next to them to stay warm, we were now trying to escape them, retreating behind a giant stack of decorated metre-wide stoneware plates that shielded us from the relentless radiating warmth. 353

The kiln with the Oribe pots was reaching its peak. Green, coppery flames sputtered from the tiny gaps in the brickwork and the entire metal chamber looked as if it was bulging, the metal framework expanding. Towards the end we periodically drew out the test tiles and, once they were satisfactory, the green glaze fully molten and seeping out across the tile, the gas was switched off. The room suddenly quietened, but only slightly, as one of the roaring dragons was still combusting.

The kiln with the Shino pots plodded on. It was kept reducing for what felt like an eternity, the iron slowly being pulled through the Shino glazes. At long last it reached 1300°C – Shino wares benefit from a long, slow firing. Then, whilst the kiln was still in a heavy reduction, when we were really throttling the exhaust and firing the pots in an atmosphere that lacked oxygen, we started to slowly fire it downward, reducing like this all the way to 1170°C. Some of the atmospheres we were seeking were very subtle, and Ken periodically came in to check them with us. We'd do this by holding up a gas torch to a spy-hole. If the kiln sucked the flame into the hole it was oxidizing, and if the gas torch's flame was pushed away it was reducing.

Thereafter the kiln was put into an oxidized atmosphere by opening up the dampers. Air rushed in and the gas could finally burn efficiently and, as it did, the black iron that had now permeated the glaze via the reduction process would start to lighten in tone. A single brick in the wall of the kiln was removed and a test tile was cautiously lifted out in its basket on the end of a metal rod. It had an iron stroke painted beneath a layer of Shino glaze and the initial tests came out black and dull; the iron was on the surface but it wasn't the colour we wanted yet.

As the oxidation continued, and as the temperature *very* slowly decreased over three long days, the black started to turn red and then pink, the tone progressively brightening. The small tiles would come out white hot and as the oxygen interacted with them you could see the colours on the tile change in front of your eyes. These test tiles weren't dunked in water – I didn't

ask why – and instead we carefully laid them out in a long row, the black changing from tile to tile in a gradient to a warm pink tone. On one occasion Doi's protective glove instantly caught fire as he pulled a tile out and he ran over to submerge it in the same basin of water we threw the Oribe tiles into. Covering the walls of the shed were squares of plywood with tiles from previous firings glued onto them, like there were for the Oribe firing too. Ken compared the tiles exiting my firing with those from firings past and concluded that there was still another day left to go.

It was unbelievably warm inside the shed now. Six days and five nights of surging infernos meant the residual heat had diffused through everything. The kiln's bricks were saturated and you could have easily cooked on the metal casing. The stack of colossal plates we'd been using as a barrier was searing hot to the touch, and they were a good few metres away, as was all concrete around the kiln too. Five minutes inside, beside the kiln and you'd begin to sweat, and this was in the dead of winter. I asked Doi how firing the kiln was in summer and he just laughed: 'No-no-no!' he chuckled. 'This better!'

I was both awed and at times saddened by Doi's stamina. He had practically no work–life balance; it was just work–work. Even during my busiest months with Lisa, when we were travelling to fairs or doing back-to-back soda firings, I'd almost always have time in the evenings to myself. As far as I could tell, Doi spent many of the hours of darkness assisting Ken in the studio – and this had been his routine for *ten years*. It seemed almost as though Doi had committed himself to a monastic way of life.

The final night arrived. Our sleep interrupted constantly by the ring of an alarm, we'd jot down notes and both instantly fall asleep again. Ken came down earlier than usual and we pulled out the final test tile together. The black was now a deep, lustrous pink. We switched the gas off and the room became silent. Utter relief. I'd spent the past week constantly listening to the rush of gas, like tinnitus, a hum in my ears, a persistent drone that had now, thankfully, come to an end.

The sun was just coming up and I was given a day and night off – this wasn't the case for Doi, though, who followed Ken straight into the workshop. I was dizzy, sleep-deprived, hungry and in a trance-like state after spending a week in the same room. Cycling home felt like a dream. I glided through town and into bed and didn't wake up until late that evening. I couldn't sleep any more, though; I knew we'd be opening the Oribe kiln the next day and I was nervous. My dreams from that long slumber had been full of disastrous kiln openings, split shelves and pots shattered from trembling earthquakes. Like a child waiting to open presents on Christmas morning I was giddy, itching, restless. What on earth would we find inside?

I SPAN THE WHEEL to open the kiln's door, light flooding inside, the pots revealed half still in the shadows. A wall of glassy green pots, their surfaces now molten, running from light yellow-greens into thicker bands of dark, almost blue, viridescent glaze. They caught the light and the glazes chimed as the glass contracted slightly over the stoneware underneath, resulting in a glorious cacophony of ringing, like thousands of pealing bells only at a much higher frequency. This sound swiftly stops, although pots can still 'ping' weeks, months or even years after they've been fired, as the stressed glassy surface suddenly releases tension. We waited for the symphony to end before steadily pulling the trolley out. It all seemed fine ...

Unpacking began and the process of soaking pots immediately commenced. A really large metal basin was brought out and filled with water, and after some commotion and discussion about the pots and the firing, I was left to unload the kiln, pot by pot, and submerge them. They flickered under the water, light entering and refracting, like looking at a straw in a glass of water from one side. All the pots appeared distorted, their proportions crooked with shadows cast over the basin from bare boughs of skeletal trees above. It's an image that'll stick with me for ever. Here the pots would stay, soaking overnight so the water could seep inside. I spent

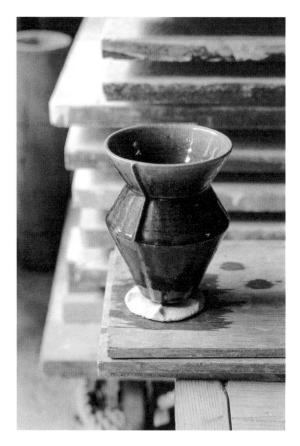

This angular Oribe vase, decorated with a simple protruding line that was waxed so the bare clay shone through, felt distinctly like one of my pots – a successful combination of my design with Japanese materials. Whereas the bowls, brushed with iron, dipped in Oribe and sieved over with rice husk ash (this is what creates the blue glaze), felt a little unfamiliar to me.

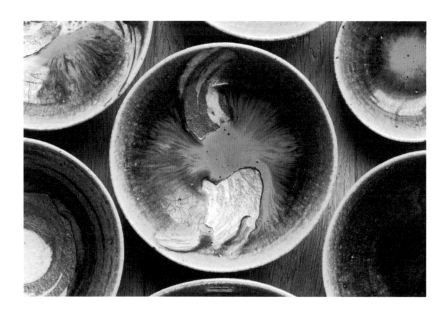

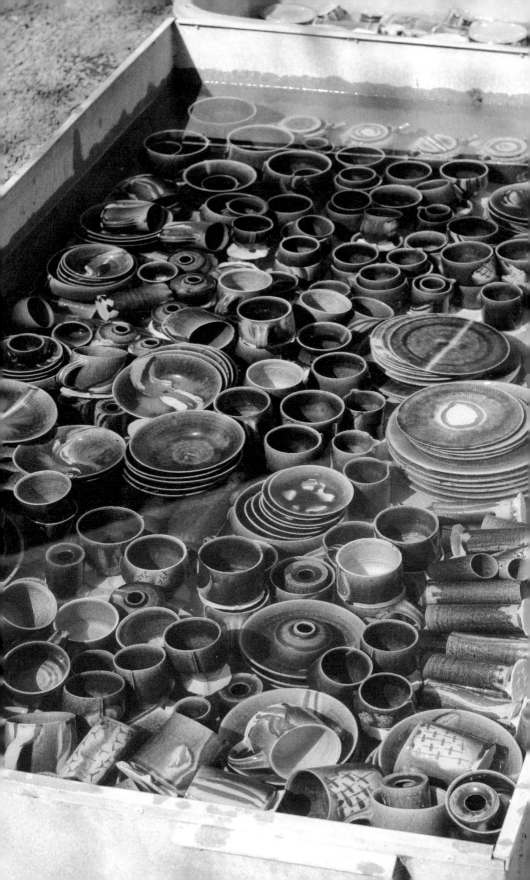

the next few hours unloading all of the kiln props, the now crusty shelves too, and ground them clean.

Then it was the Shino pots' turn to be unpacked. The three of us stood around the kiln, lifting the lid up like a chest full of treasure, the hot air rushing up into our faces. The first, and most notable, things we saw were Ken's *guinomi*, which had sunk in on themselves, like flattened balloons but cast in stone. He chortled as he saw the collapsed pots and spoke in a surprised inflection as he gathered them up in his arms and took them out to the shard pile. We heard a few loud crashes echo across the grounds as he smashed them to smithereens. It seems they'd been made with the wrong clay, and didn't withstand the prolonged heat. Everything else had survived, though, the pots only really visible via their glinting rims in the shadowy depths of the kiln.

The surface qualities of these pots varied greatly but they tended to have an eggshell-like finish. They were mostly matte in places, with a sheen that was exacerbated when water was poured over them. A few were white and milky, others orange, red and even pink and purple. Others were dotted in pinholes, some appeared as if they were scorched by flames, and a number were quite painterly, the iron brushwork still visible in long, meandering traces underneath the white glaze. Ken took my camera again and photographed Doi and me as we unpacked together. The teapots were my favourite; some were pink and white and flecked with thick, globular streaks of glaze, and others were gunmetal black, lustrous and angular, like little tanks, their spouts jutting out like gun barrels. Then there were the *chawan* I'd made with Ken's help – definitely not made in my style, but with my hands at least. I picked them up and clasped them, searching for a face, the side of the vessel that would be presented to a guest when used in the tea ceremony. Each one had its own.

I laid these pots onto ware boards, the sun setting over them now. All they needed was a quick polish around their bases. I had the whole lot cleaned in a matter of minutes. On the other hand, the Oribe work had

I'm still amazed nothing chipped when all the pots were loaded into this container. Here, water seeps into the fine crackles in the surface of the glaze, saturating them in preparation for their acid wash and thus preventing the acid from being drawn all the way into the pots.

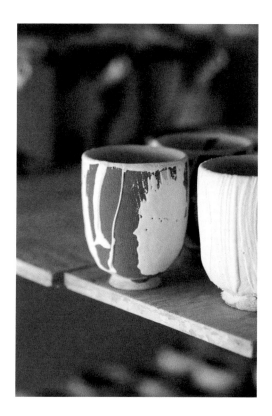

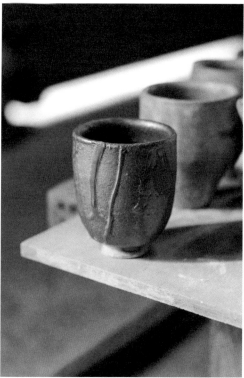

The same Shino *yunomi* teacup before and after firing. The end result looks as if it's cast from metal, the red iron encasing the pot and burning through the thicker Shino haphazardly brushed over.

a *long* way to go yet: hours of soaking in water, then acid, then they'd all need to be washed again with fresh water and, finally, all the dribbled glaze ground smooth. Worst of all, though, were most of the lidded jars. I'm not sure what happened. I should have double-checked them but, somehow, I forgot to wax the rims and undersides of the lids. This would have stopped the glaze from adhering to those areas once dipped. Instead, they weren't waxed, glaze coated those parts, and all the lids and bodies had fused together, creating useless, sealed cylinders. Some prised off, but for the rest I'd end up spending an entire day painstakingly using a rotary tool to slide a diamond saw-bit carefully between lid and body to separate them – it was excruciatingly delicate work that had me going cross-eyed from focusing intently, so as not to ruin them.

The following morning started like any other. It was rotten outside and my bicycle ride to the pottery left me smitten by the cold, howling wind. There was thick ice all over the roads and the hill was a treacherous death-trap, so I walked and pushed, my boots and bike slipping. I ambled over to the basin but couldn't make out all the pots properly. Then it struck me; as you might have guessed, the metal tub containing 450 pots had completely iced over. The green vessels were swallowed up in it and some stuck out of the frozen surface like icebergs. Doi idled up beside me and let out a slow low sigh that turned into a typical Doi chuckle. He knew it was bad. We both stood, dumbfounded for a moment, then he pulled in air through his teeth and rubbed his chin with his hand. 'Usually we put inside,' he said, nodding towards the workshop.

We tried plucking at the thick sheets of ice and poured hot water over them, but it had little effect. Doi helped me slowly chip the pots out, dislodging chunks of ice and ceramic, our hands turning red and raw. I could barely move my digits, they were so numb. Ken, seeing the pain to which we were subjecting ourselves, let a tirade out at Doi, who apologetically ushered me over to the truck and we drove off to the supermarket to find thick gloves with long sleeves. Only one pot was harmed by the freeze. 361

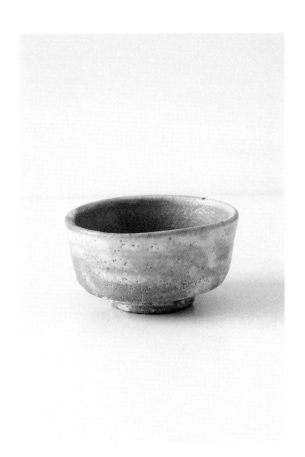

One of a dozen *chawan* that I made to
Ken's specification. It has a purposely
crooked shape, fingerprints in the slip
and an undulating rim. Many of these
have remained keepsakes, as pots
I'll probably never reproduce again.

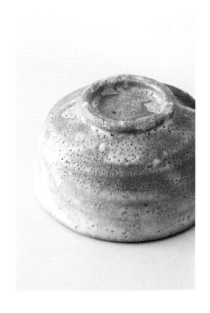

What followed was a week of soaking pots in acid, grinding their bases and weaving akebia vine handles for the teapots, which attached to two clay lugs and sprang over the lid like a basket. Ken asked me to photograph everything, which I did, and to pick out a selection of my favourite pots. These weren't to exhibit but to take back to London with me.

The rest were placed on long rows of ware boards outside on the dirt – dirt swept very clean I should add. A vat of weak hydrochloric acid sat there and Ken pointed at a few pots as he picked his way through, deciding some needed a little more life. Doi scrubbed acid onto the surface with a cloth, to lighten the greens, and then went inside to thoroughly wash them. I was watching from a walkway above for much of this. They hadn't asked for my assistance, which they normally would. This felt like an assessment: Ken was scrutinizing my work.

Hundreds of finished pots lay in neat rows, categorized by object and how they were glazed. Then, Ken and Doi inspected everything, moving along the lines, picking up pots and talking about them. The owner of the Kanoya Gallery was due to arrive and together we'd all select the pots for my first solo exhibition, pots all crafted by my hands and shrouded in traditional Japanese glazes – a proposition both terrifying and riveting.

The work was chosen, wrapped and packed up into plastic crates. Ken decided how it would be priced. I had shown him a rough price-list of wares I'd sold previously, but I don't think he followed it. Everything was then driven down to the gallery in the back of the trusty pickup.

The exhibition space was austere. The pots lined up in groups, each with its own tiny paper tag that included the price and the name of the vessel. Everything was heaved out onto the displays. Rather than the pots being given some space, they were positioned en masse, which is a stylistic choice I had become accustomed to after being here a while: at least you knew that nothing was hidden in the back room. It makes exhibitions like this feel a bit more like you're in a shop, compared to 363

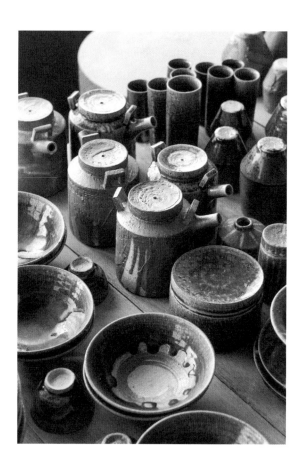

Ken and Doi inspecting rows of my wares, scrubbing acid onto those that needed it, and making sure they were all presentable for my exhibition at Kanoya Gallery. I've always wondered what they really thought of them, as few words were ever spoken, although Ken did tell me once that he saw 'a spark in the Oribe', and Doi purchased one of my taller green bud vases to accompany a trio I gave him – that's all I have to go on.

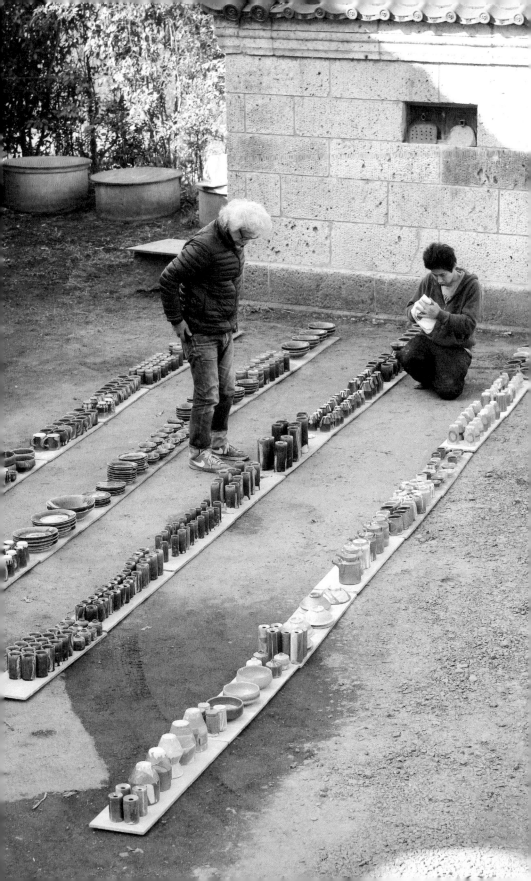

a gallery. I wondered whether it was because ceramics are often seen as more of a craft than an art, and thus are displayed accordingly.

The exhibition would run for eight days and I came up with the name 'Divergencies'. I was given that entire weekend off and spent it with my mother, who had flown over for three weeks. We travelled to Nikkō, a town in the mountains north of Tokyo that's known for its sprawling Shinto shrine, built in 1617. The largest temple was being renovated, so instead of it being out in the open air, it was hidden beneath a vast complex of scaffolding and plastic sheeting, onto which a *trompe l'œil* image of the temple had been perfectly painted. Lavish structures towered above the surrounding canopy of trees and we spent the day jostling around with all the other visitors. It felt like a holiday – at last I was a tourist rather than an apprentice.

IT WAS SPRING. My making and firing had taken most of January and February and the trees were just starting to blossom, finally some colour. For my exhibition opening, Ken had told me local potters were coming, the mayor too. I made a speech that was translated as I spoke by Ken's daughter Reiko and my mother stood in the background, grinning from ear to ear; really it was she who had helped everything lead up to this point. We all gathered around the entrance of the gallery, the sun beaming over us; there were refreshments. I met each of those who attended and bowed continually – it was becoming second nature by this point. Even after arriving back in London I kept it up for a few months, unconsciously. I received wrapped bundles of pristine flowers and a letter adorned with delicate pressed florets imbedded in the paper from the president of a local bank. There was a piece in a local paper too, a little teapot of mine printed in black and white with a sea of Japanese text surrounding it.

For the next eight days I lived at my exhibition. Every morning I'd turn up at the gallery and make myself at home. People came and went steadily during this period, and to my utter surprise most pots actually sold.

Labels, prices, pots in lines and lots of options. That's how my work was displayed in Kanoya Gallery. Many I liked, lots I didn't, and if I had the chance to do it all again my output would be very different. My *chawan* were sold with accompanying *tomobako*, the wooden boxes in which they can be stored. Each box bore my signature and a description of what was inside, plus my maker's mark stamped in red. I've never felt more nervous about writing on anything in my entire life.

Visitors told me they were from Tokyo, two hours away, with others coming from still further afield. A handful of my online followers even made the journey, people who had been following my pottery posts for three years. We'd have tea together and I'd bow profusely as they left, another little red sold sticker stuck to a pot's label. At midday the gallery owner would disappear to fetch lunch and she'd return with thick, fluffy sandwiches in decorative boxes.

I'd had to carve a rubber stamp for this show; first it was pressed into sticky red ink and then this seal was stamped onto the wooden *tomobako* Ken had had made for my *chawan*. The pots fitted perfectly inside and, once they were closed, I wrote on the lid in flowing inky strokes what was held inside. I asked the gallery owner if she knew where I could purchase one of these red ink containers and she cried out in laughter as she rooted around in her desk, pulling out a little wrapped gift.

The exhibition came to an end. I had sold far more than I imagined I would and what was left was packed into crates to bring back to Ken's. I'd liked my time there, the brief change of pace felt like a holiday, but my old routine immediately kicked back into life.

Ken had me throw *yunomi* for a week, by now a task that seemed almost second nature to me. I could zone out almost entirely whilst throwing these; it's incredible what muscle memory can do. My mind focused on the music that filled the studio, thoughts about home and plans after my return. Throwing on an electric wheel has its rhythms but they're confined to the movements you do with your arms and hands and the shifting of the pedal. Whereas on a kick-wheel you're constantly thinking about momentum – at least at the start I was. I'd throw and think about when the wheel had to be kicked to retain rotation, but after a certain point it becomes subconscious, my leg suddenly kicking out of its own accord to keep the wheel spinning. If throwing on an electric wheel is seen as a meditative and mindful activity, then mastering the kick-wheel is like reaching enlightenment. I most certainly didn't master it but I think I got the hang of it.

As I worked Doi would bring me new clay bodies to try and I'd lay the full ware boards out in the sun to dry, the colours ranging from bright yellow to red, to muddy brown and dusty grey, the raw materials different in each. A new style of plate joined the ranks too, painless compared to the last, with a straight-sided rim surrounding a wide expanse of clay that had Ken's distinguishing swirl pressed into the surface, a motif of his I had been curious about. It looks like two intersecting spirals and I always envisioned that it would be difficult to do. In reality, Ken just ran a wooden kidney over the surface, pressing one corner in, starting on the outside, swiping it into the middle of the dinner plate, and then sliding the tool outward again. One spiral in, another spiral out, the two intersecting. It couldn't be simpler yet it took me a few tries to get it right, looking purposeful, not contrived.

Alongside throwing I had two other tasks, both of which were outside. The weather was glorious now; sun poured over me as I worked preparing kiln shelves for a wood firing Ken would do in a few months. He and Doi were inside making pots for this firing day and night, as, in comparison to the trolley kiln, the *noborigama* wood kiln was many times larger, fitting some 900 pots inside and encompassing half a year's income. It took 2,500 bundles of wood and 50 sacks of charcoal to fire and I was tasked with preparing the kiln and much of the fuel.

After sweeping it inside and out, leaving the dirt floor immaculately swept, there were sixteen tons of wood for me to get through, to split, pile up and move closer to the multi-chambered kiln. I would sit with a mechanized splitter in front of me, which I'd drag around so it stayed in the sunlight. I'd refuel the petrol-guzzling machine and top up the oil and then to start it I'd heave with all my might on a long cord, like you do for a lawnmower. It stank of oil, spluttering and jigging into life. The machine was loud and droned as it turned logs to splinters. I'd load the logs onto it, cutting them into smaller, more manageable pieces, which I would then throw into an ever-growing heap. At the end of the day Doi would drive the 369

For my final few weeks in Japan, Ken had me throw batches of *yunomi*, each made with a different stoneware clay body. Some were buttery smooth and threw with such ease, others split and tore as I bellied the walls out, and some were so coarse they left my hands red and raw.

A few hours' worth of wood, neat here, soon to be a mess from being poured out onto the ground. Each wood-firing required 16 tons of split wood, much of which I stacked neatly around the kiln, ready to be lobbed in.

truck over and together we'd move all the slats of wood over to the kilns, where it was stacked neatly and tied up with rope to prevent earthquakes or wind from sending the towering walls of wood crashing down. On the tops of these walls, I fastened sheets of corrugated metal, to keep the rain from soaking it.

This period feels like a dream. I was content in a way I can't ever remember feeling before and there was an eagerness building up each day as the time to return home drew closer. Six months isn't long, but it had certainly felt like it was – the sheer amount I'd packed into those months was staggering. I'd more or less been thinking about pottery every second for six months straight and I think that's why those final few weeks were so peaceful as now I wasn't thinking about pots. Rather, I took each day as it came, the anticipation of returning home to my family and friends flooding me with a sensation of warmth that grew ever greater, yet I still savoured my last few turns kicking *yunomi* into life for Ken.

The quality of the work you produce becomes so important when you work in a town with four hundred potters all essentially competing, and I'd miss the respect the local people had for clay, for pots, for rituals and green tea at three o'clock. There is one part of the routine that has stuck with me since. I have to have lunch at midday on the dot, just like we did in Mashiko. I can feel my stomach yearning, waiting, conditioned for when the hands hit twelve.

My flight home was very early in the morning, and the plan was to drive to Tokyo and spend a day there; then, very late at night, Ken would drop me off at the airport and we'd part ways. I asked Ken if I could take a photograph of all of us on my final day in Mashiko, and I came in early in the morning to find them all dressed quite smartly; Doi had even put a clean shirt on. I collapsed my clay-encrusted tripod, scouted for a good spot, and settled on taking a group picture outside the main studio's sliding doors. Ken and Yoko stood to my right and Doi to my left and I kept them there for ten minutes as I walked

Stills from my commute on 31 March 2018, a few days
before my departure. Mashiko was covered with
blossom and a warm, almost dream-like, golden light.

back and forth between them and my camera, setting the timer and taking long bursts of images after I'd rushed back – I couldn't afford not to get a successful photograph.

It was our final teatime at three o'clock. I ambled up to the house after stacking the last bundles of wood, and Ken handed me a beautifully wrapped object. As I took it in my hands, it felt strangely familiar. Unwrapping it, I recognized it immediately: it was the golden *yunomi* I had sipped tea from every day for the past six months. It's my most prized possession, a vessel I only drink from these days on very special occasions.

THIS WAS THE END of the road, the last few days of my ceramics education. I'd been purposefully working with clay since I was sixteen, and now I was twenty-five years old. I wasn't sure what normal life would look like after returning home, there'd always been something else lined up. Since becoming an adult, I had always worked somewhere for a potter, learning and apprenticing, but soon I'd have to propel myself forward alone. I was nervous, again, for what the future might hold but there were some aspects I couldn't wait for. I had fallen into a rather unhealthy routine of waking myself up at five in the morning every day to post online, in order for my posting schedule to remain the same – this was to account for living nine hours ahead of where my larger audiences online lived. At this point I'd posted every single day for three years, without ever missing a single one, no time zone would stop that. It's been eight years now and I'm still yet to miss a day. On those rare days I post late, if I'm on the Tube or seeing a film in the cinema, I end up with a slew of texts from my family checking in, asking if I'm OK.

I ate my final supper in Mashiko. All of Ken's family and Doi were sitting around the table we'd had our tea-time at most days, hunched in silence as we sipped and contemplated the work ahead, the tea shimmering in my golden *yunomi*. I said goodbye to Doi, awkwardly.

It's hard to say farewell when you can't really understand each other but goodwill there was,

Yoko, Ken, me and Doi. I can't look at this picture
without a smile spreading across my face.

the bond of apprentices. We understood what it takes, the hours invested, the fatigue, the ceaseless repetition, the sacrifice of freedom in order to gain skills that'll hopefully stay with us for the rest of our lives. I was sad he wouldn't be coming to Tokyo with us the following day; we'd spent practically every day together since I had arrived after all, and suddenly he'd be gone. We shook hands, bowed too, goodbye Doi ...

I cycled home and thoroughly cleaned the apartment, stuffing my suitcases. One had remained on the floor half unpacked this entire time. I wrapped clothes around pots and two precious bundles of pottery tools. I scrubbed clean my camera equipment and carefully positioned it encased in underwear, and then I was done. I left a pot I'd made in the kitchen for a future visiting apprentice to find, stacked, surrounded by all the others, and switched the heated toilet-seat off – goodbye, friend.

Ken said he'd be at the apartment early the following morning to drive Yoko and myself to the city. I hadn't spoken to Yoko much but she was always there, always smiling. She was quiet, at least when I was around, but I could see that she ran the place. We arrived at lunchtime, parking down in the depths of the city in a sparkling clean carpark, waved in by uniformed guards. It was heaving, people ebbed and flowed neatly and we crossed through the crowds, up a tiny staircase to a secluded sushi restaurant, the smell of warm rice and miso hitting my nostrils. We sat along a glassy smooth wooden counter and the chef in front of it served us *nigiri* sushi that melted in my mouth, one by one, each very light and stupendously delicious. We stayed for an hour, eating whatever was placed in front of us, and I asked questions I thought I might never be able to again.

Afterwards, bellies full, we slowly strolled through the many levels of Roppongi Hills, cherry blossom falling like snow, and as dusk approached we hopped back into the car and drove to a yakitori restaurant, where we met Takashi, Ken's friend and colleague from Mashiko Potters International Association, who'd helped arrange

my trip. The night ran on, the chicken skewers too, and my glass of beer never seemed to empty. I'd miss them but I missed home more and I was ready to return.

I was filled with emotion on the long flight home, thinking back over the years of exertion, of learning a craft, becoming a maker, a potter – I was no longer anyone's apprentice. From my experience, for the most part, potters tend to be compassionate people. Both Ken and Lisa have poured so much into this craft, and beyond their own practice they pursue routes to help others into it, to make sure the craft persists. Apprentices learn their secrets and arm themselves with extraordinary talent, with which they can then head off into the world. Hopefully, one day I will be in a similar position where I can take on apprentices of my own, so that I can pass knowledge on in the same way it was given to me.

As a culture, the Japanese commit themselves to craft like nobody else. They master it to a point that's often unseen in the West and that's what I travelled there to experience, to see the minds behind the pots and how people dedicate themselves to a craft. That was enough for me. I'd prefer to leave it as a one-off experience, rather than taking physical aspects from it, such as making the same traditional pots and glazes and jamming them into my still-developing aesthetic. The qualities I hope to have absorbed are an appreciation of material and of handmade objects, and an industrious work ethic; or perhaps there's something deeper that hasn't made itself known yet. Ken made vessels of all shapes and sizes, bowls of ever-changing form and vases that followed suit. As a maker, I tend to have a strict, self-imposed set of rules of how to create, but after seeing Ken blow that out of the water and still somehow manage to make a legion of shapes resemble his style, I have tried to push myself to be more adventurous and to vary the types of forms I create. Since departing Japan, I keep an eager eye on what Ken and other Mashiko-based potters are up to. There's something idyllic about the pottery towns that exist in Japan, and as a ceramicist visiting from another country I'm quite jealous 377

of them. I want a close-knit community of craftspeople, to have access to nearby raw materials and for dozens of local tool shops, museums and galleries to be a short walk or car ride away. I'd be lying if I said anything like it exists back home and I frequently long for such a society here; not only the widespread appreciation of craft, but the collective caring for one's streets and neighbourhood. After experiencing that for six months, even only indirectly, it makes me wonder why such a way of life isn't possible back home. Or perhaps it will be one day. As Ken once told me, 'We've grown up' – I presumed he meant as a country.

Nowadays, I'm often asked for advice on how to pursue a life as a potter. My initial response is to say that I feel like a fraud: I'm still only near the start of my career in ceramics and most of that so far has been spent as an apprentice. I don't consider myself an authority on the craft in the *slightest* but I've found that having a sizeable audience online can skew people's assumptions of how successful you are. And whilst having a lot of followers is remarkable and, frankly, still surreal, I feel like my pots are always lagging behind, not quite reaching the image I see in my mind. I continually see other potters' work and dream of being at their level, but maybe that's just what it's like for all of us. So, the advice I try to pass on is this.

First, if you're able to, test out as many different methods and techniques as you can before settling on one. The world of ceramics is vast and there are infinite paths you can take, and typically potters choose one or two styles to dedicate themselves to – but if you haven't tried as many options as you possibly can, you may never settle and find the one you truly love, the methodology that honestly reflects you. Secondly, and perhaps even more importantly, if you want to become a ceramicist, a potter, an artist, invest in your own personal skill. Even as a wary advocate for using social media as a tool for propelling a business, as in my career, I didn't let it become the focus until after I'd built up a certain level of expertise. Your own personal skills will last your *entire* life, whereas the online world may only be fleeting.

Craft, making and art are much more than just school subjects for me; they've become my whole life. I've found fulfilment from throwing and using handmade pottery that I never imagined I'd find in anything; and that has seeped into everything I do. It has led to an appreciation of the objects that surround me, and I like to think that all of our lives are made richer when we care about the possessions that can accompany us for decades, especially when those objects tell the tale of someone who has dedicated their life to craft.

Sometimes, pots can bear importance beyond that, too – I'm thinking in particular here of burial urns. There's a solemn conversation I've had with my father a handful of times, albeit normally in a light-hearted manner, if that's possible, about the creation of his urn – the pot he'd like to spend the rest of his days in. He wants to inspect it before he goes, to make sure it's acceptable, and I have visions of a room piled high with rejected vessels as I spend decades pursuing a satisfactory repository.

THE YEAR FOLLOWING my pilgrimage to Japan was spent searching for a studio in London. I visited dozens of spaces, most up steep flights of stairs or down long corridors, and many had no water access at all. East London is packed with useless, expensive studios that are progressively being made for desks and screens, not ceramicists or artists. I needed ground-floor access, double doors, a water source and a landlord who was happy for a gas kiln to be installed and a chimney shoved through the roof.

It was demoralizing, and I came to the conclusion that I'd have to be content with a smaller space and an electric kiln, which meant proceeding without reduction firing, or the glazes I'd come to love. The decision had been forced on me, and I would have to let all those years learning to gas fire simply evaporate.

I'd compiled a long, exhaustive list on my computer of websites that were regularly updated with new work-shops, studios and live–work spaces, and every morning I'd open all of them, refresh them, and

trawl through the list. No, no, horrible, no water access, tiny, too far away, too expensive, I'd never fit a kiln in there. Then I saw it. High Barnet, all the way up in north London. Old brick walls washed white, a mezzanine that would be ideal for storing all my packaging materials and a pitched roof, perfect for sticking a chimney through. Double doors on the outside and thick teal swinging doors inside. A bathroom! Even a bathtub! A kitchenette! And a large open area I could already picture a kiln in.

My face was practically pressed against the screen. I had to see it. I grabbed my phone and made the call, arranging to visit that same day. It took two buses to get there. I ran up the hill and through the high street. Out of breath, I met the agent, mumbling my words as I told him my story while we looked around. It needed some work, and it wasn't nearly as clean as the pictures online had suggested. The tiny kitchen was in a state, with vinyl tiles curling off the floor and black grease smeared on the wall where an oven had been. Otherwise, it was perfect.

'Has anyone else come to see it yet?' I queried. 'No, you're the first, but someone else is coming in five minutes or so.' She arrived, looking around perhaps even more enthusiastically. I loitered outside, taking some pictures and inspecting the roof where a chimney could possibly go. They walked outside together, the lady speaking loudly: 'Yes, of course! I'll be in touch this afternoon, I'm *very* interested!'

My heart sank. It was now or never. I'd already told the agent I was interested too, and as I looked over he simply gave me a wink. It was mine.

My very own studio in north London. Workbench built and
shelves drilled to the walls, waiting for pots to fill them.
Is it strange that I miss how empty it was?

The Making of a Mug

The mug is a fundamental shape that potters learn to create whilst first practising to throw on the wheel. Centring the clay, pulling up a basic cylinder, trimming the cup's foot and attaching a usable handle – with so many skills rolled into one object, to this day I still relish the challenge of making a batch. And then there's the matter of clay type, decorating, glazing and firing the mugs, offering practically infinite variation. Mugs can be simple or complex, straight-sided or textured with throwing rings or facets. They can be plain, colourful, highly patterned or decorated simply by the flames particular to wood or soda kilns. There's no one way of making a mug, but this is how I do it.

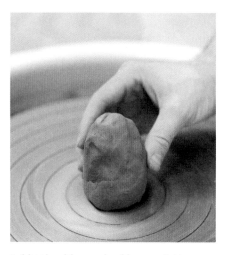

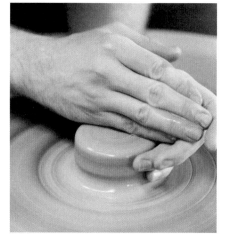

1. I begin with a wedged lump weighing 300 grams, rolled and patted into an oblong shape ready to be thrown with. I use soft clay for mugs so it's easy to centre quickly, as I usually throw them in batches of fifty to a hundred.

2. This piece of clay is thrown firmly onto the wheel head as centrally as possible, then the stoneware itself is centred. Wet hands are paramount, as is a rapid wheel speed and lots of manoeuvring to get all the clay particles (platelets) nicely knitted together, a process called 'coning'. Centring is the foundation for our mug, so it needs to be solid.

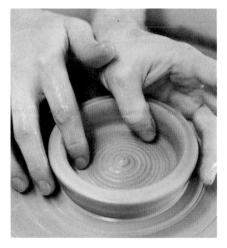

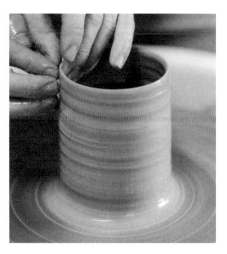

3. With a forefinger and thumb, I create a well in the centre, opening a hollow with clay left in the base approximately 4mm thick. Once this depth is set, and with the same hand position, I draw my fingers horizontally across the bottom to form the base. Once it's widened to my liking, I'll use the side of my thumb to compress the more prominent lines, neatening the floor of the vessel.

4. Between a knuckle on the outside and fingers on the inside the clay walls are lifted up in numerous pulls. Each consecutive pull thins the sides, my aim here being to keep them consistent in thickness from bottom to top. I pinch the rim between finger and thumb to bevel it, creating a lip that's pleasant to drink from.

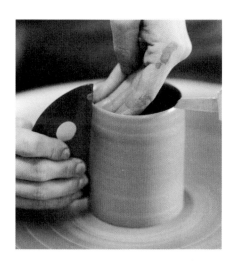

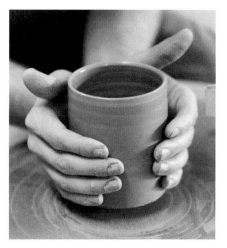

5. With the height and width set, tidying up can begin. I hold a metal kidney, just hovering over the clay, following the profile I want, then I push the clay from the inside out against this sharp edge, from bottom to top. This scrapes away all the excess slip, straightening the walls and leaving me with a surface that's slightly tacky as opposed to sopping wet.

6. Excess water is sponged out and a chamois leather is draped over the rim to soften it. Then, a textured metal wire is dragged underneath the mug, separating it from the wheel head. I quickly scrape any slip off my hands, then, with dry palms, I clasp my hands around the pot and gently lift it away, spinning the wheel at the exact moment I lift, to break any seal there might be.

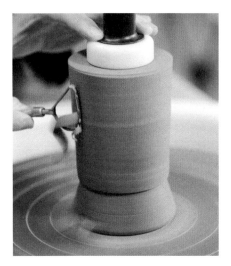

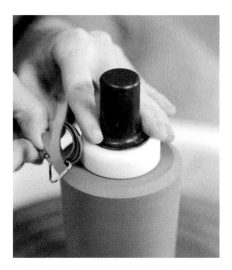

7. Once the mugs have turned leather hard, typically the following day, the forms are placed over a chuck – this is a solid lump of clay with a tapering shape that holds the pot in place and keeps the rim round. I tap centre it in place and gently push it down with a nylon spinner tool (the black and white device made by Richard Carter). I use a tungsten carbide trimmer to remove clay from the walls, thinning them and refining the shape.

8. After the sides have been dealt with, I move on to the bottom, bevelling the encircling edge to create a more obtuse angle that will ultimately be more robust and harder to chip. The spinner is then prised off, the bottom trimmed flat, and the whole thing burnished with a smooth metal kidney to a glassy finish.

9. This is one of my maker's marks, carved from a block of porcelain; it's used at this stage to stamp all my vessels with my minuscule 'F' symbol.

10. My mark is pushed lightly into the trimmed base and rocked from corner-to-corner, so as to imprint legibly. It's small, and can be hard to find on reduction fired wares, since the clay takes on a toasty colour and blots of iron freckle the surface, yet it'll always be there.

11. Upturned mugs, all trimmed and now drying slightly before the next stage, which is handling. As I've just removed a thin skim of clay from the outside of these, they are slightly soft, and if I were to attempt pulling their handles immediately, there's a very good chance they would deform as the additional clay is joined and shaped.

385

12. I take a block of clay and fashion it into this shape. This is where all the handle 'blanks' will be pulled from. I roll it on the table so that it has a thinner, tapered end, and from there, with a wetted hand, I'll pull it longer and finer.

13. The block is held aloft with my left hand, which is kept dry, whilst my right hand is dunked in water and squeezes the clay, right close to the top of the block, before pulling down the length, maintaining the same pressure from top to bottom. My aim is to pull a long strand of handles, in a similar way an extruder might, only with this method there's no machinery to tidy up afterwards.

14. Once long enough, with a consistent cross-section, each 'blank' is snipped off against a sharp table, or board's edge, each equally long and touching. Fingerprints don't matter at this stage as these blanks will be attached to the mugs and pulled further. In fact, it can help if they touch each other, since it stops them from drying out too much.

15. A small patch on the mug's wall is scored (scraped with a serrated kidney) and slipped (daubed with clay the consistency of cream). This creates a softer patch of clay on what was a leather-hard body, which should make attaching the blank easier, with less chance of joints splitting.

16. The stub of clay is forcefully, yet carefully, pushed onto the prepared area. I wiggle the blank as I do, clasping it from the back so as not to deform the length. Inside the cup I brace opposite the area I'm applying pressure – that way the wall doesn't bow inward as I press the stub on.

17. The handle blank is then neatly blended into the body, which helps to secure it in place, then the length is once again pulled in a similar manner to earlier, only this time I make it much thinner, with an ovoid cross-section so as to remain comfortable. The key here is quick, consistent pulls with plenty of water.

18. When the strap handle is long enough, I use the tip of my thumb to score three grooves down its back. Then with dried fingertips, I loop the handle back down in a graceful arch and smear it firmly back into the body near the base – all before using a wetted finger to clean over any prominent fingerprints or smudges in the clay.

19. A few days later, once leather hard, the mugs are packed tightly into my electric kiln for a bisque firing to 1000°C. This hardens the clay, drives away most of the moisture and results in a body that's absorbent, so the water in the glazes can be drawn into it, leaving a layer of raw materials on the surface of the mug.

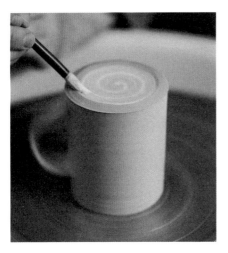

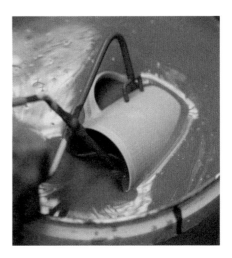

20. After being bisque fired, the clay lightens in colour and the mugs can be handled comfortably in a way that doesn't deform them. After unpacking, each mug is centred on my potter's wheel and a layer of wax emulsion is brushed over the base. This means that when the mug is dipped into glaze, the liquid won't adhere to the bottom – otherwise it would stick to the kiln shelves.

21. Each mug is held with a pair of tongs, tightly, but not too tightly, as an overly strong grip can cause the pointed arms to pierce the thinly trimmed walls. I dip each in glaze for several seconds before removing them and moving them around in such a way that the glaze settles neatly, in an even layer, over the surface.

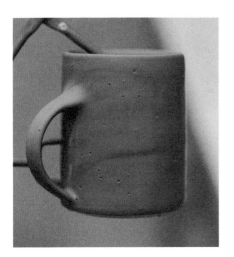

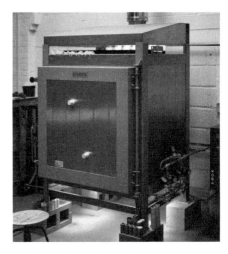

22. Once glazed, the mugs are set aside to dry out for a day or two. This way, much of the moisture leaves the vessel, and, for this specific glaze recipe, the surface becomes easier to clean up. I fettle over the tong marks, the powdery glaze that's removed as I rub my fingers over them filling the holes, and the bases are sponged impeccably clean.

23. My gas kiln is filled with mugs, the gas lit, the door closed and then a nine-hour firing commences. At 860°C the kiln is set into a reduction atmosphere, which continues, lessening off, until 1290°C, or until cone ten is flat. As the firing takes place, I peek at the pyrometric cones through spy-holes in the door, taking care not to singe my eyebrows.

24. The finished, glazed mug, unpacked from the kiln roughly two days later, once cool. Each is more or less the same, yet these glazes and the reduced atmosphere create subtle differences from pot to pot. I can't wait to see how my mugs look in ten years' time.

Glossary

Bone dry. Clay that hasn't been fired yet, but has completely dried out prior to bisque firing. It's very fragile at this stage and needs to be handled carefully.

Bisque/bisque ware. The name that is given to pots which have been fired to approximately 1000ºC. The clay becomes stronger, and porous, ready to be glazed and fired again.

Coning. The process of moving the clay up into a cone shape, and squashing it down again during the centring process. It aligns the particles of clay (platelets), making it easier to throw, as if a continuation of **Wedging** (see below).

Fettling. Tidying up and cleaning off any rough clay or stray drips of glaze. This is usually done before the pot has been glaze fired.

Greenware. This describes pots that are still in the process of being created, such as bowls drying after being thrown, waiting to be trimmed, prior to bisque firing. (Derives from 'green wood', which is alive, soft and pliable.)

Grog. A material that's added to clays to add strength. It's often crushed, fired ceramic, which is ground to various grades and mixed back into clay. It adds texture, causes the pot to shrink less, and helps to prevent cracking and warping.

Leather hard. Clay that has partly dried out and is no longer completely malleable and soft. At this stage wares are often trimmed and finished before being bisque fired.

Oribe. A type of Japanese glaze, characteristically very green and glossy, although it can come in other colours. It's very fluid, often flowing down the sides of pots, and is sometimes paired with iron brushwork, white and transparent glazes.

Pugging. Clay can be prepared with a pug mill, a machine that churns the clay up, making it completely homogeneous, before extruding it through a die plate. Pugging is the process of running clay through the machine. (Some even de-air it by way of a vacuum, which makes it easier to work with.)

Pyrometric cones. These are tools used to measure heatwork during the firing (heatwork being heat measured over time). They're made from similar material to pots, but the different coloured cones are subtly different to one another, each bending over to mark a specific temperature range. They're placed alongside the pots during a firing and are observable via spy-holes in the side of the kiln. Once they've bent over sufficiently the firing can be concluded. I use cones 8, 9 and 10, covering a temperature range of about 1250–1300ºC.

Raku firing. The process of removing pots from a red-hot kiln during the firing and thereafter allowing them to cool, either simply in the air, or by covering them in combustible materials to create special effects. This is done at the relatively low temperature of 1000ºC.

Raw firing. This is when you fire pots only once, skipping the bisque firing – or rather, incorporating it *into* the glaze firing. This saves time and energy, but it doesn't work with all types of clay and glazes.

Raw glazing. The process of glazing leather-hard wares, as opposed to glazing them after they've been bisque fired. The glazes used are slip-like, meaning they contain a high percentage of clay, which helps it adhere to leather-hard pots that aren't as porous as bisque fired wares.

Reduction atmosphere. The state a gas or wood kiln can be placed into, where there's insufficient oxygen for the fuel to burn properly, resulting in a chemical reaction that produces certain colours and effects.

Saggars. Ceramic containers into which wares are placed while being fired. They protect the pots from flames, debris and smoke, which could discolour or warp them.

Setters. Specially made ceramic stands that are used to help fire certain shapes – typically plates, but they can be made for a variety of forms.

Sherds/potsherds. Pieces of smashed pottery that are typically found in archaeological sites.

Shino. A broad term used for Japanese glazes that are commonly white, contain a high percentage of feldspar and are traditionally fired for long periods of time. The surface is often covered in pinholes, crazing and trapped carbon from the firing process.

Slip. Watered-down clay, creating a slurry that can be used to stick separate pieces of leather-hard clay together. A clay slip can also have colourants and stains mixed into it, which can be used for decoration, brushed onto leather-hard wares. Liquid slip is also poured into moulds when mass-producing pottery, a process called slip casting.

Soaking. The process of sustaining a specific temperature during a firing, often towards the end, to help mature and properly melt the glaze.

Soda firing. This is when bicarbonate of soda is introduced into a kiln's internal atmosphere when it is near its top temperature. The soda turns to vapour and binds with the silica in the clay, creating a glaze that follows the path of the flames.

Stillage. A drying/storage rack, often wooden, into which ware boards, carrying pots, can be slotted.

Throwing batt. An external board that's placed on the wheel head and thrown upon. The batt can then be lifted away with the pot still on it, without having to touch the vessel itself.

Wadding. A clay-like material with a range of uses, such as for placing underneath pots while they're fired – especially useful for wood/salt and soda firing – or for positioning between a pot and its lid, so they can be fired together without fusing. (I mix my wadding from 50% kaolin and 50% coarse alumina hydrate.)

Ware board. A wooden plank that pots are placed on during the creation process, or when stored afterwards. Often lifted and balanced on a shoulder to be carried around.

Wedging. The process of kneading clay by hand to fully blend it to one, even consistency – this removes air pockets, and makes it ready to use.

Further Reading

Books

A Potter's Book by Bernard Leach (Faber & Faber, 1940). I used to carry this book around with me as a student – it lived in the bottom of my backpack. The words, combined with the illustrations, set my mind alight.

Functional Pottery by Robin Hopper (A. & C. Black, 2000). Same as the above. Seeing all those cross-sections of thrown pots helped me see what I was doing wrong. My copy is falling apart from use and held together with tape.

An Illustrated Dictionary of Ceramics by George Savage & Harold Newman (Thames & Hudson, 1974). I've opened this book up thousands of times to remind me of things that I should very well remember.

Lucie Rie: Modernist Potter by Emmanuel Cooper (Yale University Press, 2012). I'm for ever in awe of the world Lucie span for herself and the legacy she left behind. I've always been inspired by her powerful dedication to the craft.

The Japanese Pottery Handbook by Penny Simpson & Kanji Sodeoka (Kodansha, 1979). A book that lived in Ken's studio during my visiting apprenticeship – simple, illustrative and completely invaluable. Thank goodness it exists, since it solved many moments lost in translation.

The Complete Guide to High-fire Glazes: Glazing & Firing at Cone 10 by John Britt (Lark Ceramics, 2004). My precious volume is covered in glaze and scribbles – this is one of the first books that got my interest in glazes going.

Websites

www.digitalfire.com A website perfect for filling in the blanks and providing more information about pottery than you or I will ever need to know.

www.youtube.com Specifically videos by Simon Leach and Hsin-Chuen Lin. As a teenager I watched these late into the night, looking for something that would make spiral wedging, or pulling up the walls of clay, 'click'. Nowadays you'll find a wealth of high-quality videos here, enough to help you learn almost any aspect of the craft.

www.cfileonline.org
www.ceramicreview.com
www.ceramicartsnetwork.org
Three websites filled with articles, images and exhaustive information.

www.vam.ac.uk/collections/ceramics The V&A's ceramics collection is unrivalled, and their online archive of imagery and information is a goldmine. I've trawled it for hours, and often look longingly at my favourite pot of all time (FE.175-1974).

Acknowledgements

This hefty tome would not exist, were it not for the help of so many people over the past thirty years. I hope you all know how happy you've made this hermit potter. Boundless thanks to the following:

Caroline Hughes, for first showing me how to make pots and giving me a purpose in life. Gus Mabelson, Geoffrey Healy and Ann McInerney, for your dedication to teaching enthusiastic, budding potters. You've shaped a generation of ceramicists.

Lisa Hammond, who set the foundations of my career, taught me how to soda fire and let me tirelessly hone my skills. Darren Ellis, who guided me through that apprenticeship and to this day answers all my annoying questions about clay, glaze and firing.

Ken Matsuzaki, for showing me so much and for letting me share it with the world. Doi Tsutomu, for shepherding me throughout those six months. I wish I'd got to know you both better.

Mark Reddy, Anatole Gadsby, Paul May, and most of all, Kate Gadsby, my mother, who set all of this in motion, driving me around the country to ceramics fairs and even starting conversations with potters when my younger self was too shy to do so.

To all my Waldorf Steiner classmates, for your very wise notes on growing up. I miss those years dearly. Peter Montgomery, Steve Meek and Chloë Dowds, friends made in Ireland, who helped me recall two gruelling, studious years. I owe you far more visits.

Ben Clark, for initially reaching out and proposing a book. I'm glad you were persistent.

Richard Atkinson, my editor, for believing in the book and for your candour and scrawled red notes that will for ever stay with me. Matthew Young, the book's inspired designer, who took pots themselves as the starting point for his layout. Sam Fulton, Millie Andrew, Imogen Scott, Fiona Livesey, Ingrid Matts, Thi Dinh and the whole of Penguin Press. What a committed team, a lively bunch, always smiling, always helpful; it was a pleasure crafting this book with you.

Nigel Slater, for being a constantly supportive figure since I was a lowly apprentice. Anna Ploszajski and Callum Forbes, for your knowledge and for carefully reading through my many mistakes.

Daria and Ciro, two sparks who kept me company as all of this went down on paper. Sorry for the ceaseless pottery-talk and for more hours than I'd like to admit staring at the computer. You both made what was difficult at times far less painful.

And finally, to the millions of you who've followed my journey online now for almost a decade. Who'd have thought this is where it would all end up?

Index

N

O

Published in the United States by Ten Speed Press,
an imprint of the Crown Publishing Group, a division
of Penguin Random House LLC, New York.
TenSpeed.com
CrownPublishing.com

Ten Speed Press and the Ten Speed Press colophon are
registered trademarks of Penguin Random House LLC.

Originally published in the United Kingdom by
Particular Books, an imprint of Penguin Books,
a division of Penguin Random House UK, in 2023.

Typefaces: FS Brabo and Drescher Grotesk BT

Library of Congress Control Number: 2023940656

Hardcover ISBN: 978-1-9848-6358-4
eBook ISBN: 978-1-9848-6359-1

Printed in China

Acquiring editor: Molly Birnbaum
Designer: Matthew Young
Production manager: Serena Sigona
Marketer: Chloe Aryeh

10 9 8 7 6 5 4 3 2 1

First US Edition